CRAFTING TRADITION

JOE R. AND TERESA LOZANO LONG SERIES

IN LATIN AMERICAN AND LATINO ART AND CULTURE

MICHAEL CHIBNIK

Crafting Tradition

THE MAKING AND
MARKETING OF
OAXACAN
WOOD
CARVINGS

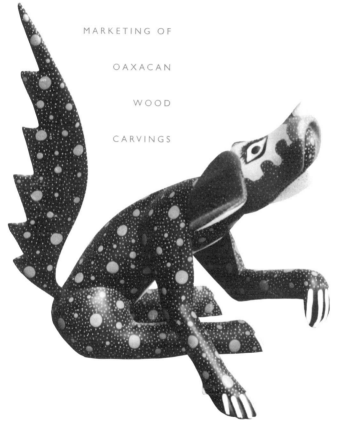

UNIVERSITY OF TEXAS PRESS, AUSTIN

LIBRARY OF CONGRESS CATALOGING-IN-PUBLICATION DATA

Chibnik, Michael, 1946–
 Crafting tradition : the making and marketing of Oaxacan wood
carvings / Michael Chibnik.
 p. cm. — (Joe R. and Teresa Lozano Long series in Latin
American and Latino art and culture)
Includes bibliographical references and index.
 ISBN 0-292-71247-2 (cl. : alk. paper)
 ISBN 0-292-71248-0 (pbk. : alk. paper)
 1. Indian wood-carving—Mexico—Oaxaca Valley. 2. Indian
business enterprises—Mexico—Oaxaca Valley. 3. Culture and
tourism—Mexico—Oaxaca Valley. 4. Folk art—Mexico—Oaxaca
Valley. 5. Marketing—Mexico—Oaxaca Valley. 6. Oaxaca Val-
ley (Mexico)—Social conditions. 7. Oaxaca Valley (Mexico)—
Economic conditions. I. Title. II. Series.
F1219.1.O11 .C443 2003
380.1'457364'097274—dc21 2002151873

CONTENTS

LIST OF ILLUSTRATIONS

BLACK-AND-WHITE PHOTOGRAPHS

COLOR PHOTOGRAPHS FOLLOW PAGE XX

MAPS

TABLES

PREFACE

The first time I saw a wood carving from the Mexican state of Oaxaca was in September 1987 in the living room of a friend's house in Iowa City. This large, roughly formed sculpture of an unfamiliar animal was dully painted in a sickly green shade. Despite (or perhaps because of) its simplicity and weirdness, the carving had a certain charm, and I was intrigued when my friend told me that such pieces were increasingly sold in markets and shops in Oaxaca. She then showed me some better-made, colorful carvings of dogs, snakes, and lizards that had been purchased on a recent Mexican trip. Although I enjoyed looking at the whimsical pieces, I had no idea that the trade in Oaxacan wood carvings would be the main focus of my research in the next decade.

In the late 1980s and early 1990s I took several short vacations in Oaxaca immediately after my teaching obligations for fall semester at the University of Iowa were over. Oaxaca is sunny and mild in December, and I enjoyed the good weather, pleasant cafes, comfortable hotels, and inexpensive, delicious food. The main reasons I kept returning, however, were the state's archaeological

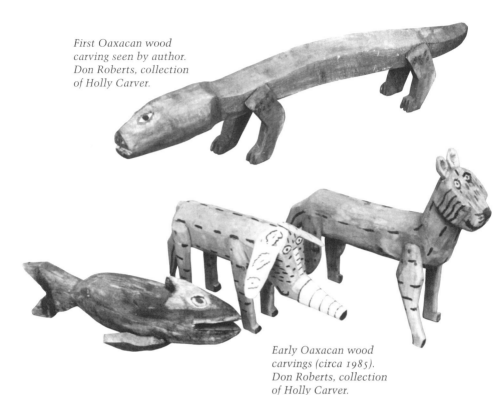

First Oaxacan wood carving seen by author. Don Roberts, collection of Holly Carver.

Early Oaxacan wood carvings (circa 1985). Don Roberts, collection of Holly Carver.

sites, museums, markets, fiestas, and crafts. I was particularly struck by the wood carvings, which seemed omnipresent in hotels, restaurants, markets, and shops. The pieces were more elaborately painted and carved each year as artisans competed for customers. I wondered who the makers were, how they organized their work, and what their incomes were from carving. I was also curious about why the carvings appealed to so many middle- and upper-class tourists from Mexico, the United States, and Europe.

During one of my vacations in Oaxaca, I took a bus tour that included a thirty-minute stopover in Arrazola, an important wood-carving center. I found out on this trip that I had been making several incorrect assumptions about the wood-carving trade. I had thought that carving was a minor source of income for rural residents; Arrazola's large houses and many cars suggested that some people were prospering from craft production. I had been under the impression that the carvers were speakers of an indigenous language; the ones I met were monolingual in Spanish. I had assumed that most carvings were sold to tourists, but houses in Arrazola were filled with pieces that had been ordered by wholesalers and store owners from the United States.

In the early 1990s I began to think seriously about conducting fieldwork on the wood-carving trade. The anthropological literature was full of accounts of misguided development projects, and I had studied several such fiascoes in previous research in Peru and Belize. Many wood-carving families, without being part of a planned development project, were quickly improving their standard of living. Perhaps their experiences would provide some clues about what conditions lead to successful small-scale development. Furthermore, I was reading more and more about how globalization was undermining the economic base of rural communities in Africa, Asia, and Latin America. The carvers' success obviously depended on their participation in an international folk art market. Could globalization sometimes help the rural poor? Or would the wood-carving boom inevitably lead to uneven development, with only a few merchants and carvers prospering? Were the carvers being enticed into relying on a source of income that would disappear when tastes for crafts changed among their middle- and upper-class buyers?

Because many anthropologists work in Oaxaca, I wondered if someone else had conducted research on the wood-carving trade. After talking with colleagues from both Mexico and the United States, I learned that the only significant research on the wood-carvers had been carried out by a journalist named Shepard Barbash, who had written an article for *Smithsonian* magazine (Barbash 1991) and a short popular art book (Barbash 1993). Both the article and book included many striking color photographs by Vicki Ragan. Although I thought that the article and book were readable, intelligent, and witty, the Barbash/Ragan publications were quite different from the more comprehensive and scholarly study that I had in mind. The sociocultural anthropologists working in Oaxaca—a remarkably supportive, cohesive group—encouraged me to proceed with the project.

After an exploratory two-week research trip to Oaxaca in summer 1994, I began serious fieldwork in June 1995. I found a room in the heart of the historic center of Oaxaca on a quiet street directly across from the enormous, ornate Santo Domingo Church. When I walked around the area near my room, I passed many ethnic arts stores where wood carvings were sold. I soon became friends with Saúl Aragón and Víctor Vásquez, the owners of two of these shops. Saúl and Víctor introduced me to many artisans and wholesalers and provided helpful information about the wood-carving trade. On my strolls around the city I also met many other merchants who sold wood carvings.

The bulk of my research in Oaxaca consisted of visits to three wood-carving communities—Arrazola, San Martín Tilcajete, and La Unión Tejal-

apan. Most days I would take public transportation to one of the communities and spend several hours talking to artisans (and sometimes buying their carvings). Saúl lives in Arrazola and introduced me to many people there. In San Martín and La Unión, I met people on my own. The artisans in these communities initially thought that I was either a tourist or a wholesaler. When I explained what I was doing, they immediately assumed that I was a journalist like Shep Barbash who would provide welcome publicity for their pieces. Most people were therefore pleased to talk to me even after I tried to explain that my book (in contrast to Barbash's) would take a long time to come out and might have relatively few photographs. Because the artisans seek publicity for their carvings, I have avoided pseudonyms in this book except where indicated in the text. Pseudonyms are used only where the information presented might place people described in an unfavorable light or otherwise cause problems for them.

My research took place during many short trips to Oaxaca between 1994 and 2001. Although most of my fourteen months of Mexican fieldwork occurred in summers, I went to Oaxaca almost every January for a few weeks and spent three months there while on leave in spring 1998. This sporadic fieldwork contrasted greatly with my earlier research in Peru and Belize, which had been concentrated in a few long stays. Somewhat to my surprise, I found that the short stints of fieldwork spread over a long time had significant advantages. As the peso rose and fell and new marketing channels developed, I was able to observe changes in wood-carving styles, household economic strategies, and the lives of artisan families. My repeated visits over several years also improved my relationships with the carvers and local shop owners as they came to see me as someone with a commitment to Oaxaca (as well as a regular customer for their pieces).

As the years passed, I realized that I could not understand the wood-carving trade without doing some research in the United States. I therefore took advantage of opportunities while traveling around the United States to visit local ethnic arts stores. I interviewed owners of such stores, collected ethnic arts catalogs, surfed the Internet for sites where carvings were sold, and kept track of online sales via eBay. In May 1998 I spent a couple of weeks in Arizona and New Mexico talking with wholesalers and store owners about the wood-carving business. On this trip and several others I went to Mexican border cities such as Nogales, Matamoros, and Nuevo Laredo to look at markets and stores where carvings were sold. Although I learned a lot from my fieldwork in the United States and in Mexican border towns, my research in these places was less intense than my Oaxacan fieldwork.

I know much more about the beginning and middle of the wood-carving commodity chain than I do about the end.

My long-term, intermittent research created certain difficulties for the writing of this book. In some chapters, the descriptions of the activities of particular artisans are based primarily on interviews carried out on research trips between 1995 and 1998. During subsequent fieldwork, I learned about important changes in the lives of some of these artisans but doubtless was unaware of equally significant changes in the lives of others. I therefore have largely avoided the use of the "ethnographic present" (where descriptions are made in an ahistorical context) and have attempted to be as specific as possible about time periods when presenting case studies of artisans' lives.

In June 2001 I traveled to Oaxaca to work with Fidel Ugarte in taking photographs for this book. During this trip, I learned of dramatic changes in the wood-carving trade over the preceding year. While the demand for high-end carvings remained strong, the market for simple, inexpensive pieces had weakened greatly. The collapse of the market for cheap carvings had significant effects on household economic strategies and the organization of labor. Although I have incorporated discussions of these changes into the text, my exposition of the decline in demand is considerably less detailed than my descriptions of the wood-carving boom.

Throughout this book I have used the figures in Table 1.1 to calculate the exchange rate between U.S. dollars and Mexican pesos. When these calculations refer to sales or incomes at particular times and places, they must be regarded as approximations. Although exchange rates fluctuate daily, the figures in Table 1.1 are yearly averages. Furthermore, the rates at banks and change houses in Oaxaca always differ slightly from the official national figures included in Table 1.1.

Crafting Tradition is first and foremost an ethnography of the Oaxacan wood-carving trade. The book can also be read as an extended examination of the double-edged effects of globalization in several rural Mexican communities. Many families in these villages have prospered because of the demand for their wood carvings by wealthy consumers in places such as Boston, Santa Fe, Tucson, Los Angeles, and Minneapolis. Artisan families are often both pleased and mystified by the willingness of tourists and wholesalers to pay so much for their pieces. But they know that tastes change, and their carvings may be worthless tomorrow. The artisans also have seen the carving boom lead to increased socioeconomic stratification within their communities. These uncertainties, dependencies, and inequities are the costs of their success.

Miguel Santiago in his workshop, Arrazola.

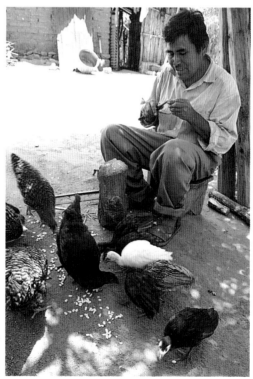

Reynaldo Santiago carving among some chickens, La Unión.

COLOR PHOTOS ARE BY FIDEL UGARTE.

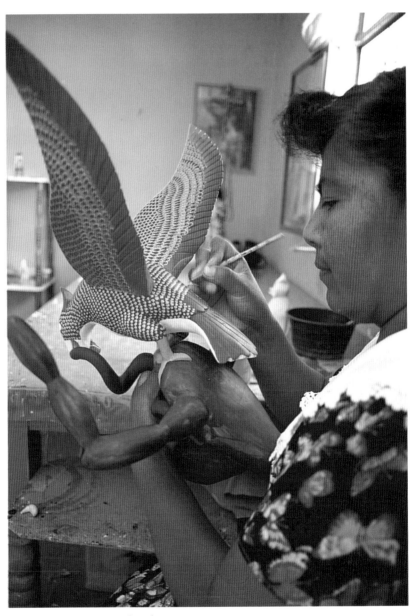

María Jiménez painting details, San Martín.

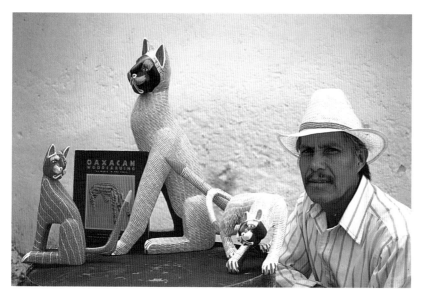

*Margarito Melchor Fuentes
with cats similar to those on
cover of book by Shepard
Barbash, San Martín.*

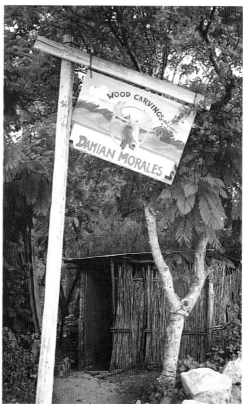

*Sign advertising carvings of
Damián Morales, Arrazola.*

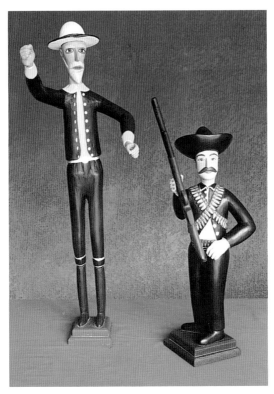

Soldiers by Epifanio Fuentes and Laurencia Santiago, San Martín.

"Rustic-style" carvings by Martín Santiago, La Unión.

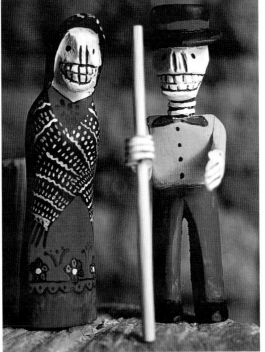

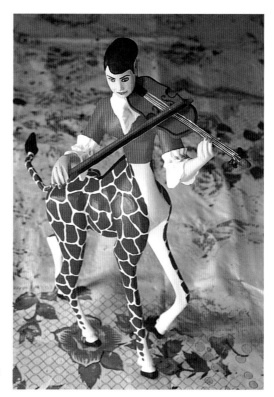

Human/giraffe violinist by Inocente Melchor and Reina López, San Martín.

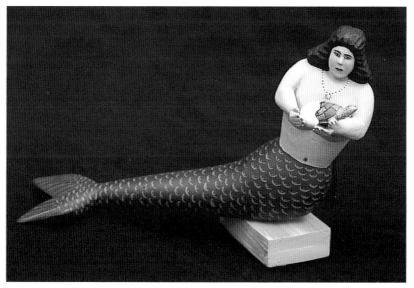

Mermaid by Gabino Reyes, La Unión.

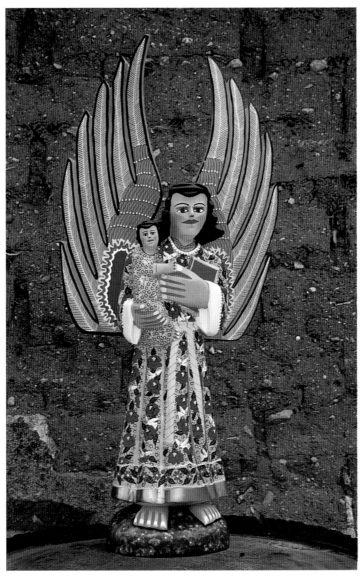

Angel by María Jiménez and her brothers, San Martín.

Devil by Margarito Melchor Santiago, San Martín.

Day of the Dead figures by Eloy Santiago and Plácido Santiago, La Unión.

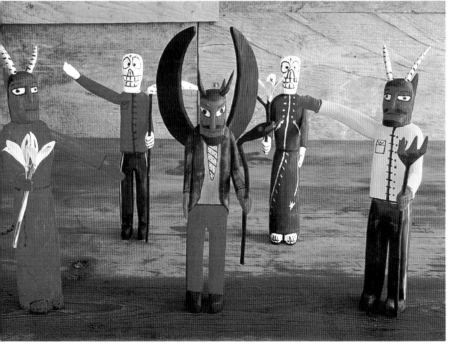

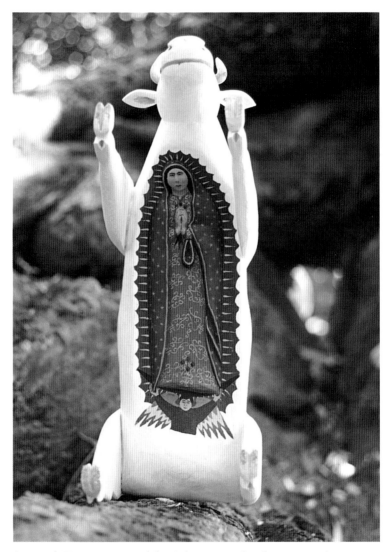

*Cow with Virgin on stomach by Gabino Reyes (work in progress),
La Unión.*

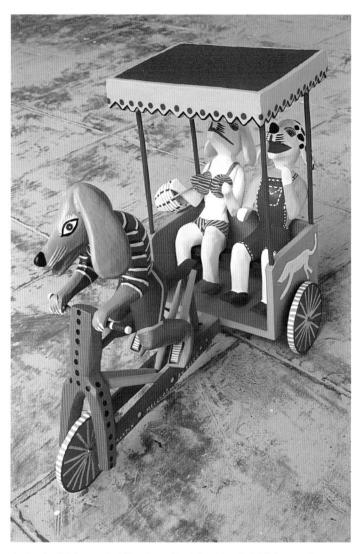

Animals driving and riding in pedicab by Martín Melchor and Melinda Ortega, San Martín.

Cat by Manuel Jiménez family, Arrazola.

Frog by Isidoro Cruz, San Martín.

Cat and mouse by Sergio Santos, La Unión, displayed in Amate bookshop, city of Oaxaca.

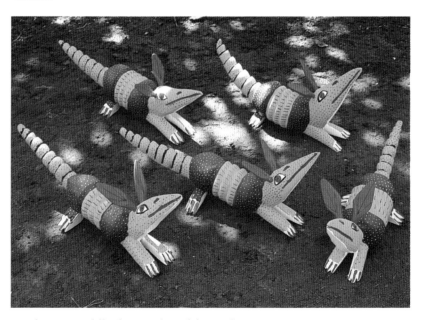

Acrobatic armadillos by Coindo Melchor and Eva García, San Martín.

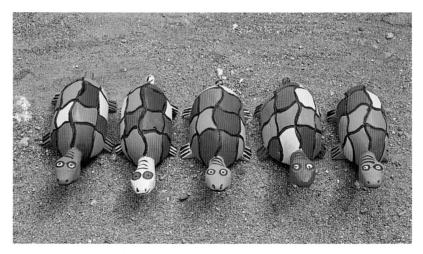

Turtles by Angel Cruz, La Unión.

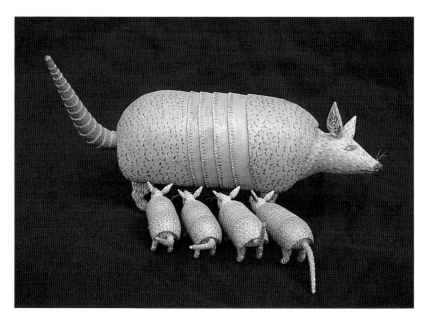

Armadillo family by Gabino Reyes, La Unión.

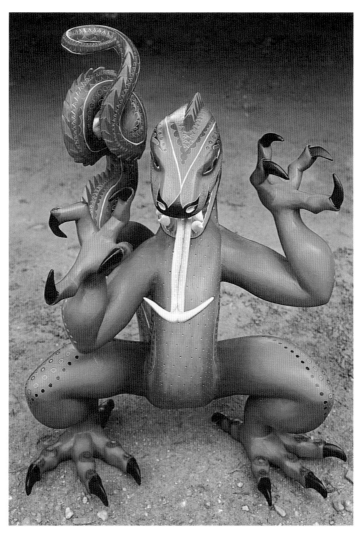

Monster from workshop of Jacobo Angeles, San Martín.

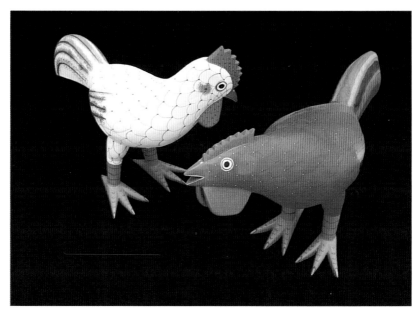

Roosters by Avelino Pérez, La Unión.

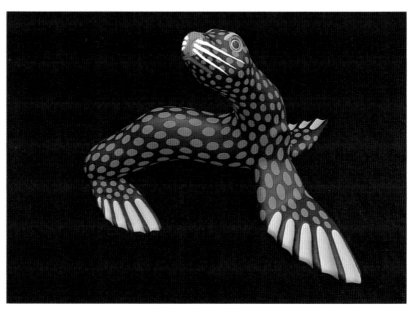

Seal by Luis Pablo, near Arrazola.

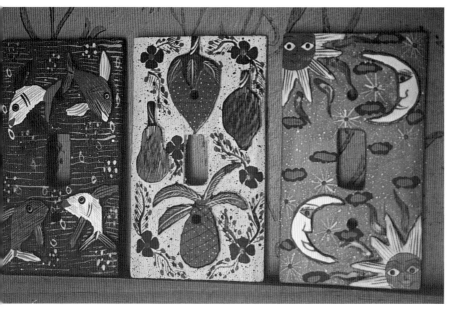

Pine light switch covers by Roberto Matías, San Martín.

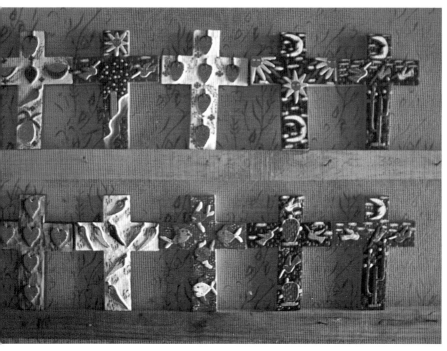

Pine crosses by Roberto Matías, San Martín.

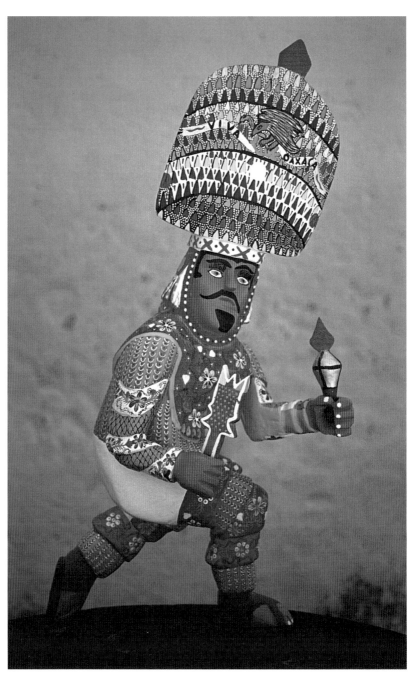

Historical figure by Margarito Melchor Santiago, San Martín.

ACKNOWLEDGMENTS

This book is based on research carried out during numerous trips to Oaxaca between 1994 and 2001. fieldwork was supported in part by grants from International Programs and the Office of the Vice-President for Research at the University of Iowa, the University of Iowa–Grinnell College Bridging Project, and the Oaxacan Summer Institute in History. The Instituto Welte de Estudios Oaxaqueños provided logistical support throughout my fieldwork. Almost all of the photographs in the book were taken by either Fidel Ugarte (assisted by Berenice Manzano) in Oaxaca or Don Roberts in Iowa. I greatly appreciate the skill, resourcefulness, and patience of both photographers. Patricia Conrad carefully drew the maps in Chapters 1, 4, and 11.

My greatest debt is to the artisans who showed me their pieces and answered my questions. Because of their hospitality and good humor, this was by far the most enjoyable fieldwork that I have carried out. The names of many of the wood-carvers I worked with are scattered throughout the book. Antonio Aragón, Sergio Aragón,

Alma Arreola, Isidoro Cruz, Epifanio Fuentes, Aguilino García, María Jiménez, Inocente Melchor, Margarito Melchor, Martín Melchor, Melinda Ortega, Gabino Reyes, Miguel Santiago, Sergio Santos, and Jesús Sosa were particularly helpful. The contribution of Saúl Aragón to this project, however, must be singled out. Saúl is a talented and intelligent artisan from Arrazola who has a university degree in business and has worked for a number of years as a buyer for a crafts wholesaler from Arizona. We have spent countless hours talking about the wood-carving trade. Of all the people I worked with in the field, I learned the most from Saúl.

Numerous residents of the city of Oaxaca have aided me over the years. Gudrun Dohrmann, the librarian at the Instituto Welte, put me in touch with other researchers working in the area, kept me informed of relevant talks and conferences, and provided useful bibliographic assistance. My landlady, Alicia Cruz, allowed me to rent a spacious room in a splendid location and went out of her way to help me solve various practical problems. Jane and Thornton Robison introduced me to many artisans and were gracious hosts at their guest house when I was exploring possibilities for fieldwork in 1994. Rafael Ricárdez accompanied me on some of my first trips to wood-carving communities and was a constant source of wisdom about Oaxacan culture and history. My Mexican colleagues Jorge Hernández, Fidel Luján, and Pedro Lewin made insightful comments about local art, economics, and politics. Víctor Vásquez, Angela García, Nicodemus Bastulo, Henry Wangeman, and Rosa Blum told me much about their shops and the crafts they sell.

I have been helped throughout my research by wonderfully supportive friends and colleagues in Mexico and the United States. Holly Carver, who introduced me to Oaxacan wood carvings many years ago, continues to draw my attention to new artisans and changing styles. Amy Todd, Martha Rees, Lois Wasserspring, Lourdes Gutiérrez Nájera, Art Murphy, Jeff Cohen, Tad Mutersbaugh, Joe and Genie Patrick, and Ron and Carole Waterbury were working on their own projects in Oaxaca while I was conducting fieldwork. These good friends cheerfully shared their vast knowledge of Oaxacan culture. The ecologists Gene Hunn, Silvia Purata, and Ana María López taught me the economic botany of *copal*, the wood most often used by the carvers. I learned much about Oaxacan businesses, social movements, and medical beliefs while observing the fieldwork of my students Steve Tulley, Michelle Ramírez, Cynthia Fetter, and Will Heintz. At the University of Iowa, I benefited from discussions with my colleagues Rudi Colloredo-Mansfeld, Tad Mutersbaugh, Joe Patrick, Charles Hale, and Paul Greenough.

Bert Roberts, a former anthropology graduate student at Iowa, assisted my research on websites selling wood carvings.

I am also grateful for the help given me in Mexico and the United States by the following individuals: Shepard Barbash, William Beezley, Frances Betteridge, Katharine Chibnik, Carol Cross, Steven Custer, Bill Dewey, Ramón Fosado, Clive Kincaid, Enrique de la Lanza, Enrique Mayer, Beverly Poduska, Al Roberts, Sandra Rozental, Jim Weil, Bill Wood, Julia Zagar, and Isaac Zagar.

Chapters 7, 8, and 10 are revised versions of previous publications:
Chapter 7: Oaxacan Wood Carvers: Global Markets and Local Work Organization. *In* Plural Globalities in Multiple Localities: New World Borders, Martha Rees and Josephine Smart, eds., pp. 129–148. Lanham, Md.: University Press of America, 2001.
Chapter 8: The Evolution of Market Niches in Oaxacan Wood Carving. Ethnology 39(3) (2000):225–242.
Chapter 10: Popular Journalism and Artistic Styles in Three Oaxacan Wood Carving Communities. Human Organization 58(2) (1999):182–189.

I have indicated at the end of each photo caption the photographer (and where relevant the collector). Photographs by Fidel Ugarte (including all photos in the color section) were taken in June 2001. Photographs by Don Roberts were taken in October and November 2001. Photographs by Michael Chibnik were taken in June 2001. The photograph by Holly Carver was taken in January 2002. Unless otherwise specified, where two artisans are listed, the first is the principal carver and the second is the principal painter.

CRAFTING TRADITION

INTRODUCTION

On January 1, 1998, Jimmy Carter visited the small Mexican town of San Martín Tilcajete to look at brightly painted wood carvings. The ex-president of the United States was vacationing in the state of Oaxaca with his wife, Roslynn, their four children, six grandchildren, and ten other relatives and friends. The group was accompanied by bodyguards, government officials, and guides on their excursions to the colonial churches, archaeological sites, craft villages, and markets of the Central Valleys of Oaxaca. They stayed in San Martín for half an hour, buying numerous pieces and chatting with artisans.

The Carters had decided to go to San Martín after seeing a display of carvings from the town in the *zócalo* (central square) of the city of Oaxaca. Although the residents of San Martín were honored by the visit of the former president, they were not surprised that such a famous man would spend part of New Year's day looking at Oaxacan wood carvings. Since the mid-1980s these whimsical pieces have adorned the shelves of gift shops and private homes in Mexico, the United States, and Europe and have

been the subject of countless magazine and newspaper articles, museum exhibitions, and television programs. Oaxacan wood carvings appear on calendars, postcards, and T-shirts and are sold in catalogs and over the Internet. Artisans from the principal carving centers of San Martín Tilcajete, Arrazola, and La Unión Tejalapan have traveled throughout the United States giving exhibitions of their craft. Many families in these communities have prospered by selling their pieces to wholesalers, store owners, and tourists. Men and women who once eked out a living through farming and wage labor are now able to build concrete houses and purchase automobiles, satellite dishes, cell phones, and compact disk players.

Oaxacan wood carvings are part of a growing trade in what Nelson Graburn (1976) and others have called "ethnic and tourist arts." Crafts such as Otavalan weavings (Colloredo-Mansfeld 1999), Kuna *molas* (Tice 1995), Côte d'Ivoire carvings (Steiner 1994), and New Guinea masks (Silverman 1999) change hands in complex, multistranded commodity chains that usually link artisans from Latin America, Africa, Asia, and Oceania with consumers from the upper and middle classes of the United States, Canada, and Europe. The commercialization of crafts has improved the standard of living of many artisans in some communities but has enriched only a few merchants in others. This trade is part of an increasingly rapid flow of people, commodities, and images across national borders in recent years that has led some anthropologists (e.g., Kearney 1996; Marcus 1995; Roseberry 1989) to advocate a global perspective that entails multilocal fieldwork and a rethinking of long-established ideas about cultural boundaries.

This book examines the history, production, marketing, and cultural representations of Oaxacan wood carvings. These colorful pieces are an extraordinarily apt illustration of how the global demand for exotic "indigenous crafts" can lead to an invented tradition (Hobsbawm 1983). The origins of Oaxacan wood carvings differ from those of most other ethnic and tourist arts. Accounts of craft commercialization ordinarily describe how objects that were at one time integral parts of indigenous cultures become transformed as the result of a global marketplace. The hybrid nature of such crafts leads to heated debates about their artistic merit and "authenticity." The Oaxacan wood carvings, however, are late-twentieth-century creations made mostly by monolingual Spanish speakers. The pieces nonetheless are stylistically similar in some respects to other local crafts with longer histories and are often promoted as a symbol of "Zapotec Indian" identity by merchants dealing in ethnic arts.

The growth of tourism during the late nineteenth century in areas inhabited by non-Western peoples led to an increased production of art objects as souvenirs. Although some of these souvenirs were replications of objects with long-standing cultural significance, many others were innovative hybrid art forms. Despite the economic importance of the souvenir trade, anthropologists paid little attention to ethnic and tourist art until the 1970s. They focused instead on ways in which traditional arts were symbolically embedded in local ritual and politics. Because ethnic and tourist arts were produced in colonial or neocolonial trade contexts, they were of less analytic interest (Graburn 1999:345).

In the past three decades, anthropologists have written extensively about ethnic and tourist arts (e.g., García Canclini 1993; Graburn 1976; Marcus and Myers 1995; Nash 1993b; Phillips and Steiner 1999b). By 1970 many scholars recognized that a failure to emphasize political and economic ties between local communities and the wider world had been a shortcoming of most previous ethnographic research. Their efforts since then to understand these connections have led to numerous investigations of the cultural representations, economic structures, and sociopolitical relations associated with the flows and transformations of commodities as they move from producers in poor countries to consumers in rich countries. While ethnic and tourists arts did not fit easily into the functional studies and ethnohistorical reconstructions that most anthropologists carried out in the first half of the twentieth century, they have been fertile ground for more recent approaches focusing on economic and cultural connections between particular localities and the outside world.

Many anthropologists describing commodity flows (e.g., Mintz 1985; Wolf 1982) have been strongly influenced by world systems (e.g., Wallerstein 1974) and dependency (e.g., Gunder Frank 1969) theories that emphasize the ways in which individuals and institutions in the centers of economic power extract wealth from subordinate regions. Several studies of the trade in ethnic and tourist arts in Mexico (e.g., Littlefield 1979; Stephen 1993; Stromberg-Pellizzi 1993), for example, describe how putting-out systems (where merchants provide artisans with tools and supplies in return for delivery of goods at set piece-work wages) and factory-like workshops have developed as a response to national and international markets for particular crafts. Other researchers examining the spread of international capital (Cook and Binford 1990; Nash 1993a) note how the activities of intermedi-

aries in global commodity chains affect the economic strategies and division of labor of craft-producing households. These anthropologists influenced by world systems and dependency theories often emphasize how indigenous arts are transformed in efforts to appeal to Western tastes.

In the 1980s and 1990s many scholars (e.g., Gupta 1998; Roseberry 1989; Scott 1985) argued that dependency and world systems approaches neglect local history and culture and underemphasize the activities subordinate peoples have taken to change their circumstances. Their critiques have influenced studies focusing on ways in which tourist art both "adheres to traditional aesthetic canons and cultural themes . . . [and] conveys messages about emergent notions of village, regional, and national ethnicity" (Silverman 1999:51). Most anthropologists looking at craft commercialization nowadays agree that commoditization is not an impersonal force. They think instead that Christopher Steiner's conclusion in his book about the trade in African art (1994:164) is relevant to many ethnic arts and crafts:

> . . . [the] penetration of capitalism [in the African art trade is] a series of personal linkages, forged one at a time by different individuals each with their own motives, ambitions, and set of goals. At all levels of the trade, individuals are linked to one another by their vested interest in the commoditization and circulation of an object in the international economy. Yet, ironically, the very object that brings them together does not have the same meaning or value for all participants in the trade.

Contemporary research on ethnic and tourist arts is often placed in the context of "globalization." This ill-defined term sometimes refers to an alleged cultural homogeneity brought about by the spread of Western goods and images around the world. However, there is a growing recognition that the effects of improvements in transportation and communications have led to multidirectional cultural and economic flows rather than the one-way penetration from centers described by world systems theory (Appadurai 1996; Kearney 1995; Little 2000; Wood 2000a). The increasing flow of images and information from previously remote areas of Latin America, Africa, and Asia clearly influences the demand for non-Western crafts by consumers in Europe and the United States. Moreover, indigenous artisans are learning the values and categories of the intermediaries who control the market for ethnic crafts (Graburn 1993).

Ethnic and tourist arts and crafts are both cultural artifacts and com-

modities. Most anthropologists conducting research on these objects (e.g., Myers 1991; Price 1989) have taken a cultural approach, examining their multiple meanings and messages for producers and consumers. Economic anthropologists interested in the trade in ethnic and tourist art, in contrast, have ordinarily studied how national and international markets for crafts have affected work organization and social stratification in particular villages and small towns. This focus reflects certain long-standing debates about the effects of increased production for sale on the social organization of rural economies.

Two of the most influential theoretical positions concerning the effects of the penetration of capital were put forth many years ago by V. I. Lenin (1964 [1899]) and A. V. Chayanov (1966 [1920s]). Lenin thought that as capitalism spreads in rural areas some farmers and artisans accumulate more land, tools, and machinery than others. The inevitable result is the destruction of the peasantry, rural-urban migration, and the creation of separate classes of entrepreneurial landowners (capitalists) and landless wage laborers (rural proletariat). Chayanov, in contrast, argued that the economic logic of peasant farming and craft production is fundamentally different from that of capitalistic enterprises. Because peasant farmers and artisans use unpaid family workers, they can often compete successfully with commercial businesses employing hired labor. The spread of capitalism therefore does not necessarily result in extensive rural stratification ("differentiation") and the breakup of the peasantry. The Lenin-Chayanov debate has taken diverse forms over the years depending on the particular situations being analyzed. Many modernization theorists who abhor Lenin's political views agree with his contention that large-scale production units are inevitable in rural areas under capitalism. Chayanov's ideas have been adopted by numerous quantitatively oriented scholars who reject both Marxist and modernization theory. Contemporary anthropologists (e.g., Nash 1994) often write about the extent to which rural peoples are able to retain autonomy as they become integrated into a global economy.

Artisans have played an important role in analyses of differentiation in rural areas in Mexico (e.g., Cook and Binford 1990; García Canclini 1993; Littlefield 1979; Novelo 1976; Turok 1988) and elsewhere (e.g., Goody 1982; Schmitz 1982; Tice 1995). Craft sales can enable households to meet subsistence needs and increase incomes even where land is scarce or unevenly divided. Chayanov-oriented scholars (called *campesinistas* in Mexico) have therefore encouraged artisan production as a way of maintaining small-scale family enterprises in the countryside and stemming migration to

crowded cities. Leninist-oriented scholars (called *proletaristas* in Mexico) argue that much rural household production that appears to be autonomous is actually controlled by entrepreneurial subcontractors who specify what is to be made. Modernization theorists think that artisanal development requires capitalist systems of production such as workshops with hired laborers.

Economic anthropologists (e.g., Blim and Rothstein 1992; Collins 2000) examining work organization are increasingly finding "post-Fordist" systems of flexible accumulation that are said to be characteristic of late capitalism. Such systems allow enterprises to react quickly to new market niches by changing labor processes and creating innovative products. They are contrasted with older, more rigid, "Fordist" businesses that involve long-term, large-scale fixed capital investments in mass production systems (Harvey 1989:142–147; Wood 2000a). Flexible accumulation systems, which have developed since the 1970s, often rely on subcontracting, outsourcing, and dispersed sites of production. These arrangements, however, cannot always be attributed to the workings of late capitalism. Piece work and sharecropping, for example, have been found in many societies in the past.

OAXACAN WOOD CARVING: ART AND COMMODITY

Oaxacan wood carvings are in some ways archetypal examples of a commoditized craft. They were invented recently and have always been sold to tourists, collectors, and merchants. Their sale in large volumes has been made possible by transportation and communication improvements linking Oaxaca, Mexico City, and the United States. Although artisans take pride in their work, they almost always say that they make pieces in order to make money and would abandon the craft if the market for carvings disappeared. Carvers change styles and develop specializations in response to the volume of sales of particular types of pieces. The overall demand for carvings ebbs and flows as the fluctuating exchange rate between the dollar and the peso affects the potential profits of U.S.-based intermediaries.

The socioeconomic effects of the trade in Oaxacan wood carvings have been somewhat different from those of most other commoditized crafts. Anthropologists writing about the commercialization of ethnic and tourist arts (e.g., Littlefield 1979; Waterbury 1989) have frequently told a Leninist story of how increased stratification develops as some artisans are more successful than others and local merchants establish themselves as intermediaries between producers and consumers. The less-successful artisans

earn little from their crafts, which may not be as remunerative as agriculture and wage labor. While the Oaxacan wood-carving trade has certainly increased socioeconomic stratification in the principal artisan communities, class differences seem less than in many other places where crafts are exported. The extent of exploitation of artisans by store owners and wholesalers also seems rather limited. The relatively benign socioeconomic consequences of the wood-carving trade are the result of both production techniques and market factors. The low cost of materials allows families to make carvings without loans from intermediaries. The existence of a sizable high-end market enables large numbers of skilled carvers and painters to earn substantial incomes by selling commissioned individual pieces. The complex logistics of exporting wood carvings have prevented a substantial local merchant class from developing.

The history of the trade in Oaxacan wood carvings, however, is more than a microeconomic tale of supply, demand, cost-benefit analyses, and strategizing in a free market. The carvings did not develop in a vacuum. Villages and towns in the state of Oaxaca have long specialized in particular crafts. Since the Mexican Revolution in the first part of the twentieth century, successive governments have consistently promoted the production and sale of indigenous arts in order to increase income in rural areas and aid in the creation of a national identity that fuses Indian and Spanish heritages. The demand for Mexican crafts in the United States is driven by buyers' diverse cultural motives.

CRAFTS, IDEOLOGY, AND ECONOMICS IN POSTREVOLUTIONARY MEXICO

Certain states in Mexico (e.g., Michoacán, Oaxaca) have long been known for their crafts, especially those made by people identified by themselves or outsiders as "Indians." Although some "Indian" crafts have remained unchanged since pre-Columbian times, many others are complex mixtures of indigenous and Spanish technologies and artistic styles. For example, communities around Teotitlán del Valle in the state of Oaxaca wove cotton for local consumption prior to the Spanish conquest. After the Spanish introduced wool to the area in the 1500s, large numbers of blankets were made from that material during the colonial period (Stephen 1993:30). These wool blankets have been widely regarded since that time as an Indian (specifically Zapotec) craft.

Mexican elites in the eighteenth and nineteenth centuries adopted European ideas about artistic merit and largely ignored indigenous crafts. Af-

ter the Mexican Revolution in the first part of the twentieth century, however, intellectuals (e.g., Atl 1922) and politicians began to praise and publicize popular (usually Indian) arts and crafts (García Canclini 1993:43; Kaplan 1993:113; Novelo 1976:32–39; Wood 1997:107–112). Famous Mexican muralists such as Diego Rivera and David Siqueiros extolled Indian themes in their paintings. State agencies were soon established to promote and preserve popular arts, and by the later part of the century there were more than fifty such governmental institutions (Novelo 1976:47).

The postrevolutionary state's interest in popular arts and crafts was initially ideological. The leaders of Mexico were seeking to unite a country divided along ethnic, linguistic, and political lines (Knight 1990). In particular, they sought to draw the indigenous population into the state by creating national symbols of identity that reflected the country's pre-Columbian past (Wood 2000b). Although the eventual goal was to integrate the Indians into a mestizo state, the first step was to make all Mexicans value aspects of indigenous cultures such as dance, music, painting, weaving, and pottery. The syncretic nature of many of these cultural features was rarely emphasized by the intellectuals and politicians who promoted this *indigenismo* and encouraged collectors such as Nelson Rockefeller (see Oettinger 1990) to purchase folk art.

By the mid-twentieth century the state's promotion of popular art was also motivated by economic concerns. An increase in tourism spurred by transportation improvements had brought many visitors willing to buy Mexican crafts. At same time, most rural residents were finding it ever more difficult to support their families through agriculture because of small plots, low crop prices, and poor soils. The economic situation of many peasant farmers had worsened as land became more scarce as a result of population growth and government policies that favored large-scale, capital-intensive agriculture. The state therefore encouraged craft production in order to foster rural development, reduce rural-urban migration, and attract tourists to regions where there are large indigenous populations. State agencies have engaged in diverse activities in their efforts to promote the production and sale of crafts. Government stores in major cities buy popular arts; banks give credit to artisans. The state puts on exhibits of crafts both in Mexico and abroad and sends artisans to demonstrate their work at such shows. Arts and crafts are displayed in state-run museums and featured extensively in brochures and videos put out by government tourist offices. State arts institutions sponsor craft contests about specific themes in which the winners receive significant amounts of money.

The state's goals of preserving "indigenous" art forms (notwithstanding their usual syncretic origins) and promoting craft sales have often been partly contradictory. Merchants sometimes find that "traditional" crafts sell better after they have been transformed in ways that appeal to foreign tastes. Many rugs from Teotitlán, for example, have designs taken from the work of European artists such as Pablo Picasso, Paul Klee, and M. C. Escher. Furthermore, tourists have been willing to buy entirely new crafts that do not have long-standing cultural significance, such as jewelry and wallets with pre-Columbian motifs. The transformation of "traditional" arts and the creation of new crafts conflict with the Mexican state's aim to promote popular arts as the symbol of the nation's indigenous heritage. Some scholars have noted that commercialization fundamentally changes the meaning of crafts (and presumably also their usefulness as symbols of national identity) even when they are not transformed. Néstor García Canclini argues (1993:61), for example, that when indigenous weavers sell their work to intermediaries:

> . . . they lose, together with part of the value, the global conception of the process. Their loss is even greater if outside intervention causes a fissure within production itself by turning artisans into mere wage laborers (in a workshop or home) who limit themselves to doing designs imposed by others and stylings of a traditional Indian iconography that are not theirs . . . The distance that a capitalist organization of labor and the market establishes between artisans and their crafts parallels the rupture between the economic and the symbolic, between material (economic) and cultural (ethnic) meaning.

Craft commercialization, according to García Canclini (1993:63), actually divides the country by creating stratification and disrupting community solidarity:

> Practices by both private intermediaries and certain state organizations that promote crafts encourage the separation of individuals from the community . . . they select the best artisans, they deal with them on an individual basis, and urge them to compete with one another.

The state's ideological and economic goals in promoting popular arts are most compatible when crafts (however transformed by market demands) have a long history of use by "Indians." Buyers both in Mexico and abroad

also seem especially attracted to such crafts. As Arjun Appadurai has observed (1986a:47), in tourist arts, the status politics of consumers revolves around the group identity of producers. Both state organizations and merchants selling hybrid art forms aimed at the tourist and export market therefore emphasize their indigenous origins and downplay the transformations that have been made in attempts to appeal to buyers. It is difficult, however, to reconcile entirely new crafts made by people who are clearly not Indians—such as the papier-mâché sculptures of the Linares family of Mexico City (Masuoka 1994)—with an ideology that promotes popular arts as a symbol of national indigenous heritage. The state thus has had an ambivalent attitude to crafts such as the Linares' sculptures and Oaxacan wood carvings. Such crafts seem worthy of state support since they provide needed income for poor people and attract tourists. But they do not fit well into the national discourse about popular arts. Perhaps for this reason the state has promoted the Linares' sculptures and Oaxacan wood carvings less than many other crafts. Intermediaries in the wood-carving trade, aware of the appeal of the ideology linking crafts with the past, have often imputed an indigenous origin and long history to the pieces they sell.

MOTIVATIONS FOR THE PURCHASE OF ETHNIC AND TOURIST ARTS

The Mexican state's effort to promote popular arts would not have succeeded without a demand for indigenous crafts among the middle and upper classes in the United States, Canada, and Europe. An examination of the trade in Oaxacan wood carvings and other ethnic arts thus requires some attention to customers' reasons for buying such items. Despite a paucity of empirical studies, scholars are in general agreement about why Westerners purchase indigenous crafts.

In a discussion of the burgeoning market for ethnic and tourist arts during the Victorian era, Ruth Phillips and Christopher Steiner say (1999a:9) that buyers were motivated by both admiration for the technical expertise and aesthetic sensibility of non-Western artists and a "romantic and nostalgic desire for the 'primitive' induced by the experience of modernization." Writers discussing the reasons behind the purchase of contemporary tourist and ethnic art (e.g., García Canclini 1993:40–41; Lee 1999; Little 1991:156–157) seem to think that customers' motivations resemble those that Phillips and Steiner attribute to the Victorian era. García Canclini remarks (1993:40), for example, that Mexican crafts "introduce . . . novel designs and a certain degree of variety and imperfection that offer the

opportunity both to be different from the rest and to establish symbolic relations with simpler life-styles, a yearned-for nature, or the Indian artisans who represent that lost closeness." He cites the work of Gobi Stromberg (n.d.:16–17), who studied the reasons tourists give for purchasing silver in Taxco, Mexico. These included proof that a trip abroad had been taken (with the implied socioeconomic status associated with such travels), a demonstration of broad taste for exotic objects, and a rejection of the products of a mechanized society. Carol Hendrickson (1996:110) additionally notes that catalogs selling Guatemalan Mayan goods emphasize the makers of crafts and the "touch" between different peoples created by handmade objects.

The globalization at the end of the twentieth century appears to have stimulated the market for tourist and ethnic art. Steiner and Philips point out that the wider public acceptance of such arts can be seen in a series of publications (e.g., Barnard 1991; Hall 1992; Innes 1994) advocating the use of "natural" objects in interior design. These texts on interior decorating assume

(1) that "ethnic" art is closer to nature and therefore less artificial than its modern counterparts;
(2) that the "ethnic" arts of all regions share a common denominator, making them largely interchangeable and somehow comparable on a formal level; and (3) that "ethnic" art represents the final, fleeting testimony to the tenuous existence of rapidly vanishing worlds. (Phillips and Steiner 1999a:16–17)

In these texts, ethnic arts are regarded as a complement to modern design rather than a rejection of industry and capitalism.

SALES OF ETHNIC AND TOURIST ART IN CONTEMPORARY OAXACA

The trade in ethnic arts in Oaxaca has been greatly affected by the economic importance and cultural character of tourism in the state. In the early 1980s Mexico plunged into an economic crisis precipitated by declining oil prices. In their attempts to recover from the crisis, the political and economic elite of Oaxaca promoted tourism more than ever. Traffic was barred from the zócalo in the heart of the city, which became a lively square filled with cafes, musicians, and artisans. The government improved air connections, paved roads, subsidized museums, and sponsored public folkloric performances. Hotels, travel agencies, and schools teaching Spanish

TABLE 1.1 Exchange Rate between Mexican Peso and U.S. Dollar, 1975–2000

Year	Pesos/Dollar[a]	Year	Pesos/Dollar
1975	.013	1988	2.27
1976	.015	1989	2.46
1977	.023	1990	2.81
1978	.023	1991	3.02
1979	.023	1992	3.09
1980	.023	1993	3.12
1981	.025	1994	3.38
1982	.056	1995	6.42
1983	.120	1996	7.60
1984	.168	1997	7.92
1985	.257	1998	9.14
1986	.61	1999	9.34
1987	1.38	2000	9.36

SOURCES: 1975–1998: International Financial Statistics Yearbook 1999:648–649; 1999–2000: http://www.stat.usa.gov/tradtest.nsf, downloaded October 17, 2000.

[a] In 1993, Mexico switched currencies from the peso to the new peso. One new peso equaled 1,000 old pesos. The figures in this table from 1975 through 1993 have been converted from old pesos to new pesos. The figures from 1975 through 1998 are yearly averages. The 1999 and 2000 figures are for September.

were established in efforts to attract tourists to the city. Oaxaca gained a reputation in guidebooks as a place with a good climate, impressive archaeological sites, and a variety of crafts.

Tourism is now one of the most important sources of income in the state of Oaxaca. Although most tourists to Oaxaca are Mexicans, many visitors come from other countries. Foreign tourism has been encouraged by a weakening peso. The peso/dollar exchange rate jumped from 25 to 1,380 between 1981 and 1987 (see Table 1.1). Although prices tourists had to pay for food and lodging rose during this period, the rate of inflation was considerably less than the rate of devaluation. A subsequent sizable peso devaluation in the mid-1990s has made it even cheaper for foreign tourists to visit Oaxaca.

There are two distinct types of tourism in Oaxaca. Most visitors to the Pacific Coast of the state are seeking beach vacations in places such as Huatulco, Puerto Angel, and Puerto Escondido. Their goal is to eat and drink well, soak up the sun, swim, and get away from the tensions of their

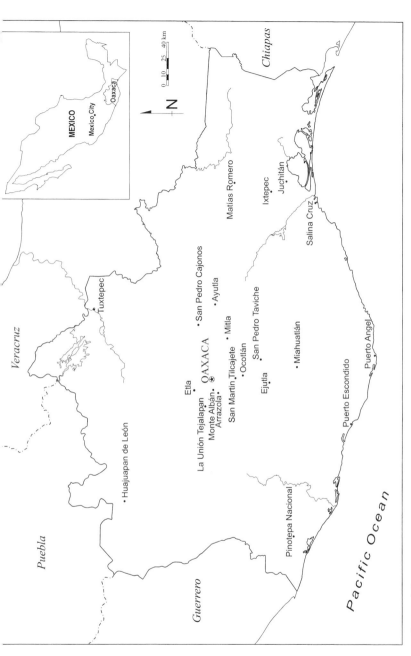

State of Oaxaca

Tourists in city of Oaxaca. Fidel Ugarte.

everyday lives. Tourism in the city of Oaxaca and the surrounding Central Valleys focuses on culture and shopping. The principal attractions are archaeological sites, churches, museums, markets, fiestas, ethnic arts stores, and craft-producing villages. Many people also come to the city of Oaxaca to study Spanish and local culture or to participate in the lively contemporary art scene. The culture-seeking tourists in the city and Central Valleys (in marked contrast to the sun and surf seekers along the coast) are especially likely to be interested in ethnic and tourist art. Furthermore, the city's pleasant climate and comfortable hotels attract many older tourists who can afford to spend considerable sums of money on crafts. A sizable community of retired people from the United States who winter in Oaxaca provides another market for local art and culture.

The ways in which the cultural attractions of Oaxaca have been sold to the outside world over the past two decades are exemplified by a recent English-language book (Hancock Sandoval 1998) published by the government of the state. In *Shopping in Oaxaca*, Judith Hancock Sandoval writes (1998:15–16):

The eternal pastimes of visitors to exotic places are sightseeing, eating well, shopping, and taking it easy, four kinds of fun Oaxaca has per-

fected. You can climb magnificent archaeological ruins from civilizations unknown beyond these valleys, cool down in tree-filled, fountain sprinkled parks, wander leisurely on cobblestone streets into Spanish colonial mansions with patios blooming flowers, turned into shops, hotels, restaurants, and museums . . . Absorb the experience of time (going back into) and space (floating in an exotic culture); clean your cassette and let in the new music. Oaxaca is a safe, comfortable, and inexpensive place to delve into an ancient world where the traditions, handicrafts, costumes, festivals, and market places go back thousands of years and are still throbbing with life. And what a place to shop!

At the end of the twentieth century, popular ethnic and tourist crafts in the city of Oaxaca and the Central Valleys included rugs and sarapes, handmade textiles such as huipiles (blouses) and tablecloths, metalwork (especially tinware), and pottery (see Hernández-Díaz et al. 2001 for an excellent anthropological overview of local crafts). Because the brightness and whimsicality of wood carvings is similar to that of other regional expressive and plastic local arts, the new craft appeals to many tourists, wholesalers, and store owners already familiar with local textiles, pottery, and tinware. The wood carvings, moreover, have certain advantages in comparison to other crafts. They are cheaper than rugs and more portable than pottery. The carvings fit in well with a "southwestern" style of home design that has been popular in parts of the United States since the late 1980s. The range in prices of carvings makes them suitable purchases for tourists seeking inexpensive souvenirs, collectors looking for one-of-a-kind items, and merchants stocking shops. Perhaps because of the diversity of the carvings, local store owners sometimes say that they appeal to a wider variety of customers than any other craft.

THE SOCIAL LIFE OF OAXACAN WOOD CARVINGS

As anthropologists have focused more on ties between local communities and the outside world, they have faced methodological problems in delimiting what they will study. There is now a consensus that multilocal fieldwork is necessary for many research questions related to global interdependence and cross-cultural exchange. For example, anthropological studies of the effects of temporary and permanent migration from Mexico to the United States (e.g., Kearney 1995; Rouse 1988) nowadays often involve research in both countries. But if fieldwork in one community is a

difficult endeavor in which anthropologists must budget their time and money carefully, fieldwork involving people living in dispersed, connected groups is logistically and theoretically much more complicated. Researchers have limited resources and cannot possibly investigate everything of possible interest in several places.

Anthropologists studying transglobal trade (e.g., Roseberry 1989; Steiner 1994) have suggested following the "social life" of commodities as they move through time and space. The term "social life" (Appadurai 1986b) refers to changes in the value, meaning, and use of commodities as they move from hand to hand and place to place. Emphasis is placed on the socioeconomic relations among the various people involved in a trading network and the cultural representations of commodity in different contexts. Such an approach is especially well suited to analyses of the trade in ethnic and tourist arts, which often involves long commodity chains in which the participants are producers, merchants, and consumers scattered around the globe. Nevertheless, anthropologists taking this approach to study of a craft trade must think carefully about what will be examined at each node of the commodity chain. A too narrow focus on one commodity may ignore relevant history, culture, and economics in particular localities; a too broad study may result in superficial examination of important topics.

Much of my research took a follow-the-commodity approach to the trade in Oaxacan wood carvings. This was hardly a straightforward undertaking since the carvings can take quite different paths in their journey from a collection of raw materials to their final destination on someone's shelf. The following hypothetical examples show some of the trips that a carving might take:

(1) A man from San Pedro Taviche cuts wood from a copal tree in the forest surrounding his mountain village on a pleasant February morning. After taking the tree limbs home, he carves a small turtle. He makes a two-hour trip to San Martín Tilcajete in March, where he sells the unpainted piece for 10 pesos to a family living near the center of town. The wooden turtle is then painted by two teenage girls, one a member of the San Martín family and the other a hired laborer from a nearby village. The finished piece is sold in May for 20 pesos to a young man from Arrazola who works as an intermediary for a large-scale wholesaler from Arizona. The Arrazola intermediary ships the carving to the Arizona dealer, who has ordered fifty turtles from the family. At a gift show in San Francisco in August, the Arizona dealer sells three turtles at $5 apiece (about 50 pesos) to a store

owner from Portland, Oregon. The carving made in San Pedro Taviche and painted in San Martín Tilcajete is sent from a warehouse in Arizona to Portland, where it is sold in November for $12 to a 30-year-old woman looking for a Christmas gift for a friend. The turtle is displayed on a counter in the friend's house for five years and then is sold in a yard sale for $1.

(2) A wealthy couple from California in their sixties on vacation in Oaxaca takes a cab to Arrazola to visit the workshop of 80-year-old Manuel Jiménez, a charismatic man generally recognized as the founder of contemporary Oaxacan wood carving. The bilingual driver interprets as they talk for fifteen minutes with Jiménez and two adult sons in a comfortable showroom, where all the carvings are priced in dollars. The couple eventually buys a wooden deer for $200 that has been made by the sons with cedar sent from Guatemala. The piece is signed by Jiménez and the sons. The couple takes the deer home, where it is prominently displayed in their living room.

(3) A man steps out of a truck filled with copal and knocks on the door of a wood-carving family in Arrazola. He is from a community about 20 kilometers from Arrazola where copal is abundant. The family members use the wood they buy to make elaborately curved, beautifully decorated lizards that can be hung on a wall. The decoration is done using house paint bought in a store in the city of Oaxaca. The husband and a teenage son carve the pieces; painting is done by the wife and a daughter in her early twenties. The cost of the wood and paint used in an iguana carving is about 4 pesos. The iguanas are bought by the owner of a store in the historic district of the city of Oaxaca for 150 pesos apiece. The price of the iguanas in the store is 200 pesos. Some iguanas are bought by tourists passing by the shop. Others are picked up by a wholesaler from California, who resells the pieces in the United States to store owners for $40 apiece. These iguanas cost $80 in U.S. shops.

(4) A woman from Minneapolis drives from the city of Oaxaca to La Unión in a rented car to buy a wooden angel for 100 pesos from a local family. The husband in the La Unión family gathered the wood and did the carving; his wife and a teenage son painted. The Minneapolis woman takes the carving home and sells it for $30 over a website she has created for ethnic arts from Mexico. The website includes photographs of the angel and the artisans at work as well as a brief text linking Oaxacan wood carvings to ancient Zapotec Indian religious ceremonies.

(5) A 30-year-old Arrazola woman runs a small business in which hired workers make wood carvings. She sells a brightly painted wooden rabbit for 60 pesos to a man from Teotitlán del Valle, who takes wood carvings

and other Oaxacan crafts on a truck to Matamoros, a Mexican border town across the Rio Grande from Brownsville, Texas. He sells the rabbit for 90 pesos to a woman who has a stall with tourist crafts near the bridge that links Brownsville and Matamoros. A college student from Illinois on spring break in south Texas crosses the border for a few hours and buys the rabbit for 120 pesos as a gift for her mother.

Despite the diverse paths that Oaxacan wood carvings can take over their lifetimes, their journey from production to consumption can be generally outlined. After the raw materials (mostly wood and paint) are obtained, the carving is made by a work group living in a small community near the city of Oaxaca. Although some pieces are sold directly to tourists, more are bought by intermediaries in the wood-carving trade such as shop owners from Oaxaca and wholesalers from the United States. Some carvings are sold in stores in Oaxaca; others end up in markets and shops elsewhere in Mexico. Most Oaxacan wood carvings, however, are ultimately sold in ethnic arts and gift shops in the United States and Canada.

A strict follow-the-commodity approach would be insufficient to tell the story of the wood-carving trade. There are specific historical reasons why the craft became economically important in Arrazola, San Martín, and La Unión and why the impact of the wood-carving trade has been different in these three communities. The production strategies and organization of labor in wood-carving communities cannot be understood without an examination of local economic possibilities and sociopolitical organization. This book therefore begins with a history of Oaxacan wood carving and an ethnographic overview of Arrazola, San Martín, and La Unión. The obvious starting point is Manuel Jiménez, the colorful founder of the craft.

HISTORY OF OAXACAN WOOD CARVING
(1940–1985)

*Mine is a sacred history . . . I am not just anybody.
I am a real tiger. I was born intelligent. Everyone here
is living off my initiative. If I hadn't started carving,
no one would be doing anything. I invented the whole
tradition. They should make a statue for me in the
plaza, with an arrow pointing to the house, and re-
name this street Jiménez Street.*

(MANUEL JIMÉNEZ, QUOTED IN BARBASH 1993:19)

I had heard a lot about Manuel Jiménez before I first met
him in August 1994. Jiménez was famous among buyers
and sellers of Mexican crafts as the oldest and most suc-
cessful Oaxacan wood-carver. The proud, opinionated
maestro held court for visitors most days at his home in
Arrazola, where he and two sons sold their colorful frogs,
dogs, bears, deer, and rabbits for hundreds of U.S. dollars
apiece. Jiménez, born in 1919, had been interviewed
many times during his long career (e.g., Barbash 1993:
15–19; Peden 1991:67–69) and obviously was good copy
for the journalists he talked to. Their reports told of the

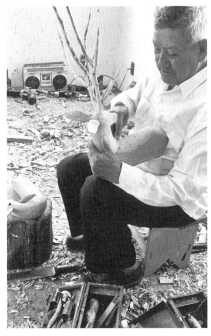

Manuel Jiménez in his workshop. Fidel Ugarte.

wood-carver's impoverished childhood, artistic inspiration, deep religious faith, and practice as a medical curer. The interviewers described a man who thought his talent was a gift from God and who dismissed most of the other carvers in the region as unoriginal copiers. Most of the articles were brief and focused on Jiménez's genius, pride, and religion. Only an M.A. thesis written three decades ago (Serrie 1964:11–35) had much to say about his business activities.

My initial visit to the house of Manuel Jiménez took place during a two-week trip in which I was exploring fieldwork possibilities. I was staying at the Casa Colonial, a comfortable guest house in Oaxaca that caters to tourists interested in local arts and crafts. The owners of the Casa Colonial, Jane and Thornton Robison, help their guests arrange guided trips to nearby weaving, pottery, and wood-carving villages. I was pleased when Andy and Jeannette, a young couple from California, asked if I wanted to go with them on such a trip to Arrazola. This visit would allow me to unobtrusively observe interactions between Jiménez and potential customers. Andy, Jeannette, and I would be accompanied by Sheila and Joyce, about forty, who were teachers at an elementary school in Massachusetts. Sheila had been awarded a grant by their school district to buy crafts for use in a multimedia project about Mexico.

Our taxi driver and guide was David Sánchez, an enterprising man who works as an intermediary for several galleries and ethnic arts stores in the United States. David speaks English well and translated for those members of our group (Andy, Jeannette, and Joyce) who could not understand Spanish. As we drove the short distance to Arrazola, David told us a bit about the scene at Jiménez's. All prices were in U.S. dollars and no carving cost less than $100. There was no point in trying to bargain since prices were fixed. Although the pieces were signed by Manuel, they were mostly made by his sons Angélico and Isaías. Because I knew that many fine Oaxacan wood carvings could be purchased for $30 or less, I wondered if anyone in our group would be willing to buy an expensive Jiménez piece. Sheila, in particular, had only a limited amount of money from her grant to spend on crafts.

David took a left at the newly built Arrazola plaza, drove past a school, and pulled up in front of the largest house in town. We were met at the door by Manuel's wife, Viviana, who left us after telling her husband of our presence. The maestro, dressed nattily in a guayabera (a lightweight tropical shirt with clean lines, four-pocket design, and decorative embroidery) and white pants, greeted us warmly and invited us into his showroom. Manuel

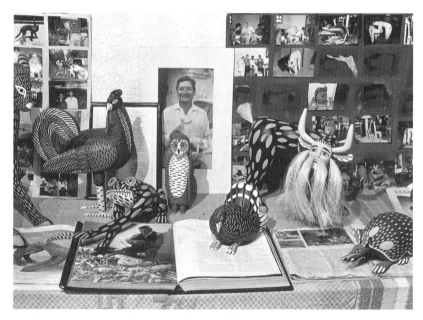

Display room in Manuel Jiménez's house. Fidel Ugarte.

apologized that he could not show us a video that had been made about his work; electricity was temporarily out in Arrazola. The walls of the showroom were covered with photographs and drawings of the artisan as a younger man. Art books and magazines with articles about Manuel filled tables; on the floor were about twenty carvings of different sizes. There were no price tags on the pieces, which were mostly imaginative depictions of animals.

As we looked at the carvings, Manuel genially gave us a short version of what seemed to be his usual talk for visitors. He said that he had started off by making figures out of clay while tending animals as a young boy. Later he began carving and selling wooden pieces in the market in Oaxaca. Eventually his work was noticed in the 1960s by people connected with a museum in Mexico City. Manuel said little more about his life and seemed more interested in talking to us about religion and the artistic gift that he had been blessed with. He cheerfully posed for pictures and made no direct effort to sell pieces.

Jeannette, who had apparently intended from the outset to buy some pieces by Jiménez, spent $300 on two carvings. Despite Sheila's tight budget, she bought the smallest carving in the room for $100. Although Jeannette and Sheila paid with cash, I later learned that the Jiménez family allows payment by checks drawn on U.S. banks. They do not, however, accept credit cards.

As my research progressed in the ensuing years, I occasionally stopped by the Jiménez house in what were usually futile attempts to interview the maestro. Our visits were often interrupted by small groups of English-speaking tourists accompanied by a bilingual guide. It became clear to me that my first visit had been more or less a standard performance by the celebrated carver. The only way in which this trip had been atypical was the

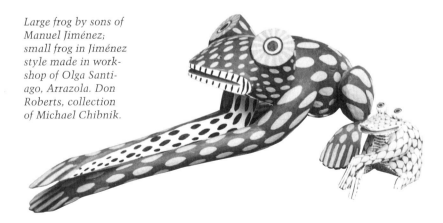

Large frog by sons of Manuel Jiménez; small frog in Jiménez style made in workshop of Olga Santiago, Arrazola. Don Roberts, collection of Michael Chibnik.

absence of Angélico and Isaías. Ordinarily, Manuel would greet visitors and talk for a while about his life and philosophy (predictions about the forthcoming end of the world were common). Such socializing, which could last as long as forty-five minutes, was clearly enjoyed by both Jiménez and the prospective buyers. The commerce was handled by Angélico and Isaías. Over time signatures on the pieces became more explicit about who did the actual work. When I first visited the workshop in 1994, most pieces were signed "Manuel Jiménez." In 1998 I bought a big-eyed frog that is perhaps the family's most typical piece. On the underside of one of the frog's leg was written "autor Manuel Jiménez"; another leg was signed by Angélico and Isaías.

On one of my visits I asked Manuel, Angélico, and Isaías if they had any old carvings they could show me. They told me that they sold all their pieces. The only places where Jiménez carvings made before 1980 could be found were museums and private collections.

MANUEL JIMÉNEZ AND THE COMMERCIALIZATION OF WOOD CARVING

Manuel Jiménez is justifiably proud of his important role in the development of Oaxacan wood carving. Manuel's work emerged almost in isolation from his neighbors. Although Oaxacans had made wooden masks and toys for centuries, Jiménez's innovations transformed the craft. His commercial success opened the way for an international demand for pieces made by other carvers. Nonetheless, Manuel's artistic genius only partly accounts for the popularity of his work. He became a full-time artisan during a time when merchants were seeking new crafts for a growing tourist market. As Hendrick Serrie has observed (1964:116), without these merchants Manuel would have remained an occasional carver, making pieces for sale in a few stalls in the Oaxaca marketplace.

Longtime residents of Arrazola point out that Manuel Jiménez was not the first skilled wood-carver in their community. Artisans such as Pascual Santiago and José Monjardín were renowned in the 1930s for the masks they made for Todos Santos (All Saints' Day) celebrations. During the 1940s Jiménez began selling such masks and other carvings in the Oaxaca market through a man who had a stall there. As tourists from Mexico, the United States, and Europe asked Jiménez to make new kinds of pieces, he gradually expanded his carving repertory. Manuel eagerly sought out help from people in Oaxaca as he sought to master his new craft. Amador Ramírez, a noted church sculptor, gave Jiménez some pointers on tools and techniques.

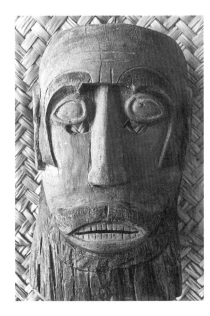

Mask by Pascual Santiago. Fidel Ugarte, collection of Miguel Santiago.

Carlos Bustamente, who had run a crafts shop called Casa Cervantes since 1926, showed Manuel the watercolor (aniline) paints that he came to use on most of his carvings. Bustamente's store, the first of its type in Oaxaca, occasionally sold Manuel's pieces (Serrie 1964:20–21).

Throughout the 1940s and early 1950s Jiménez supported his family primarily through adobe masonry and agriculture. As Manuel sold more pieces, he was able to devote more time to carving. He began selling at Monte Albán, a famous archaeological site where he had once been employed as a guard. Using contacts he developed at Monte Albán, Manuel made some trips to Mexico City to sell pieces to museums of popular arts (González Esperón 1997:76). He did not become a full-time wood-carver, however, until the late 1950s, when two Oaxacan merchants, Arthur Train and Enrique de la Lanza, gave him an exclusive contract for unlimited production.

Train and de la Lanza were among a number of Oaxaca-based entrepreneurs who were taking advantage of an increased demand for local arts and crafts. The extension of the Pan-American Highway to Oaxaca in the 1940s had led to a great increase in tourists from Mexico City and the United States. Many of these visitors sought out "traditional" crafts, which had been promoted by Mexican governments and intellectuals since the Revolution. Oaxacan merchants learned that such tourists were also willing to buy folk art that did not have long-standing cultural significance. Some merchants designed new items and hired workers in the city of Oaxaca to

make them. Others such as Train and de la Lanza preferred to encourage innovation among the many talented artisans in the countryside.

Arthur Train, an energetic man from the United States, was the manager of a newly opened tourist shop called Casa Schondube. Enrique de la Lanza, a Mexican described by Serrie as Train's "semipartner" (1964:24), ran Yalálag, another new store. Arthur and Enrique eventually joined forces at Yalálag, with Train being in charge of exports and de la Lanza being responsible for retail sales. Although Enrique made the partners' first purchase from Jiménez at Monte Albán in 1956, the contract that enabled Manuel to became a full-time wood-carver was arranged by Arthur in 1957. Train's practice at both stores was to pay contracted artisans a guaranteed price that did not vary according to changing demands resulting from seasonal rises and falls in tourism.

Manuel took advantage of this unprecedented opportunity to experiment and innovate. He tried different types of wood, eventually settling on copal (*Bursera* spp.) in the early 1960s. Manuel consulted picture books as he sought new ideas for carvings. He made angels, saints, the Virgin, Hernán Cortés, Montezuma, old women, sirens, mermaids, devils, burros, horses, zebras, dogs, coyotes, rabbits, coatis, antelopes, tigers, cats, cows, oxen, camels, and elephants. Manuel's most expensive carvings at this time were a set of the Three Wise Men, who were about three feet tall and took a month or more to make (Serrie 1964:22–28).

Jiménez quarreled often with Train and de la Lanza, and contracts were frequently ended and reestablished. Because the demand for large, expensive carvings was limited, the merchants were not always willing to buy Jiménez's creations at the prices he demanded. Manuel drank a lot during this period (he is now a teetotaler) and was by all accounts very hard to work with. He was nonetheless an indefatigable worker and earned enough money during this time to become the wealthiest man in Arrazola. Manuel acquired land, lent money at high rates of interest, and bought a car, a motorcycle, and a gasoline engine irrigation pump. Serrie reports (1964:33a) that Manuel had little contact with his neighbors aside from money-lending and did not let them see his carvings.

Even as late as the mid-1960s Manuel Jiménez was the only artisan in the Oaxaca area earning a significant amount of money from wood carving. The market for the craft was limited to a few stores in Oaxaca, and no other carver had Manuel's skill, energy, and contacts with intermediaries. This situation slowly changed for two reasons. First, Train and de la Lanza grew weary of dealing with Jiménez and encouraged other artisans to take up

wood carving. This eventually led to the spread of the craft to La Unión Tejalapan. Second, the state increased its promotion of crafts of all types during the presidency of Luis Echeverría in the early 1970s. A man from San Martín Tilcajete obtained a government position during this time that enabled him to buy and sell wood carvings from his neighbors.

THE BEGINNINGS OF WOOD CARVING IN LA UNIÓN TEJALAPAN

One day in 1967 Martín Santiago decided to visit Enrique de la Lanza at Yalálag. Martín, who was thirty-six, had made seven different trips to the United States in the past fifteen years to work in agriculture. He also farmed small plots in La Unión and worked in construction around the city of Oaxaca. After the U.S.-Mexican agreement (the bracero program) which had sponsored Martín's seasonal agricultural migration ended, he found that brick-making, roof construction, and subsistence agriculture provided meager support for his growing family. Although Martín had no experience as an artisan, he was skilled with his hands and had heard that Yalálag bought crafts.

Martín picked a good time to talk to Enrique. Yalálag was no longer working with Manuel Jiménez, and Enrique was looking for new wood-carvers. He decided to give Martín a chance and suggested that he try making something in wood. If Enrique liked the piece, he would buy it. Martín returned a few days later with an extremely crude unpainted copal carving of an elderly man. Even though the piece lacked hands and clothes, Enrique thought that Martín had artistic ability. He gave Martín money for tools and aniline paint and suggested ways to improve the figure. When Martín returned with an improved version of the elderly man, Enrique gave him 20 pesos (about US$2.50) for the piece. Martín resolved to devote himself to wood carving. He thought that he could make as many as five pieces a week. Even if he sold only one or two of them, he would make more money than was possible from the three-peso daily wage in construction.

The neophyte artisan reliably and uncomplainingly turned out simple, charming carvings of animals, humans, and religious figures. Even though Yalálag seldom paid him more than 5 or 10 pesos per piece, Martín found carving more pleasant and profitable than other kinds of work. He soon did not have time to complete all his orders and hired his 21-year-old brother Plácido to help him. Three other brothers soon learned the craft, and wood carving became an important source of income for a few families in La Unión.

Most accounts of Mexican folk art (e.g., García Canclini 1993; Kaplan 1993; Novelo 1976) have emphasized the ways in which postrevolutionary governments have promoted crafts. In comparison with many other Mexican crafts, the state has played a relatively small role in the commercialization of Oaxacan wood carving. There have been few wood-carving contests in recent years, and artisans only occasionally sell to government stores. There was a brief period, however, in which government craft promotion had an important impact on the commercialization of wood carving. Between 1971 and 1975 a government buying center in Oaxaca purchased many wood carvings from artisans in the region. This center was run by Isidoro Cruz of San Martín Tilcajete, a remarkably talented and original carver who encouraged his neighbors to take up the craft.

Isidoro Cruz, born in 1934, left school after three years to help his family in their fields. Like Manuel Jiménez, Isidoro began carving as a young boy while herding animals. When he was confined to bed with a mysterious illness for several months in 1947, Isidoro improved his carving and learned how to make the wooden masks then worn at Carnaval and other fiestas. (Plastic masks are used nowadays.) In the ensuing years Isidoro would sometimes give his mother carvings of circus performers to sell in the market in Oaxaca. These carvings were made from zompantle (*Erythrina coralloides*), the wood that Isidoro still uses for most of his pieces. In 1958 Isidoro's woodworking skills helped him obtain a job making ox-carts in a workshop in the city of Oaxaca. Isidoro was still working as an ox-cart maker in 1968 when he had a lucky encounter with an important government official.

Tonatiúh Gutiérrez was the director of expositions of the National Tourist Council of Mexico. He had come to Oaxaca to see the Guelaguetza, an enormous state-sponsored folkloric festival that takes place every July. Gutiérrez was spending the Sunday before the beginning of the Guelaguetza driving around the Central Valleys of Oaxaca in a search for interesting examples of local crafts. A major part of his job was arranging exhibits of Mexican folk art in national museums and in other countries.

This particular Sunday Gutiérrez was driving along the Oaxaca–Ocotlán road looking for old-fashioned ox-carts (*carretas*). As he passed the turnoff to San Martín, he asked a man along the road if he knew anyone who made carretas. When the man replied that "Beto" Cruz did this, Gutiérrez headed into San Martín, where he found Isidoro at a friend's house. Although Isidoro did not in fact make carretas, he took Tonatiúh to another house where

there was an old ox-cart. The carreta was exactly what Gutiérrez was looking for, and he bought it from the owner for 25 pesos.

Isidoro and Tonatiúh began a friendship and business relationship that was still important during my fieldwork in the 1990s. Tonatiúh learned that Isidoro made masks and knew where to find the types of crafts that the National Tourist Council was interested in. Gutiérrez sent Isidoro 250 pesos to buy carretas, decorated boxes, and other items for the council and told Enrique de la Lanza about Isidoro's masks. Isidoro began working regularly for Gutiérrez and was able to sell numerous wooden masks, clowns, and animals to Yalálag. Through his connections with Gutiérrez, Isidoro became involved in exhibitions of crafts in Mexico City and elsewhere. One important exhibition, which both Isidoro and Manuel Jiménez emphasize when telling their life stories, took place in the early 1970s in the Museo de Artes e Industrias Populares in Mexico City. President Echeverría attended this event and posed for pictures with the wood-carvers. But the exhibition that Isidoro regards as the most important in his career took place in California in 1971.

Tonatiúh had arranged work for Isidoro at an exhibition of Mexican folk art at a Los Angeles Museum. The letter he wrote in support of Isidoro's application for the necessary papers to enter the United States does not mention Isidoro's carving, saying instead that Isidoro was

> . . . a museum employee in charge of repairing and maintaining the pieces of popular art which will be shown in an exhibition that the National Council of Tourism, representing the government of Mexico, . . . is presenting in the California Museum of Science and Industry.
> (my translation)

Nonetheless, Isidoro gave a well-attended wood-carving demonstration at the museum in December. Isidoro's showroom in San Martín prominently displays a news story from the *Los Angeles Times* about the performance. To publicize the demonstration, a photographer took a picture of Isidoro accompanied by the museum director and Miss Mexico. Isidoro and the beauty queen are wearing vaguely "ethnic" outfits. I once asked Isidoro about the colorful shirt he was wearing. He replied that he thought that the shirt was modeled on some sort of Triqui clothing. The Triquis are a relatively small indigenous group whose colorful clothing makes them highly visible to tourists in Oaxacan markets. No one from San Martín is even remotely related to the Triquis.

The presidency of Luis Echeverría (1970–1976) was especially support-ive of Mexican arts and crafts. Tonatiúh Gutiérrez served during most of Echeverría's administration as the head of the Fideicomiso para el Fomento de las Artesanías, an important state trust for the promotion of folk art. This organization, which became FONART (Fondo Nacional para el Fomento de Artesanías) in 1974, operates buying centers in Mexican cities that pur-chase crafts sold in government stores and state-sponsored exhibitions. In 1971 Gutiérrez named Cruz the manager of a new buying center in Oaxaca. Isidoro ran the buying center until 1975, when the forthcoming change in governments led him to resign. Because Gutiérrez knew that each Mexican president liked to put his own people into high positions, he left FONART shortly before the end of Echeverría's term. Isidoro also resigned, knowing that the loss of his patron meant that his days with FONART were numbered.

When Isidoro ran the buying center, he purchased many different crafts and came to know important people in cultural affairs in the Mexican gov-ernment. He took advantage of his connections to get jobs for men from San Martín in FONART offices in Mexico City and other parts of the coun-try. Isidoro's position at the buying center and ties with the government led a number of men in San Martín to take up wood carving. They sold pieces to Isidoro and learned the ins and outs of the artisan world by work-ing for FONART. Men from San Martín who began carving at this time in-clude such successful contemporary artisans as Epifanio Fuentes (Isidoro's brother-in-law), Abad Xuana, Justo Xuana, Coindo Melchor, and Margarito Melchor.

Between 1971 and 1975 Tonatiúh and Isidoro sponsored four wood-carv-ing contests that offered substantial prizes. Although Manuel Jiménez and his son-in-law José Hernández won some prizes, most entrants and win-ners came from San Martín. Men developed individual styles in their at-tempts to win the contests and get good prices from Isidoro's buying center. Isidoro continued to work with zompantle, but every other San Martín carver soon adopted copal, Manuel Jiménez's favorite wood. The carvings from San Martín that won prizes usually were related to themes important in local culture. Contest winners made Christ figures, angels, devils, farmers, and ox-teams.

After Isidoro resigned his post, the Oaxaca office of FONART bought fewer wood carvings. San Martín men had lost an important market for their products and no longer could easily find artisan-related government jobs. The state had little further influence on the development of the wood-

carving trade. About ten men in San Martín, however, had become skilled artisans as the result of government programs.

THE FORMATION OF "WOOD-CARVING COMMUNITIES" (1970–1985)

At the end of the twentieth century there were four communities—Arrazola, San Martín Tilcajete, La Unión Tejalapan, and San Pedro Taviche—where many families supported themselves primarily through wood carving. The types of carvings done in these communities differ considerably in quality, subject matter, and price. Visitors to Oaxaca often wonder why these four places and not others have become known for their wood carving. They also are puzzled by intercommunity differences in carving styles, prices, and labor organization.

Although there was no significant craft production of any type in San Pedro Taviche until the 1990s, the other three communities were well known as "wood-carving villages" by 1985. The commercialization of wood carving first occurred in these particular places, of course, because of the activities of Manuel Jiménez, Isidoro Cruz, and Martín Santiago. The different ways in which the craft initially developed in the three communities can largely be attributed to the idiosyncratic manner in which these early carvers interacted with their neighbors and the outside world. However, the geography, economics, and sociopolitical organization of each community ultimately were more important influences on the divergent paths that the wood-carving trade subsequently took.

ARRAZOLA

During the early 1970s there was a striking difference in wealth between Manuel Jiménez's immediate family and everyone else in Arrazola. The maestro was now internationally known, and his pieces were avidly sought out by collectors of Mexican arts and crafts. Manuel and his family regularly sold pieces to folk-art shops, museums, and private collectors. Despite Jiménez's fame and economic success, he had only a few visitors each month. Arrazola was just too hard to get to. After the road to Arrazola was paved in 1976, communications with the outside world improved greatly. The frequency of bus service increased, and taxi drivers from the city of Oaxaca were now eager to make a trip they had previously avoided. A steady stream of tourists, collectors, and the curious made the pilgrimage to the Jiménezes' imposing compound. Nelson Rockefeller, longtime governor of

New York and a noted collector of folk art, bought many of Manuel's carvings. Some of these pieces are displayed today in the Museum of International Folk Art in Santa Fe, New Mexico; others were stored in crates and eventually suffered extensive damage from insects.

As late as 1980 the only wood-carvers in Arrazola were Manuel Jiménez, his sons Angélico (twenty-two) and Isaías (fifteen), and his son-in-law José Hernández (thirty-six). The village was still among the poorest in the region. Arrazola had less land than many neighboring communities, and families supported themselves primarily through wage labor in the city of Oaxaca, subsistence agriculture on small plots, and the sale of masks and replicas of archaeological artifacts at nearby Monte Albán.

Manuel's neighbors realized that they might be able to make some money by selling inexpensive carvings to visitors to Arrazola. These prospective carvers faced great difficulties compared to their counterparts in San Martín. While Isidoro Cruz cheerfully shared his knowledge with anyone who asked, Manuel's methods and materials were carefully guarded secrets. People in San Martín, moreover, knew how to market crafts. Women from San Martín sold embroidered blouses and wedding dresses to Oaxaca-based merchants; men sold carvings to Isidoro and worked at FONART. The only experiences most people in Arrazola had in selling crafts, in contrast, were furtive attempts to peddle replicas to tourists at Monte Albán.

The experiences of Miguel Santiago illustrate the stubborn, and often naive, early efforts of Manuel's neighbors to earn money from artisanry. Miguel, who is now a prosperous and well-known carver, was born in 1966 in Arrazola. Although Miguel briefly attended *secundaria* (more or less the equivalent of junior high school), he did not enjoy studying and soon dropped out. His grandfather Pascual Santiago had been a noted mask-maker, and Miguel recognized that he shared his relative's artistic ability. Like many of his neighbors, he decided to try selling clay archaeological replicas to tourists at Monte Albán. To while away time at the archaeological site, Miguel sometimes whittled small wooden pieces. After a tourist turned down a clay replica one day in the early 1980s, Miguel offered a wood carving for sale. The tourist bought the wood piece, and from then on Miguel began regularly selling carvings at Monte Albán. He sometimes invited tourists he met at the archaeological site to visit his house in Arrazola. Because the tourists were unfamiliar with Arrazola, Miguel would arrange to meet them at the plaza. While he sold some carvings this way, he lost a lot of time waiting for people who never showed up. Miguel also was able to sell a few carvings in shops and hotels in Oaxaca. Between 1981 and 1984 he

earned about the same amount of money from wood carvings and clay replicas. His total income from both sources was not much more than he could have earned through unskilled wage labor.

The biggest technical problem Miguel faced during this time was figuring out what paint to use. He tried a paint used on posters but gave this up when a potential customer's hands became smeared while handling a carving. Because Miguel knew that Manuel had abandoned aniline for another type of paint, he would search the ravines around Arrazola and Monte Albán for paint cans that Manuel and other family members had discarded. According to Miguel, these cans rarely had labels. When Miguel finally found a can with a label, he was still unsure what the paint was. He suspected that the Jiménez family was using a kind of house paint but was not certain about this until a local shop owner confirmed his hunch.

Discouraged with his low income from crafts, Miguel accompanied several friends from Arrazola in 1985 on a trip to the state of Sinaloa to pick tomatoes. While working in Sinaloa, Miguel received a letter saying that a wealthy Mexican folk art dealer had stopped by his house and was interested in buying his carvings. On his return home, Miguel was robbed of most of his clothes and money in Mexico City. But the trip back was worthwhile. The dealer bought some of Miguel's carvings, and his career began to take off.

Miguel was not the only young man in Arrazola trying to earn money from wood carving in 1985. Store owners and wholesalers from both Mexico and the United States were beginning to realize that the Jiménezes were not the only talented artisans in Arrazola. Nonetheless, the only full-time carvers were Manuel Jiménez, his sons, José Hernández, and Miguel Santiago.

SAN MARTÍN TILCAJETE

After Isidoro Cruz left his job at FONART in 1975, wood carving in San Martín became less profitable. Some men who had taken up the craft (including a brother of Isidoro's) migrated permanently to the United States; others returned to wage labor as their major source of cash income. About ten men continued to earn some money through wood carving, selling occasionally in the markets, artisan shops, and government buying centers of the city of Oaxaca. Not long before he died in 1979, Nelson Rockefeller bought a carved ox-team made by one of these men. A photo of this carving appears on the cover of a book about Rockefeller's collection of Mexican folk art (Oettinger 1990). The book does not credit the artisan (Coindo Melchor), saying only that the carving was made in San Martín in the 1970s.

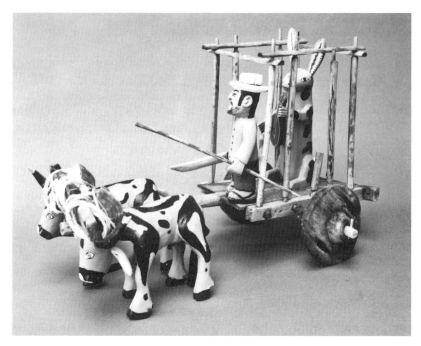

Ox-team, cart, and driver by Coindo Melchor and Eva García, similar to one on cover of book about the Rockefeller collection (Oettinger 1990); rabbit by Alberto Pérez, La Unión. Don Roberts, collection of Michael Chibnik.

Although Isidoro Cruz and Epifanio Fuentes had some success selling pieces in the late 1970s and early 1980s, carving was of minor economic importance in San Martín at this time. Because the community has considerable arable land, most families cultivated several hectares of corn, squash, and beans. The most important commercial artisanal activity in San Martín was the sale of embroidered blouses and wedding dresses woven by local women. Because there were good transportation connections to the outside world, many men worked at construction and other jobs in the city of Oaxaca. Some young men migrated temporarily to Mexico City in search of work. More crossed the border (usually without papers) to California and other parts of the United States, where they worked in construction, restaurants, and agriculture. Some of these migrants stayed in the United States; others returned to San Martín. Almost all of the migrants to the United States sent money to their families in San Martín.

Around 1983 the market for wood carvings from San Martín began to

improve. As tourism became more important in Oaxaca, the number of shops selling folk art increased. Local store owners started making regular trips to San Martín to buy carvings and encouraged their favorite artisans to experiment with new techniques and styles. Epifanio Fuentes was the first to start using house paints; other carvers noting his success gradually abandoned aniline. (Isidoro Cruz persisted with aniline and to this day refuses to use the commercial paints favored by every other carver in San Martín.) Because the store owners' customers preferred animal carvings, the artisans made fewer human and religious figures.

Several longtime artisans stress the importance of one particular shop in the history of wood carving in San Martín. Roberta French, the U.S. consul in Oaxaca, owned a store called Salsa Picante located a few blocks from the city's busy zócalo. Salsa Picante was managed by Jean Pfakunch Martínez, a U.S. citizen who has been credited with having "done more for the carvers than anyone alive" (Barbash 1993:108). Martínez sought out new pieces and publicized the work of talented carvers. She encouraged intermediaries and tourists shopping at Salsa Picante to visit San Martín and told them how to find particular artisans. By 1985 store owners and wholesalers from the United States and elsewhere were beginning to buy directly from carvers such as Margarito Melchor, Coindo Melchor, Epifanio Fuentes, and Inocencio Vásquez.

LA UNIÓN TEJALAPAN

Plácido Santiago made the mistake one morning in the late 1960s of accompanying his brother Martín on a visit to Yalálag. Enrique de la Lanza became angry when he found out that Plácido had been helping Martín carve. Enrique wanted the pieces he bought to be made by a single artisan and demanded that Martín work unassisted. Plácido was unruffled since he knew of another possible outlet for his work. Nicodemus Bastulo, who had formerly worked at Yalálag, was running an artisan store called El Arte Oaxaqueño. Nicodemus, born in a mountain Zapotec-speaking community (Yalálag), is an entrepreneurial man still important in the marketing of Oaxacan handicrafts. He has always attempted to give contracts to artisans on the condition that his shop has exclusive access to their work.

After Plácido had been working with Nicodemus for a few years, he sold a few pieces to Enrique de la Lanza. Nicodemus was unhappy about this, and Plácido had to choose between the two store owners. (Arthur Train

was no longer connected with Yalálag.) Plácido picked Enrique because he paid somewhat better. Two other Santiago brothers, Francisco and Quirino, continued to work with Nicodemus. Ventura, the oldest Santiago brother, was the last to enter carving, in 1970. He soon began to work with Ezequiel Ruiz and Frank Hale, co-owners of a shop called Cocijo. The Santiagos sold some pieces to FONART in the 1970s and early 1980s. Their most important customers, however, continued to be store owners in Oaxaca. Although these merchants did not usually insist on exclusive contracts, each brother worked mostly with one or two shops.

In 1985 the Santiago brothers and their sons were still the only carvers in La Unión. The painting and carving styles of the family members had not changed much over the years. Their aniline-painted pieces were consistently related to the daily lives and religious beliefs of campesinos. The Santiagos made dogs, cats, jaguars, deer, saints, angels, devils, market women, and old men. Their specialties were multipiece sets of rodeos, church celebrations, and Nativity scenes. The Santiagos ordinarily sold their pieces in the city of Oaxaca. Store owners did not like to travel the short distance to La Unión because the road was bad and often impassable during the rainy season. Furthermore, the Santiagos rarely had much to sell in their houses. They worked slowly and spent most of their time on subsistence agriculture and construction work.

THE START OF THE WOOD-CARVING BOOM

In 1985 there were perhaps ten artisans in the state of Oaxaca who supported their families primarily from the sale of painted wood carvings. For the most part, wood carving was an individual activity that a few talented men did to supplement their family's income from other sources. Women and children occasionally helped with sanding and painting. Writers about crafts in Oaxaca sometimes mentioned Manuel Jiménez but otherwise ignored wood carving.

In the next five years most households in Arrazola and San Martín began selling brightly painted wooden animals to tourists, shop owners, and wholesalers. Carving became an activity carried out in family workshops, in which adult men contributed much less than half the total labor. Some families found that they could not fill large orders using only household labor and hired one or two workers to carve, sand, and paint. The wood-carving boom had begun.

CHAPTER THREE

CONTEMPORARY WOOD CARVING

In 1994 a new business called Arte y Tradición opened in an attractive blue and white building in the historic center of Oaxaca. Arte y Tradición included a restaurant, a travel agency, a bookstore, and four or five rooms devoted to various local crafts. One room, called "Fantasía de Madera" (fantasy from wood), was run by Saúl Aragón, a 23-year-old university student who commuted to his shop each day from his home in Arrazola. There were few customers, and Saúl spent most of his time painting carvings and studying for his courses in business and accounting. When Saúl was in classes or otherwise occupied, his girlfriend, Alma Arreola from Oaxaca, would tend the store. Saúl's older brother Antonio, who paid the rent on the shop and was married to Alma's sister Beatriz, would occasionally stop by to discuss the business.

I spent a lot of time in Fantasía de Madera at the beginning of my fieldwork. Saúl is an intelligent and thoughtful man who likes to talk about the wood-carving trade. My visits in the summer of 1995 broke up the monotony of his days, and we soon became friends. I have occasion-

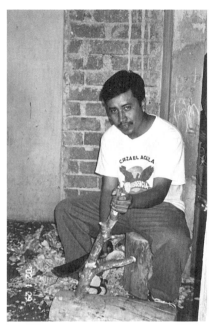

Saúl Aragón.
Holly Carver.

ally hired Saúl over the years to help me with my work and have come to know his large family well. Although Saúl did not close the shop in Arte y Tradición until 2000, his principal source of income at the end of the 1990s was as the local representative and buyer for Clive Kincaid, a large-scale crafts wholesaler based in Arizona. Saúl, who married Alma in 1996, finally finished his university work in 2000.

The work history of Saúl's family between 1984 and 1990 illustrates how the wood-carving boom transformed the economies of many households in Arrazola and San Martín. In 1984 nobody in the Aragón family earned money from craft production. By 1990 wood carving was the major source of income for some family members and a potential work opportunity for others.

In 1984 the family consisted of Antonio Aragón Hernández; his wife, Adelina Ramírez; and their children Ramiro, Fidencio, Ariel, Antonio, Leticia, Saúl, and Sergio. Antonio the elder was selling replicas of antiquities at Monte Albán and cultivating a few hectares of corn, beans, chiles, and tomatoes. Adelina spent most of her time running the household. The children were all unmarried and living in the family compound. Ramiro, the oldest, was twenty-three; Sergio, the youngest, was nine. Ramiro, who had just returned from several years in the army, worked both as a musi-

cian and as a policeman in the city of Oaxaca. Fidencio and Antonio repaired electrical equipment in the city. Ariel was a mechanic's helper at a Ford dealership there; Leticia, Saúl, and Sergio were in school.

Ramiro had tired of police work and was seeking other ways to earn a living. He tried to sell carvings of armadillos, deer, and other animals to tourists in Arrazola looking for Manuel Jiménez. At first Ramiro's carvings were crude, and he had many fiascoes in his efforts to experiment with different types of paint. Sales were slow. After Ramiro's technique improved, he began to sell pieces to shops in Oaxaca. Craft production became a family enterprise. Ramiro carved and painted decorations. Antonio helped with carving; Saúl sanded and applied a first solid coat of paint.

In 1988 Ramiro, now married, moved out of the family compound. Antonio, also married, began carving on his own in Ramiro's former workshop. Saúl worked with Ramiro for another year but in 1989 began helping Antonio, who had developed a successful specialty making finely carved small goats, deer, and foxes. When Saúl stopped working for Ramiro, Sergio took his place. Because Ramiro was getting orders from wholesalers and store owners from the United States, he sometimes had insufficient family help to complete his work. Ramiro therefore hired several local teenagers to help with sanding and painting. The boys Ramiro hired were paid by the day at roughly the minimum state wage. By 1990 Antonio the elder, Fidencio, and Ariel were the only Aragón men who were uninvolved in the woodcarving trade. Antonio senior had become the leader of a state-recognized union of replica-makers at Monte Albán in 1988, and Fidencio was content with his work as an electrician. Ariel was less happy with his job in the city but was still not ready to try wood carving. (After working as a taxi driver for several years, he began carving in 1995.)

By the late 1980s the women in the Aragón family were beginning to work as artisans. After running the government community store in Arrazola for a year, Adelina spent six months learning to carve. She decided, however, not to pursue carving and instead began selling jewelry, bracelets, and earrings at Monte Albán. Leticia became a skillful painter, working with her husband, Catarino Carrillo. Fidencio's wife, Marisol, also painted, working with several of her brothers. Beatriz Arreola, who had married Antonio the younger in 1985, painted many of her husband's carvings.

The experiences of the Aragóns during the late 1980s parallel those of many other families in Arrazola and San Martín. Individuals who knew nothing about wood carving when the boom began quickly became skilled artisans. As wholesalers and store owners visited carving communities in

increasing numbers, teenage family members began working long hours to fulfill orders. Eventually some families needed to hire neighbors to keep up with the demand for their pieces. Artisans innovated and developed specialties in their attempts to establish niches in a competitive and complex economic environment.

By 1990 Arrazola and San Martín were well-established wood-carving communities where most families included at least one artisan. I characterize the 1986–1990 period as "the wood-carving boom" in an effort to portray the rush of individuals and families into the trade, the increasing prosperity of many villagers, and the widespread feeling during this time that the market might be short-lived. Jesús Sosa, a successful artisan from San Martín who began carving during the boom, captured the spirit of times in an interview with Shepard Barbash around 1990:

> This work has been a blessing from God . . . but who knows how long it will last? That's why we have to work night and day. Frankly, I don't have a day of rest. We never stop working. While I sleep, my wife paints. I'm trying to finish my house. When the buyers stop coming, I want to at least have the house as a memory. (Barbash 1993:42)

Dog by Jesús Sosa and Juana Ortega; cat by José Olivera, all of San Martín. Don Roberts, collection of Michael Chibnik.

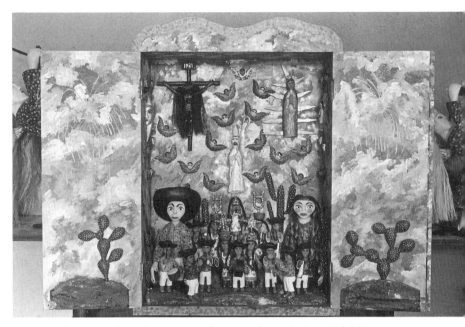

Combination of wood carvings and painting by Jesús Sosa. Fidel Ugarte.

The term "boom" nonetheless exaggerates the scale of the Oaxacan wood-carving trade in the late 1980s. The number of carving families in Arrazola and San Martín was at most 200 in 1990; and their incomes from wood carving, while noteworthy by local standards, rarely matched those possible from temporary migration to the United States for work in restaurants and fields. There were only about twenty wholesalers and store owners from the United States and Mexico who regularly made trips to the villages to buy carvings. Furthermore, the upsurge in business was not as temporary (boomlike) as many feared; the wood-carving trade was still strong at the end of the twentieth century.

When wood carving became a household enterprise at the start of the boom, families rapidly developed internal divisions of labor. Sanding, the simplest task, was reserved for those who were unwilling or unable to become skilled artisans. Some sanders were children; others were adults whose time commitment to other activities prevented them from learning more complex tasks. Although women quickly learned how to paint in the late 1980s, there has never been a cultural supposition that they are better suited to this task than men. Many adult men pride themselves on their painting, and it is not uncommon to find men who paint better than they carve.

Nonetheless, most painting is done by women, perhaps because carving has always been a predominantly male activity. The gendered division of labor in wood carving is partly related to boys' childhood experiences. From a very early age, they are given the responsibility for getting firewood. Boys also learn how to make wooden tops, which are often their favorite toys. By cutting firewood and making tops, boys become familiar with knives and machetes. Girls' tasks and play, in contrast, rarely involve woodworking.

ARTISANS AND DEALERS

Artisans learning to carve in the late 1980s usually sold their first pieces to shops in Oaxaca. They learned, however, that more money could be made from sales to wholesalers and store owners from the United States. Artisans experimented in their efforts to attract the attention of dealers visiting their community. Animal carvings sold the best and soon dominated the trade. Water-based aniline paints gave way to house paints that did not run as much and were less likely to fade in the sun. Carvings became more complicated and paint jobs more ornate as families competed to show their skills. Artisans learned how to depict animals in motion and took particular pride in making contorted carvings out of one piece of wood. Families developed painting styles that made their work readily identifiable.

Although many different dealers occasionally bought pieces, there were a limited number of wholesalers and store owners who bought in quantity and regularly returned to Arrazola and San Martín. Because these important wholesalers and store owners shared information, many artisan families who developed connections with one or two dealers were later able to sell to others. Economic and social stratification among carvers rapidly developed. The more successful carvers sold mostly to dealers from the United States; the less successful carvers sold mostly to tourists and store owners in Oaxaca. Relationships with dealers therefore became tremendously important for artisans. The experiences of two successful carving families from San Martín during the 1980s show the complex and often happenstance ways in which ties between dealers and artisans were formed and maintained.

When artisans from San Martín discuss the origins of wood carving in their community, they usually mention the activities of Coindo Melchor, who began carving around 1970. Coindo, a close friend of Isidoro Cruz, is a versatile carver willing and able to make a variety of pieces. He is particularly known for making imaginary beings such as Pegasuses, mermaids,

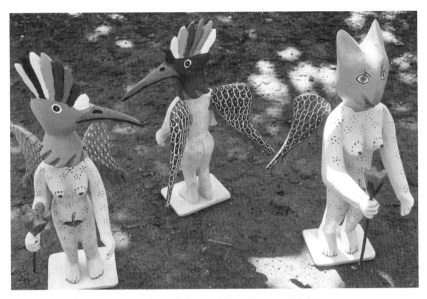

Imaginary beings by Coindo Melchor and Eva García. Fidel Ugarte.

and birdwomen (*ilusiones*). While Isidoro ran the government buying center in Oaxaca in the early 1970s, Coindo regularly sold pieces through this outlet. Nonetheless, his main occupations remained farming and masonry.

After Isidoro left FONART in 1975, Coindo had difficulty selling his pieces for almost a decade. FONART continued to buy some carvings, but most of Coindo's sales were to store owners and operator of stalls in the markets in Oaxaca. Even though sales were slow during this time, Coindo stopped working as a mason around 1980 and supported himself primarily from farming and the sales of carvings. Although Coindo and his wife, Eva García, were not especially well-off economically, they somehow managed to provide exceptionally good educations for their two sons, Jesús and Inocente. Both sons almost finished university degrees in engineering in the 1980s.

Because Coindo Melchor was already well known for his carvings, he was one of the first artisans sought out by dealers visiting San Martín in the 1980s. Coindo's pieces were also featured in catalogs put out in the mid-1980s by Patrick Charles of Emeryville, California. In 1986 Charles commissioned Coindo to make 300 dinosaurs every two months. Since Coindo continued to work as a farmer, he could not possibly fill such a large order working alone and enlisted Eva and his sons to help. Charles told the family that he anticipated making orders of this size for at least ten

years. Around 1988, however, Charles had business problems, and his orders stopped. By this time, the family had sufficiently many other customers that the loss of his orders was not disastrous. Jesús (who had worked for a while as an engineer) and Inocente became full-time carvers, while Eva did much of the painting.

María Jiménez, who is without a doubt the best-known painter of Oaxacan wood carvings, has a distinct style that is immediately recognizable. She paints pieces carved by her brothers with tiny, repeated decorations involving geometric, religious, and animal motifs. The family is particularly known for meticulously painted Virgins, angels, and saints that sell for hundreds of dollars apiece. They have so much business nowadays that clients often are told that a requested piece will not be ready for six to nine months.

Despite their current fame and prosperity, the pious, close-knit Jiménez family had a hard time gaining the patronage of wholesalers in the late 1980s. The five sons and three daughters of Agapito Jiménez and Celia Ojeda ranged in age from eight to twenty-three in 1985. The family sewed embroidered dresses and farmed about seven hectares of corn, beans, and squash. In 1986 the Jiménezes started making pieces carved by two teenaged sons and painted by 21-year-old María. At the beginning the family had little luck in their attempts to sell their crudely carved, simply painted pieces. Around 1987 María developed her intricate painting style. The family's first clients were twin sisters who ran a store near the Artisans' Market in the city of Oaxaca. The unsigned Jiménez carvings sold well, and the sisters put in frequent orders.

The Jiménezes' second client provided an entree to the high end of the wood-carving market. Mary Jane Gagnier Mendoza, a Canadian married to a noted Teotitlán weaver, started an upscale art gallery in Oaxaca in the late 1980s. The gallery, which features both fine and folk art, is now a major artistic center in the heart of the historic district of Oaxaca. In the 1980s the gallery was less influential than it is today but nonetheless was already a magnet for collectors of Oaxacan art. After Mary Jane began buying pieces painted by María, a few tourists and collectors started making the effort to find the Jiménez house in San Martín.

Clive Kincaid was the first wholesaler to buy María's pieces. In 1989 Clive saw several wonderfully painted pieces in the store run by the twin sisters. He asked who made the pieces, but the sisters would not give out this information. Not long afterward Clive was in San Martín at the end of a difficult day when María's 11-year-old brother Aron asked Clive if he

Business cards of dealers in workshop of Martín Melchor and Melinda Ortega, San Martín. Fidel Ugarte.

wanted to see "the best carvings in town." Clive reluctantly accompanied Aron to a modest adobe house and discovered the origins of the pieces he had seen in Oaxaca. He stayed until ten at night talking with the family. Clive thought that the pieces were carved stiffly and made suggestions about how to indicate motion by showing examples of other artisans' work. The family's carvings improved, and by the early 1990s the Jiménezes were selling to a variety of dealers. Although Clive remained friends with the family, he eventually found himself unable to afford their better pieces.

DIFFERENCES AMONG THE CARVING COMMUNITIES

There has never been much communication between artisans in the three principal carving villages. Perhaps because of this, Arrazola, San Martín, and La Unión had developed distinct carving styles by 1990. The three communities also differed greatly in the extent to which they were able to take advantage of the wood-carving boom.

Dealers and tourists can visit the workshops of artisans in Arrazola easily. The town can be reached on good roads from the city of Oaxaca in about twenty-five minutes. The houses of most artisans are close together and not far from the town plaza. Because of the ease of access and the fame

of Manuel Jiménez, Arrazola has always been visited by more tourists and store owners than San Martín and La Unión. Since the late 1980s tour groups based in the city of Oaxaca have included Arrazola on regularly scheduled day-trips. Buses stop in Arrazola for about a half-hour as part of a Thursday tour that also includes nearby markets and churches.

When the wood-carving boom began, many residents of Arrazola were working at low-paying jobs in the city of Oaxaca. Because wood carving was an attractive alternative to unskilled wage labor, many men and women in Arrazola quit these jobs during the boom. Some families even stopped farming. Arrazola—more than either San Martín or La Unión—became a place where wood carving was the major source of income. A number of carvers in Arrazola began to specialize in expensive pieces. Some high-end carvers such as Miguel Santiago, José Hernández, and Manuel Jiménez developed idiosyncratic styles. Others created carvings that came to be regarded as typical of Arrazola. The most noteworthy of these pieces are iguanas and lizards with elaborately curled tails.

During the 1990s Arrazola workshops using hired labor focused on sales to tourists. These "factories" (fábricas) churned out small, cheap pieces that can be bought as souvenirs or gifts. Some family workshops also specialized in sales to tourists. Boys greeted incoming taxis and tour buses and offered to guide visitors to wood-carving workshops. If tourists bought from the workshops, the boys collected a small fee from the owners. Taxi drivers and guides asked for and received larger commissions (10 percent is common) for taking tourists to particular workshops. Even though most of the fábricas stopped operating around 2000, many family workshops in Arrazola continue to sell to tourists.

While carvers in San Martín are hospitable to visitors, their community is not as tourist-friendly as Arrazola. There are no regularly scheduled bus tours of the village. During the 1980s and much of the 1990s tourists entering San Martín by car or taxi had to drive two kilometers down an unmarked, rutted, unpaved road away from the Oaxacan-Ocotlán highway. The town is dispersed, and most of the best-known artisans (e.g., Isidoro Cruz, María Jiménez, Coindo Melchor, Jesús Sosa, Inocencio Vásquez, Antonio Xuana) live away from the town center. Buses and collective taxis from Oaxaca leave passengers off at the crossroads, forcing San Martín–bound riders to walk into town. Furthermore, taxi drivers from Oaxaca are often unfamiliar with San Martín, do not like driving on the often muddy roads, and usually do not know where particular artisans live.

While these logistical obstacles deterred tourists and some store owners

in the late 1980s, large-scale dealers during this time were usually willing to travel to San Martín. The wood-carving business in the community since then has been dominated by sales to wholesalers and store owners who buy large quantities of small, inexpensive pieces. A typical order in 1995 might have been for fifty turtles, twenty armadillos, and ten rabbits for 10 to 20 pesos apiece.

By 1990 about 70 percent of households in Arrazola and San Martín included someone in the wood-carving trade. Although the two communities had about the same number of high-end carvers, San Martín had many more families that produced inexpensive pieces. The experienced carvers in San Martín frequently derided the cheap, simple pieces made by many of the newer artisans. The carving and painting styles of both the veteran and newer carvers in San Martín varied greatly and were less easy to characterize than those in Arrazola and La Unión.

The economic effects of the wood-carving boom of the late 1980s were less dramatic in San Martín than in Arrazola. At the beginning of the 1980s San Martín was considerably more prosperous than Arrazola; by the end of the decade Arrazola was the wealthier community. Because agricultural land was abundant in San Martín, most families in that community continued to grow much of their food. In 1990 remittances from the United States were at least as important in the local economy as wood-carving sales. Many of the new carving families selling cheap pieces to large-scale wholesalers only modestly improved their standard of living. Nonetheless, the wood-carving boom transformed the economy of San Martín. Few families continued to make embroidered blouses; agriculture became a secondary, subsistence-oriented occupation scorned as unprofitable by many young men and women. Husbands and wives who previously operated in distinct economic spheres now worked together making wood carvings. Children learned to sand, paint, and carve at early ages and became important contributors in family workshops.

In the late 1980s La Unión was much harder to get to than either Arrazola or San Martín. Although La Unión is not far from Oaxaca, the hour-long trip from the city involves taking an unpaved road for much of the way. This road crosses several rivers, which sometimes flood, making the village inaccessible to most vehicles. (A bridge completed in 1998 has made it much easier to get to La Unión in the rainy season.) Dealers face further problems even after arriving in La Unión. Carvers lived in houses dispersed over a large hilly area crisscrossed confusingly with footpaths. Most houses do not sell carvings; those that do lack signs advertising their pieces. And

even when dealers manage to find a carving family, the artisans are often away in fields. Because of these logistical problems, few dealers and almost no tourists visited La Unión in the late 1980s. The extended Santiago family continued to sell to only a few wholesalers and store owners, often bringing their pieces to the city of Oaxaca. Only a few other artisans (notably Gabino Reyes) began carving as a result of the boom. Styles in La Unión remained simple, and many artisans continued to use aniline paint. By 1990 pieces from La Unión were readily recognizable by their anachronistic quality. The evolution of complicated painting and carving styles characteristic of the boom in Arrazola and San Martín had not yet happened in La Unión.

The boom had relatively little economic effect in La Unión. The number of artisans in the community increased only moderately. Jaime Santiago was the only artisan who earned enough money to build a concrete house. The other carvers continued to live in adobe houses, spent much of their time farming, and had a standard of living little better than their noncarving neighbors. While neighboring villages envied the material possessions of people in Arrazola and San Martín, La Unión was economically unexceptional in the Central Valleys of Oaxaca.

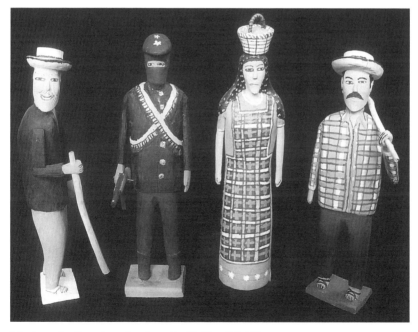

Mexicans by Francisco Santiago, La Unión. Fidel Ugarte.

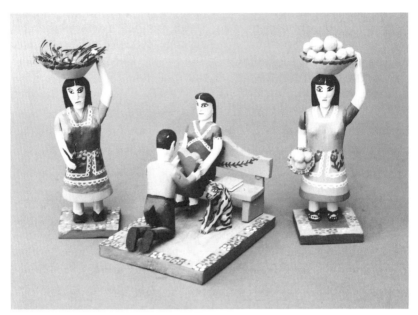

Market women and courting couple by Maximino Santiago and Yolanda López, La Unión. Don Roberts, collection of Michael Chibnik.

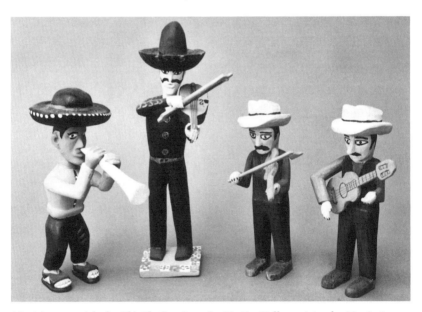

Musicians on right by Plácido Santiago, La Unión. Tall musician by Maximino Santiago, La Unión; musician on left by Miguel Díaz, San Pedro Ixtlahuapa. Don Roberts, collection of Michael Chibnik.

When sales leveled off around 1990, many wood-carvers worried that their craft was just a passing fad. These concerns were shared by Shepard Barbash (1993:40) in his popular art book about the carvers. I was therefore surprised to learn that business was better than ever when I began my research in 1994. During the first few years of my research, sales from the three best-known carving communities leveled off, but artisans from other places had increased success selling pieces. In the later years of my research, overall sales of carvings in most places in the state of Oaxaca probably dropped because of the lesser demand for inexpensive pieces.

In his pessimistic comments about the future of the wood-carving trade, Barbash referred to the "sick" U.S. economy of the early 1990s. I am not sure how relevant this was for the market for wood carvings even then since many people in the United States were able to afford inexpensive and moderately priced pieces. Nonetheless, the remarkable economic growth in the United States in the mid- and late 1990s provided middle-class families with more money that could be spent on nonessential items such as wood carvings. I once asked Clive Kincaid why he thought people from the United States were willing to spend several hundred dollars on high-end wood carvings. I commented that I could easily see how tourists in Mexico could afford forty or fifty dollars for a carving but was puzzled as to why there was still a market in the United States for the same piece costing five times as much. Clive first noted the playfulness and ingenuity of the carvings and the appreciation people in industrial societies have for handmade objects. But he then observed that "there are a lot of people in this country with disposable income." This, of course, cannot explain why some people choose to spend money on expensive wood carvings. But such expenditures would be impossible for many potential buyers without the disposable income provided by a healthy economy. Although I am dubious about the causal connection, it must be noted that the decline in wood-carving sales at the beginning of the twenty-first century took place during an economic downturn in the United States.

NEW SOURCES OF CARVINGS

There have been wood-carvers in places other than Arrazola, San Martín, and La Unión since the 1960s. Some of these artisans are former residents of the three main carving communities. Others independently took up wood

carving, often with the encouragement of shop owners and representatives of state artisan agencies. In the 1960s and 1970s Nicodemus Bastulo, Isidoro Cruz, and Tonatiúh Gutiérrez all bought pieces from places other than the principal carving communities. More recently, shop owners such as Mary Jane Gagnier Mendoza, Víctor Vásquez of Teresita, and Angela García of Taly have sought out carvers in new places. Every time I go into Teresita or Taly, I discover carvings from surprising places such as Santiago Atitlán, a Mixe community near Ayutla, and San Martín Toxpalan, located 130 kilometers north of the city of Oaxaca along the road to Mexico City.

The ten or so families who make carvings in the Zapotec-speaking community of San Pedro Cajonos are all related to the entrepreneurial Blas brothers, who have had considerable success in recent years making eerie, elaborately carved dragons, insects, butterflies, and monsters. Because San Pedro Cajonos is in the mountains a couple of hours away from the city of Oaxaca, dealers and tourists rarely visit the Blas brothers in their workshops. The brothers therefore bring their pricey pieces (selling wholesale for US$20 to $50) to the city, where they meet dealers and store owners. Their distinctive, strangely formed carvings make a strong impression on many visitors to Oaxaca.

The most important new carving community is San Pedro Taviche, a village of about 900 people in the mountains 25 kilometers southeast of Ocotlán. Because the road between Ocotlán and San Pedro Taviche is in poor condition, this short trip takes an hour and a half by collective taxi or bus. Copal is abundant around Taviche, and entrepreneurs from the area have been selling wood to San Martín carvers since the 1980s. Perhaps for this reason, a few residents of Taviche learned to carve during the boom. In the early 1990s both men and women from Taviche began making and selling large numbers of unpainted carvings to families in San Martín. The San Martín families paint the pieces and sell them to dealers or tourists. The Taviche carvers also sell unpainted pieces to the large workshops in Arrazola. These carvings are painted by women from communities near Arrazola and then sold to tourists. Sellers of pieces carved in Taviche and painted elsewhere are seldom candid when they talk to tourists (and even, at first, inquiring anthropologists) about the origins of their pieces. They will say that their carvings are made in family workshops. Tourists are likely to believe this because they often see carvers at work when visiting places where Taviche pieces are sold. Most families selling Taviche carvings also make some pieces themselves.

Around 1995 a few people in Taviche began painting their pieces. By the end of the decade shops in Oaxaca regularly sold pieces both painted and

carved in Taviche. In 1998 Taviche wood-carvers were represented for the first time in a state-sponsored artisans' sale in the zócalo during Guelaguetza. The man from Taviche staffing the community's stall told me that fifty artisans provided pieces for the exhibition. He gave me a printed card advertising the work of a family from Taviche and urged me to visit. Almost every family in Taviche, he said, was now involved in carving.

By the end of the 1990s wood carving was clearly economically more important in Taviche than in La Unión. Nonetheless, many dealers and some tourists knew about artisans in La Unión, while few knew about the wood-carving trade in Taviche. This was partly because of the longer history of wood carving in La Unión and the publicity given to pieces from that community in the Barbash/Ragan publications. The higher quality of pieces from La Unión is also relevant. While some carvers from La Unión make cheap pieces, artisans such as Gabino Reyes, Aguilino García, Sergio Santos, Octaviano Santiago, Plácido Santiago, and Maximino Santiago are known for their fine work. In 1998 the Museum of Popular Arts in San Bartolo Coyotepec had a two-month-long exhibit of carvings from La Unión. The opening ceremonies were attended by high-ranking bureaucrats and politicians. Nobody is going to put on a museum exhibit of work from Taviche in the near future. Their pieces, while often charming, are for the most part quickly made, cheap, and unoriginal. The invisibility of Taviche in the wood-carving trade, of course, is also related to the community's production of unpainted pieces sold to entrepreneurs in San Martín and Arrazola. Tourists buying pieces signed by someone from Arrazola or San Martín have no idea that they were carved in Taviche.

ARTISANS' ORGANIZATIONS

Cooperatives ordinarily form when a group of producers can accomplish something working together that is impossible for individuals working alone. Farmers, fishers, and artisans in Latin America have formed cooperatives for tasks such as obtaining credit, buying equipment, and transporting products to market (Annis and Hakim 1988; Hirschman 1984; Kleymeyer 1994). Such organizations have been relatively unimportant in the wood-carving trade since materials are cheap and dealers travel to the artisans' communities to buy pieces. Nevertheless, in the 1990s several organizations of wood-carvers formed in Arrazola and San Martín in attempts to increase sales to tourists and the state government.

In 1993 an organization was formed in Arrazola to create and staff an

artisans' market, where pieces are sold to tourists visiting the town. The market is a pleasant multiroom building on the town square that is immediately noticed by any tourist driving into Arrazola. In 1998 artisans were paying 20 pesos a month (about US$2.50) for space in the market. Artisans usually sold only pieces made by members of their family. Because adults preferred to spend time in their home workshops, teenage family members typically had the responsibility of selling in the artisans' market.

The artisans' market has not been particularly successful. The group has never had more than sixteen members and was down to seven members in January 1998. Taxi drivers and boy guides preferred to take tourists to workshops and family homes because the artisans' market did not give commissions. Furthermore, tourists on their own often found it more interesting to visit artisans' homes than to buy in a marketplace that looked like many shops in the city of Oaxaca. While the prices of pieces in the artisans' market were competitive, the wood carvings displayed there were for the most part not of particularly high quality. The members of the group knew that they could get more money for their best pieces by selling to dealers in their homes.

In 1995 a multipurpose artisans' organization was founded in Arrazola. By February 1998 this group had thirty-six members, all adult men. Since there were at the time about sixty adult male carvers in Arrazola, this group included more than half the men in the village earning money through wood carvings. The group's membership overlapped with that of the artisan's market. Most members were moderately successful independent carvers. The group did not include operators of large workshops, artisans who sold unpainted pieces, or extremely successful carvers such as Manuel Jiménez and Miguel Santiago.

This unnamed group exists because the state government would rather deal with organizations than with individuals. The group has negotiated with the state about problems that developed when Arrazola carvers attempted to cut copal from a neighboring community. Members have asked the government to finance workshop construction and sought state medical benefits available to members of the government-defined "formal sector." (These efforts have been unsuccessful.) The major reason for the group's formation, however, was to obtain permission to participate in state-sponsored exhibitions in front of the government buildings on the Oaxaca zócalo during the four times of the year when the city is crowded with tourists. These peak tourist seasons are Christmas, Semana Santa (Easter week), Guelaguetza, and Days of the Dead (beginning of November). Artisans from Arrazola were not able to participate in these exhibits in the early 1990s because they were not

members of a state-recognized organization. The Arrazola group is now able to sell carvings on the zócalo during important holidays.

In the mid-1990s the artisans' group complained to the town council of Arrazola about the boy guides who take tourists to see wood carvings in exchange for commissions. The group's complaint was based on both economic and moral considerations. The boys take tourists to the artisans that pay the highest commissions. Independent artisans understandably do not want to get into bidding wars with one another for the boys' services and fear losing customers to owners of the wood-carving factories. Tourists complain that the guides can be a nuisance and worry about hitting the boys with their cars. Furthermore, the artisans' organization disapproves of parents who encourage boys to work as guides during school hours. The group thinks that such parents are taking advantage of their children. The groups' complaints have had some effect; the number of boy guides during school hours has decreased.

During the 1990s two artisans' organizations were established in San Martín with the straightforward goal of increasing sales. These groups of ten to twenty artisans sell pieces at the government-sponsored exhibitions during holidays. They also provide carvings for a state-run shop attached to the government tourist offices near the Oaxaca zócalo. The San Martín groups have had some success in incorporating their carvings into state-sponsored cultural exhibits in other parts of Mexico, Europe, and the United States. At least one artisan from San Martín has accompanied carvings to these shows.

There is considerable political maneuvering associated with having one's group selected as part of a state-sponsored exhibit. The rewards for being chosen can be substantial. When Jimmy Carter and his large entourage visited San Martín in early January 1998, their first stop was at the house of Elpidio Fabián, the head of one of the artisan organizations. Carter's group had met the artisans in Elpidio's organization at the Christmas sales on the zócalo. There artisans were able to earn quite a bit of money from sales to Carter's group. Moreover, Elpidio was able to display a picture in his workshop of a smiling Jimmy Carter with his family.

THE INSTITUTIONALIZATION OF WOOD CARVING AS A OAXACAN CRAFT

A recent *Lonely Planet* guidebook emphasizes the importance of crafts in Mexican tourism:

Mexico is so richly endowed with appealing *artesanías* (handicrafts) that even the most hardened non-hunter of souvenirs finds it hard to get home without at least one pair of earrings or a little model animal. There's such a huge and colorful range of arts and crafts, many of them sold at reasonable prices, that virtually every visitor is irresistibly attracted to something, somewhere along the way. (Noble et al. 1999:978)

As this passage suggests, tourists in the state of Oaxaca are always on the lookout for new crafts. Nonetheless, until the mid-1990s most guidebooks describing the tourist attractions of Oaxaca seemed to regard wood carving as a fad without roots in Mexican culture that was likely to disappear soon. In recent years, however, guidebooks to Mexico aimed at tourists from the United States and Canada ordinarily include wood carving along with textiles and ceramics in sections devoted to Oaxacan crafts. Although the guidebooks ordinarily focus on Arrazola and Manuel Jiménez, they are paying increasing attention to San Martín. Their sections about the wood carvings can be quite enthusiastic, if not always entirely accurate:

Arrazola is well-known for *alebrijes*, brightly painted whimisical animals carved from copal wood. The first village carver to really let his imagination run wild in the present genre was Manuel Jiménez two decades ago. He and his entire family work on the often-very-tall animals painted in bright colors. A giraffe can stand as high as three feet tall or an "alien" animal only two inches tall. All are painted pink, or orange, or blue, or—who knows?—with polka dots and fine geometric designs. (Cummings and Mallan 1999:922)

Arrazola . . . is the home of the local woodcarvers and painters who produce the delightfully boldly patterned animals from copal wood that you'll see in Oaxaca and all over Mexico. Carvers from other villages are catching on to the popularity of these whimsical, spiky figures and producing the polka-dot, hooped, or expressionist examples themselves, but few, if any, are better than in Arrazola. (Fisher 1998:435)

San Martín Tilcajete is a recent addition to the tour of folk-art towns. Located about ten miles south of San Bartolo Coyotepec, San Martín is noted, as Arrazola, for its wood-carvers and their fanciful, brightly

painted animals and dragons. The Sosa and Hernández families are especially prolific, and you can easily spend half a day wandering from house to house to see the amazing collections of hot-pink rabbits, 4-foot-long bright blue twisting snakes, and two headed Dalmatians. (Baird et al. 1999:427)

The inclusion of wood carvings in guidebooks demonstrates the craft's widespread acceptance as an emblematic Oaxacan folk art. This increased appreciation of the carvings is in part the cause and consequence of trips taken by artisans to the United States and museum exhibits both in Mexico and abroad. The institutionalization of painted wood carving as a Oaxacan craft is also illustrated by the signatures on artisans' pieces, the signs on their houses, and their business cards.

EXHIBITIONS

Manuel Jiménez and Isidoro Cruz were the only carvers to give exhibitions in the United States prior to the late 1980s. Since that time, other artisans have made trips abroad to show their pieces in shops, museums, and schools. These visits are ordinarily paid for by a sponsor in the United States, who arranges for air transportation, lodging, and food and helps with the paperwork required by customs and immigration in Mexico and the United States. Artisans usually are able to sell pieces at their exhibitions and demonstrations. The number of carvers (almost all male) who have made such trips is not large, perhaps no more than twenty. Two artisans from La Unión have given exhibitions in the United States; almost all the rest are from Arrazola and San Martín. An invitation to make such a trip is a good indication that an artisan has achieved success, and most carvers giving exhibitions greatly appreciate the attention they get and the opportunity to travel comfortably in the United States. Nonetheless, some well-known artisans either by choice or by chance rarely or never make such trips. Miguel Santiago has exhibited only once in the United States (in the 1980s) and says that he is "too busy" to accept the many other invitations he has received. María Jiménez got her first invitation to exhibit in the United States in 1999.

Although only a few artisans have given exhibitions in the United States, the impact of their trips on the carving trade has been substantial. The trips, which often last for two weeks or more, have brought the wood carvings to the attention of thousands of people who otherwise would never have seen them. Exhibitions of wood carvings have been held at prominent

cultural institutions such as the Heard Museum in Tucson, the Children's Museum in Chicago, the Mexican Fine Arts Center Museum in Chicago, and the Mexican Museum in San Francisco. Such exhibitions have led to pieces being sold in museum shops, usually alongside Barbash's book. People who have seen the carvers in shops, galleries, and schools often recommend that friends touring Mexico buy pieces at the artisans' workshops in Arrazola and San Martín.

A trip by Margarito Melchor Fuentes and his 21-year-old son Margarito Melchor Santiago to Chicago in July 1997 shows both how Oaxacan wood carving is represented in museum exhibitions and how such trips are economically helpful to the artisans. The Melchors, well-known artisans in San Martín, were invited to spend a week at the Chicago Children's Museum demonstrating how to carve and paint. This was part of a new exhibit at the museum called "Magic in the Trees: Woodcarvings from Oaxaca." (The title of the exhibit was obviously borrowed from the Barbash book.) In August two other San Martín carvers (Epifanio Fuentes's sons Zeny and Ivan) spent another week in the museum as part of the publicity for the exhibit. These trips might seem atypical since few Oaxacan carvers have demonstrated their craft at museums specifically aimed at children. Carvers visiting the United States often spend large amounts of time at elementary schools, however, and their museum and shop demonstrations always include many families with young children.

This was the second U.S. trip for Margarito the elder and the first for his son. The museum sent them airplane tickets and elaborate instructions (in English) about what materials the Melchors could bring to the exhibit. They ended up shipping two baskets of carvings and machetes and carrying another basket (with wood and more pieces) on the plane. They were met at the airport in Chicago by Rosi Romero, who had proposed the "Magic in the Trees" exhibit. Rosi also provided housing for the Melchors during their ten-day visit.

The wood-carving demonstrations were part of what a museum brochure (featuring a picture of the two Margaritos on the cover) described as a "one-of-a-kind cultural exhibition":

The entire museum will come alive, showcasing Mexican culture and folk art traditions. The Artabounds Gallery will be home to Oaxacan wood carvings called *alebriges* (creatures of fantasy). Children can invent their own creatures, by placing arms, horns, tongues, antennas, whiskers and more on monster bases. From dancing reptiles and

flower-print cats to burrows with wings and bewitching devils, these brilliantly colored woodcarvings of Oaxaca delight the imagination. *Alebriges* will also be for sale in the Museum store . . . The Great Hall will host a Oaxacan *Zócalo,* or town square, where children can dress up in traditional Oaxacan clothing, embroider creations on an embroidery table, make alebriges, and play Mexican games.

The back page of the brochure was entirely devoted to a "museum activity to do at home"—"practicing the art of Oaxacan woodcarving with soap."

The exhibit, funded partly by the Joyce Foundation, was incorporated into the museum's Latino Neighborhoods Initiative, a program designed to involve families from Chicago's Latino communities with the museum. Besides demonstrating their craft in the museum, the Melchors participated in a "Family Alebrige Workshop" costing $30 per family and a "Members-Only Night" in which the carvers performed alongside a children's marimba band. Rosi Romero also arranged for a demonstration in a school in a Latino area.

The Melchors were able to keep all the money they received from sales of their carvings in demonstrations in Chicago. The exhibition was obviously successful from the museum's perspective. When I talked with the Melchors in June 1998, they were working on an order for 300 pieces for the museum shop. In 1999 they returned to the museum for another week of demonstrations.

SIGNATURES

Néstor García Canclini argues in an influential book (1993:63) that signatures on artisans' pieces are a crucial indicator of the commercialization of a craft:

> The use value and the sense of community that crafts hold for the village that both produces and uses them—predominantly practical as far as earthenware or textiles are concerned, symbolic in the figures of devils or ceremonial objects—are neutralized by the signature . . . The value that stemmed from the usefulness of the object to the community comes to depend on the singular gesture of the producer. Thanks to the signature, the meaning of crafts . . . is no longer comprehensible in terms of their bond with nature or social life, but must instead be interpreted in relation to the creator's other works. For most artisans . . . the deculturation of their works entails a double life: they

carry on sharing life in the community from where their objects come, and at the same time they take them to shops and markets, where they are subject to the vicissitudes of a foreign meaning.

García Canclini's remarks seem of limited applicability to a market-driven craft with little use value that has only existed for several decades. Nonetheless, signatures on wood carvings are clearly the result of the desires of collectors, tourists, and dealers wanting to know the makers of their pieces. Few carvings were signed before 1985, and even today many cheaper pieces in Oaxaca shops are unsigned. The existence of a signature on a wood carving, as García Canclini suggests, draws attention to the creator of the object and away from the community the maker comes from. By doing so, signatures help artisans establish niches for their carvings in a segmented market. The assignment of a signature to a carving differs from workshop to workshop. In most cases, pieces are signed by the best-known person in the workshop, usually the principal male carver. Some pieces are signed by the painter; others indicate that a carving was created by a family.

Two examples illustrate the connection between signatures and the economics of the wood-carving trade. In February 1998 I bought an inexpensive carving from a San Martín family that I had just finished interviewing about their division of labor when making pieces. The carving was signed by a son in his early twenties who had been in the United States the past several months. His mother told me that wholesalers knew him as the carver in the family and would be less willing to buy pieces signed by someone else. Later in that year I took a trip to the Mexico-Arizona border to look at the marketing of Oaxacan wood carving. On both sides of the border, I saw many pieces signed "Olga Santiago," the name of a woman who operates a small workshop in Arrazola. Although Olga does some painting, the great majority of the pieces in her workshop are made entirely by hired laborers. Olga's signing of these pieces suggests to buyers that the carvings are made by an individual rather than by several piece workers. This doubtless helps sales since dealers of wood carvings report that their customers like some sort of personal connection with the maker of their pieces. Furthermore, Olga's signature brings her name to the attention of tourists and dealers who may later decide to visit her workshop in Arrazola.

SIGNS AND BUSINESS CARDS

Visitors to Arrazola and San Martín see many colorful, attractive signs on

houses indicating the presence of wood-carving workshops. These signs usually include a painting of a piece, the name of the artisan, and a line or two saying that wood carvings can bought at the house. Although some signs are in Spanish, most are in imperfect English. Since most dealers know where carvers live, the principal purpose of signs is to attract tourists to wood-carving workshops. For this reason, signs are seldom found in places where tourists rarely venture. There are no signs at all in La Unión and not many in parts of Arrazola and San Martín away from the town centers. Furthermore, some successful artisans who sell primarily to dealers (e.g., Antonio Aragón of Arrazola and María Jiménez and Antonio Xuana of San Martín) did not have signs on their houses in the summer of 1999.

Many artisans in Arrazola and San Martín now have business cards that they give to tourists and dealers who visit their workshops. These cards are often adorned with drawings of wood carvings. Unlike the signs, the cards are usually in Spanish. They always give the artisan's name and address and sometimes also include a telephone number. While many carvers in Arrazola have phones, until recently the only way potential buyers could contact artisans in San Martín was via the community phone on the one line into the town. Since problems with telephone communication led to the loss of business for San Martín carvers, they often complained about the lack of lines. Jesús Sosa and Epifanio Fuentes bought cell phones, but other carvers could not afford this alternative to the community phone. In 1999 the number of cell-phone users in San Martín increased greatly when a cheaper service became available.

Since 1986 wood carving has been incorporated into the culture of several craft-producing communities in the state of Oaxaca. Many men and women in Arrazola, San Martín Tilcajete, La Unión, and elsewhere now think themselves as wood-carvers and teach the craft to their children. But wood carving is still only one aspect of their lives and identities. The artisans' work must be understood in the context of the history, economics, and sociopolitical organization of their communities. The next two chapters therefore present an ethnographic overview of the places where wood carvings are made.

WOOD-CARVING COMMUNITIES

Casual visitors to wood-carving communities in the Central Valleys of Oaxaca often encounter scenes of pastoral tranquillity. Farmers slowly lead their ox-teams over corn and bean fields set against wooded hills. Carvers and painters talk quietly as they work on their pieces in outdoor courtyards on sunny days that are neither too hot nor too cool. Goats, chickens, turkeys, donkeys, and pigs cross dirt roads. Even the most oblivious tourists soon find out, however, that Arrazola, San Martín Tilcajete, and La Unión Tejalapan are very much part of the wider world. The artisans listen to rock music on the radio, watch soccer on television, and use cellular telephones. Construction workers are building large concrete houses; roads are being paved. Some of the picturesque farmers turn out to have spent years in California.

This mix of the modern and the not-so-modern is, of course, characteristic of much of contemporary Latin America. Nonetheless, many observers of the Central Valleys have largely ignored recent changes and focused instead on long-standing cultural traditions. They em-

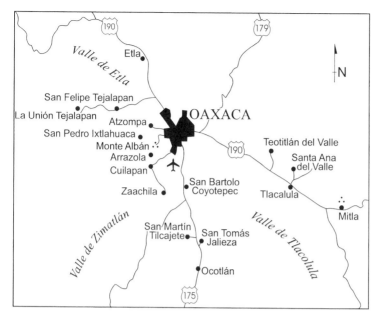

The Central Valleys

phasize subsistence production and aspects of religion, material culture, and social organization that either can be linked directly to pre-Columbian times or were introduced to Oaxaca by the Spanish prior to Mexican independence. As Michael Kearney notes (1996:95), "scores of investigators . . . have seen the Valley of Oaxaca . . . as populated with subsistence and petty commodity producers operating outside of capitalist relations." Although this analytic approach is now rare among both Mexican and foreign anthropologists conducting research in Oaxaca, it continues to be common in tourist brochures, newspaper accounts of artisan communities, and advertisements for wood carvings and other crafts.

By the latter part of the twentieth century, the majority of anthropologists writing about Mexican crafts were stressing connections between local communities and the wider world. Many scholars emphasized the place of folk art in government policy and capitalistic development. Writers such as Néstor García Canclini (1993), Scott Cook (1993), and Victoria Novelo (1976) showed how communities had been transformed by government policies encouraging craft production and the activities of intermediaries seeking to profit from the folk-art trade. Some of these writers (e.g., Cook and Novelo) downplayed cultural aspects of crafts and focused on the economic articulation between household producers and capitalist intermedi-

aries. Others (e.g., García Canclini) argued that the cultural losses were inevitably associated with the immersion of crafts into national and international marketplaces.

Most contemporary anthropological scholarship on Oaxacan craft communities (e.g., Cohen 1998; Kearney 1996:165–169; Wood 1997) pays considerable attention to the movement of people, images, and goods across national borders, especially the U.S.-Mexican frontier. Writers have noted that income from craft exports and remittances from temporary or permanent emigrants living in the United States help maintain community fiestas (Cohen 2001:962) and allow the persistence of long-standing systems of cooperative labor and government. Kearney (1996:141) has coined the term "polybian" to describe the identity of migrants who move back and forth "from 'peasant' to 'proletarian' life spaces." Although I cannot agree with Kearney's interpretation of wood-carving styles in terms of transnational identity, his comments (Kearney 1996:166) are thought-provoking:

> Just as the creators of tourist art are a complex polybian type, so are the artifacts they produce. One such style that has recently occurred in Oaxaca is painted wood carvings characterized by a whimsical combination of morphologies and surface designs . . . At first glance, many of the creatures represented in this genre of tourist art appear *ambiguous* in the sense that ambiguous creatures inhabit indefinite places betwixt and between worlds . . . But whereas ambiguity mediates dual opposition, the creatures of contemporary Oaxacan wood-carvers, who are situated in complex transnational fields that lack dual polarity, are appropriately polybious. Rather than hybrid monsters formed by combining species from conventional habitats, they are formed from combinations of multiple real and imagined species, as benefits beings that inhabit multiple real and hyperreal habitats.

The magical realism that Kearney describes is characteristic of much of Latin American art and literature, whether created by urban intellectuals, indigenous Amazonians (see Luna and Amaringo 1991), or "polybians." Nonetheless, his principal argument about the impact of transnationalism on Oaxacan craft communities is well taken.

The ethnographic overview of Arrazola, San Martín, and La Unión that follows suggests that a combination of the approaches described is necessary to understand the contemporary activities of wood-carvers. The three carving villages share many long-standing features of social organization

with other communities in the Central Valleys. Craft production has flourished in the region in the past several decades because of encouragement from the state, increased tourism, and a thriving international market for ethnic arts. Temporary and permanent migration to the United States has had significant effects on the economics and culture of Arrazola, San Martín, and La Unión.

THE CENTRAL VALLEYS OF OAXACA

The Y-shaped Central Valleys of Oaxaca are the largest relatively flat area in a mountainous state. This semiarid region averages 1,500 meters above sea level and is frost-free the year round. Agricultural activities are constrained by the availability of water. Rainfall averages 550 millimeters (22 inches) yearly but is highly variable. In many communities crop growing is limited to the rainy season from May through October. Other villages with high water tables or nearby rivers are able to grow crops year round using wells and small-scale canal irrigation. The primary subsistence crops for millennia have been the Mesoamerican trio of corn, squash, and beans. Where irrigation is possible, cash crops such as garlic, onions, and chile peppers are sold in an extensive regional marketing system.

The Central Valleys, the site of large pre-Columbian urban centers at Monte Albán, Mitla, and elsewhere, were densely populated when the Spanish conquered the territory in 1521 (Blanton et al. 1999; Murphy and Stepick 1991:9–15; Taylor 1976). The inhabitants at the time of the conquest were mostly Zapotec and Mixtec speakers who lived in communities scattered along the valleys. In contrast to many other parts of Mexico, the Spanish established few large haciendas, and the indigenous population for the most part retained control of the land. Communities specialized in particular crops and crafts which were exchanged in the city of Oaxaca and in rotating weekly town markets (*tianguis*) which had existed prior to the Spanish conquest.

By the end of the colonial period, villages in the Oaxacan valleys had developed forms of social organization that persisted well into the twentieth century (Cook and Diskin 1976:11–12). Villages were internally governed by a civil-religious hierarchy in which adult men participated in a series of ranked, age-graded positions. The religious part of the hierarchy entailed the costly sponsorship of celebrations associated with major saints (the mayordomo system), particularly the patron namesake of the community. The prestige of various sponsorship positions was roughly proportional

to their cost. Each village in addition required that adults engage in communal labor service (*tequio*) on projects such as irrigation canals, harvesting, and the construction of public buildings. An institutional mechanism for reciprocal exchange (*guelaguetza*) enabled community members to borrow money from their relatives and neighbors in order to pay for the food, drink, and music at saint's day celebrations, weddings, and other ritual events.

Although Oaxaca was a production center for the red dye cochineal in the late eighteenth and early nineteenth centuries (Baskes 2000), the state has usually been a provincial backwater. By most measures, Oaxaca has long been among the poorest states in Mexico. The communities in the Central Valleys have always been somewhat better off than those in the mountains. Nonetheless, the material conditions, schools, and public health facilities in Valley communities have never been as good as those in most places in central and northern Mexico.

The Mexican Revolution had less effect on land tenure in Oaxaca than in many other parts of the country. Even though some large estates were established during the long presidency of Porfirio Díaz (1876–1910), most indigenous communities in rural areas held onto their land. The principal postrevolutionary agrarian reform program in much of Mexico involved the establishment of *ejidos,* community-owned lands which residents could farm but not individually own. Many ejidos were established on haciendas expropriated by the state, especially during the presidency of Lázaro Cárdenas (1934–1940). The creation of ejidos greatly reduced the number of landless rural Mexicans. Land reform in Oaxaca, while significant, was less dramatic. In 1960 communal land units (property owned by villages that usually predated the revolution) comprised 38 percent of the total area censused in the Valley, compared to only 13 percent in ejidos (Cook and Diskin 1976:13–14). The remaining land was privately owned or federal, state, or municipal property.

While there is no longer a civil-religious hierarchy in which adult men sequentially participate in mayordomo sponsorship and political leadership, the ritual celebration of saints' days remains important in contemporary Central Valley communities. Individual mayordomo sponsorship is rarely obligatory. In some villages participation in the mayordomo system is voluntary; in others, saints' days are sponsored by a church or the community as a whole and not by individuals.

Civil hierarchies involving obligatory community service are central to the sociopolitical organization of the Central Valleys. In most communi-

ties, adult men must participate in a governmental system called *usos y costumbres.* The details vary among villages, but all require that adult males spend at least one year voluntarily working at a community position. Years of community service alternate with years of rest, and it is not uncommon for older men to have held three or four different political positions. Positions in many places are ranked and age-graded, with men first holding lower positions (e.g., as policemen) and later taking on more significant jobs such as treasurer or vice-president. Age-grading is breaking down in an increasing number of communities. Young, educated men hold high-ranked jobs as their first or second position because they are considered especially able to deal with certain complex tasks. The leaders in usos y costumbres systems of local government coordinate tequios in which families are periodically obliged to send a representative to work on village communal labor. Guelaguetza loan systems still flourish in some communities (Cohen 1999; Stephen 1991) but are less significant in others.

Visitors to villages in the Central Valleys are often struck by the number and frequency of fiestas. The fiesta for a community's patron saint, usually the biggest celebration of the year, may last several days. Many families host fiestas around Christmas and Semana Santa. Fiestas for weddings, baptisms, birthdays, school graduations, and *quinceañeras* (girls' fifteenth birthdays) occur throughout the year. Weddings, which are especially expensive and ostentatious, may be attended by more than one hundred guests.

For decades migrants from the Central Valleys have sought employment in Mexico City. The United States is now a much more popular destination. Transnational migrants are ordinarily young men who cross the border without legal papers and work in agriculture, restaurants, and construction. Many migrants stay in the United States; more eventually return to Oaxaca. While women also go to the United States, they cross the border less often than men. Because migrants usually settle in places where there are other people from their community, there are strong ties between Oaxacan villages and certain towns in the United States. Although California has been the most common destination of migrants, Oaxacans are increasingly settling in other parts of the United States.

Ethnicity in the Central Valleys can be confusing to both tourists visiting the area for a few days and anthropologists who have worked in the region for many years. In the twentieth century Spanish became the dominant language in the Valleys. Some communities which were inhabited almost entirely by monolingual and bilingual Zapotec speakers in 1900 nowadays are populated largely by men and women who speak only Span-

ish. Zapotec and (to a lesser extent) Mixtec continue to be spoken by large numbers of people, but the great majority of speakers of these languages also know Spanish.

Outsiders often label communities in the Central Valleys as "Indian" or "mestizo" according to the percentage of speakers of an indigenous language. Scott Cook and Jong-Taick Joo (1995) have persuasively argued that such an approach to local ethnicity is simplistic. As Cook and Joo point out, identities in the Valleys seem to be based more on class, residence, occupation, and citizenship than on language-based ethnicity. Moreover, Valley residents rarely refer to one another by direct ethnic terms such as *mestizo, indígena,* or *Zapoteco.* The one major exception, Teotitlán del Valle, appears to be a situation where local people have embraced a Zapotec identity in their efforts to promote the export of their textiles to the United States. Aside from language, there do not seem to be many significant ways in which Valley communities inhabited by monolingual Spanish speakers differ from those populated by men and women who are bilingual in Spanish and Zapotec. Tequio, mayordomía, guelaguetza, and usos y costumbres are as important in monolingual Spanish communities as they are in places where most people are bilingual. Cook and Joo (1995:39–46) were able to find few economic differences between monolingual Spanish and bilingual Spanish/Zapotec communities in the Valleys.

Although Arrazola, San Martín, and La Unión have different histories and economic bases, these three wood-carving communities share common religious traditions and forms of social organization. While evangelical Protestantism has made inroads into some places in the Central Valleys, Arrazola, San Martín, and La Unión are still overwhelmingly Catholic. Fiestas, reciprocal loans, and obligatory community service have remained important in the three towns.

ARRAZOLA

Arrazola was the surname of an early-nineteenth-century owner of the lands around the present-day community. This man sold his property to a family named Larrañago Calvo that had immigrated from Spain. Arrazola was only a small part of the Larrañago Calvo family's extensive holdings, which included Monte Albán and surrounding communities. The landed estate (*finca*) at Arrazola grew sugarcane, corn, beans, and squash. The inhabitants of Arrazola migrated to the finca from various places in the state of Oaxaca. Some migrants spoke indigenous languages such as Zapotec, Mixtec, and

Chatino, but by 1900 the community had become virtually monolingual in Spanish. The inhabitants were either sharecroppers, who gave half of what they grew to the finca owners, or poorly paid agricultural laborers. Residents of Arrazola were forced to buy most of their clothes and food at a finca store which offered credit but charged high prices. They rarely had the time or energy to shop in the city of Oaxaca, which was connected to Arrazola only by dirt paths.

The finca survived the Mexican Revolution and was not broken up until the agrarian reform during the presidency of Lázaro Cárdenas. Arrazola residents received relatively little good agriculture land after the breakup of the finca and their ejido was much smaller than that of many nearby communities. In 1937 Arrazola was formally recognized as an independent community. (Although its official name is San Antonio Arrazola, the community is almost always referred to simply as Arrazola.) Between 1937 and 1944 residents supported themselves through subsistence agriculture and archaeological labor on the excavations at Monte Albán. In 1944 men from Arrazola began participating in the bracero program, in which Mexicans legally migrated to the United States to work as short-term agricultural laborers. When work possibilities at Monte Albán ended in 1948, the number of participants in the bracero program increased greatly. Since the end of the bracero program in 1964, men and women from Arrazola have continued to work in the United States, usually without legal papers.

During the 1950s men began working as construction laborers in the growing city of Oaxaca. The workers would walk to their jobs in the city, rising at four in the morning and returning at seven at night. The lack of easy transport to the city and the absence of a crafts tradition restricted women's work opportunities during this time. Except for schoolteachers, women's work was usually limited to domestic and agricultural chores.

Even though the population of Arrazola was only about 400 in 1960, the small amount of land in the community made it impossible for most families to feed themselves through subsistence agriculture. The ejido was about 140 hectares. Even with men's income from construction and seasonal agricultural migration to the United States, Arrazola remained one of the poorest communities in the region. Economic opportunities improved somewhat when a dirt road built in the 1960s enabled automobiles to travel between the village and the city of Oaxaca. Buses made the round trip between Arrazola and the city on Wednesdays and Saturdays. Women were now able to work as vendors in the busy Saturday market in Oaxaca. After the road connecting Arrazola with the outside world was paved in 1976,

inexpensive collective taxis began running regularly between the community and the Abastos market, the largest in Oaxaca. The improved road and collective taxis made it much easier for Arrazola residents to commute to jobs and schools in the city.

In an effort to supplement their meager incomes, men from Arrazola and nearby communities had illegally sold artifacts from Monte Albán for many years. As time went by, the sellers had a harder time finding artifacts and keeping their dealings away from the attention of the guards and archaeologists at Monte Albán. In the 1950s men from Arrazola began making clay replicas of artifacts and selling them to tourists on the site. This enterprise proved worthwhile, and by 1970 stone replicas of artifacts were also being sold. Contemporary replica-makers also sell masks, figures of pre-Columbian deities, and earthenware vessels at Monte Albán. They must walk from Arrazola to their workshops, which are near the site. Until 1988 the sellers had to operate clandestinely because the guards at Monte Albán would periodically take their figures. Antonio Aragón Hernández, father of Saúl and Antonio Aragón and a longtime replica-maker, recalls that "they treated us like criminals." According to Antonio, the guards would sell figures confiscated from the replica-makers. Nonetheless, selling replicas was more lucrative for men from Arrazola than most other types of work.

By 1988 the men selling at Monte Albán had grown weary of their constant conflicts with the guards and archaeologists. When the replica-makers learned of laws in Mexico that protected artisans, they talked to professors of law at a university in Oaxaca and eventually were able to meet with the governor of the state. The replica-makers formed a legally recognized civil association (usually referred to as a "union") of artisans with the right to carry out business in Monte Albán. Although the recognition by the government gives the replica-makers legal protection, their verbal agreement with the archaeologists at Monte Albán is more relevant to their daily activities. This agreement stipulates that the replica-makers carry out certain chores around the site in return for being granted permission to sell there. The members of the union clean the area of trash, cut the grass with machetes, and look out for thieves who try to rob tourists (usually by purse snatching). In 1996 forty of the sixty members of the union were from Arrazola. About one-third of the members were women, who made necklaces and bracelets that they sold to tourists near the entrance to the site.

The pieces sold by the replica-makers are not inexpensive. In 1996 prices ranged from 80 to 400 pesos (US$10 to $50). Antonio, who was president of the union at the time, reported that he averaged 100–150 pesos a day, a very

good salary by local standards, even if one figures in the cost of materials and long hours. (When Antonio told me this, I observed that there must be many days when he sold nothing. He readily agreed and said that he was happy if he sold two pieces in a day.) Despite Antonio's success, replica selling is ordinarily less remunerative than wood carving. Almost all of the replica-makers in Arrazola in the 1990s were men older than forty-five. Many families have fathers who make clay and stone figures and sons and daughters who carve and paint.

The wood-carving boom had a greater effect on local standards of living in Arrazola than in San Martín and La Unión. In 1985 most residents of Arrazola lived in adobe or thatch houses. Only a couple of families owned televisions and automobiles. The community had dirt roads and only one phone. Most children ended their education after primary school. By 2000 all houses in the community had cement walls and almost every family owned televisions and other electronic devices. The town had built an impressive plaza and paved several roads. While automobile ownership was still uncommon, it was no longer noteworthy. More than twenty households had phone lines and a number of others had cellular phones. Garbage collection had begun in 1997, and a new public health center staffed by a doctor and nurse had just been built. The population of Arrazola had passed one thousand.

Despite these material improvements, socioeconomic development has been uneven in Arrazola. Although the village has had running water for many years, there was no sewage system in 2000 and latrine facilities were variable. Most children graduate from a primary school in the village and then begin secundaria elsewhere. A number have graduated from a *preparatoria* (general-purpose high school), *colegio de bachilleres* (high school preparing students for specific professions such as accounting and business administration), or technical school. Many children, however, drop out during secundaria to work as artisans, and some Arrazola residents think that parents are not investing enough of their income from wood carving into their children's educations. Of the eight Arrazola students attending universities in Oaxaca in 1996, only Saúl Aragón came from a wood-carving family. The rest had parents who worked at good jobs in the city of Oaxaca.

Most families in Arrazola no longer farm. Because the community has little land, those families that do farm rarely cultivate more than a hectare. Although agriculture is ordinarily subsistence-oriented, a few farmers are able to earn some income from growing alfalfa, tomatoes, and peas in an irrigated part of the ejido three kilometers from the village. In 1992 a new

law in Mexico enabled users of ejidos to gain title to parcels and to sell or rent their land. While illegal land transfers had been common previously in Arrazola, the law nonetheless encouraged many wood-carving families to either sell or rent their parcels. To date, these transfers of agricultural land have all been to other residents of the community.

The mayordomo system is stronger in Arrazola than in either San Martín or La Unión. New mayordomos are installed each year during a major fiesta in June. Mayordomos are responsible for hosting meals and performing rituals at a series of fiestas throughout the year. A principal mayordomo and a number of ranked secondary mayordomos are associated with each fiesta. Participation in the mayordomo system is voluntary, and everyone who signs up is given a position. The number of mayordomos in a year ranges from ten to twenty. Although the majority of mayordomo positions are held by men, a few women have been office holders in recent years. Volunteers are asked if they are willing to take on the top-ranked mayordomo positions, which are time-consuming and may involve considerable expenses for food, drink, and musicians. The principal mayordomo at a major fiesta in June in 1995, for example, hosted a dinner that was attended by 600 people.

Only a few mayordomos can afford to hold their position without borrowing money from relatives and neighbors. Such borrowing also occurs for other ritual events such as weddings, funerals, and baptisms. These loans serve the same purpose as the well-developed guelaguetza system found in other communities in the Central Valleys, in which details of reciprocal loans are recorded in notebooks. The term *guelaguetza* is rarely used in Arrazola, and people do not keep precise track of loans.

Most residents of Arrazola in the late 1990s supported either the long-governing PRI (Partido Revolucionario Institucional) or the center-left PRD (Partido de la Revolución Democrática). Vicente Fox, the victorious candidate of the center-right PAN (Partido Acción Nacional) in the remarkable 2000 presidential elections, narrowly edged Manuel Labastida of the PRI. These fluctuations in support for the national political parties are largely irrelevant to the internal governing of the village, which has a usos y costumbres system requiring the participation of all adult males between eighteen and sixty. The top positions are eight members of the town council (*cabildo*), elected in community assemblies in which each family has one representative. Women are allowed to be representatives only in cases where there are no male family members between eighteen and sixty. Although the system was once age-ranked, the average (median) age of the

1996–1998 cabildo was thirty-three. The cabildo consists of two four-person committees. The administrative committee maintains public buildings, runs assemblies and other public events, and decides when tequios should be held and who should participate in them. The justice committee is responsible for punishing people who commit minor crimes or fail to show up for assemblies and tequios. There are also a multitude of committees responsible for electricity, water, schools, and community-sponsored fiestas. The lowest positions in the system are the police, who must work on Sundays and during community-wide fiestas and are on call during other times. Some committees operate outside of the usos y costumbres system. These include the artisans' organizations, the ejido commissions, the mayordomo committees, and a group in charge of the small public market.

SAN MARTÍN TILCAJETE

Tourists arriving in San Martín by bus or collective taxi walk into town along a road that was not paved until 1999. During the summer visitors see farmers working in the fields, often with pairs of oxen pulling plows (*yuntas*). Wealth differences are apparent. Some families live in large cement houses and own automobiles, color televisions, and comfortable furniture; other households have few material possessions and cook on wood stoves. San Martín, which is larger than Arrazola and La Unión, has an impressive church, a primary school, a secondary school, numerous small stores selling basic necessities, and a health center staffed by a paramedic. A small market sells vegetables on Wednesdays.

The state of Oaxaca arranges communities in a political hierarchy in which San Martín Tilcajete is one step higher than Arrazola and La Unión Tejalapan. San Martín is a *municipio;* Arrazola and La Unión are *agencias,* which for certain administrative purposes are part of municipios. (Arrazola is an agencia of Xoxocotlán; La Unión is an agencia of San Felipe Tejalapan.) Because Mexican censuses are recorded by municipios, population data are more readily available for San Martín than for the other two wood-carving communities.

The census data for San Martín illustrate well the difficulties of regarding ethnicity as language-based in the Central Valleys. The area around the town has been inhabited since long before the Spanish conquest. The community was almost certainly predominantly Zapotec-speaking through much of the nineteenth century. In 1900, however, only 312 of the 823 inhabitants of San Martín spoke Zapotec. There were still many Zapotec

speakers in 1930, when the total population had dropped to 712. Of 608 people more than four years old, 278 were bilingual in an indigenous language (doubtless almost always Zapotec) and Spanish, one was monolingual in an indigenous language, and the rest were monolingual in Spanish. There were 171 bilingual speakers older than four as late as 1950, but this number had dropped to 38 by 1960 (Consejo Estatal de Población 1994). The most recent census listed 1,649 inhabitants. Only eight people over the age of four could speak an indigenous language (INEGI 1995). Although these language shifts might be interpreted as reflecting a gradual transformation over time from an Indian town to a mestizo one, it is unclear how San Martín differs culturally from Valley communities where most people are bilingual in Zapotec and Spanish.

The 1995 census provides some useful information about education and material conditions. San Martín is a literate community, with 89 percent of the residents older than fourteen able to read and write. Households are fairly small, averaging about five people per residence. (Other census data show that average family size in San Martín, as in the rest of rural Mexico, has dropped dramatically in the past two decades.) Of 336 residences, 331 had electricity, 232 had running water, and 41 had drainage.

Interpreting these figures can be difficult because the census does not make clear how households and residences (*viviendas*) are defined. In San Martín and other Valley communities, many people live in compounds (*solares*) in which two or more related families share a courtyard and sometimes eat together. The most common arrangement is for parents to live in one part of the compound (often with unmarried children) and married sons and daughters with their spouses and offspring in other parts of the compound. (Wives often move immediately after marriage into compounds with their husbands' parents, but this patrilocal rule is frequently broken.) Census takers must make difficult decisions when attempting to determine how many families and residences there are in a compound.

A report by the paramedic who staffs the health center (Cabrera Santos 1998) provides additional information about the standard of living in San Martín. According to this report, 91 percent of the houses had cement walls, with almost all the rest adobe. Some households were putting in toilets, but 26 percent of residences lacked even latrines. Despite the poor sanitation in some homes, gastroenteritis was becoming less common because of an improved water supply. A changing diet had resulted in an increase in the illnesses of the developed world, with diabetes common and heart disease the most frequent cause of death.

The four-room health center is open Mondays through Fridays. Rene Cabrera Santos, the paramedic, estimated in 1998 that he saw 100–150 patients each month. Rene gave vaccinations (tuberculosis, polio, diphtheria, measles, rubella, tetanus), distributed birth control materials, and provided antibiotics and other medicines. Patients had to pay 10 pesos for a consultation, but the medicines were free. There were no childbirth facilities. For serious illnesses, residents of San Martín had to go to the city of Oaxaca. There was a healer (*curandero*) in the community who practiced a plant-based "traditional" medicine (actually a complex combination of European and indigenous ideas), but he had only a few local patients and supported himself primarily by farming.

Agriculture is much more important in San Martín than in Arrazola. Families have access to both communal land around the town that has been used for centuries and an ejido farther away that was acquired during the Agrarian Reform after the Mexican Revolution. The ejido land is hilly and generally of lower quality than the fields near the village. While a few families have access to irrigated land on which they grow vegetables as cash crops, most agriculture consists of subsistence production of corn, squash, and beans on unirrigated fields plowed usually with yuntas and occasionally with tractors. Residents of San Martín do not seem to have problems gaining access to agricultural land, and many families plant three to six hectares of corn and beans. Although families like to grow their own food, agriculture is regarded as a risky activity because of the variable rainfall. The selling prices for corn and beans are so low that few people regard them as cash crops.

Despite the availability of farmland, some San Martín households are abandoning agriculture as incomes increase from wood carving, migration to the United States, and wage labor. Several noted middle-aged artisans in San Martín say that they have continued to farm only because they enjoy the activity (in contrast to sedentary wood carving). Their sons and daughters rarely feel the same way and often become full-time artisans after they marry and establish their own households.

Before the wood-carving boom, subsistence agriculture was central to the economy and identity of people from San Martín. Because the community had access to large amounts of farmland, its overall standard of living, while much lower than today, was at least average in the Central Valleys. Since the road connecting the city of Oaxaca and Ocotlán was completed in the 1940s, men and women from San Martín have worked outside of their community in construction, hotels, stores, and schools. Before the

wood-carving boom, women also earned considerable amounts of money by making embroidered dresses for tourists (see Waterbury 1989 for an account of this business in the nearby town of San Antonino). A few women such as the mother of María Jiménez continue to sew and sell dresses.

When I first saw a number of large cement houses in San Martín, I assumed that they were financed from income from wood-carving sales. While this sometimes turned out to be the case, the houses were more often built using money sent or brought back by migrants from the United States. There are even a few large houses that are occupied only for a month or two around Christmas when semipermanent migrants return to visit their families and friends. The owners say that they will eventually live year-round in these houses, but this might not happen until they retire.

Rene Cabrera Santos attempted to estimate the magnitude of migration to the United States in his report on health and socioeconomic conditions in the town. In his census of households in 1997 (he counted 1,743 people), Rene asked about children, spouses, and parents in the United States. He arrived at a figure of 265 such people. It is difficult to interpret this number since some of these migrants do not send money back or otherwise participate in community life. The figure also ignores the many current residents of San Martín who have spent time in the United States. Whatever the exact figures might be, migration is obviously substantial. In July 1998 alone, sixteen people from San Martín crossed the border to the United States.

A survey carried out in July 2000 by Jeffrey Cohen of Pennsylvania State University, Sylvia Gijón-Cruz of the Universidad Benito Juárez de Oaxaca (UABJO), Rafael Reyes of the Instituto Tecnológico of Oaxaca, and others provides further information about migration in San Martín (personal communication). The survey team collected data on migration from a random sample of thirty-eight households. Thirteen of these households included current or former migrants to the United States, four included current or former migrants to Mexico City, and two included current or former migrants to both the United States and Mexico City. At the time of the interviews, twelve households included family members away in either the United States or Mexico City. These households reported remittances ranging from US$10 to $3,000(!) per month, with a median of $500. Converting these figures to average yearly incomes is difficult since the lengths of migrant stays vary and the sizes of remittances fluctuate from month to month. It is clear, however, that remittances are a very important source of income in San Martín.

The motivations and experiences of San Martín residents who go to the

United States are similar to those reported in countless scholarly and popular publications about Mexican migration. The migrants are mostly young single men who go to places where other people from San Martín have settled. The most common destination is California, particularly around Los Angeles and Santa Cruz, but several influential families have settled in other areas such as Albany, New York, and Aurora, Illinois. Attempts by the United States to deter illegal immigration seem to have had little effect on young men's willingness and ability to cross the border.

Former migrants to the United States have mixed feelings about their experiences. Their work and living conditions in the United States were often unpleasant, and most missed their families and village life. Some did not save as much as they had planned. But all appreciated the wages they could earn in the United States, and many enjoyed the opportunity to travel. Because most former migrants spent their time in the United States surrounded by other Spanish speakers, few learned much English.

The experiences of Pedro and Fidel Hernández (pseudonyms) resemble those of many other migrants from San Martín. When Pedro was twenty-one in 1988, he went to pick strawberries in Santa María, California. He knew none of the other strawberry pickers and worked at first without papers. Pedro's employer obtained legal papers for him during an amnesty for undocumented workers. Pedro did not much like picking strawberries and was pleased when a friend told him about a job in a Chinese restaurant near the University of California at Santa Barbara. After washing dishes for a while, Pedro worked his way up to busboy and later food preparer. Pedro was paid less than the minimum wage, but he was given a free room and did not have to pay for food at the restaurant. A couple of years later Pedro found a better job at a nursery, where his salary was eventually a bit higher than the minimum wage. After learning how to drive a semi, Pedro spent much of his work-time delivering plants. Pedro lived simply and managed to save $30,000. He invested $20,000 of this in a house in San Martín, to which he returned in 1996.

While Pedro was working in Santa Barbara in 1993, he was joined by his brother Fidel, who is four years younger. Fidel worked at three different restaurants in Santa Barbara, saving up enough money to buy a series of used cars. He learned more English than Pedro, but nonetheless was lonely in the United States and returned to Mexico in 1996 with some savings and a 1991 Nissan. Fidel bought a clothing shop in Oaxaca and carved and painted pieces. He later sold his clothing store and bought a tractor in order to earn money plowing his neighbors' fields. Fidel married and built a house near the com-

pound where his parents and unmarried siblings still live. He also continues to carve. Pedro, who is not a particularly skilled artisan, worked for a while rather desultorily on his own carvings and helped Fidel with the store while it operated. Still single, Pedro returned to California after about two years in San Martín. Several years later Fidel crossed the border without papers and joined his brother for a short time in order to earn some money quickly.

The experiences of Pedro and Fidel show the limited effect of the wood-carving boom on migration in San Martín. They are from one of the most successful wood-carving families in the community. When Pedro's family earned significant income from wood carving after he had already migrated, the thought never crossed his mind to return home and work as an artisan. Furthermore, the family's success in craft production did not deter Fidel from migrating. Even after Fidel returned to San Martín, craft production played only a minor role in his efforts to earn a livelihood.

Residents of San Martín spend some of their income from migration and wood carvings on large fiestas. Hosts also pay for fiestas with money lent by neighbors and recorded in notebooks according to the guelaguetza system. During Christmas (when migrants return to visit) and when the elementary school year ends in late June or early July, parties sometimes seem nonstop. San Martín does not have the enormous fiestas hosted by mayordomos that are an important part of the ritual calendar in Arrazola. Several decades ago the town decided to end the mayordomo system. Instead, there is a commission in charge of the three village-wide fiestas which collects a small fee to support the celebrations. In 1997 this fee was 40 pesos (about US$5) collected from every male eighteen or older. There is one person called the "mayordomo" who has responsibility for the mass on November 11, the day of the town's principal fiesta. But the mayordomo does not have to contribute any extra money for the day's celebrations.

The town is governed by a complex usos y costumbres system involving a hierarchy of positions and rotation in and out of office. The ten top administrators are selected by a forty person ayuntamiento (almost always all men). Members of the ayuntamiento have previously served in lower-ranking positions in the system. One can pay a large fee (800 pesos in 1998, the equivalent of US$90) to avoid community service in any particular year. Because of the expense, this option is rarely exercised.

Unlike Arrazola, young men in San Martín must begin at the lowest ranks of the hierarchy, usually working as police. This results in an age-ranked system in which most of the top administrators are in their fifties and sixties. Because men that age usually have only several years of school-

ing and may have problems with certain bureaucratic tasks, there is some feeling in San Martín that the age-ranked hierarchy has outlived its usefulness. Hardly anybody, however, wants to abandon usos y costumbres, and community members take great pride in their internal management of San Martín problems and their independence from national political parties.

LA UNIÓN TEJALAPAN

Despite the logistical problems of buying wood carvings in La Unión, dealers and tourists who make their way to the village are often enchanted. On some days the community presents a picture-postcard view of rural Mexican life, with farmers working in hilly fields, burros lazily walking along the road, children playing in adobe houses, and women making tortillas in outdoor kitchens. Nobody seems to be in a hurry. Although the artisans in La Unión are accustomed to visitors, they nonetheless still find tourists interesting, are willing to talk forever about local life, and often offer food and drink to their guests even if they have no wood carvings on hand to sell.

Unsurprisingly, La Unión is not nearly as idyllic and rustic as first-time visitors sometimes think. The community's attractive rusticity depends partly on the poverty that prevents most residents from building big houses and buying cars and compact disk players. This is a place where most families struggle to earn a living through subsistence agriculture, some cash cropping, wage labor in Oaxaca, and tortilla sales in the Abastos market.

Although people have lived in what is now La Unión for hundreds of years, the community has existed as a separate political entity only since 1973. The area that is now La Unión was formerly part of the town of San Felipe Tejalapan. The residents established La Unión as an agencia because they wanted their own schools, police station, and other governmental buildings and wished to govern themselves via usos y costumbres. By the late 1990s the approximately one thousand inhabitants of La Unión had a primary school, a government-subsidized general store, and a police station. The community finally got a public telephone in the late 1990s. The overall standard of living in La Unión, while markedly lower than that in Arrazola and San Martín, is nonetheless about average in the Central Valleys. There is enough income from craft production, wage work, farming, tortilla sales, and remittances from national and international migration to allow approximately half of the houses in the community to be constructed with concrete or brick. Almost every family in La Unión has potable water and color televisions; there are about twenty trucks in the village.

Most families in La Unión farm on communal land. Wood-carving families typically cultivate one to three hectares of corn, squash, and beans on unirrigated land, sometimes supplemented with alfalfa or vegetables grown on small irrigated fields. Women from La Unión and San Felipe are known for their corn tortillas, which they sell in the Abastos market in Oaxaca. Although the vendors grossed an average of about 100 pesos a day (US$11) from tortilla sales in summer 2000, their net daily income was only about 50 pesos after deducting the costs of transport, milling, and firewood. Women from La Unión spend at least as much time in the city as men. I have often been one of the few adult men taking an afternoon bus from La Unión to Oaxaca. The majority of the passengers were either women taking tortillas to market or schoolchildren going home.

Because farming is mostly for home consumption and wood carving is not especially remunerative, many young men and women in La Unión work on and off in the city of Oaxaca or else migrate temporarily to Mexico City. The jobs they take are varied, depending on their education and luck in finding good employment. The most common job for men, as elsewhere in the Valleys, is in construction. Young women sometimes work as domestics, clerks, or secretaries.

Many current residents of La Unión had parents or grandparents who spoke Zapotec or (less commonly) Mixtec. The youngest speaker of an indigenous language in 1998 was a 53-year-old bachelor who had lived with his Zapotec-speaking parents until their recent deaths. All other speakers of indigenous languages were bilingual men and women over sixty. La Unión will certainly be a completely monolingual community in the not-too-distant future.

Fiestas are as important in La Unión as they are in Arrazola and San Martín. Perhaps because La Unión is materially not as well off as the other two communities, the impact of fiestas on economic decision-making seems especially noteworthy. This is the only carving village where my interviews and purchases were significantly affected by weddings, birthdays, and school graduations. Several carvers have completed pieces quickly for me because they needed my money to pay for an upcoming fiesta. Others have been unable to fill my orders because they were busy attending or hosting fiestas. One three-day wedding in 1998 transformed community life for almost a week. I unsuccessfully tried to interview one of the best-known carvers in town on the Friday before the wedding, but he was occupied killing chickens for the event, which did not involve anyone in his immediate family. He told me that he would be busy with the wedding until the next Tuesday. When I interviewed him the following Thursday,

he was still hung over. Delays because of fiestas happen less often in Arrazola and San Martín, where artisans have learned that dealers and tourists are likely to be unhappy when pieces are not delivered on time.

Perhaps because it is a new community and lacks a patron saint, there are no village-wide fiestas in La Unión. In 1997 some families instituted a mayordomo system and held the initial fiesta of the Sacred Family on December 30. This met with a mixed response among other community members. While some enjoyed the celebrations, many made clear their feeling that participation in the mayordomo system should be voluntary.

By 2000 some of the better artisans in La Unión had become discouraged by their incomes from carving. Three migrated to the United States (two legally), and two others were making plans to cross the border as undocumented workers as soon as they finished their community service obligations for the year. These artisans, who ranged in age from thirty-five to forty-seven, were all married men with children. Although none planned to stay in the United States for more than a year, their temporary absence from La Unión had significant effects on the availability of high-end wood carvings.

ECONOMIC STRATEGIES

Residents of Arrazola, San Martín, and La Unión farm, work in the city of Oaxaca, run stores, attend school, and migrate temporarily or permanently to Mexico City and the United States. The production and sale of wood carvings in Arrazola, San Martín Tilcajete, and La Unión Tejalapan therefore must be understood in the context of individual and household economic strategies that involve a mix of activities. The extent to which particular households are willing and able to participate in wood carving depends on their age-sex composition, the goals and skills of individual family members, and the relative profitability and risk of craft production in comparison with other possible economic activities. Some individuals and families concentrate primarily on wood carving for long periods; most, however, must make complex decisions about how to allocate labor-time between craft production and other activities as economic conditions and personal circumstances change.

The ways in which wood carving is embedded in overall household economic strategizing can be seen by an

examination of the activities of a San Martín family that is neither particularly well off nor particularly poor. In February 1998 this family consisted of 47-year-old Atinacio Melchor (a pseudonym), his 43-year-old wife, Lucía Velasco, and their four sons and three daughters. The sons were 23-year-old Víctor (a pseudonym), José Manuel (18), Efraín (16), and Rolando (10); the daughters were Silvia (20), Iraís (13), and Liliana (5). Four of the children were enrolled in school. José Manuel was studying in a technical high school. Efraín was in secundaria; Iraís and Rolando were in primaria. Víctor had left school after completing secundaria; Silvia ended her education with primaria. As a group, the children were considerably better educated than their parents. Lucía finished primaria, but Atinacio had only two years of schooling.

Before the late 1980s the Melchor/Velasco family supported itself entirely through farming and Atinacio's work in construction. Thirteen-year-old Víctor began to carve in 1988, and over time craft production became the family's primary source of income. Although the family sells some carvings to tourists, most of their pieces are bought by two large-scale wholesalers from the United States. Until late 1997 Víctor was the most important carver in the family. The other carvers—Atinacio, José Manuel, and Efraín—spent less time on craft production. Atinacio worked five or six months a year in construction; José Manuel and Efraín were busy with school. The principal painters—Lucía, Silvia, and Iraís—were occasionally aided in this task by male members of the household. This division of labor lasted until Víctor decided to try his chances in the United States in late 1997, and Atinacio, José Manuel, and Efraín had to devote more time to carving.

The Melchor/Velasco family farms on an unusually large scale. In 1997 they raised ten hectares of corn and beans for home consumption on hilly ejido land located several kilometers away from residential areas of San Martín. Eight hectares were sharecropped on fields controlled by other households. The sharecropping, which is uncommon in San Martín, demonstrates the family's commitment to growing their own food. Although the family took some goats and chickens to market, they sold none of their food crops.

Since the family's monetary returns from wood carving are doubtless greater than those from other local economic activities, a naive observer might wonder why they do not allocate more labor-time to craft production. The simple answer is that expanded production might not result in more sales. The family's craft sales depend heavily on two wholesalers whose demand for Melchor/Velasco pieces may already be met. A more sophisticated answer would consider household economic strategies related to risk aversion and long-term planning. By producing most of their own food and having

some wage labor income, they insure that they will get by if dealers stop buying or carving production drops because of the absence of one or more key family members. The household's diverse income sources made it possible for Víctor to migrate to the United States, where he may later send relatively large sums of money to the family members who have remained in San Martín. The time José Manuel and Efraín are spending in school may also eventually lead to increased earnings for them and their families.

MULTIPLE ECONOMIC GOALS OF INDIVIDUALS AND HOUSEHOLDS

The activities of the Melchor/Velasco family illustrate the diverse and sometimes contradictory economic goals of individuals and households. Woodcarving families attempt to insure a steady, inexpensive food supply and to avoid engaging in risky economic activities that might lead to financial disaster. They try to improve their material conditions and to maintain the flexibility necessary to take advantage of new economic opportunities. Families seek out economic activities that involve the participation of many household members rather than depending on the work of one or two principal wage earners.

Anthropologists frequently report that poor rural families in Africa, Asia, and Latin America are reluctant to try risky, although potentially profitable, economic options. Although this reluctance was once attributed to a "peasant conservatism" typical of "traditional" cultures (e.g., Foster 1962; Rogers 1969), most researchers (e.g., Barlett 1982; Ortiz 1979) eventually reached the conclusion that such risk aversion is economically sensible because poor rural families cannot afford the loss of a substantial investment of land, labor, or capital. One widely noted aspect of risk avoidance behavior is participation in a diversity of economic activities. Such diversity is not in itself evidence of risk aversion since individuals and households may engage in a variety of activities because of seasonal economic opportunities and differential skills. Nonetheless, there is often a conscious attempt by individuals and households not to rely too much on any one economic activity. The wood-carvers are no exception to this generalization. Most artisan households in Arrazola, San Martín, and La Unión worry that the demand for their pieces may not last. Some family members therefore work as wage laborers; others migrate temporarily to the United States. Academically talented children are encouraged to study practical fields such as accounting and computer programming.

In some parts of the world (e.g., Chibnik 1994:152–155; Scott 1976), the

economic strategies of poor rural families aim first at insuring a reliable home-grown food supply and only secondarily at increasing cash income. While some families in wood-carving communities have a firm commitment to subsistence agriculture, production for home consumption is a less important economic goal in others. Even among families with access to relatively large amounts of land, uncertain rainfall makes unirrigated subsistence agriculture a risky venture in the Central Valleys and forces many rural residents to supplement farming with craft production and wage labor. Furthermore, some families have access to so little land that subsistence farming can provide only a fraction of their food needs even in years where there is sufficient rainfall. In addition, many communities in Central Valleys of Oaxaca—while hardly well-off—are not nearly as poor as those in parts of the world where a "subsistence ethic" dominates. The potential earnings from craft production and migration in recent years have led some families in the Central Valleys to conclude that subsistence farming is not worth the effort.

The commitment to subsistence farming varies greatly in the wood-carving villages. In Arrazola, where land is scarce and profits from wood carving high, many families have sold or rented the little land they have and concentrated their economic efforts on craft production and wage labor. In La Unión, where profits from wood carving are low and land is relatively abundant, almost every artisan family continues to place considerable importance on farming. Although artisan families in La Unión rarely grow enough food to feed themselves for an entire year, they appreciate the money saved by production for home consumption. They also often need the income from sales of cash crops and tortillas. The situation in San Martín, where land is also relatively abundant, is more complex. Some carving families are so well off that subsistence agriculture would not seem to be worth the effort. Many of these families have abandoned farming, but others persist in raising corn and beans on several hectares. The poorer families in San Martín might be expected to have a greater commitment to subsistence farming. This is not always so. A number of poorer families in San Martín support themselves through wage labor and painting and reselling pieces carved in San Pedro Taviche. These families dismiss the possibility of significant savings from subsistence production, citing the miserable yields in the many years when there is not enough rain.

Although certain economic activities in wood-carving communities require careful scheduling, individuals and households have considerable flexibility in allocating their labor-time. The most obvious constraint on wood carving might appear to be the agricultural cycle. Social scientists writing

about rural Mexico (e.g., García Canclini 1993:39) sometimes assume that craft production is ordinarily a not-particularly-profitable supplement to agriculture. In such circumstances, craft production would be expected to slow down considerably during busy parts of the agricultural cycle. Since wood carving can be quite profitable in Arrazola, San Martín, and La Unión, the relationship between craft production and the agricultural cycle is not so straightforward. Although certain artisans in San Martín and La Unión spend a lot of time in the fields during the growing season, their absence does not always have a significant effect on craft production since other family members may increase the amount of time that they spend carving and painting. Migration in Arrazola and San Martín has had surprisingly little effect on wood carving. Most migrants are young unmarried men who have been helping their family with carving. Their usually temporary absence from the family may slow craft production but rarely is too significant. Other family members spend more time carving; piece workers are hired when necessary.

Perhaps the biggest scheduling constraint on economic strategizing occurs when families agree to provide large numbers of carvings to dealers. Typically dealers place such orders several months before they are due. In the month or two before the order is picked up, families often work long hours carving, painting, and sanding. Wage labor may be impossible during these busy periods. Migrants delay their departures; studies and even fields may be neglected.

The size and age-sex composition of a household obviously have significant effects on economic strategies. The options available to a young couple with an infant child are quite different from those possible for a family consisting of a middle-age couple, a teenage son, and two teenage daughters. The reduction in average family size in the past several decades has enabled households to provide better education and health care for children. Small households, however, are not particularly flexible labor forces.

In a perceptive passage, Sheldon Annis (1987:37–38) observes how intensely intercropped fields (*milpas*) absorb household labor in a Guatemalan town:

> What is remarkable about the *milpa* is its capacity to absorb "inputs" that might otherwise be wasted—microquantities of resources that the family may have in abundance, but have no use for without the transformative superstructure. The *milpa* utilizes "resources" that may be abundant, but are otherwise unusable; dawn weeding hours, after-school hours . . . it reinforces the family and household unit as the basis for social organization by optimizing "resources" that exist largely

as a result of sociodemographic fact of the family (e.g., a grandmother's availability for weeding) . . .

Annis argues that milpas work against capitalist accumulation and are antithetical to entrepreneurship. Without disputing his specific point about Guatemalan milpas, I find it interesting to observe that the profoundly entrepreneurial Oaxacan wood-carving workshops also have a remarkable capacity to absorb household labor and increase family cooperation. Because the work is done around the house at any time of day, women can easily combine craft production with child care, food preparation, and other domestic chores. Students and wage-laborers are able to work on carvings before or after work or school and on weekends. Young children and older people who lack skills in painting and carving can contribute to craft production by sanding and soliciting sales from tourists.

Individuals and families in Arrazola, San Martín, and La Unión must balance short-term and long-term economic strategies. The activities that enable people to cope with immediate economic problems may not be those that provide that best chances for improving material conditions in the future. Although wood carving requires some training, craft production is basically a short-term economic strategy providing quick returns that enable families to meet daily needs and to improve their standard of living in tangible ways. In contrast, education and migration require a deferral of immediate local income in the hope that large amounts of money will be earned later. The causal relationships among wood carving, education, and migration are complex and variable. Some children leave school to concentrate on wood carving. However, money earned from wood carving has financed the higher education of people who otherwise would have had to leave school after primaria or secundaria. Income from wood carving has certainly deterred some people from migrating. But in other households, wood-carving income has enabled families to finance the costs of migration and to prosper even when migrants fail to send money back.

Because wood carving is a cooperative endeavor, the potential exists for conflicts within families concerning the extent to which particular individuals participate in craft production. Teenagers may prefer to further their education or work at wage labor rather than help their parents by carving. New mothers may find that they have less time available for painting. Although I looked for examples of conflicts concerning the amount of time people spent in craft production, I did not find many. Families seemed to understand the constraints that domestic responsibilities placed on wood

carving and accepted the differential participation of teenagers. I suspect that this is because labor shortages rarely caused severe crises for wood-carving families. The profits from wood carving were sufficiently great that hiring piece workers was a feasible option for most families whose labor forces were insufficient to meet the demands of large orders.

EXAMPLES OF HOUSEHOLD ECONOMIC STRATEGIES

Artisan households in Arrazola, San Martín Tilcajete, and La Unión Tejalapan can be roughly classified into four groups with differing economic strategies. Some households focus almost exclusively on wood carving. Others combine wood carving with farming; still others combine craft production and wage labor. Finally, there are households in which wood carving is only one of several economic activities. Households in all four groups may use migration or education as a long-range strategy aimed at upward mobility.

There is considerable income variation within each group. For instance, some households focusing almost exclusively on wood carving are high-end producers who are among the wealthiest people in Arrazola, while others are impoverished, landless families in San Martín who repaint pieces carved in San Pedro Taviche. In the examples presented here, I have attempted to select households whose incomes are near the average for each of the economic strategies. The examples were selected from thirty-seven detailed interviews carried out in the first six months of 1998 when the exchange rate was about 9 pesos per dollar. I give one example of each of the first three strategies (wood carving only, wood carving and farming, wood carving and wage labor) and three examples of mixed economic activities. The ages of household members and the economic activities described are those at the time of the interview.

Because my sample was not random, I cannot estimate the relative proportion of artisan families in the wood-carving villages that follow each of these strategies. The survey carried out by Jeffrey Cohen, Sylvia Gijón-Cruz, Rafael Reyes, and others in the summer of 2000 provides some relevant information about household economic activities in San Martín. Of thirty-eight randomly sampled households surveyed, twenty-three participated in wood carving. Five of the twenty-three artisan households worked only at wood carving, eight combined wood carving and farming, three combined wood carving and wage labor, and seven pursued complex mixed economic strategies. My impression is that full-time wood carving is much more common in Arrazola than in San Martín. There were no households

in La Unión in 2001 that relied on wood carving as their exclusive source of income, although the members of one La Unión household had been full-time wood carvers throughout the 1990s.

AN EXCLUSIVE FOCUS ON WOOD CARVING

Damián Morales Martínez of Arrazola began carving in 1992 when he was twenty-one. After graduating from secundaria, he tended animals in an agricultural research institute in the city of Oaxaca for about a year. Damián then moved to Cuernevaca in the state of Morelos, where he made and sold sandals in the local market. Tiring of this, he returned to Oaxaca and married Beatriz Morales Ramírez. In 1995 their daughter Jenifer was born.

After Damián returned to Arrazola, he concentrated exclusively on wood carving. At first he sold unpainted pieces to other residents of Arrazola, who then resold the carvings after painting them. When Damián's carving skills improved and Beatriz learned to paint, the couple began working on their own. Their division of labor is typical of a moderately successful small carving family in Arrazola. Beatriz does most of the painting; Damián carves and does a little painting. When the family has large orders, they hire piece workers to help with sanding and painting.

In 1994 the family sold their first piece to a dealer. The buyer was Jerre Boyd, a large-scale wholesaler who continues to be their most important customer. Damián and Beatriz nowadays also sell carvings to other dealers, tourists who visit Oaxaca, and stores in Oaxaca. Although the family lives on the outskirts of Arrazola, they meet customers at the house of Beatriz's parents near the town plaza.

The family's decision to concentrate so much on wood carving results from both their success and their household composition. They have been able to sell many wooden deer, giraffes, moose, goats, rabbits, and other animals for 300 pesos apiece and have had no shortage of orders. Although Damián's mother has some farmland, he is so successful in craft production that he is not tempted to use it. The family's small size limits the possibility for economic diversification. Beatriz and Damián find their time occupied with wood carving and child care; there are no other immediate family members who might participate in wage labor.

WOOD CARVING AND FARMING

Juventino Melchor of San Martín began carving in 1976 when he was fif-

teen. He is from a established artisan family and learned the craft from his uncle, Coindo Melchor. After graduating from secundaria, Juventino has worked as both an artisan and a farmer. His wife, Aurelia Roque, who is seven years younger, left school after primaria. They have three children: an 11-year-old son, a 10-year-old daughter, and a 3-year-old daughter. The family division of labor in craft production is identical to that of Damián Morales and Beatriz Morales. Aurelia does most of the painting; Juventino carves and does some painting. When they have large orders, they occasionally hire piece workers.

The family began selling carvings to store owners from the city of Oaxaca in the mid-1980s and not long afterward attracted the attention of wholesalers. Their pieces are now bought almost entirely by dealers, with only occasional sales to tourists and stores in Oaxaca. The family makes small and medium pieces, specializing in gazelles, rabbit, giraffes, mariachis, and marimba bands with animal musicians. Their carvings are inexpensive, mostly selling for 45 to 50 pesos apiece. Although Juventino and Aurelia are experienced artisans, they have chosen to focus on consistent sales of workmanlike pieces rather than attempting high-end, original carvings.

Juventino and Aurelia farm four hectares of unirrigated, communal land on which they grow corn, beans, and squash. In good years they are able to sell some surplus crops from their three parcels. In most years they do not grow enough to feed themselves and must supplement their harvests with purchases of corn and beans.

When I first began my study of the wood-carvers, I thought that the economies of most artisan families would resemble those of Juventino and Aurelia. While there are a number of families in San Martín and Arrazola that combine craft sales to dealers with farming for home consumption, they are a distinct minority. Most artisan households either concentrate exclusively on wood carving or earn some income from sources other than carving and agriculture.

WOOD CARVING AND WAGE LABOR

The family headed by 41-year-old Fernando Espinal and 36-year-old Angélica Jiménez is less successful economically than most in Arrazola. Although Fernando has been carving since the mid-1980s, his family's earnings from craft production have never been particularly high, and he has often had to work as a wage laborer. Fernando and Angélica both left school after primaria. They have three daughters, 18-year-old Judit, 17-year-old Columba,

and 3-year-old Mercedes. Judit, who suffers from several illnesses, has required special care for many years. The family's artisanal work force consists of Fernando, Angélica, Columba, and a teenage niece and teenage nephew who are paid piecework wages. Angélica, Columba, and the niece paint and sand. Fernando mostly carves but also does some painting and sanding. The nephew only carves.

Before becoming a wood-carver, Fernando farmed with his father on land he describes as "dry and not very good." He also worked as a policeman in the city of Oaxaca for a year. During Fernando's first two years as a carver, he was employed in a tile-making factory and worked in construction. He then gave up wage work and concentrated exclusively on wood carving for the next several years. In 1993 Fernando decided to supplement his income from wood carving with work as a trombone player in a thirteen-member band in Oaxaca. Fernando now estimates that he earns as much from trombone playing as from wood carving.

The Espinal/Jiménez family makes a variety of pieces that are sold to tourists visiting Arrazola. Fernando is the president of the artisan's market, and he or another family member can often be found there. Most of their small cats, dragons, mosquitos, and other animals cost 50 to 70 pesos at the artisans' market. The family also sells to a few dealers and to stores in the city of Oaxaca. Perhaps because he keeps track of sales at the market, Fernando is one of the few carvers willing to estimate his monthly income from wood carving, which he said ranged from 400 to 1,200 pesos in 1997–1998. Assuming an average of 800 pesos a month and an equal income from trombone playing, the family's annual cash income during these years was approximately 19,200 pesos.

The combination of craft production and wage labor is especially common in Arrazola, where land is scarce. If Fernando lived in San Martín, he would probably also raise some crops for home consumption. His family's income is small enough that the food budget must be a significant expense. Fernando and Angélica have in addition the particular problems associated with the care of Judit. If she were healthy, their economic situation might be considerably better.

MULTIPLE ECONOMIC ACTIVITIES

Because there are diverse ways in which families can engage in multiple economic activities, I illustrate this strategy with three examples. Juana Calvo and Gonzalo Ramírez earn money from carving, store owning, and

wage labor. Sergio Santos and Adelina Cruz combine carving, farming, and wage labor. Jaime Méndez, Socorro Gómez, Isidoro Méndez, and Imelda Fabián also earn income from carving, farming, and wage labor, but the details of their activities differ greatly from those of Sergio and Adelina.

Juana Calvo is an entrepreneurial 39-year-old secundaria graduate who operates a general store in the center of San Martín. Her 37-year-old husband, Gonzalo Ramírez, who left school after primaria, works as a chauffeur and is often away from San Martín. The couple's children are 15-year-old Laura, 12-year-old Juan, and 2-year-old Raúl. Laura and Juan are both secundaria students. The family has no land and expresses no interest in farming.

In 1992 Juana decided to see if she could earn some money from craft production and began carving and painting. She concluded after a year or two that she lacked carving talent but continued to paint. Since Gonzalo did not carve, Juana was forced to purchase unpainted pieces from men in San Pedro Taviche and San Martín. After painting these pieces, she sold them from a workshop next to the general store. Juana also began buying unpainted pine chairs and frames from carpenters, which she painted and then sold. Around 1995 Gonzalo started to carve pieces that Juana and Laura paint. Because Gonzalo's job as a chauffeur limits the amount of craft production he can do, most of the pieces the family sells are still carved by nonfamily members.

Juana is one of the few artisans in San Martín who sells exclusively to tourists. Although Gonzalo carves large cactuses that sell for 500 pesos, most of the family's pieces cost between 20 and 100 pesos. Their biggest sellers are pine frames. Because tour buses stop near Juana's store, many of her craft sales are to passengers seeking something to drink or eat. Juana and Gonzalo have considerable economic autonomy. Gonzalo's earnings from driving, which provide the bulk of the family income, are used for himself and the children. Juana's earnings from craft sales and the general store are for the most part hers to spend as she wishes. Gonzalo shares, however, in the profits of the pieces that he carves.

In 1998 Sergio Santos and Adelina Cruz were living in a three-household compound in La Unión (in 2000 they moved to a new house not far from the old compound). One household consisted of 36-year-old Sergio, his 29-year-old wife, Adelina, and their two children, 10-year-old son Nelson and 7-year-old daughter Vianey. The members of the second household were Adelina's parents and three of her teenage sisters; the third household consisted of Adelina's brother, his wife, and their three children. Although the

households were essentially independent units, there was a certain amount of economic cooperation. Here I focus on the activities of Sergio and Adelina and their children.

Sergio, who is originally from San Felipe Tejalapan, began to carve in 1988 after marrying Adelina. He learned to carve from Adelina's father, Santiago Cruz, who had been an artisan for a number of years. Nowadays Sergio spends much more time carving than Santiago does. Sergio is one of the better-known carvers in La Unión and has pieces featured in the Barbash book (1993:67). Adelina does most of the painting, although Sergio occasionally helps out with this task. Nelson sands and is learning to carve. The family's pieces include cats with mice, dogs with bones, deer, frogs, goats, zebras, pigs, armadillos, and angels. Their slowly made small and medium-sized pieces cost between 60 and 200 pesos when bought in La Unión. They sell to a number of different dealers as well as to three stores in the city of Oaxaca. The few tourists that visit La Unión are likely to stop by the family's house, but they often find nothing for sale.

Sergio and Adelina both left school after finishing primaria. Before Sergio took up wood carving, he farmed in San Felipe Tejalapan and worked for long periods (including one three-year stretch) in Mexico City. Sergio did not like Mexico City and his work there selling tacos and was happy to return to Oaxaca. Sergio continues to farm on a very small scale in San Felipe, where he retains land rights. He grows alfalfa for animal feed on a quarter-hectare of irrigated land and corn and beans for home consumption on a hectare of unirrigated land. The only money Sergio and Adelina make from farming comes from eggs sold at a peso apiece.

Sergio supplements his income from wood carving by operating a tractor for farmers in San Felipe and La Unión. He receives 20 percent of the tractor rental fee of 100 pesos per hour. Since Sergio sometimes operates the tractor six or seven hours a day, his daily wages for this work are 100–120 pesos. Sergio works two to three months a year as a tractor operator. If he averages three days a week on this work, his yearly wages from tractor operating can be estimated at about 3,000 pesos.

Despite Sergio's skills at wood carving and tractor driving, his family's material conditions, while about average in La Unión, are well below the typical standard of living in Arrazola and San Martín. In summer 2000 Sergio and Adelina still lived in an adobe house and were worried about obtaining money to educate their children. Sergio was seriously considering temporarily migrating to the United States.

Jaime Méndez of San Martín lives in a three-generation, five-member

household in San Martín. The older household members are Jaime's 64-year-old father, Isidoro, and his 62-year-old mother, Imelda Fabián; the younger residents are 24-year-old Jaime, his 20-year-old wife, Socorro Gómez, and their 4-month-old son Jaime. Isidoro and Imelda have several other children, all of whom live in Mexico City. Jaime and Socorro finished primaria; Isidoro and Imelda have only a few years of schooling.

Jaime learned how to carve when he was fourteen by watching various artisans in San Martín. After Jaime sold some pieces, Isidoro learned how to carve. Socorro does most of the painting, with help from Jaime. Imelda occasionally sands pieces. The family is only moderately successful in craft production. Their best-selling pieces are cats, dogs, Nativity scenes, iguanas, jaguars, and dinosaurs. They mostly sell small pieces for 15 to 20 pesos and have never sold a carving for more than 200 pesos. The family relies mostly on regular sales to Clive Kincaid, the only dealer they work with. The rest of their sales are to tourists.

The Méndez family farms on a small scale on two half-hectare parcels of unirrigated land. One hectare is on communal land near town; the other is in the more-distant ejido. They grow corn, beans, and squash for home consumption but do not raise enough to come close to meeting their yearly needs. They have fourteen goats, a cow, two calves, and an ox-team and earn a little money by selling cheese.

Jaime has worked in recent years as a wage laborer, mostly on government road construction crews. In 1998 the pay for such work was 40 pesos a day. Jaime averages a week or two on road construction most months. In the late 1990s he also worked some summers as an archaeological laborer on a long-term project in San Martín run by Charles Spencer of the American Museum of Natural History (Spencer 1999; Spencer and Redmond 2001). The pay for archaeological labor was similar to that for road construction, but the work was pleasanter and closer to home.

According to Jaime, the Méndez/Jiménez household makes more money from carving than from wage labor. Jaime's income from wage work in 1997 was approximately 5,000 pesos; the household earned perhaps 8,000 pesos from craft production. The household may also have received some remittances from Jaime's siblings in Mexico City. Although the household's total income was probably a little below average in San Martín, their standard of living was about average because Jaime and Socorro have only one small child. If Jaime's family grows, he might be tempted to consider temporary migration to Mexico City or the United States.

In recent years anthropologists (e.g., Cancian 1989; Kearney 1996; Weil 1995) have become increasingly aware that many rural households in areas of Africa, Latin America, and Asia support themselves through diverse types of work. Families at any one time might obtain food and income via subsistence farming, cash cropping, craft production, piece work, and wage labor. Individuals readily change occupations and residences.

The multiple livelihoods and mobility of many rural people have led some anthropologists (e.g., Kearney 1996) to question the continued relevance of terms such as "peasants" and "rural proletariat." Frank Cancian, who understands well the multiple activities of rural peoples, has attempted to preserve the concept of "peasant" by proposing a looser definition (1989:165):

> People who have some ability to produce their own food or have a close kinship connection to people who have some ability to produce their own food, or interact in a local economy with people who have some ability to produce their own food.

While such a definition would obviously encompass many rural people, I am unsure of its analytic usefulness. Rural schoolteachers, priests, and nurses would all be peasants according to this definition.

The examples of household economic strategies given in this chapter illustrate the futility of attempts to place the wood-carvers into any particular socioeconomic category. Popular writers about the carvers have usually described them in one of two ways. Some say the carvers are former farmers who have become artisans; others depict the carvers as traditional rural folk who combine subsistence farming with craft production. In recent years anthropologists have sometimes argued that rural Mexican artisans who sell their crafts are really members of the bottom rung of an inequitable capitalist system. None of these characterizations fit the Oaxacan wood-carvers well. They are much better understood as people who pursue multiple livelihoods in an attempt to improve their material conditions. Individuals and families who are wood-carvers today may be doing something very different tomorrow.

MAKING WOOD CARVINGS

One day in March 1998 I accompanied three wood-carvers from La Unión on a copal-cutting expedition to some hilly land belonging to the municipio of San Felipe Tejalapan. Because La Unión is an agencia of San Felipe, the artisans—Aguilino García, Gabino Reyes, and Sergio Santos—did not have to ask for permission to cut on these hills, which are used for grazing but not for crops. The carvers chose their wood carefully. Each man gathered three to four branches of medium thickness. Thin branches were rejected because they broke too easily; thick branches were not needed for the artisans' medium-sized pieces. Aguilino, Gabino, and Sergio estimated that a branch provided enough wood for about ten carvings.

As we walked through the hills, the carvers noted that they preferred female trees (*hembras*) to male trees (*machos*). The hembras, they said, were better for carving because of their softness and fewer knots. Although four botanists later told me that copal trees could not be easily sexed, many wood-carvers insist that hembras can easily be distinguished from machos. According to these

artisans, hembras are darker colored and have less of an odor. The two best-educated carvers (Saúl Aragón and Jesús Melchor) and the botanists agree, however, that the commonly made hembra/macho distinction is unrelated to biological sex and instead describes different types of copal. Ana María López Gómez (2001:13), who has examined this question carefully, reports that Arrazola carvers call *Bursera bipinnata* "hembra" and *Bursera glabrifolia* "macho."

Obtaining wood is the first of several steps involved in making a piece. After the wood dries, artisans select a branch that roughly matches the shape of the carving they intend to make. From this branch, they cut off a piece of suitable size and strip away the bark. Carvers then whittle the piece into its general form with a machete. Knives, gouges, and chisels are used for more detailed carving. Some carvings are made of one piece; others consist of several pieces nailed together.

Pieces are dried and sanded before being painted. Painting is a two-stage process. After a solid coat is quickly applied, carvings are painstakingly decorated with dots, wavy lines, and other details.

This chapter describes each of these steps in more detail and examines the economics of making individual pieces. Because carvers and painters have considerable flexibility in how they carry out their work, making pieces involves complicated decisions about the use of tools and supplies. Decisions about time allocation among different tasks are also complex. The input/output ratios associated with carving and painting are difficult to estimate for both artisans and economic anthropologists.

OBTAINING WOOD

The great majority of pieces are made from copal, a light wood that is easily cut when wet and hard after drying. Some carvers specialize by making some or all of their pieces out of other types of wood. Chairs, tables, frames, and magnets are made from pine. Isidoro Cruz and a few other carvers in San Martín use zompantle; Manuel Jiménez and his sons nowadays make all their pieces with cedar imported from Guatemala.

In La Unión and San Pedro Taviche, where copal is abundant, carvers ordinarily use wood from trees in their community. Until around 1990 artisans in Arrazola and San Martín also had easy access to wood. The carving boom depleted the supply of copal in these communities. Copal is a slow-growing tree that ordinarily takes five to ten years to reach a size where the branches can be used for carvings. Although there are reforesta-

tion programs in Arrazola and San Martín, almost all contemporary carvers in these communities must rely on outside suppliers for their wood.

In recent years, most artisans from Arrazola and San Martín have obtained wood from entrepreneurs who deliver copal by truck or mule. As time has passed, wood has been brought in from more distant places. While wood in Arrazola continues to be brought in by both mule and truck, in San Martín trucks are now the ordinary form of transport. The copal used in most pieces carved in Arrazola and San Martín now comes from communities 20 to 50 kilometers away. Wood is sold by the *carga*, the approximate load that can be carried by a mule, and the *estiba*, equal to about eight cargas. In 2000 carvers in Arrazola and San Martín paid 50–90 pesos (US$5 to $9) per carga of copal (López Gómez 2001:27).

The number of pieces that can be made from a carga varies according to the characteristics of the branches and trunks. Saúl Aragón estimates that his brothers Antonio and Sergio make sixty small pieces from a carga. The cost of the wood used in each of these pieces is about a peso. Since the Aragón brothers' carvings sold for 30 to 60 pesos in the late 1990s, wood was not a significant expense for Antonio and Sergio. The price of wood was more important for carvers selling cheaper pieces.

Artisans in Arrazola and San Martín face numerous problems in their attempts to find a reliable supply of good wood. Carvers are often unhappy about the quality of the copal they buy, saying that it is too dry or too knotty or too hard or the wrong shape for their needs. They reserve their biggest complaints for unpredictable deliveries that may result in carvers' running out of wood just before a large order is due. These delivery problems usually arise when suppliers have conflicts with the communities where wood is cut. Suppliers cutting trees illegally may suddenly stop trucking wood after being confronted by angry community members. The distribution of wood is also sometimes halted while suppliers are working out agreements with the leaders of communities where they gather wood. Even when truckers have made informal arrangements to cut copal in particular communities, they may be harassed on the road by police seeking bribes from suppliers without the required papers.

A copal crisis in Arrazola in early 1998 illustrates the complexities of wood delivery. Carvers complained that they were having a hard time getting wood and that the price of copal was rising rapidly. The crisis was especially severe for carvers who had to be choosy about the wood they used. Antonio Mandarín, for example, makes large animals that require thick branches for their torsos. While carvers specializing in small pieces

(such as the Aragón brothers) were able to find some suitable wood during the crisis, Mandarín totally ran out of copal and had to stop working.

At the time of the copal crisis, most carvers in Arrazola were using wood brought in on trucks from San Juan del Estado, a community about 30 kilometers away. The truckers attributed their delivery problems to three disputes concerning fees for cutting and transporting wood. The suppliers were involved in conflicts with the owner of the land where the wood was gathered, the local authorities in San Juan del Estado, and the government branch responsible for maintaining roads. While the suppliers' accounts of these conflicts struck me as plausible, people in Arrazola were skeptical. Many carvers thought that the suppliers were exaggerating their problems and intentionally withholding copal as an excuse to raise prices.

During the crisis, carvers in Arrazola explored other ways of obtaining wood. One family with a car began taking all-day trips to cut copal illegally in a place three hours away. Others attempted to reestablish delivery by mule from nearby communities. The carvers were also exploring the possibility of getting wood from a place called El Vado, more than 100 kilometers from Arrazola. When I returned to Oaxaca after an absence of two months in June 1998, the crisis had abated for unclear reasons and Arrazola carvers were again dealing with their former suppliers.

Because artisans in San Martín have access to more wood suppliers than their counterparts in Arrazola, they complain less about the cost and availability of copal. They nonetheless were sufficiently unhappy about wood supplies in early 1999 that they seriously considered a proposal from an entrepreneur who wanted to sell them copal cut along the Pacific coast of the state of Oaxaca. The proposal was rejected primarily because the supplier insisted on an exclusive contract with potential buyers. This stipulation was certainly understandable from the perspective of the supplier, who needed a guaranteed market in order to pay for the transport of wood from a place 150 kilometers away. The carvers worried, however, that the wood from the coast might not always meet their needs. The coastal entrepreneur was experimenting with fast-growing trees raised in plantations, which the carvers thought might lack curved branches needed for certain types of pieces. They also were concerned that the wood from the coast might be too wet to be usable.

Plans for large-scale delivery of wood over long distances are often attractive to carvers frustrated by the quality and quantity of copal. These plans face a fundamental organizational obstacle. Because each carving family uses only a limited quantity of wood, suppliers attempt to form exclusive con-

tracts with groups of artisans. The artisan groups in Arrazola and San Martín are loosely organized, and the members have so far cooperated only in strictly limited ways. Potential large-scale suppliers therefore have difficulty finding a group of families willing to agree to work together in signing contracts. Supply problems may have to worsen considerably before families are willing to limit their flexibility in choosing among alternative sources of copal.

CARVING, SANDING, AND SOAKING

When I began my research in Oaxaca, one of the first things I asked artisans about was how they had learned to carve. The answers were disappointingly vague and short. Even the most loquacious and extroverted artisans would say something like "by watching my brothers" or "from my cousin" without giving further details. Many carvers claimed that no one in their immediate family taught them and that they learned through their own experimentation and by looking at pieces and tools.

Another question that most artisans would not or could not answer was the origin of the ideas for their pieces. The answers were either vague ("looking around," "from picture books") or formulaic ("in a dream"). I was not surprised that carvers could not give illuminating answers to this question since I have seen many writers, artists, and musicians in the United States become inarticulate or give canned, uninformative responses when asked about the sources of their inspiration. Yet I had seen some of these same creative artists in the United States give long, well-thought-out responses to questions about how they learned their craft. What, I wondered, was different about the wood-carvers?

The vague responses resulted in part from the naivete of my question. Carving is still very much a folk art, passed on informally between relatives and friends rather than being taught in formal settings. If I had asked villagers how they had learned to cook or farm, I might have received equally vague answers ("my parents taught me" or "by watching other people"). Better answers might have been forthcoming if I had specifically asked how carvers (or cooks or farmers) had learned particular techniques.

When I conducted a series of interviews about wood-carving techniques in 1997 and 1998, I was impressed by the variability in artisans' methods. Nonetheless, a few generalizations can be made. Carvers begin working on a piece immediately after removing the bark from a branch. By doing this, they take advantage of the malleability of fresh ("green" or "wet") copal. Carvers all use a machete and knives to make their pieces. Some carvers

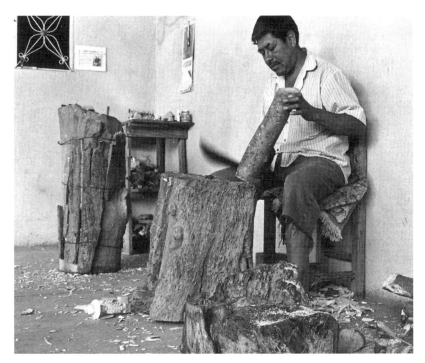

Inocencio Vásquez, San Martín, working with machete. Fidel Ugarte.

outline their pieces with pencil; others say they do not find this step neces-
sary. Many carvings have attachments such as ears, wings, and tails. At-
tachments are either joined to the figure with nails or glue or else fit into
slots. Judgments about the technical skill of carvers often rest on the care
with which details and attachments are done. Another indication of tech-
nical skill is the ability to make contorted pieces such as iguanas or lizards
out of one piece of wood.

Because wet carvings cannot be sanded properly, completed pieces are
left in the sun to dry. The amount of time a piece is dried depends on both
its size and the weather. In sunny weather, a small piece dries in a day or
less and a medium-sized piece in two or three days. Especially big pieces
can take as long as a month to dry. Sanding is a mindless task roundly
disliked by most artisans.

Buyers of carvings are sometimes dismayed to find piles of wood dust
next to their pieces. Carvings are subject to depredations by weevils and
beetles and can be completely destroyed if not cared for properly. Newspaper

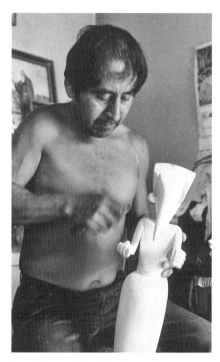

Justo Xuana, San Martín, carving details. Fidel Ugarte.

Francisca Calvo, San Martín, one of the few female carvers. Fidel Ugarte.

articles about carvings therefore often suggest that buyers put pieces in a freezer (or outside if the weather is cold enough) for several days in order to kill the insects. The carvers know that nothing could hurt sales more than a product that self-destructs. After sanding, many artisans therefore soak their pieces in gasoline in an attempt to kill insects. Carvers sometimes seem unaware that seeing this process might be off-putting to potential buyers. I have often unhappily interviewed artisans while standing next to a metallic tub filled with unpainted pieces immersed in gasoline. Some artisans dislike soaking carvings because of health concerns and the possibility of fire. They carefully inspect the wood they use in order to avoid pieces with evidence of insect damage. When these carvers nonetheless find holes on a piece, they may inject gasoline to kill insects. Other carvers—especially those making cheap pieces for dealers—do nothing to prevent bug infestations. They sometimes say that insect depredations are not a problem with small pieces.

Whatever the carvers do seems to work fairly well. Although I have been inconsistent in freezing my pieces, I have only occasionally confronted dust

piles near my carvings. As the carvers suggest should be the case, I have had more problems with large pieces than with small ones. Despite my luck with unsafe carving care practices, recommendations to put pieces in the cold are sensible. None of the pieces that I have frozen has had insect problems.

CARVING TOOLKITS

Before I began my interviews about carving methods in 1997, I asked Saúl Aragón what he thought a carver minimally needed to make a piece. I had two goals with this inquiry. First, I wanted to have some idea of the tools and supplies that every carver was likely to use. Second, I was curious about what would be the startup costs for someone entering wood carving without any tools. The latter question, as I knew even then, was purely hypothetical since paints are often shared and neophyte carvers usually acquire tools at no cost from relatives.

At the time I asked Saúl about the cost of tools and materials, the exchange rate was about 8 pesos per dollar. Saúl listed the following essential tools and supplies used in carving and sanding: one machete at 120 pesos, a big knife at 60 pesos, three small knives of different shapes at 25 pesos apiece, a manual drill at 12 pesos, two pieces of sandpaper at 4 pesos apiece, a sharpening stone for knives at 15 pesos, noninstant glue (*resistol*) at 4 pesos, resin at 5 pesos, nails at 5 pesos, and wood (one carga) at 50 pesos. Some of these items last a long time (the machete, knives, drill, and sharpening stone); others (sandpaper, glue, resin, nails, and wood) must regularly be replaced. Saúl pointed out that in theory this would be a considerable expenditure (and would be greater if paints and brushes were included); unskilled laborers at the time were earning 40 pesos a day in the city of Oaxaca.

Interviews with several carvers showed me that Saúl's list only provided a start in understanding toolkits. Everyone has a machete, uses some sort of knife and drill, and has the supplies—sharpening stone, glue, resin, nails, and (obviously) wood—that Saúl mentioned. The examples that follow show that otherwise there is considerable variation.

(1) Inocente Melchor, the younger son of Coindo Melchor, is a versatile San Martín carver who makes both simple and elaborate pieces. He has won prizes in nationwide contests for his imaginative carvings inspired by an illustrated book of Spanish folktales that an uncle found in a Mexico City bookshop. I had read in Barbash's book (1993:30–32) how Inocente, attracted by the excitement and material goods of the United States, had abandoned carving in his early twenties and migrated to Albany, New York,

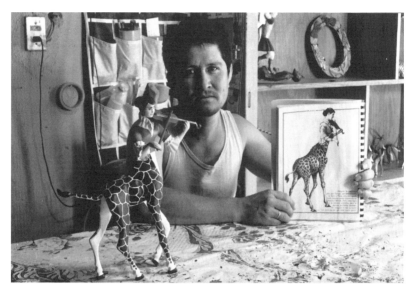

Inocente Melchor with illustrated book of Spanish folktales. Fidel Ugarte.

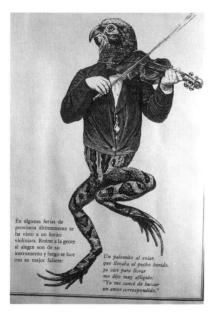

En algunas ferias de
provincia últimamente se
ha visto a un lorito
violinista. Reúne a la gente
al alegre son de su
instrumento y luego se luce
con su mejor falsete:

Un palomito al volar,
que llevaba el pecho herido,
ya casi para llorar
me dijo muy afligido:
"Ya me cansé de buscar
un amor correspondido."

Illustration of parrot musician in book of Spanish folktales, the inspiration for a carving by Inocente Melchor and Reina López. Fidel Ugarte.

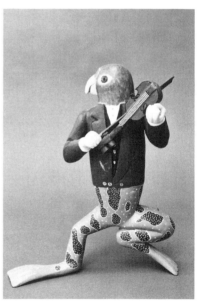

Parrot musician by Inocente Melchor and Reina López. Don Roberts, collection of Michael Chibnik.

in the early 1990s. (He went to Albany because two sons of Isidoro Cruz had settled there.) I was surprised in 1995 to find Inocente living happily in San Martín with his wife, Reina López, and a young son. Inocente, one of the most articulate and intellectually curious carvers, had not enjoyed his menial jobs in restaurants in Albany and seems to have little interest in returning to the United States.

When Inocente makes simple pieces, he uses only a machete and a knife (*cuchillo*). Although Inocente's knife is curved, both his father and his brother Jesús prefer a straighter knife. Inocente used a jackknife (*navaja*) when he began to carve but later discovered that he could more easily control the larger cuchillo. Inocente makes extensive use of gouges in his more elaborate carvings. He obtained a large set of differently shaped gouges made in the United States from Shep Barbash but ordinarily uses only five of these (triangle, large half-moon, small half-moon, flat, and curved). Inocente makes holes for attachments such as ears and tails with an electric drill, which cost about 500 pesos (US$55) at the time of my interview in 1998. A series of holes that would take half a day to make manually can be made in fifteen minutes with an electric drill. (While Inocente and other carvers would readily tell me about their use of electric drills, they were more reticent in answering questions about other machines. I once heard a loud noise coming from the house of an artisan who makes high-end carvings. When I asked about the noise, he reluctantly showed me a large electric saw in a back room.)

Inocente's tool use is idiosyncratic in two important ways. Unlike most carvers, Inocente often uses a saw (rather than a machete) to cut branches. The saw cuts in a straight line, whereas the hacking back and forth with a machete wastes wood. Instead of using a hammer, Inocente pounds nails with a polished rock he found in the fields.

(2) Martín Melchor is a talented carver about fifteen years older than his cousin Inocente Melchor. Martín and his wife, Melinda Ortega, began making pieces in the late 1980s and are now among the most successful artisans in San Martín. Martín's toolkit is relatively small, consisting of a machete, four knives, an electric drill, a gouge, and two hammers. The knives, bought in Oaxaca, were all originally the same rectangular shape. Over time they have been worn and filed and are now quite different from one another. One knife, which is the same shape as when bought, is for chopping; a very small cuchillo is used to make relief carvings on pine chairs and tables. The third knife is mostly for carving legs of animals; the fourth is used to make trunks of elephants. All these knives have other uses as well. The gouge is a vee.

Martín pounds nails with a metal hammer; a homemade wood hammer is used when banging other pieces of wood (such as horns into a hole). Martín says that the wood hammer reduces breakage. Other carvers have told me that the repeated use of metal hammers can lead to elbow injuries. I have often heard the phrase "wood on wood."

(3) Catarino Carrillo was the president of the artisans' group in Arrazola when interviewed in July 1998. Catarino has used the same toolkit ever since he began carving. His principal tools are a machete, a small flat knife, and a chisel. Catarino owns a store-bought metal hammer but prefers his almost spherical homemade wooden hammer. He uses a manual drill to make holes.

(4) Fernando Espinal (profiled in the previous chapter) has a simple toolkit consisting of a machete, one knife, a chisel, and a home-made wooden hammer. Most low-end carvers have small toolkits similar to Fernando's. A number of high-end carvers say that they really need only a machete and a knife to do most of their work. Miguel Santiago, who has an extensive collection of gouges, knives, and chisels, is emphatic about this and points out that the most important tool is "one's head."

(5) Gabino Reyes is the priciest and arguably the most talented carver in La Unión. He is a perfectionist who works slowly and carefully. Gabino's toolkit consists of a saw, a machete, a knife, and a number of gouges. Like Inocente Melchor, Gabino has a large collection of gouges but ordinarily uses only five of them. These gouges play an important role in his carvings, which are noteworthy for their detailed eyes, fingernails, teeth, and noses. Gabino does not soak pieces in gasoline and instead attempts to destroy insects by holding sanded pieces near a fire.

My toolkit interviews with these and other artisans show that carvers have considerable flexibility in the ways in which they make pieces. Some rely heavily on gouges; others use chisels; still others work only with machetes and knives. Tools vary in their shape, size, and material. Although young artisans learn from someone else how to carve with a knife and machete, the particularities of adult tool choice and use seem to be the outcome of individual experimentation over long periods. This is why artisans so often say that they taught themselves to carve.

PAINTING

Until around 1985 most carvers painted with aniline, a powder mixed with large quantities of water. While Isidoro Cruz of San Martín and some members of the Santiago family of La Unión continue to use aniline, almost

everyone else has switched to glossier acrylic (vinyl) house paints that were introduced to Mexico in the mid-1980s. There are at least three reasons why most artisans and buyers prefer acrylic. Because acrylic paints are mixed with less water than aniline dye, they do not run as much. Aniline pieces often fade over time, especially when exposed to sunlight. Unlike acrylic paint, aniline may eat into wood. Nonetheless, aniline pieces have a "rustic" quality that some dealers and consumers like. Perhaps because aniline tends to run, carvings painted with this dye are ordinarily simply decorated in one or two colors without the elaborate dots, lines, and waves characteristic of many contemporary acrylic pieces.

The artisans ordinarily use COMEX, an acrylic paint made by a Mexican company. The cost of paint varies considerably according to color. In general, brilliant colors are the most expensive. A liter of the most expensive paint, bright yellow, sold for 75 pesos in July 1998. The price of a liter of red paint was 60 pesos; white, the cheapest color, cost 45 pesos. Most artisans buy paint by the quarter-liter, which is considerably more expensive. A quarter-liter of white paint, for example, cost 18 pesos.

I once asked Saúl Aragón to estimate how many small-to-medium pieces could be made from a quarter-liter of paint. Despite his university training in economics and extensive painting experience, Saúl found this a difficult task. Artisans ordinarily use paint from several different cans on a piece; they also commonly mix paints to create colors not sold by COMEX. Saúl eventually estimated that forty-five small pieces or twenty to twenty-five medium-sized pieces could be painted from a quarter-liter. (Inocente Melchor, when asked the same question, estimated twenty-five small pieces or twenty small-to-medium pieces.) If one assumes that the Aragón brothers make thirty-five pieces per quarter-liter of paint and that a quarter-liter costs 25 pesos, the cost of their paint can be estimated as about 0.7 pesos per piece (about the same as the cost of their wood).

Artisans employ several brushes of different thickness when painting a piece. The base coat is ordinarily applied with a wide brush (*brocha*); thinner brushes (*pinceles*) are used to make finer decorations such as geometrical (e.g., waves, lines, diamonds) or representational (e.g., flowers, birds) designs. The price of most brushes was 20 to 30 pesos apiece in 1999; a few of the better-off artisans had invested in more costly ones. Even though brushes have to be replaced periodically, their cost is insignificant. A brocha can be used for as much as a year. A pincel used every day will last a month or two. If one assumes that artisans use an average of three different pinceles a day (doubtless an overestimate), that pincels used every day last a month,

and that the price of a pincel is 25 pesos, the cost of brushes per month (making the unrealistic assumption of painting every day) can be estimated at about 75 pesos. The cost of brushes per piece—a figure never calculated by artisans—is doubtless less than a peso.

The base coat is occasionally sponged on rather than painted with a brush. Artisans often apply the base coat twice to ensure that the piece is completely covered with paint. Applying the base coat (sometimes called "bathing") is an easy task sometimes given to children or others learning to paint. Decorating is a much more difficult task. Painters are no more articulate than carvers when asked how they learned their skill. The reasons for their unilluminating answers to this question seem to be, as with carving, related to the informal way in which the craft is learned and the flexibility with which tasks can be carried out.

Variability in painting is exemplified by the brushes that painters use to make their decorations. The brush sets the painters buy are numbered according to thickness. The numbers range from 00 to 16, with higher-numbered brushes being thicker. The thinner, lower-numbered brushes are used for fine decorations. As the following three examples show, there is considerable variation in which numbered brushes painters use to make decorations.

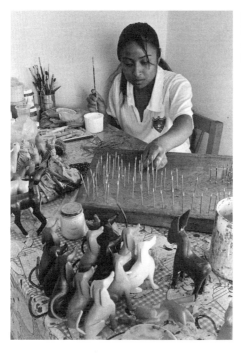

Miriam Gómez, San Martín, painting pieces carved by Jesús Melchor. Fidel Ugarte.

*Reina López and son Juan
Carlos. Fidel Ugarte.*

(1) Although Reina López does not come from an artisan family (her parents run a store and mill tortillas), she learned to paint after marrying Inocente Melchor. Reina now does almost all the painting on the family's carvings; Inocente occasionally does exceptionally difficult decoration. Reina and Inocente buy about twenty different paint colors, which are often mixed to make additional hues. They most often use strong colors such as yellow, red, green, and blue. Reina and Inocente also buy large quantities of black and white paint. Reina uses five brushes—oo, o, 6, 10, and 16. The two thickest brushes, especially the 16, are for putting on the base coat. The 6 is used for thicker lines, the o for dots, and the oo for especially fine designs. Reina also makes dots with a stick that Inocente made.

(2) The division of labor between Melinda Ortega and Martín Melchor is similar to that between Reina and Inocente. Melinda does most of the painting with the help of a daughter and a hired piece worker, while Martín does all the carving. Martín sometimes paints exceptionally detailed decorations. The paint colors the family buys most often are red, black, white, green, turquoise, Olympian blue, royal blue, colonial blue, two shades of purple, lilac, pink, Mexican pink, flamingo, orange, yellow, lime green, and forest

green. The only color they mix is gray (from black and white). Melinda uses a number 12 brush for the first coat on chairs; on most other pieces she applies the base with a 6 or 8. The family uses a 2 or 4 for stripes and a 0 or 1 for eyes and other especially fine work. Because Melinda's painting is not as detailed as Reina's, she has less need for very thin brushes.

(3) The division of labor between Leticia Aragón and Catarino Carrillo is somewhat different than that between Martín and Melinda. Catarino, like Martín, does all the carving. Because Leticia spends a lot of time caring for the family's two young children, painting is split more or less evenly between her and Catarino. They usually buy nine different colors—pink, red, turquoise, black, white, tangerine, yellow, sky blue, and colonial blue. The colors they paint with most are black and blue. Leticia and Catarino use four brushes—2, 3, 5, and 12. Because the family specializes in large pieces (mostly animals) with broad decorations, they do not need thin brushes.

COMPARING THE ECONOMIC VALUE OF CARVING AND PAINTING

There can be no question that almost everyone in the wood-carving trade—artisans, wholesalers, shop owners, and tourists—places more emphasis on carving than on painting. This can be seen most clearly in the name of the craft, which is never called "wood painting" and only occasionally referred to as "painted wood carvings." Furthermore, pieces are ordinarily attributed to a single person, typically an adult male carver. This is exemplified by the signatures on pieces, which usually carry the name of one carver. Such referential practices deemphasize both the artistic value of painting and the labor contributions of women and girls.

The devaluation of painting is especially troublesome in a craft where tourists and dealers alike routinely say they are attracted by the brightness and color of the carvings. What distinguishes the Oaxacan pieces from the carvings from many other parts of the world is not the technical skill with which they are made. Instead, they are valued for their "whimsicality" (a repetitive cliché in advertisements), a characteristic that derives at least as much from painting as from carving.

I have never been able to devise a straightforward way to compare the contributions that painting and carving make to the economic value of a piece. I do have information about several cases where a piece was bought unpainted and then resold after being painted. In each of these cases, the price of the unpainted carving was less than half that of the painted piece. One cannot conclude from this large difference in price, however, that paint-

ing accounts for more than half the market value of a Oaxacan wood carving. Sellers of unpainted pieces, who tend to be among the least economically powerful people in the wood-carving trade, are often so desperate for money that they will sell their work for very little. Furthermore, the seller of an unpainted wood carving is most often at the *first* point of a commodity chain stretching from the maker's community to a house somewhere in the United States. After their pieces are painted, they are sold to wholesalers or store owners in the *second* link of the same commodity chain. In commodity chains, the price increases after each transfer even if there is no value added. This is necessary if each participant in the chain is to make a profit. Thus it is problematic to assess the value of painting by comparing the prices of unpainted pieces sold at the first link of a chain with the prices of painted pieces sold at the second link of the same chain.

The obvious way to solve these methodological problems would be to compare the prices of identical unpainted and painted carvings sold by the same maker. The only relevant case that I could find suggests that painting contributes quite a bit of economic value to a carving. Pablo López, a low-end Arrazola artisan, sells painted carvings for more than twice the price he gets for selling similar unpainted pieces. The prices may not be directly comparable since unpainted and painted carvings are sold in different kinds of commodity chains. The painted pieces are sold directly to tourists; the unpainted pieces are sold to people who paint the carvings and then sell them to tourists (doubtless for more money than Pablo received for his painted pieces).

HOW LONG DOES IT TAKE TO MAKE A PIECE?

At the beginning of my research, I often asked artisans how long it took to make particular pieces. My idea was to try to calculate an earnings per hour figure based on the amount of time spent making a piece and the price the carving sold for. Both my question about labor inputs and my attempt to calculate earnings per hour turned out to be fraught with methodological and conceptual difficulties.

The most basic problems arise when people simply cannot remember exactly how much time they spent on a piece. I once asked María Jiménez how much time she had spent painting a large angel that a dealer had ordered for 2,000 pesos. She gave the seemingly straightforward response of "one week." But María could neither tell me precisely how many days she had worked on the carving (it might have been five and it might have been

nine) nor say how many hours she worked on it each day. My attempts to estimate an input/output ratio foundered more when I asked about the time her brother Alberto had spent on the carving. Alberto had taken more than a month to make the angel, interspersing carving with work in the fields. María had no idea how many hours Alberto had spent on the piece. When I later asked Alberto, he was only able to vaguely estimate "a week."

Although artisans could make better estimates of the amount of time spent making simpler pieces, there are still difficult methodological issues that must be considered. Should I count the time while a piece is drying in the sun (probably not) or soaking in gasoline (maybe)? What about artisans who work slowly because they are often interrupted by their children while painting or carving? If some tasks (e.g., sanding or painting the first coat) are done by hired piece workers, should I include their labor when making input/output calculations?

This last question raises an issue that has long been of concern to analysts of peasant economies. Starting with Chayanov (1966 [1920s]), many scholars have argued that the use of household labor by peasant agriculturalists and artisans means that their economic enterprises cannot be analyzed in the same way as capitalist firms. In particular, input-output calculations cannot be made in which "profits" are figured by imputing a monetary value to unpaid household labor. The best one can do is to estimate the returns per unit of labor invested. Such blanket statements ignore the use of both paid and unpaid labor by many peasant agriculturalists and artisans. In the case of the wood-carvers, understanding the extent to which hired labor is used is often essential when analyses are made of the economics of making a piece. The two extremes are artisan households using only unpaid family labor and the "factories" in Arrazola making pieces exclusively with hired labor. Comparisons of the input/output ratios for these very different types of workshops are clearly plagued by the analytic problems first raised by Chayanov. However, there are many carving families who hire one or two piece workers. As the following hypothetical (but entirely realistic) example shows, neither Chayanovian nor conventional economic calculations seem quite right when attempts are made to calculate input/output ratios for such partly capitalized workshops.

Suppose that a family in San Martín has an order from a dealer for twenty rabbits at 15 pesos apiece and fifty cats at 25 pesos apiece. Some of these pieces are carved by an adult man and two teenage sons; other pieces are bought unpainted from San Pedro Taviche artisans. The principal painters are the man's wife, a daughter in her early twenties, and a hired 17-year-old

girl from a neighboring village who is paid by the piece. The males also occasionally paint. Most sanding is done by an 11-year-old daughter and the wife's elderly mother, who lives with the family.

In such situations, the work of family members is sufficiently important that Chayanovian reasoning would seem to rule out conventional economic calculations of profit imputing a value to unpaid labor. But input/output ratios ignoring labor costs also seem inappropriate because of the purchase of unpainted carvings and the use of hired piece workers.

Despite these methodological issues, artisans are often willing to make estimates about their work inputs. I end this chapter with one such estimate, so that readers can have a general idea of the time involved in making a small piece. Sergio Aragón works alone, specializing in small, finely carved pieces. In July 1998 Sergio was filling an order from Clive Kincaid for 70-peso lizards, 40-peso panthers, and 35-peso frogs. He estimated that he could carve three lizards, five to six panthers, or fifteen frogs per day. Sergio added that he could paint six to seven lizards, eight to nine panthers, or perhaps fifteen frogs per day. These estimates suggest that Sergio's approximate earnings (ignoring the cost of materials) were 140 pesos per day for lizards, 130 pesos per day for panthers, and 260 pesos per day for frogs. While these are excellent daily wages by local standards (US$15 to $30 at the prevailing exchange rates), Sergio did not always have such lucrative orders to fill. The greater profitability of frogs per day does not mean that Sergio was wasting his time making lizards and panthers. Clive had asked for a mix of animals, and Sergio did not have customers for an infinite number of frogs.

GLOBAL MARKETS AND
LOCAL WORK ORGANIZATION

Even the most casual tourist in Mexican states such as Oaxaca, Yucatán, and Michoacán can see that craft production is an integral part of the local economy. Few visitors to Mexico realize, however, that artisans' direct sales to tourists are only a small part of the craft trade. The livelihoods of most potters, backstrap-loom weavers, and hammock makers depend primarily on sales to intermediaries from both Mexico and the United States. Anthropologists (e.g., Cook 1993; García Canclini 1993; Littlefield 1979) have shown that the profits from such sales often end up in the hands of a few local merchants and artisans. Nonetheless, some Oaxacan towns and villages have clearly benefited from craft production. The most successful artisan community in the state is Teotitlán del Valle, a Zapotec-speaking, rug-making town where most households have been able to improve their standard of living considerably over the past thirty years (Stephen 1991; Wood 1997). Other Oaxacan communities that have prospered through craft sales include Santa Ana del Valle (rugs), San Antonino del Castillo (embroi-

dered dresses), and San Bartolo Coyotepec (blackware pottery). Teotitlán, Santa Ana (Cohen 1999), San Bartolo, and San Antonino (Waterbury 1989) were all thriving craft centers decades before the beginning of the wood-carving boom.

The commercialization of craft production has transformed the economics and social organization of some rural Mexican communities. Anthropologists examining these changes (e.g., Cook and Binford 1990; Littlefield 1979) have paid particular attention to the organization of work. Although the machine production characteristic of much capitalist expansion is impossible in a business where consumers value handmade individualized objects, entrepreneurs have set up workshops where hired laborers make items such as rugs (Stephen 1993), pots (Thompson 1974), and silverware (Stromberg-Pellizzi 1993). Perhaps even more common are putting-out systems where piece workers at home use materials provided by merchants (Cook and Binford 1990; Littlefield 1979; Waterbury 1989). Communities may be divided into classes of merchants and piece workers. Sometimes merchants are concentrated in a town, with dependent piece workers living in neighboring "satellite" villages (Cook 1993:65).

As might be expected, the growing market for wood figures spurred the development of new types of production units in the two most successful carving communities. Some male carvers and female painters in Arrazola and San Martín began to support themselves largely through piece work. In Arrazola in the 1990s several medium-sized workshops were established where wooden figures were carved, sanded, and painted. In San Martín a growing number of households bought unpainted carvings trucked in from San Pedro Taviche, an archetypal satellite community. After these pieces were painted, they were sold to local intermediaries and international wholesalers. These changes in work organization were less drastic than those in many other Mexican craft-making communities. Despite the proliferation of capitalistic forms of labor organization, most wood carvings continued to be made in family workshops. Arrazola and San Martín did not become occupationally stratified communities with separate classes of merchants and piece workers.

The decreased demand for inexpensive carvings at the beginning of the twenty-first century has led to significant changes in the organization of labor. The wood-carving "factories" in Arrazola have either shut down or greatly reduced their scale of operation. Family workshops use less hired labor. There are fewer sales of unpainted figures from San Pedro Taviche to merchants in San Martín.

When the demand for wood carvings grew in the 1980s, families found that they occasionally needed to hire relatives in order to fill large orders. As families learned they could rely on a steady stream of orders from certain dealers, they also began to employ nonrelatives. Hired workers today are usually teenage boys and girls or young unmarried adults. Some are paid by the piece; others earn daily wages. In fall 2000 piece workers and salaried laborers earned 50 to 80 pesos (US$5 to $9) per day.

Teenagers who paint and carve for their parents without being paid sometimes earn money by doing piece work for others. Girls work as hired painters for their neighbors; boys sell unpainted carvings. Economic relations between parents and adult children can be complex. Children who continue to paint and carve with their parents after marrying expect to be paid for their work. Parents and children sometimes share workshop space but run essentially independent operations. Many households contain two or more workshops. Parents and unmarried children make figures in one workshop; married children and their spouses carve and paint in the others. Most married children eventually build houses and workshops away from their parents.

There can be considerable variability in the labor processes associated with the different carvings that can be found for sale at a "family" workshop. Some pieces might be made entirely by household members, while others involve a combination of family and hired labor. A few carvings might be made by relatives living in parts of a village where tourists rarely go. Many workshops therefore cannot be easily pigeonholed as "family operations" or "semicapitalist enterprises" or "sites of petty commodity production."

The workshop of Antonio Mandarín and Berta Ramírez in Arrazola illustrates how pieces for sale in the same place can involve very different labor processes. Antonio and Berta, who were in their late thirties during my research, began carving around 1985. They are known for distinctive, large, ornate animal carvings that sell for several hundred pesos apiece. The couple has three young children who were just beginning to learn to carve and paint in the late 1990s. The family's carving income is supplemented by money that Berta makes by sewing.

Berta and Antonio have a large workshop in which numerous pieces are displayed. Visitors' eyes are most likely to be drawn to the large animal carvings. Most of these pieces are carved by Antonio and painted by Berta

and two teenage female piece workers; others are carved by Antonio and painted by his brother Nicolás. There are also some large animal carvings for sale that involve the labor of neither Antonio nor Berta. Antonio's brothers Nicolás and Jacinto share a workshop in another part of Arrazola. His brothers work with their wives and do not share their earnings with one another. Because the workshop of Berta and Antonio is centrally located, Nicolás and Jacinto bring some pieces there for possible sales to tourists.

In the mid-1990s Berta began to deal in wood carvings independently from Antonio. Berta first obtained pieces in exchange for sewing. She later bought carvings from people living in Arrazola and elsewhere. Some of the pieces that Berta now purchases are high-quality, expensive carvings made by Felipe Morales, a relative of Antonio. Berta has noticed, however, that the tourists who visited the workshop are often reluctant to buy the large, expensive pieces carved by Antonio, Nicolás, Jacinto, and Felipe. She therefore also buys inexpensive carvings that are easy to pack and make good gifts. Berta also purchases some unpainted pieces from a man in San Martín, which she paints and then sells.

Perhaps ten carving workshops employing three to twenty workers were established in the 1990s. These workshops, which were mostly in Arrazola, provided significant economic opportunities for entrepreneurial women. In the late 1990s two such workshops were run by women whose husbands were not involved in the business; a third was run jointly by a married couple. Two other thriving small workshops had recently been set up by young single women.

The first wood-carving workshop was established by Pepe Santiago and Mercedes Cruz in Arrazola. Pepe, who is from a large Arrazola family, worked as a policeman in the city of Oaxaca before taking up carving. Mercedes, who is from the city, was employed for a number of years at Casa Brena, a now-defunct store in Oaxaca which included a number of craft workshops. While painting clay figures at Casa Brena, Mercedes learned about the economics of craft production. Pepe and Mercedes began making wood carvings together in 1987, selling both to tourists and to dealers. In 1990 Pepe and Mercedes hired a few workers. Their business grew rapidly, and by 1992 they had about twenty employees. Although the business flourished throughout the 1990s, by summer 2001 Pepe and Mercedes had reduced their work force to only a few carvers and painters.

In 1996 the workshop employed eight carvers, four sanders, and ten to fifteen painters. The carvers and sanders were men; the painters were women. Most of the employees were teenagers or in their early twenties.

Although the workshop employees in the early 1990s were all from Arrazola, by 1996 the great majority came from nearby communities. By the mid-1990s even neophyte carvers and painters from Arrazola had opportunities working with relatives that were more remunerative than employment at the workshop. The employees from places other than Arrazola ordinarily stayed at the workshop from Monday morning to early Saturday afternoon. The typical work schedule was eight to six Monday through Friday (with an hour for lunch between one and two) and eight to one on Saturday. Pepe or someone else associated with the business gave the workers rides back and forth to their home communities on the weekends.

The pay at the workshop was about the same as that for unskilled wage labor in the city of Oaxaca. In the 1996 sanders received 180 pesos weekly (about US$24), while carvers were paid 200 pesos. Painters were paid by the piece and could make as much as 250 pesos a week. While it might seem surprising that female painters received more than male carvers and sanders, the painters on average were somewhat older and worked longer hours.

Not all the pieces sold at the workshop were carved there. Pepe and Mercedes bought many unpainted pieces from carvers (often former employees), which were painted in the workshop and then resold. (This is the principal reason why the workshop hired more painters than carvers.) Although most of the unpainted pieces were made in nearby villages, some came from as far away as San Pedro Taviche, Ocotlán, and San Martín Tilcajete. Pepe and Margarita also bought finished pieces from artisans who could not find other outlets for their work.

The workshop of Pepe Santiago and Mercedes Cruz was one of two factory-like wood carving businesses in Arrazola in the 1990s. The other large workshop was run by Margarita Ruiz, an entrepreneurial woman who also owns a general store. Margarita is married to Gerardo Ramírez, a high-end carver who was not involved in the day-to-day operations of either the workshop or the store. In 1993 Margarita began carving and painting her own pieces. When she had little success selling her work, Margarita hired a couple of young men to carve and convinced her teenage daughter Rocio to paint. The enterprise grew quickly, and by 1996 pieces made in or bought by the workshop occupied five rooms in back of the general store. The great majority of Margarita's carvings were sold to tourists stopping by the store. In 2000 Margarita closed down the factory end of her operation. She continued to sell high-end pieces carved by family members and painted by Rocio.

In June 1996 Margarita employed fourteen female painters and ten male carvers and sanders. The employees, mostly from Arrazola, were paid by

the piece. Eight women painted in the workshop. Beginning painters received 20 pesos for completing ten small figures. Later on they received 25 pesos for painting ten pieces. They could usually paint fifteen to twenty small pieces a day. The other six painters worked at home. Because these women often had years of painting experience and worked on more complicated pieces, they were paid considerably better. They sometimes made as much 300 pesos for painting a large carving, which might mean a daily income of 75 to 100 pesos. The carvers and sanders were young men in their late teens. The sanders made about as much per day as the less-experienced painters. The carvers were paid 50 pesos for every ten small pieces and might make as much as 75 pesos on a good day.

Margarita bought numerous unpainted pieces from carvers in Arrazola, San Martín Tilcajete, and San Pedro Taviche. These were painted in the workshop and then resold for perhaps two or three times the buying price. Margarita also bought finished pieces from artisans in San Martín who could not find other customers. In these practices, her workshop was similar to that of Pepe and Mercedes. Unlike Pepe and Mercedes, Margarita sold some high-quality pieces made by family members. In 1996 she displayed an iguana carved by Gerardo and painted by Rocio that was priced at 2,000 pesos. The great majority of pieces for sale, however, cost between 20 and 100 pesos.

A smaller workshop run by Gabriela Velásquez shows the fuzzy boundaries between family craft production and capitalist enterprises. Gabriela, who is originally from Chiapas, moved to Oaxaca when she was in her late teens. She was in her early forties during my field research and had lived in Arrazola (where her husband is from) for two decades. Gabriela's husband is a driver and is not involved in her workshop. Gabriela's workshop uses some unpaid family labor but depends more on the labor of piece workers. In 1997 all of Gabriela's employees were relatives. Her 17-year-old son and a 15-year-old male nephew carved. Gabriela and two teen-aged nieces painted; her 12-year-old son sanded. Gabriela paid all of the workers except for her 12-year-old son. A nephew who had previously done much of Gabriela's carving had recently left for the United States.

Gabriela began her business in 1988 with two hired workers and has never had many employees. For several years she worked with Manuel Duarte and Miguel Díaz from nearby San Pedro Ixtlahuaca. The San Pedro men bought Gabriela's pieces and then sold them in various markets in the Central Valleys. Although Gabriela no longer works with Manuel and Miguel, she does sell carvings to the owners of two stalls in markets in the

city of Oaxaca. In recent years most of Gabriela's sales have been to store owners and dealers. She occasionally travels to Chiapas and Mexico City to deliver pieces made in her workshop. Despite her entrepreneurial ability, Gabriela makes little effort to sell to tourists and does not even have a sign on her house indicating that wood carvings are sold.

The selling of unpainted pieces became increasingly common throughout the 1990s. These carvings are usually made in places such as San Pedro Taviche where many artisans have elementary carving skills, but few people can paint well. Longtime carving families in San Martín and Arrazola regard these figures with open condescension. They point out that such pieces are often ineptly carved and display little originality. Not all sellers of unpainted carvings live in communities off the tourist trail. Many teenage boys and unmarried young men in Arrazola and San Martín sell such pieces. Some have learned to carve in large workshops and have not yet had the opportunity to paint much. Others simply lack the skill or the inclination to become decent painters. The closest equivalent in San Martín to the two large workshops in Arrazola are a few sizable family businesses that buy unpainted carvings, mostly from San Pedro Taviche. These carvings are then repainted and sold to tourists in shops in the center of San Martín.

The relative importance in the 1990s of the various types of production units differed somewhat in Arrazola and in San Martín. Merchant-entrepreneurs were more important in Arrazola; San Martín had more families that supported themselves by buying, painting, and reselling carvings made in other communities. These differences seem less significant than the similarities between the two towns. Both Arrazola and San Martín include many households earning substantial amounts of money from carvings made in family enterprises employing little or no hired labor. These households are as well off as any of the families that ran the large workshops. Furthermore, the low cost of materials enabled employees of capitalistic workshops to quit their jobs while still young and begin to work independently.

Many anthropologists writing about Mexican crafts have pointed out how artisans are embedded in capitalist relations of productions. These writers (e.g., Cook 1993; Cook and Binford 1990; García Canclini 1993; Littlefield 1979; Novelo 1976) place particular emphasis on the power that intermediaries have to dictate the productive activities of artisans. They point out that seemingly independent artisan households in rural communities are often actually piece workers in urban-based enterprises. These observations seem pertinent to some aspects of the wood-carving trade. Certainly a carver in San Pedro Taviche who sells a piece to a painter in San

Martín that has been ordered by a dealer wanting "100 turtles at 15 pesos apiece" has little autonomy. The situation of low-end carving families in Arrazola and San Martín is not very different. The employees of the Arrazola workshops, moreover, were obviously involved in prototypic capitalist enterprises.

Nevertheless, most carving families in Arrazola and a large number in San Martín have considerable control over what they produce. These skilled workers with individual styles are producing an item that for the time being is in considerable demand. Although most are more than willing to make whatever a wholesaler requests, they are not at the mercy of the dealers. The carvers can demand prices for their pieces that provide locally good returns for labor. Few express any antagonism toward wholesalers. Most successful carvers are still extraordinarily grateful to the dealers who first bought from them. They continue to appreciate the patronage of wholesalers and seldom complain about prices. I have, however, heard some complaints about low prices paid by merchants in San Martín and (to a lesser extent) Arrazola who buy pieces (both unpainted and finished) and then resell them. Because of their economic circumstances and their position in the commodity chain (pieces often go from artisan to local intermediary to dealer from the United States), the resellers cannot afford to pay as well as dealers from the United States. While artisans may understand this, they still resent the low prices they get from local merchants and seek out clients (whether collectors or dealers) who will pay better.

COMPARISONS WITH OTHER OAXACAN CRAFTS

In an ambitious article, Scott Cook (1993:62–63) presents a table comparing seven crafts in the Oaxaca Valley with respect to social demand, marketing modes, production forms, and patterns of value distribution. Unsurprisingly, the wood-carving trade differs greatly from the three utilitarian crafts (palm plaiting, metate making, brick making) that Cook examines. Comparisons with the four products made for export (treadle-loom weaving for cotton, treadle-loom weaving for wool, backstrap-loom weaving, embroidery) seem more pertinent. The returns to labor for carving are similar to those in treadle-loom weaving for wool and better than those for embroidery, treadle-loom weaving for cotton, and backstrap-loom weaving. Only the treadle-loom weavers for wool have as much contact as the wood-carvers with intermediaries from the United States and make as many items designed for the high end of the market.

Cook's table shows that the wood-carving trade most closely resembles the Teotitlán-based rug industry (treadle-loom weaving for wool). A scholarly comparison is not really necessary to reach this conclusion since anyone spending a week looking at crafts in the Oaxaca Valley quickly finds out that the two most prosperous artisan communities are Teotitlán and Arrazola, with San Martín and Santa Ana not far behind. The wood-carvers themselves often cite Teotitlán as a model for the establishment of a long-term successful craft industry. The similarities between the rug-making and wood-carving communities are the consequence of the substantial high-end demand for these two crafts. This market has enabled many people to earn substantial incomes from items produced in family workshops. The continuing demand for individualized, well-done pieces has enabled skilled artisans to command high prices for their creations.

There are significant differences between the wood-carving communities and Teotitlán with respect to work organization. Local merchants are much more powerful in Teotitlán than their counterparts in the wood-carving towns. The Teotitlán merchants operate workshops with hired laborers, supply yarn and dye to piece workers, and provide important links between weavers and intermediaries from the United States. Stephen (1991:24–25) has characterized the merchants and weavers of Teotitlán as comprising distinct "class-based groups." Furthermore, the merchants of Teotitlán are patrons of many weavers in Santa Ana (Cohen 1999:47–54). Merchants in Teotitlán make contracts with the weavers of Santa Ana for the delivery of rugs with particular designs on specified dates. Because the merchants sell these rugs to wholesalers, Santa Ana is to a certain extent a satellite village of Teotitlán.

The lesser importance of local merchants in Arrazola and San Martín is related to the low capital investment required for wood carving. The high cost of yarns, dyes, and looms makes merchant-run workshops, putting-out systems, and contracts profitable for Teotitlán merchants, who can rely on piece workers needing supplies and credit. Because even the poorest families in Arrazola and San Martín could afford paint and copal, wood-carving workshops had constant turnover as employees set up businesses for themselves.

Differences in the markets for rugs and wood carvings are also relevant. Dealers importing textiles from Teotitlán and Santa Ana are trading a product with a sizable, well-defined market. They have had many years to establish ties with local merchants they can trust. The market for wood carvings, in contrast, is still embryonic. Dealers must have a sophisticated

understanding of what is likely to sell. Most wholesalers from the United States have therefore chosen to select carvings personally and have not taken the risk of relying on local intermediaries.

In a detailed, wonderfully written, and informative book, Lois Wasserspring (2000:17–18) suggests that gender may be one reason why certain celebrated Oaxacan potters earn less than many wood-carvers:

> While it is true that most artisans in Mexico make only a precarious living from their craft, the gap between effort and reward is probably greatest in ceramic work. One wonders if there is not a gender connection here. The woodcarvers of the Oaxaca valley, predominantly men, get substantially higher pay than virtually any of the female ceramists working in the area. The use of the machete by the male woodcarvers somehow elevates their craft to the category of "sculpture," while the very mundane origins of clay production, stemming from family use in the home, diminishes its value . . . In all branches of artisan work, women's contributions are often hidden or devalued . . . The men of San Martín Tilcajete, Arrazola, and La Unión sign their names on their wonderful wooden creatures. But after carving their animals they hand them over to their wives and daughters to painstakingly transform the bare wood into vibrantly colored, decorated forms that attract buyers . . . with [the] expectation of women's natural assistance comes the assumption that their creative endeavors do not require acknowledgment or pay.

Although women's contributions to craft production in Oaxaca are certainly often devalued by both local people and outsiders, I have difficulty seeing the link to the comparative profitability of wood-carving and pottery. The prices that artisans receive for their work are partly determined by the demand of consumers in industrialized countries who may not know or care about the gender of the makers of the pieces they buy. I doubt that someone looking for a wedding gift in Seattle, for example, is influenced much by whether the signature on a carving or clay piece is by a woman or a man. I am also unsure about Wasserspring's idea that the mundane family origins of pottery affect the prices that ceramists receive for their work. Huipiles (blouses made in Mexico and Guatemala) have equally mundane origins yet often are sold for high prices. What seems more relevant to me in the case of pottery and wood carvings is the portability and fragility of the two media. Tourists and dealers in Oaxaca sometimes can choose be-

tween equally clever ceramic and wood representations of Nativity scenes, market women, or angels. They may well prefer to buy wood carvings, which are much less likely to break.

Wasserspring points out (personal communication) that women artisans in Oaxaca suffer disadvantages in comparison with men when haggling over prices for their work. The women sometimes have little education, are not respected by the male merchants they deal with, and have not always been socialized to be aggressive bargainers. My observations of the wood-carving trade are consistent with those of Wasserspring. There certainly are some shrewd businesswomen in the wood-carving trade, such as Mercedes Cruz and Margarita Ruiz, but these women are not primarily artisans. Although female artisans in wood-carving families often sell small numbers of inexpensive pieces to tourists and store owners, they are usually reluctant to make business arrangements on their own with either large-scale wholesalers or potential customers seeking expensive pieces. (María Jiménez is a notable exception to this generalization.)

The extraordinarily talented ceramists portrayed so well by Wasserspring are doubtless handicapped by their gender in their efforts to get a fair price for their work. I think it is unlikely, however, that gender accounts for much of the discrepancy between the prices of ceramics and wood carvings in the Central Valleys of Oaxaca.

CONCLUSIONS

The wood-carving trade in Arrazola and San Martín is in some ways a classic case of the integration of rural "Third World" communities into the world economy. The economic well-being of artisan households depends on the demand for their products by wealthy consumers living thousands of miles away. The sale of wood carvings has become profitable for both artisans and wholesalers because of favorable peso-dollar exchange rates, customs regulations in the United States concerning craft imports, transportation improvements in Mexico, the ability of dealers to reach carvers via telephone and fax, and a burgeoning global market for ethnic arts. Increased sales of wood carvings led to capitalistic forms of labor organization and greater socioeconomic stratification within communities. The economic position of the wood-carvers, however, is better than that of most other Latin American artisans involved in global markets. Several features of the wood-carving trade—the low cost of materials, a sizable high-end market for individualized pieces, personalistic ties between artisans and

intermediaries from the United States—have enabled family workshops to prosper.

The experience of the wood-carvers could be interpreted as supporting the seemingly contradictory views of Chayanovian-oriented campesinistas and Leninist-oriented proletaristas. The economic success of many artisan family workshops in Arrazola and San Martín supports the contention of the campesinistas that in certain circumstances rural households using unpaid labor can compete successfully with capitalistic enterprises. The establishment of factory workshops, the increasing amount of piece work, and the dealers' large orders for cheap carvings support the proletaristas' assertion that increased production for sale is almost always associated with capitalistic, unequal forms of work organization. Theorists combining proletarista and campesinista views might argue that intermediaries in the wood-carving trade benefit from unpaid family labor that keeps prices down.

The apparent restructuring of the market for wood carvings at the beginning of the twenty-first century has significant implications for local work organization. An increasing percentage of wood carvings sold are high-end pieces that require highly skilled labor and cannot be made in factory-like conditions. This has resulted in even greater domination of the wood-carving trade by family workshops. Because many of these family workshops are prospering, the decapitalization of the wood-carving trade cannot be facilely attributed to declining sales. Instead, the relevant factor is the decreased demand for pieces that can be mass produced.

Theoretical approaches focusing on work organization usually largely ignore a fundamental aspect of the wood-carving trade. Artisans in Arrazola, San Martín, and La Unión specialize in particular types of pieces in their attempts to capture niches in a variegated, ever changing market. The next chapter examines the development of these niches.

SPECIALIZATIONS

Over the past two decades Oaxacan wood-carvers have developed specialties in their efforts to appeal to a diverse clientele. Some artisans make expensive, labor-intensive carvings for collectors; others churn out cheap pieces for gift shops in the United States and tourists seeking souvenirs. Artisans vary in their painting and carving styles and the size of their pieces. They make animals, human figures, devils, angels, frames, chairs, tables, and ox-carts. There are carvings of Benito Juárez, subcomandante Marcos (the Zapatista leader), *chupacabras* (imaginary beings that eat goats), "Martians," mermaids, and helicopters. The diverse economic strategies that carvers have pursued in recent years are the result of a segmented market in the United States and Mexico that promotes novelty and rewards specialization. Artisans do not, however, have total freedom in their initiatives. They are constrained by their skills and the labor and capital they are able to mobilize.

Economic development in capitalist societies almost by definition involves attracting customers to new products and expanding the market for already-existing products. Makers and sellers of an increasingly popular product often develop specialties in their efforts to gain a share of the market. Models from two very different fields, market research and ecological succession, may improve our understanding of why such "product differentiation" sometimes accompanies economic growth. Neither of these models precisely fits the evolution of market niches in the trade in Oaxacan wood carvings. Nonetheless, an examination of these models provides insights about the reasons why many carving households have become increasingly specialized in recent years.

PRODUCT LIFE CYCLES

Market researchers (e.g., Capron 1978; Onkvisit and Shaw 1989) have shown that successful products such as automobiles, cameras, and audiotapes ordinarily have certain life cycles. These business-oriented writers usually assume that their units of analysis are the firms making these products. The applicability of the product life cycle model to Oaxacan wood-carvers therefore depends in part on the extent to which the various groups making pieces can be regarded as analogous to firms. The product life cycle model has five stages. Sales build slowly during the first stage of product introduction. The second stage is early growth, characterized by rapidly increasing sales. Sales continue to increase during late growth but at a lower rate. The final two stages are maturity, when sales are relatively constant, and decline, when sales decrease until the product is finally withdrawn from the market.

During introduction, there are usually only a few pioneers making the product. The increased sales marking the end of the introductory phase attract competitors, who continue to enter the market through the early growth stage. Because sales come from the growth in the market, this is not a stage of intense competition. During the late growth phase, competition heats up as the market begins to stabilize. The number of firms selling the product decreases as the strong force out the weak. The late growth period is characterized by product differentiation and market segmentation:

> In contrast to the imitative product strategy of early growth, extensive product modification occurs as competitors seek differential advantage

through product design. Typically, product variations proliferate as competitors adapt their products to specific customer requirements . . . In contrast to the early growth phase, price becomes a major competitive weapon in late growth. (Capron 1978:5)

Market segmentation is an attempt to divide markets into groups of potential customers with similar characteristics with respect to purchasing (Berrigan and Finkbeiner 1992; Weinstein 1987). By making products designed to appeal to particular types of customers, segmenters hope to increase their sales.

The maturity stage begins when sales cease to grow. During this phase, most sales are to repeat users, and prices are competitive. Although the maturity stage may last many years, sales eventually decrease. Two common reasons why declines occur are technological obsolescence and changing consumer tastes.

ECOLOGICAL SUCCESSION

Suggestive parallels can be drawn between product life cycles and stages of ecological succession as plants invade open fields (Burrows 1990:420–464; Colinvaux 1973:549–572). The first plants in such fields are opportunists, selected for their unspecialized behavior, plastic physiology, and expensive means of widespread dispersion. In the absence of significant disturbances, opportunists are gradually replaced by equilibrium species with specialized physiologies and stereotyped responses. As the environment becomes more crowded and more predictable, natural selection favors specialized adaptations to small econiches. This leads to a great increase in the number of species in the later stages of succession.

Comparisons of the changing economic strategies of Oaxacan artisans and the ecological succession stages of plants occupying an open field are clearly limited in scope. The applicability of a succession model depends in part on the extent to which analogies can be drawn between the selection pressures on production units making wood carvings in an expanding market and those affecting plant species in a recently formed ecosystem. Such analogies have at least surface plausibility. The development of specializations by Oaxacan wood-carvers and many other artisans is a textbook example of a cultural evolutionary process (Chibnik 1981; Durham 1990). Artisans continually try out new styles in their efforts to increase sales. Some experiments are unsuccessful (do not attract buyers) and are aban-

doned. Other innovations are "selected for" (attract customers) and replicated and become part of the cultural repertory of particular families and communities.

The ecological succession and market research analogies both suggest that artisans will adopt opportunistic or generalist economic strategies in the introductory and early growth stages of a product life cycle. The models also both imply that artisans will specialize in the late growth stage as they compete for customers in a crowded, more predictable market. The analogies diverge, however, in their implications concerning the number of "competitors" in the late growth stage. The market research model suggests that there will be fewer competitors as slower growth leads to more intense selective pressures. The succession analogy, in contrast, implies that there will be more competitors as niches are established in a stable economic environment.

REASONS FOR SPECIALIZATION

Specialization in the wood-carving trade is the result of both market demands and the initiative of artisans. Buyers of wood carvings include collectors seeking original, beautifully painted pieces, tourists purchasing inexpensive souvenirs, merchants stocking ethnic arts shops, and wholesalers searching for items that can be sold in enormous gift shows. These different kinds of buyers, who have their own individual tastes, seek both items they know about and those they have never seen before. The woodcarvers therefore try to increase their sales by doing something distinctive that is attractive to some, but not all, buyers. In so doing, they hope to create a demand for new types of carvings.

The increased specialization in carving over the years cannot be neatly separated from overall changes in styles. Prior to 1980 most carvings bore clear relevance to the natural, cultural, and spiritual world of the artisans. Many carvings were of human figures (e.g., farmers, old men), ox-teams, animals from the Oaxaca region, devils, angels, and skeletons. These pieces, which are now referred to as "rustic" (*rústico*), were carved and painted in a simple, albeit charming manner. Because some buyers continue to prefer the older styles of carving and painting, a significant market remains for rustic pieces. Most contemporary artisans in La Unión specialize in modified versions of these simpler carvings, sometimes painted with aniline. Moreover, many buyers—especially those interested in Day of the Dead motifs—still seek out the saints, angels, devils, and skeletons that domi-

"Rustic" condors from Cuilapan. Don Roberts, collection of Michael Chibnik.

nated the wood-carving trade in the early 1980s. Thus, some "specialization" is actually the continued production of "traditional" (twenty-year-old!) pieces.

The diversification of wood carvings in Arrazola, San Martín, and La Unión began with experiments by Manuel Jiménez, Isidoro Cruz, and Martín Santiago. These early wood-carvers attempted to increase their overall sales by selling a variety of pieces. Before 1970, however, the small number of wood-carvers and buyers limited the development of market niches in which individual artisans and wholesalers specialized in the production and purchase of particular types of pieces. Specialization increased in the early 1970s because of the state-sponsored wood-carving contests. These competitions encouraged wood-carvers to try new pieces in efforts to win prizes and sell their pieces to the state. This stimulated a florescence of new styles in San Martín in particular because of Isidoro Cruz's connections with the state agencies running the contests. The establishment of some new crafts stores in the city of Oaxaca at this time also encouraged wood-carvers to innovate. The astonishing diversity of pieces and styles that characterizes the contemporary wood-carving trade did not develop until the mid-1980s, when increasing numbers of wholesalers, store owners, and tourists from the United States visited Arrazola and San Martín. Many villagers who previously had shown little interest in crafts began to make wood carvings. The neophyte carvers needed some way to attract dealers and tourists on

their way to the houses of established artisans such as José Hernández in Arrazola and Epifanio Fuentes in San Martín. The obvious solution was to make something different which would appeal to potential buyers.

Innovation in the wood-carving trade has not been hampered by long-standing stylistic tradition. Some Oaxacan crafts such as embroidered wedding dresses from San Antonino (Waterbury 1989) are so well established that variability is restricted to rather fixed, culturally defined limits. Buyers search for craft items "typical" of a particular place. Because there are no long-established wood-carving styles, buyers have fewer preconceived notions about what they are looking for and are more receptive to new types of pieces. Wholesalers and store owners want to diversify their stock; tourists like having something unique that will impress their friends and relatives.

In recent years certain styles of carving and painting have come to be considered typical of particular families and communities as wholesalers and store owners seek out pieces that have sold well in the past. Margarito Melchor has prospered by selling cats similar to those on the cover of the Barbash book. María Jiménez and her brothers make spectacular saints and angels; Juan Carlos Santiago of Arrazola is sought out for his penguins. Arrazola carvers are known for their iguanas; La Unión artisans make multipiece rodeos, fiestas, and Nativity scenes.

The fundamental appeal of the carvings, however, is still based on characteristics that encourage experimentation by artisans. Craft dealers whom I have interviewed in the United States and Mexico agree that customers especially appreciate the whimsy, color, and imagination of the carvings. When artisans are successful with particular kinds of carvings (e.g., frogs reading books, parrot musicians, reclining cats), some of their neighbors copy their styles in cheaper, less technically proficient knockoffs. A type of figure once regarded as original, whimsical, and imaginative may come to seem hackneyed. Successful artisans are well aware of this process and sometimes complain bitterly about copiers. Their realization that the market can become saturated with particular kinds of pieces forces them either to innovate or to develop specialties (e.g., difficult painting or carving styles) that cannot be easily copied. Even Margarito Melchor, who is an archetypal example of an artisan with a recognized, long-lasting specialty, was experimenting in the summer of 1998 with rustic devils, angels, and witches that are quite different from his well-known, ornately painted cats, deer, goats, and squirrels.

The cheapness of materials also encourages experimentation. As noted

earlier, artisans spend no more than 2 or 3 pesos for the paint and wood needed for a medium-sized carving which can be sold to a dealer for 30 or 40 pesos. Because several such pieces can be completed in a day, making something new requires minimal expenditures of time and money. If an experiment fails (a new type of carving is not bought), little is lost.

Carvers' abilities limit their freedom to experiment. Skilled, imaginative artisans typically innovate by making expensive, elaborately carved pieces with complex painting designs. Less talented carvers are more likely to experiment by making smaller, cheaper, less complicated, slightly different versions of other people's already successful ideas. Innovation is also constrained by the labor and capital available to particular carvers. Artisans with large families or the money to hire workers can afford to experiment with several new pieces while simultaneously making carvings that have sold well in the past. This economic strategy is not available to an impoverished artisan couple with young children. Because of their precarious economic circumstances and small labor pool, such a couple may be reluctant to innovate much.

TYPES OF SPECIALIZATION

Although Oaxacan wood carvings most obviously differ in what they represent, they also vary in size, color, painting style, materials, price, and a host of other characteristics. Carvers' specializations typically encompass some combination of these variables. A carving family might, for example, make many expensive iguanas painted with particular decorations. Most artisans have several specializations. Coindo Melchor carves elaborate ox-teams (two bulls, a driver, and a cart filled with animals and crops) and unique creatures (*ilusiones*) that have been described as "bird-headed-women" (Barbash 1993:31). Aguilino García sells fairly expensive skunks, crocodiles, armadillos, and palm trees. Antonio Aragón makes medium-priced, small, finely carved, realistic deer, dogs, lions, and cats. Despite such specializations, all carvers can and do make a wide variety of pieces and will readily change their product mix if what they are focusing on declines in popularity.

In the discussion that follows, I mention only the most important ways in which carvings vary: (1) representations; (2) physical characteristics; (3) carving and painting styles; and (4) price.

Carvings can roughly be classified into five categories—animals, religious or folkloric beings, humans, plants, and inanimate objects. Some carvings (e.g., trees with birds, drunks sitting on chairs around a table) include items from two or more of these categories. A few (e.g., skulls, masks) do not fit neatly into my classificatory scheme.

Animals are by far the most common carvings. They are often painted with bright colors and designs and carved with exaggerated features that bear little resemblance to what occurs in the natural world. Anthropomorphism is common, and carvings of animals playing musical instruments, golfing, fishing, and engaging in other human pursuits are very popular. Many carvings depict religious or folkloric beings important in Mexican popular culture. Angels, saints, and Virgins tend to be somber, if often brightly painted, pieces depicted alone. Devils and skeletons, in contrast, are usually parts of lively scenes. There are ox-carts filled with skeletons, devils riding dogs, and skeletons drinking with witches. Artisans often make mermaids and occasionally carve other mythical figures such as centaurs and Pegasuses. The most common carvings of imaginary beings are *alebrijes* (also spelled *alebriges*). These fantastic figures, sometimes described as "space age," are modeled on the papier-mâché sculptures of the Linares family of Mexico City. Because many buyers now use the word *alebrije* to refer to any Oaxacan wood carving, artisans are beginning to refer to the "space age" pieces as *marcianos* (Martians). Carvings of humans include old men, farmers, drunks, mariachis, fruit vendors, cooks, lovers, and prostitutes. Despite the originality and charm of many such carvings, they are made mostly by older artisans in La Unión and are much less common than they once were. Depictions of human beings evidently do not sell well.

The artisans carve many trees and cacti. The only other flora that artisans commonly make are fruits and vegetables such as avocados, chiles, watermelons, and carrots. Carvings of inanimate objects include those that are purely decorative (e.g., bicycles, wheels of fortune) and those that have some practical use (e.g., jewelry boxes, refrigerator magnets, napkin holders). The most commonly made inanimate objects are picture frames decorated with raised carvings of animals and plants. Brightly painted miniature chairs and tables are also popular and are often sold to Mexican tourists as children's toys.

Two carvings of Benito Juárez by Margarito Melchor Santiago (son of Margarito Melchor Fuentes), San Martín. Don Roberts, collection of Holly Carver.

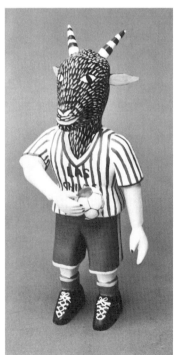

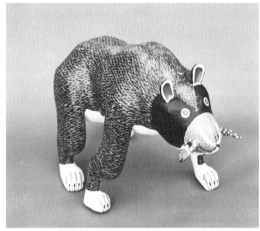

Bear by Marcos García, city of Oaxaca. Don Roberts, collection of Holly Carver.

Goat soccer player by Agustín Cruz, San Agustín de Cruz. Don Roberts, collection of Michael Chibnik.

Historical figure, Margarito Melchor Santiago, San Martín. Fidel Ugarte.

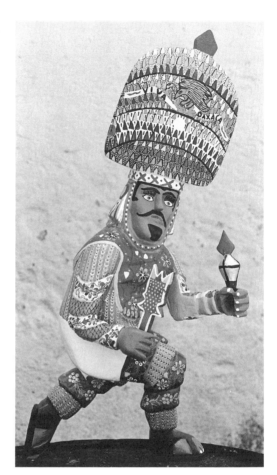

Snail by Edilberto Cortez, Arrazola; hippopotamus by Eleazar Morales, Arrazola. Don Roberts, collection of Michael Chibnik.

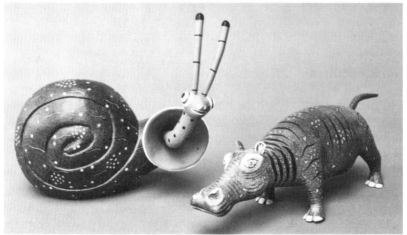

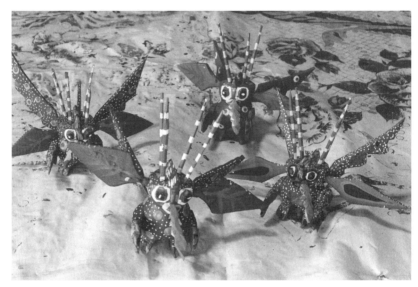

Alebrijes by Inocente Melchor and Reina López. Fidel Ugarte.

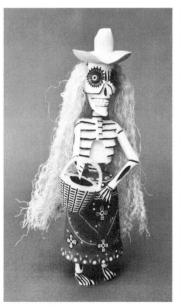

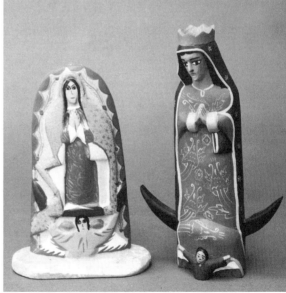

Woman with basket (Day of the Dead motif) by Antonio Xuana, San Martín. Don Roberts, collection of Michael Chibnik.

Religious figures by Rafael Mendoza, San Martín (left), and Avelino Pérez, La Unión (right). Don Roberts, collection of Michael Chibnik.

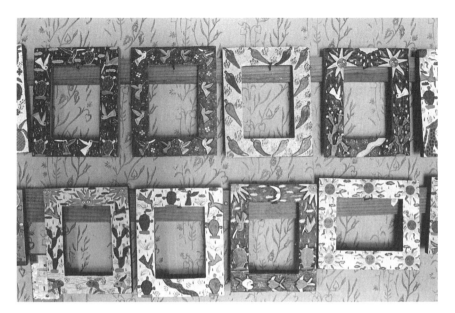

Frames by Roberto Matías, San Martín. Fidel Ugarte.

PHYSICAL CHARACTERISTICS

Although most carvings are made from copal, some artisans specialize by making some or all of their pieces out of other types of wood. In the late 1980s carvers could be divided into those that used aniline and those who were switching to vinyl-acrylic house paints. Nowadays aniline is only used by a few artisans. Aside from materials, the most obvious physical way that carvings vary is in their size. While big carvings are striking, smaller pieces have the important advantage of being more easily transported by tourists. Big pieces ordinarily take longer to make and can be sold for higher prices. They are typically bought either by collectors or by store owners wanting something flashy to highlight a shop area. Smaller pieces, which comprise the bulk of the trade, are sold to diverse types of buyers—tourists, shop owners stocking cheap gift items, and wholesalers selling to retailers in the United States. Skilled carvers whose reputations and contacts attract buyers willing to spend some money tend to spend most of their time on medium-sized and big pieces. Most, however, make some small pieces (e.g., pigs by María Jiménez and her brothers), and a few (e.g., Sergio Aragón) specialize in miniatures.

Carvings can be subdivided into individual pieces and multipiece sets. Although every carver makes individual pieces, some specialize in particular types of sets such as animal musician bands, Nativity scenes, rodeos,

fiestas, kiosks, and anthropomorphic animals sitting on chairs around a table filled with food and drink. Artisans are usually willing to sell parts of a set to an interested customer. They will only refuse to do this if the set has already been ordered by someone else who is expected to pick it up soon.

CARVING AND PAINTING STYLES

Artisans often attempt to develop unique styles that demonstrate technical ability, attract prospective customers, and cannot be copied easily. This may entail cooperation and consultation between a husband and wife since the most common division of labor involves men carving and women painting. Carvers and painters, however, have considerable autonomy in their creative efforts.

Carvers' technical skills can affect the value of their pieces. Arrazola carvers take pride in their expensive, complex pieces made out of one piece of wood. Conversely, the rusticity of some inexpensive La Unión cats can be seen in their multipiece bodies with legs nailed onto torsos. When carvers judge each other's skill, they most often look at the details in a figure. Some rustic animal carvings—which often have considerable charm—only crudely represent legs and do not realistically indicate posture. Talented carvers accurately show an animal's movement and carefully delineate toes and claws.

Painting offers more opportunity for specialization than carving. Painters vary greatly in the colors and designs that they use. Both low-end and high-end artisans have developed characteristic painting styles. La Unión rustic pieces are often painted simply with one or two colors and few decorations. Equally cheap pieces from workshops in Arrazola are elaborately painted with a particular design that is readily identifiable. The painting styles of the La Unión rustic pieces and the Arrazola workshop carvings are easy to learn. The minute, detailed, repetitive decorations used by María Jiménez, in contrast, indicate a remarkable talent.

PRICE

The wood-carving market is segmented by price into three general categories. Artisans sold their cheapest pieces for 50 pesos or less in June 1998, when the exchange rate was 8.8 pesos per dollar. Medium-priced pieces sold from 50 to 200 pesos; expensive pieces mostly cost between 200 and 1,000 pesos. The priciest carvings regularly sold are made by high-end Arrazola carvers such as José Hernández, Miguel Santiago, Francisco Mo-

Unpainted drinkers (Day of the Dead motif) by Inocencio Vásquez, San Martín. Fidel Ugarte.

Armadillos from workshop of Epifanio Fuentes, San Martín. Don Roberts, collection of Holly Carver.

rales, and Manuel Jiménez. Although a collector paid 9,000 pesos in Arrazola for a carving in the summer of 1998, only a few other pieces sold locally for more than 2,000 pesos. The highest-priced piece sold in a carving village that I know of took place in 1995, when a doctor from Mexico City paid Isidoro Cruz the equivalent of US$3,000 for a "carousel of the Americas." Cruz had spent three months working on this spectacular carving.

Price differences reflect a segmented market in the United States and Mexico (and less significantly Canada, Europe, and Japan), where some buyers seek out inexpensive carvings for gifts and souvenirs; others clever, medium-priced pieces; and still others expensive, one-of-a-kind carvings.

This differentiated market could easily be seen when I visited Santa Fe, New Mexico, in May 1998. An enormous store called Jackalope sold hundreds of cheap carvings at prices ranging from $15 to $100. The front window of a smaller shop on the main square displayed a $755 lion carved by Maximiliano Morales of Arrazola. A clerk in the store told me that they had no problem selling carvings at this price.

Although all artisans make pieces that vary considerably in cost, most focus on a certain price range. The most extreme example is Manuel Jiménez, whose pieces are all very expensive. A more typical case is Aguilino García, who slowly makes pieces that sold for between 100 and 400 pesos in the summer of 1998. There are many artisan families whose business comes primarily from small animal carvings sold to dealers for about US$3 apiece.

Artisans can only choose to a limited extent whether they will specialize in cheap, medium-priced, or expensive pieces. Obviously, not all artisans are able to command high prices for their work. Because expensive pieces—which are often large—generally take a long time to make, carvers can specialize in them only if they are sure to be able to find buyers. This depends on artisans' ability to make original, technically proficient pieces and whether or not they have an established reputation. Nevertheless, a certain amount of specialization with respect to price is possible. The owners of the workshops in Arrazola have made a conscious decision, for example, to make inexpensive pieces aimed at tourists. Some skilled artisan families in Arrazola and San Martín who have the ability to make expensive pieces have chosen instead to mainly make medium-priced pieces. They prefer the quicker, surer returns that these smaller carvings provide.

EXAMPLES OF SPECIALIZATION

The four brief case studies that follow show some of the ways in which Oaxacan wood-carvers specialize. The artisans profiled vary in the types of carvings they make, the prices of their pieces, and the kinds of customers they have. The case studies also illustrate the diverse types of labor organization used to make pieces. These profiles describe business activities in the spring and summer of 1998.

ACTIVE ANIMALS FOR DEALERS AND TOURISTS

The work of Martín Melchor and his wife, Melinda Ortega, is often featured in materials publicizing Oaxacan wood carving. Three of their animal musi-

cians appear on the back cover of the Barbash book; photographs of their animals riding bicycles have been used in brochures distributed by the Oaxaca state tourist office and posters advertising museum exhibits of wood carvings. Although Martín and Melinda always have enough orders from dealers to keep busy, their central location in San Martín also allows them to sell some pieces to tourists. Martín and Melinda, who were in their forties while I did my research, began making pieces in 1987. Their preteen daughter and a hired teenage girl were helping the family paint in the late 1990s.

Martín and Melinda are talented artisans and charming, reliable people well-liked by the dealers they work with. The family's success, however, is best explained by their specialization in certain multipiece carvings that have been successfully copied by only a few other artisans. Martín and Melinda make a lot of carvings of animals doing something. Their pieces include frogs with saxophones, elephants on bicycles, dogs playing dominos while sitting at a table under an umbrella, iguanas fishing while sitting on chairs, and cats golfing. These medium-sized sets (usually two pieces) cost between 90 and 120 pesos in the late 1990s. Buyers could buy parts of sets but rarely did. Martín and Melinda thought up the ideas for most of these sets. However, there is one interesting exception which demonstrates the globalization of the folk art market. The idea for the animals fishing on chairs was suggested to Martín by a dealer from Los Angeles, who knew that carvers from Bali made such pieces.

While most of the family's income still comes from the sale of active

Martín Melchor and Melinda Ortega. Fidel Ugarte.

Animal bicyclists by Martín Melchor and Melinda Ortega. Fidel Ugarte.

animals, Martín and Melinda developed a second line of specialization in the late 1990s when they began making elaborately painted pine chairs and tables. Although there are several other families specializing in pine chairs and tables, Martín and Melinda paint skillfully and carve the backs of the chairs in twisted, unusual shapes. They also have innovated by making chairs and tables that can be easily taken apart for packing. Nevertheless, the size of these items has limited sales, and the family now focuses on smaller chairs and tables designed to be children's toys.

In July 1998 Martín and Melinda were busy working on an order from a New Mexico dealer for 375 animal musicians (including 155 bulls) and 30 animal bicyclists. The order was due in early September, and the family would be unable to work on anything else for the next couple of months. They were paid 27,000 pesos for the order, with 6,000 pesos received in advance and the rest upon delivery. When I talked with Martín and Melinda that summer, they were usually working at a table covered with dozens of semicompleted bull musicians. They admitted finding such work a bit boring, but the prospect of the forthcoming sales compensated for the tedium.

INEXPENSIVE RUSTIC PIECES FOR DEALERS

Reynaldo Santiago and Elodia Reyes have made carvings together in La Unión since their marriage in the mid-1970s. Reynaldo, a nephew of Martín Santiago, has always supported himself by carving and small-scale farming. Elodia and

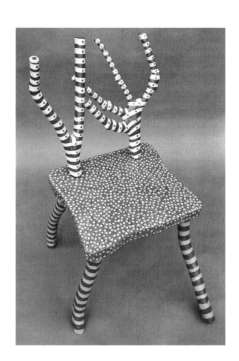

Chair by Martín Melchor and Melinda Ortega. Don Roberts, collection of Holly Carver.

Reynaldo have two daughters in their twenties and two sons, a teenager and a toddler. Although many teenagers and young adults work in the wood-carving trade, Elodia and Reynaldo receive no help from their children. One daughter works as a domestic servant in Mexico City; the other is married and is busy with her own family in La Unión. The teenage son works in the city of Oaxaca and has so far shown no interest in carving. The limited labor available to Reynaldo and Elodia forces them to work slowly. Reynaldo does all the carving, while Elodia is responsible for most painting. Reynaldo says that he helps with painting when he has the time. All the family's pieces are simply painted and carved in the rustic style characteristic of many artisans from La Unión.

Reynaldo and Elodia make some expensive pieces such as bandstands and ox-teams that sell for US$45. They also make some medium-sized (20-centimeter-high) animals that cost about $7. The family specializes, however, in miniature (7-centimeter) dogs, cats, giraffes, rabbits, and goats that sell for about $3. Elodia once used aniline paints but switched to house paints around 1985 at the request of Henry Wangeman, a dealer who bought many of the family's pieces at that time.

Because few tourists visit La Unión, Elodia and Reynaldo sell most of their pieces to Oaxaca store owners and wholesalers from the United States.

Reynaldo Santiago and Elodia Reyes with their son Lionel. Fidel Ugarte.

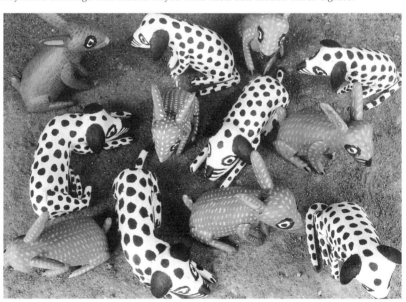

Dogs and rabbits by Reynaldo Santiago and Elodia Reyes. Fidel Ugarte.

They have always been dependent on only a few buyers. Elodia and Reynaldo's first pieces were sold to Casa Víctor, a store in Oaxaca. When Henry Wangeman began coming to La Unión in the 1980s, he was by far their most important customer. Nowadays they sell the majority of their carvings to two clients, a wholesaler in California and a store owner in Texas.

INEXPENSIVE AND MEDIUM-PRICED PIECES FOR TOURISTS AND WHOLESALERS

In 1990, when she was twenty-one, Olga Santiago began painting in the workshop run by her cousin Pepe Santiago and his wife, Mercedes Cruz. In 1995 Olga and an older sister stopped working for Pepe and Mercedes and established their own business in which they paid painters and carvers by the piece. Olga ran this workshop alone after her sister left for Tijuana in the summer of 1997. The workshop, near the house that Olga shared with her parents, was a large cement room packed with shelves of wood carvings. In February 1998 there were three women who painted in the workshop: Olga, her 17-year-old niece Analí Rodríguez, and her 20-year old friend and neighbor Lourdes Morales. A fourth woman painted for Olga at home. Many pieces sold in the workshop were carved by 24-year-old Pedro Hernández of Arrazola, who worked almost full-time for Olga. Others were carved by artisans from other communities.

The prices in Olga's workshop, while much cheaper than those for comparable pieces in the United States, were high by local standards. A small piece of less quality than Reynaldo and Elodia's US$3 miniature animals sold for $5; medium-sized pieces of middling quality cost as much as $20. Prices were negotiable, and tourists could pay considerably less if they were willing and able to bargain. Although tourists comprised a sizable part of Olga's business, wholesalers were more important customers. A Mexican wholesaler who sells to shops along the Sonora-Arizona border bought more from Olga than all tourists combined. Prices in these shops are double or triple those in Arrazola.

By summer 2001 Olga had closed her workshop. She had married and was making pieces in a family workshop with her husband.

PINE CARVINGS FOR MEXICAN WHOLESALERS

Alba Matías, born in 1969, is from a large carving family in San Martín that specializes in pine frames, chairs, tables, and magnets. Alba learned to carve

and paint at an early age and worked in the family business until she married Víctor Victoria in 1995. Víctor's family at that time was not involved in carving. His father, Luis, is a building contractor, and Víctor worked in construction in the city of Oaxaca before his marriage.

After Alba and Víctor were married, they moved in with Víctor's parents and his teenage sister Leticia. The couple quickly established a successful family wood-carving business, making pieces similar to those of the Matías family. Alba taught Víctor how to carve and paint and is still more knowledgeable about techniques than he is. The family makes pine crosses and (decorative, nonfunctional) machetes as well as frames, chairs, tables, and magnets. They also make ox-teams in which the animals are copal and the ox-cart is pine. Alba and Víctor carve and paint, Leticia paints, and Víctor's mother, Francisca, sands.

Because Alba knew many wholesalers through her family, she and Víctor had no trouble finding customers when they began working together. Their pieces range in price from US$4 for a small frame to $100 for a medium-sized table with two chairs. They sell many medium-sized frames for $6 and also do well with $30 chairs. Perhaps because transporting chairs and tables to the United States by air is costly, most of the wholesalers buying from Alba and Víctor are Mexican. Although these Mexican dealers account for the bulk of the couple's sales, they occasionally sell to tourists and high-end Oaxaca shops.

DISCUSSION

Several aspects of the Oaxacan wood-carving trade encourage innovation and specialization. Because wood carving is a new craft, buyers have few preconceived notions about what pieces should look like. The low cost of materials makes it easy for artisans to experiment without losing their livelihoods. The existence of a sizable high-end market enables some skilled carvers and painters to earn substantial incomes by spending considerable amounts of time on commissioned, individualized pieces.

Despite these particular features of the wood-carving trade, general theories about the causes of specialization are clearly relevant to the evolution of market niches in the workshops of Arrazola, San Martín, and La Unión. The product life cycle model fits well most of the changes in wood carvers' economic strategies. After a long introductory stage involving a few pioneers (1950–1984), many families began carving during an early growth phase (1985–1990). The wood-carving trade had become bifurcated by the summer of 2001,

with high-end pieces being in a mature phase and low-end carvings entering decline. As sales leveled off and the market became more predictable, carvers developed niches. This specialization reduced competition among artisans and allowed them to capture parts of a segmented market.

The number of carvers did not diminish during late growth, as the product life cycle model would predict. There are three principal reasons why prosperous wood-carvers did not drive their less successful neighbors out of business. As noted earlier, the product life cycle model assumes that the units of analysis are firms. Most carving production units, however, are family workshops which can survive economically in situations where labor costs would lead to the failure of capitalistic firms using paid employees (Chayanov 1966). Furthermore, the absence of attractive economic alternatives made struggling artisans reluctant to abandon wood carving. Finally, wood-carvers could easily change specializations if their initial efforts to find a market niche were unsuccessful.

The reduction in the number of competitors appears instead to be taking place during the current phase of maturity (for high-end pieces) and decline (for low-end pieces). As the most talented artisans are competing with one another for shares in a market that is no longer growing, some are considering other economic options such as temporary migration to the United States. Many ordinary artisans are spending less time wood carving as they find fewer and fewer outlets for their simple pieces.

While the product life cycle model clearly applies in part to the wood-carving trade, the relevance of theories about plant succession stages is less obvious. An ecological analogy, however, has the merit of drawing attention to the selective pressures affecting the evolution of market niches. Specialized plants proliferate when their ecosystem becomes crowded and predictable. Although I would not wish to push this analogy too far, the wood-carvers seemed to create more market niches as the number of artisans increased and their economic environment became (at least temporarily) more stable.

Recent trends in the wood-carving trade may lead to further specialization and innovation. In the past several years a number of carvers have prospered by selling expensive pieces to dealers. Many low-end specialists working with wholesalers, however, have seen their sales plummet. Furthermore, some artisans who sell unoriginal, inexpensive pieces to tourists have suffered economically as the number of visitors to the wood-carving communities has leveled off. Most carvers understand that they must sell distinctive, expensive pieces to dealers in order to be successful. Wholesal-

ers and store owners, unlike tourists, are familiar with many different types of pieces. The dealers' never-ending quest for originality should continue to foster the artisans' creativity.

Anthropologists examining economic "development" might focus more on who can take advantage of the market niches accompanying the commercialization of particular products. The Oaxacan wood-carving trade allows artisans within particular communities to innovate and specialize in their attempts to take advantage of such niches. The conditions of trade for certain other products (perhaps bananas and coffee), in contrast, favor standardization on the local level and regional specialization. In such cases, intermediaries can easily specialize in attempts to establish market niches, but producers have much less autonomy than the Oaxacan wood-carvers.

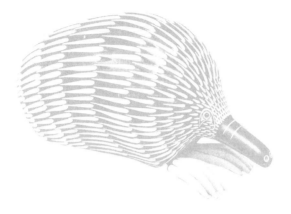

HOW ARTISANS ATTAIN SUCCESS

In a couple of thought-provoking articles, Rudi Colloredo-Mansfeld (2001, 2002) observes that anthropologists, historians, and geographers have given two principal explanations for why certain artisans are especially successful in selling their pieces. Some writers (e.g., Annis 1987; Meisch 1998; Steiner 1994) note that the extraordinary talent, originality, energy, and business savvy of a few artisans enable them to gain advantage in a competitive marketplace. Others (e.g., Stephen 1991; Tice 1995) say instead that in some communities artisans' differential success can be explained primarily in terms of access to and control of capital and labor. Colloredo-Mansfeld points out, however, that neither "selection by merit" nor "structural inequalities" can explain why in many communities a few artisans are *much* wealthier than any of their neighbors.

According to Colloredo-Mansfeld, recent research on "winner-take-all" competitions in industrial countries may help explain why some artisans prosper a lot more than others. Some economists (e.g., Frank and Cook 1995)

claim that mass media, new information technology, and low transportation costs have made it easier for consumers to learn about and obtain the "best" products and performers in particular categories. Since customers no longer have to "settle for second best" or accept local goods, the relative position of producers and performers crucially affects the allocation of awards. The earnings of the superstars in fields such as popular music and athletics, for example, are much greater than those of performers with only slightly less talent. Colloredo-Mansfeld examines income distributions in a number of craft-making communities from a winner-take-all perspective and concludes (2001:143) that in a growing variety of artisan markets a few operators realize big payoffs, but this is by no means a universal feature of craft production. He suggests that in some places exceptionally successful artisans are skilled at amassing social capital. For example, Colloredo-Mansfeld's examination of painters in Tigua, Ecuador (2001:144–146), indicates that artisans seeking to maintain high relative position must ceaselessly invest by maintaining their wardrobes, spending on their compadres, and participating in community fiestas and political meetings. This allows them to maintain the personal relations necessary to mobilize skilled labor.

This chapter examines the artistic, economic, and personal skills that have enabled some Oaxacan wood-carving enterprises to become especially well-off by local standards. During the 1990s the most financially successful wood-carving workshops could be divided without much difficulty into two distinct groups recognized by both artisans and dealers. The first group of *artesanos* consisted of individuals and families who produce expensive pieces for sale primarily to dealers and collectors. These high-end carvers and painters ordinarily use only family labor and often make commissioned pieces that take a week or more to complete. The second group of *comerciantes* included entrepreneurs who employ salaried laborers and piece workers to make large numbers of inexpensive carvings for sale to tourists and low-end dealers. Few of these workshop operators earn much money from the sale of their own pieces. By 2000 comerciantes had become less important, and almost all successful wood-carvers were artesanos.

This dichotomous typology of successful artisans is a simplification. A few artesanos occasionally hire labor and buy unpainted carvings. Some comerciantes are talented artisans who sell some expensive pieces they have made using only family labor. Jaime Santiago, one of the best-off La Unión artisans during the 1990s, fit into neither group because he sold large numbers of inexpensive pieces using only family labor. (Jaime abandoned

wood carving in fall 2000 and started a lumber business.) Nonetheless, almost all highly successful carving enterprises can fairly easily be classified as either artesanos or comerciantes.

This chapter begins by considering what constitutes "success" for Oaxacan wood-carvers. I then examine the economic strategies of four successful artesanos—Miguel Santiago of Arrazola, Isidoro Cruz and María Jiménez of San Martín, and Gabino Reyes of La Unión. These talented carvers and painters earn much more income from craft production than the vast majority of their neighbors. All four work hard, make unique pieces that are highly prized by dealers and collectors, and get along well with their customers. They differ greatly, however, in personality, market savvy, sales ability, and access to capital and labor. Their experiences illustrate the multiple routes to extraordinary success.

WEALTH, REPUTATION, AND SUCCESS

Estimating the income of wood-carving enterprises is not easy. Few keep careful records of their intermittent sales, which vary unpredictably as dealers and tourists come and go and customers develop new tastes. Artisans differ greatly in the number of pieces they make and the prices they charge. Income is often shared among a work force that changes as family members age, marry, and move away. The wealthiest carvers are frequently reluctant to say how much they earn per year; the less wealthy may have difficulty providing even rough estimates. Since new houses and cars may be financed by income earned by family members in the United States, changes in material well-being do not necessarily reflect wood-carving success.

Despite these difficulties, I was able to estimate fairly closely the 1996 income of one of the most successful wood-carving families. The Gonzálezes (a pseudonym) made about 60 pieces, from which they earned approximately 90,000 pesos (US$11,900 at the prevailing rate of exchange). While the Gonzálezes sold fewer pieces than most other high-end artisans, their prices were unusually high even for successful carvers. Their income from wood carving, I think, was similar to that of most other high-end artisan households. A typical wood-carving family in Arrazola or San Martín in 1996, in contrast, might have earned about 20,000 pesos annually from craft production. (Such households often farmed small plots and sometimes included family members who earned money from wage labor.) These figures compare with the 30 pesos per day (about US$120 per month) earned by an unskilled construction worker.

Even though artisans such as the Gonzálezes earn extraordinarily high incomes by local standards, the wood-carving trade cannot be characterized as a "winner-take-all economy." Only two "superstars" have incomes considerably greater than anyone else's. Furthermore, there are many "winners" since most households in Arrazola and San Martín have substantially improved their material well-being as a result of wood carving. These include numerous moderately successful wood-carving families whose incomes from the craft in 1996 likely ranged from 35,000 to 60,000 pesos. Nevertheless, I agree with Colloredo-Mansfeld about the importance of examining the characteristics that allow some artisan enterprises to be unusually successful. Before doing so, however, it is necessary to discuss what exactly constitutes "extraordinary success" for a Oaxacan wood-carver.

The principal features of artisanal success are obviously a large annual income and material wealth. Extraordinarily successful artisan families in Arrazola and San Martín without exception live in comfortably furnished, large cement houses and own electronic equipment such as compact disk players, video cassette recorders, and satellite dishes. Most, but not all, own automobiles, have indoor plumbing, and send their children to secondary school and sometimes university. Many have invested earnings from wood carving in other income-producing enterprises such as farmland and taxis. This degree of material success is rarely possible for wood-carvers living in other communities. The best-off carvers in La Unión, for example, have less substantial houses than the average dwelling in Arrazola.

Another aspect of success is artistic esteem. A few carvers are especially respected for their artistic ability by their peers and by outsiders such as dealers, museum officials, and journalists. Such carvers have their pieces selected for exhibitions in Mexico and the United States and are featured in books, newspapers, and magazines. They have the opportunity to take all-expense-paid trips to the United States, where they exhibit and sell their pieces in schools, museums, shops, and galleries.

For the most part, the carvers with the highest incomes are also those most respected for their artistic talent. There are exceptions to this generalization, most obviously entrepreneurs with little artisanal talent who have become materially successful by employing salaried laborers and piece workers. In 1999 there were perhaps seven such entrepreneurs—two in Arrazola, four in San Martín, and one in the city of Oaxaca. There are also critically esteemed artisans who have had only moderate financial success because of lack of business acumen, unreliability, poor health, or alcoholism.

Because the wood-carving trade is not a winner-take-all economy, it is

difficult to say exactly how many artisans should be regarded as both extraordinarily financially successful and highly respected artistically. In 1999 there were approximately ten such artisan households in Arrazola, twelve in San Martín, three in La Unión, and six elsewhere. Two of these households (Manuel Jiménez in Arrazola and Epifanio Fuentes in San Martín) were clearly the wealthiest. The three households in La Unión were considerably less well-off financially than the others. I have nonetheless counted them as "extraordinarily successful" because of their relative wealth and their production of expensive pieces prized by dealers.

ROUTES TO SUCCESS

Extraordinarily successful wood-carvers have become financially successful in diverse ways. Some (e.g., Miguel Santiago and José Hernández of Arrazola) make only expensive pieces and concentrate on selling to collectors and high-end dealers. Others (e.g., Antonio Mandarín of Arrazola and Jesús Sosa of San Martín) carve both medium-priced and expensive pieces and sell to a wide variety of high-end dealers and tourists. Still others (e.g., Martín Melchor and Inocencio Vásquez of San Martín) make pieces of all sizes and prices and sell to high-end and low-end dealers, serious collectors, and casual tourists. Some carvers (e.g., Miguel Santiago, Isidoro Cruz) make most of their pieces without help; others (e.g., José Hernández, Epifanio Fuentes) work in family enterprises in which the division of labor is fairly clear; still others (e.g., Martín Melchor, Inocencio Vásquez) hire piece workers for simple tasks.

Artistically respected, financially successful carvers are all able to sell expensive, labor-intensive, one-of-a-kind pieces to dealers or collectors. Although most of these pieces cost between US$60 and $200 in Oaxaca in the late 1990s, a few high-end artisans (e.g., Miguel Santiago, Manuel Jiménez, Francisco Morales) were able to sell pieces for $400 or more. Diverse skills enable artisans to charge dealers and collectors high prices for their pieces. The most important and most obvious of these is artistic talent. Buyers of high-priced carvings demand imaginative, original pieces that are carved and painted skillfully. But artistic talent alone is not enough to ensure that carvers will consistently be able to sell expensive pieces. Successful carvers must make accurate guesses about what kinds of pieces will appeal to different dealers in Mexico and purchasers in the United States. They also need to assess when the market for particular types of pieces is improving and when the demand for other, formerly successful, pieces is dropping.

Certain personal characteristics are helpful if a carver wants to maintain good relations with intermediaries. Dealers prefer to buy from carvers who deliver orders on time at agreed-upon prices. Some highly skilled carvers earn less than they might because of well-deserved reputations for being unreliable or otherwise difficult. Only a widely recognized genius such as Manuel Jiménez can consistently get away with temperamental behavior. And even Jiménez has become much easier to work with in recent years as he has stopped drinking and increasingly relied on his more business-oriented sons. Sales ability also helps carvers obtain high prices for their pieces. This involves more than simply convincing dealers of the excellence and marketability of particular pieces. Skilled sellers are extroverted men and women who can entice potential customers to their workshops and negotiate the often formidable linguistic and cultural barriers between artisans and dealers. Although most dealers speak enough Spanish to conduct their business, few know the language well. Because the successful carvers know only a few words of English, they have learned that their sales depend in part on their ability to communicate with dealers in slow, clear, simple Spanish. The more perceptive carvers also recognize that even the most laid-back, culturally sensitive U.S. dealers may fail to understand the complex community obligations that occasionally prevent the timely delivery of orders. To maintain good relations with dealers in such circumstances, carvers must be eloquent, charming, and persuasive.

There are a few artisans who have all the characteristics required to make and sell expensive pieces. Jesús Sosa, Jacobo Angeles, and Epifanio Fuentes (all from San Martín) are artistically talented, personable, reliable, and market savvy. Most other extraordinarily successful artesanos lack certain abilities and personal traits that are useful in increasing sales. They may, for example, be shy or not charge enough for their pieces or not react quickly enough to changes in the demand for different types of pieces. Although such artisans do not earn as much as possible, they have enough talent to make their work sought out by dealers.

PROFILES OF SUCCESSFUL ARTISANS

All artistically respected, financially successful wood-carvers make unique pieces that enable them to establish a profitable niche in the market. The very characteristics that lead certain artisans to create a demand for one-of-a-kind pieces—originality, energy, resourcefulness, and charisma—limit the "typicality" of the four wood-carvers profiled here. Extraordinary artisans

are by definition atypical, and each has achieved success in his or her own way. There are about twenty other artesanos I might have profiled, each with an unusual route to financial success.

Two of the wood-carvers described here illustrate well the compromises that must be made between artistic vision and marketability. Miguel Santiago and Isidoro Cruz are perhaps the two most "artistic" carvers in the state of Oaxaca. They have distinct individual styles and strong ideas about what particular pieces should look like. Miguel, who makes only pieces commissioned by clients, often produces carvings that differ greatly from what the customer originally had in mind. Isidoro, in contrast, generally gives his clients exactly what they request. However, he makes many pieces on his own that do not always attract buyers.

Although the other two artisans described here produce exquisite, technically remarkable pieces, their work is less experimental than that of Miguel and Isidoro. María Jiménez has created "designs" that she and her brothers paint on carved religious figures and animals. Gabino Reyes is the originator of a carving style found only among a few artisans in La Unión.

MIGUEL SANTIAGO

When I began my research on the wood-carving trade, I assumed that Manuel Jiménez's pieces were the most expensive. Manuel and his sons do earn more money from wood carving than any other artisan family. I soon learned, however, that Miguel Santiago's carvings were even more expensive than those of the Jiménezes. Miguel sometimes spends three weeks or more working on pieces which are sold to collectors for as much as a thousand dollars. While Jiménez's showroom is filled with pieces for sale to tourists and collectors, Miguel's workshop ordinarily has only four or five carvings on display, some made by his father, José. Of these pieces, only those by José are for sale. Miguel's have all been promised to buyers who ordered them many months ago.

Miguel sells about forty carvings a year to perhaps thirty-five different customers. Some sales are of individual pieces; others are multipiece sets with both human and animal figures. Although Miguel has sold to buyers from Mexico, Europe, and Japan, most of his customers come from the United States. Miguel, born in 1966, is a versatile artisan who can make almost anything a client requests. Although he bought some land in the late 1990s, Miguel has been a full-time carver since 1985. The land is farmed by José.

Arrazola is a small community in which families are often interrelated in

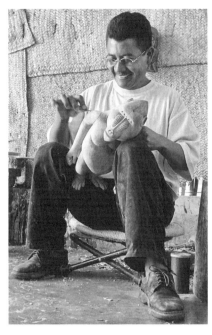

Miguel Santiago.
Fidel Ugarte.

several different ways. It is therefore not surprising that Miguel Santiago's father is a first cousin of Manuel Jiménez. Despite this connection, Manuel discouraged Miguel during his efforts to establish himself as a wood-carver in the early and mid-1980s. By 1987 Miguel was nonetheless well enough known to have his expenses paid on a trip to Texas, where he gave several exhibitions. Unlike many carvers who have given exhibitions in the United States, Miguel does not seem to have been fascinated by the experience. Although he has received many subsequent invitations to exhibit in the United States, he has no particular desire to return. Miguel says that to get ready for such shows would require six months of work and that he is already completely occupied keeping up with orders. Since other wood-carvers have little trouble finding the time to make short exhibition trips to the United States, Miguel's explanation might seem to be a rationalization to avoid a journey he does not want to take. However, a close examination of Miguel's working methods suggests that making such a trip would indeed be difficult.

Most wood carvings are made by two or more related people working together. Miguel's strong ideas about what is good work, however, have made it very difficult for him to work with relatives. In the mid-1980s, Miguel worked with his brother José, who is also a fine carver. They had artistic differences and eventually decided to work separately. Miguel later

took on his talented nephew Gabriel Pacheco as a quasi-apprentice, but they too had a falling out. Miguel's wife confines her work on pieces to sanding, and his two sons (born in 1986 and 1988) have not begun to carve.

Miguel has managed to work on some pieces with his father. José Santiago learned to carve in the mid-1980s after a motorcycle accident and a bout with appendicitis forced him to quit working as a mason. Barbash (1993:25) observed around 1989 the sometimes tense working relations between father and son:

> "Movement! Movement! Movement!" Miguel Santiago's words rang off the cement walls of his alcove. Grabbing an unpainted chicken from the floor, the carver rapped a wing, drew a line across it with his hand and threw the bird back at his apprentice. "This cock is dead!," he declared. The old man, José, gave Miguel a blank look. Miguel glared back. At last, father and son went back to work.

Miguel and José unsurprisingly failed in their initial attempts to work together. But this break was very different from Miguel's ruptured working relationships with his brother and nephew. Although Miguel lives with his family in a new house on the outskirts of Arrazola, he continues to carve at his parents' place. Miguel and José share customers and work amicably side by side. José has become an excellent carver whose pieces, if not up to Miguel's standards, are better than those of most other artisans. In recent years, Miguel and José have again begun to cooperate in the making of some pieces. The Santiagos are an enterprise with three product lines—ultraexpensive pieces designed, carved, and painted by Miguel, expensive pieces (US$80–$100) carved by José and painted by Miguel, and moderately priced pieces ($35–$50) carved and painted by José. Signatures on all these pieces indicate the carver and painter.

Miguel's slow production of his own pieces cannot be primarily attributed to his working alone. The main reason for his slow pace is the care and thought that he puts into each carving. Almost all of Miguel's pieces are commissioned. The making of pieces is a multistep process. A potential customer comes to Miguel and discusses an idea for a carving. For example, Miguel once showed me a postcard with a picture of Frida Kahlo that a not particularly original customer wanted to be the basis of a carving. Miguel had made a sketch of Frida seated on a bench surrounded by monkeys and other animals. After Miguel and the customer discussed the sketch, an agreement would be reached concerning what would be made and the delivery

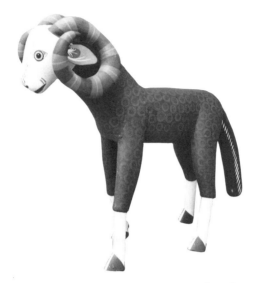

Ram carved by José Santiago, painted by Miguel Santiago. Don Roberts, collection of Michael Chibnik.

date. Miguel would send a price estimate to his client about five months before the carving was due. The price might be raised later if he decided to modify his original idea or found that the carving involved more work than he had first thought.

Most clients place their orders and pick up their pieces in person. Miguel's reputation by now is so established that he finds little need to solicit customers. There is no sign advertising pieces at Miguel's workshop, which is in a part of Arrazola passed by few tourists. Because guides know that Miguel rarely has anything for sale, his workshop (in noteworthy contrast to that of Manuel Jiménez) is never visited by taxi drivers conducting tours for customers seeking wood carvings. Miguel is unaware of yearly fluctuations in the number of tourists visiting Arrazola and is not a member of the local artisans' association. Despite this inaccessibility, in the late 1990s Miguel was regularly taking orders for pieces to be delivered two years later.

How does Miguel manage to attract so many clients willing to pay high prices for his pieces? Certainly, some of Miguel's popularity stems, as Robert Frank and Philip Cook (1995) would expect, from his reputation as perhaps the finest Oaxacan wood-carver. Wealthy buyers seeking the best carvings are likely to find their way to Miguel's workshop. But reputation alone cannot explain why Miguel has many repeat customers. Collectors genuinely like his pieces; dealers have learned that some of his carvings can be sold for thousands of dollars. Buyers who speak Spanish appreciate his charm, amusing stories, and articulate descriptions of what kinds of carvings might be possible. Even those with minimal Spanish often get the impression that they are dealing with a true artist as Miguel rapidly sketches potential pieces.

I was able to observe Miguel's selling and working methods firsthand when I bought an unusual piece from him in 1998. Miguel had some unexpected free time in February of that year because a customer had canceled an order. Rather than start on other orders, Miguel decided to take advantage of the opportunity to try something new. He was considering making an echidna (a mammal with a large snout and spiny torso found in Australia and New Guinea) during this window of opportunity for experimentation. Miguel knew about echidnas from a picture book of animals that a couple from the United States had given him in 1987. (He has a number of such books.) Miguel liked the look of the echidna because of its birdlike face and was fascinated by the technical complexities associated with carving the animal's torso. He did not want to solve the problem simply by putting sticks in holes, the solution wood-carvers have adopted in their depictions of porcupines.

After talking to Miguel in March about his carving plans (he was also considering making a meerkat), I decided to order an echidna. I knew that it would be expensive but wanted to own a piece made by arguably the best Oaxacan wood-carver. This was a rare opportunity to order a piece from Miguel and get it in less than a year. Miguel said that the echidna would cost about 2,000 pesos and that he would have the piece finished by the time I returned to Oaxaca in June. He asked for a 500-peso deposit. This would be a cheap piece by Miguel's standards (although by far the most I had paid for a carving), perhaps because I gave him free rein to make the piece. I neither wanted nor expected sketches and progress reports.

When I went to pick up the echidna in June, I was surprised to see four or five unpainted pieces in Miguel's workshop. Miguel had been having problems contacting some people who had ordered from him and had stopped work on their pieces. While this had given him plenty of time to work on the echidna, he was distressed about the order problems, which had rarely occurred previously. Miguel said half-seriously that he was considering giving the exclusive right to his pieces to a friend of his who owned a gallery in Cleveland.

The echidna is a wonderful piece—striking looking, wonderfully painted, and very skillfully carved. I was especially impressed with the care Miguel had taken to work on the echidna's feet, which are not visible unless the piece is picked up and turned over. The price of 3,000 pesos was something of a shock. I knew that the price Miguel had mentioned before was an estimate and that he often revised his prices upward after completing a piece. I could also see that the echidna must have taken a really long time to make.

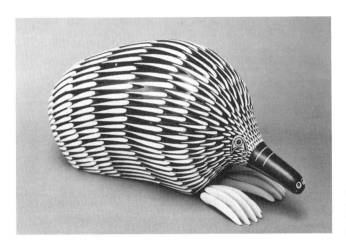

Echidna by Miguel Santiago. Don Roberts, collection of Michael Chibnik.

Still, I had never heard of a carver increasing a price this much. Nonetheless, I thought that even at more than US$300 the echidna was a bargain, costing less than most of Miguel's other carvings.

Unlike most carvers, Miguel takes considerable interest in both the history of the craft and other artisans' work. His studio is adorned by several masks made by his grandfather Pascual, other artisans' carvings, and a varied collection of Oaxacan crafts. When I wrote a short piece in Spanish for a magazine put out by the department of education of the state of Oaxaca (Chibnik 1997), Miguel tried to buy the issue in which the article appeared. When he could not find the magazine (almost all copies had been given to local schoolteachers), he asked me for a copy. After reading my piece, Miguel commented that the article was not quite right in calling Manuel Jiménez the founder of wood-carving in Arrazola. He pointed out that while Jiménez was the founder of this "modalidad," people such as his grandfather had been making masks for Todos Santos celebrations for many years. I knew this but was nonetheless struck by Miguel's insistence on setting the record straight.

The artist/artisan distinction is one that has fallen out of favor in recent years. Carvers such as Miguel suggest why this is so. Since almost all his work is commissioned, he is not an "artist" in the sense of someone who makes what he wants without regard to potential salability. Nevertheless, the interaction between Miguel and his clients is one in which artistic considerations are always coming into play as he modifies plans and makes suggestions. His working methods perhaps most closely resemble those of an architect. Miguel knows that his work is good and charges accordingly. But he is painstaking and self-critical and recognizes his limitations. Miguel's business card describes his work as "arte popular en madera" (popular

wooden art). A man in Oaxaca once wanted to hire Miguel to make a large religious carving near a local church. Miguel turned down the offer, saying that this was a task for a "sculptor," a different type of carver.

Although wood-carving techniques and market channels have changed greatly over the past several decades, the founder of the craft in San Martín Tilcajete has stuck with the methods that first brought him success. Isidoro Cruz's masks, animals, and saints are painted with aniline and cochineal (a dye made from the crushed bodies of certain insects) and carved from zompantle, cedar, and willow. He ordinarily sells his simply painted, elaborately carved pieces to collectors brought to his house by tour guides. Even though Isidoro taught many of his neighbors how to carve, his persistent adherence to his original methods now makes his work unique. Because Isidoro's work is highly respected by sophisticated buyers and promoters of Mexican crafts, he has enjoyed a comfortable living by local standards over the years. Nonetheless, Isidoro's reluctance to adapt his work to market trends may explain why a number of other artisans in San Martín now earn more than he does from wood carving.

Isidoro Cruz carving on his patio. Fidel Ugarte.

Isidoro supported himself in the 1950s and 1960s by farming in San Martín and making ox-carts in the city of Oaxaca. During this time, he made several trips to Texas and Arizona as part of the bracero program. He also married Julia López, who died in 1968. The couple had five children (one deceased); Isidoro and his current wife, Margarita Fuentes (sister of Epifanio Fuentes), have another three. Although Margarita does some sanding and painting, the children have shown little interest in wood carving. They attended secondary school; all but the youngest (a daughter still in school) have good jobs in urban areas in Mexico and the United States. The parents encouraged the education of both boys and girls; one daughter is a topographer and another is an accountant. Two sons live in Albany, New York, where Isidoro has monolingual English-speaking grandchildren.

When Isidoro ran the government craft-buying center in the early 1970s, he lived in the city of Oaxaca and was able to carve only on Sundays. Nevertheless, this was the period when Isidoro established his artistic reputation and established many of the contacts that directly or indirectly led to many sales in later years. Tonatiúh Gutiérrez, who hired Isidoro to run the buying center, has recommended Isidoro's work to many people. This is also when Isidoro met his compadre Raoul de la Sota, now a Los Angeles–based tour group operator. Raoul brings groups—often museum tours—to Isidoro's house once or twice a year. When the tour groups come, Isidoro invites some of his neighbors to join him in exhibitions that include carving demonstrations. The well-heeled, artistically inclined visitors are often good customers.

Isidoro has never worked exclusively as a wood-carver. He continues to be an enthusiastic farmer who owns several tracts of land in San Martín. Isidoro has also worked on and off as a gardener for Tonatiúh Gutiérrez in Mexico City. Despite these diverse sources of income in Mexico, Isidoro explored opportunities in the United States in 1986, when he spent a year in New Jersey and New York working as a gardener, furniture maker, and baby sitter.

Isidoro's house on the outskirts of town has a spacious patio, a well-equipped workshop, and a fine view of nearby hills and fields. His large display room is filled with intricately carved pieces painted in bright pinks, reds, and purples. Isidoro's devils and masks are perhaps the most eye-catching, with their grotesque shape and frightening expressions. He also makes somber saints and angels and playful rabbits and frogs.

Although Isidoro is pleased to take orders, he most often makes pieces without knowing who will buy them. He spends weeks on pieces which

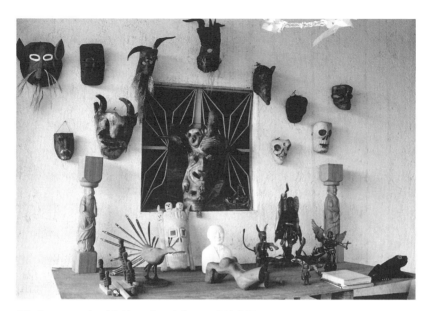

Display on patio of Isidoro Cruz's house. Fidel Ugarte.

may sit in the display room unsold for months or even years. In 1998, for example, Isidoro made a small, unpainted carving of St. Matthew. Three faces of angels were carved into the piece, which had a rotating head. Isidoro's asking price was 3,000 pesos. He had no idea when he would be able to sell this unusual carving.

Isidoro also works on commissioned projects that are totally apart from the ordinary wood-carving trade. He was busy with two such tasks in January 1997. A store owner in Oaxaca had given Isidoro a gold saint to restore. The piece was missing its head and hands. Isidoro was adding these parts to the old piece, which the store owner was planning to sell for about 3,000 pesos. The other project was commissioned by a participant in one of Raoul de la Sota's tours. The request was for a jaguar inside a wooden box that would be 38 inches by 9 inches by 5 inches. The tourist asked that the box be decorated with Mixtec symbols typical of the archaeological site at Mitla.

Isidoro makes an interesting distinction between his work and that of many other contemporary wood-carvers. He says that they are "decorators." By this he means that the appeal of their pieces comes mostly from detailed painting. For Isidoro, in contrast, the carving is what is important. The explanations that Isidoro offers for his choices of paint and wood reflect his vision of his craft. Aniline and cochineal, he says, are "native to Mexico, traditional, and natural." When I asked Isidoro why he never used

copal, he first mentioned problems with wood-eating insects. But he then gave another, deeper explanation. In previous centuries, carvers of local churches and makers of masks for religious fiestas such as Carnaval and Todos Santos did not use copal. Their preferred woods were zompantle and cedar. By using these woods, Isidoro demonstrates the links between his carvings and the work of artisans of the past. Isidoro especially likes zompantle, which he raises in back of his house.

In the late 1990s Isidoro and Margarita increasingly complained about their sales and encouraged me to bring their work to the attention of my friends. Isidoro said that he sold only about forty pieces a year. His pieces, although hardly cheap, are not as expensive as those of Miguel Santiago. Their prices usually range from US$60 to $500. Assuming an average price of $150, this would give Isidoro an annual income of about $6,000 from wood carving. A number of less talented artisans earn considerably more.

MARÍA JIMÉNEZ

Even though much of the work on Oaxacan wood carvings is done by women, almost all the best-known artisans are men. The greater prominence of male wood-carvers may be interpreted as discrimination by dealers, collectors, and journalists who tacitly accept unequal Mexican gender relations that downplay the importance of women's work. There are certainly fine pieces ostensibly "made" and signed by male carvers in which women have done all of the painting. Many prominent male carvers, however, readily acknowledge the painting skills of their wives and daughters. For example, Margarito Melchor proudly says that the distinctive painting style of his late wife, Teresa Santiago, contributed greatly to the appeal of his cat carvings. Teresa's sister Laurencia Santiago is another talented painter whose work is appreciated by her husband, Epifanio Fuentes. Nevertheless, guidebooks to Mexico mention Epifanio and Margarito and ignore the work of their wives. While gender bias clearly affects the relative prominence of men and women in the wood-carving trade, the craft's division of labor is also relevant. Very expensive pieces may be made by artisans such as Miguel Santiago who are skilled at both carving and painting and prefer to work with only minimal help from family members. Since few women carve, they almost always make pieces with considerable help from male relatives.

María Jiménez of San Martín is the only female artisan whose reputation equals that of the best-known male carvers. Although the pieces she works on are usually signed "familia Jiménez," it is María's name that is

María Jiménez.
Fidel Ugarte.

known to dealers and collectors. She also is the family member who con-ducts negotiations with potential customers.

The Jiménezes have diverse sources of income. María's father, Agapito, is a farmer and mason who was president of the community in the late 1990s. Her mother, Dionicia (Celia) Ojeda, made many embroidered dresses during the 1970s and 1980s and still sells two or three a year. María, born in 1964, is the second oldest of eight siblings whose ages in March 1998 ranged from twenty-one to thirty-five. At that time there were thirteen people living in the family compound, which consisted of two concrete houses with twelve bedrooms. The family owned two cars. The residents were Agapito, Celia, Galinda (thirty-five), María (thirty-three), Román (thirty-one), Victoria (twenty-eight), Miguel (twenty-seven), Alberto (twenty-six), Cándido (twenty-four), Cándido's wife, Guadalupe Cruz (twenty-one), their daughter Claudia (three months), Aron (twenty-one), and Aron's wife, Cristina Roque (twenty). Agapito, Celia, Galinda, María, Román, and Victoria left school after primaria; their younger siblings completed secundaria. Román, Alberto, and Miguel have all lived in the United States for extended periods. One of the houses in the compound (built by Agapito) was financed with money Román earned in California.

The labor force available for wood carving has changed over the years as family members have pursued various interests. María is the only family member who has continuously worked in wood carving since 1987. Galinda has never shown much interest in painting; Victoria has only begun painting seriously recently. Aron was too young to help when the family began carving; Román has been in the United States most of the time. Before Alberto left for the United States, he taught Cándido how to carve. Soon after Alberto returned after three years in California, Miguel decided to join Román and taught Aron how to carve.

The family's commitment to agriculture can slow the production of wood carvings. During the busiest farming season in June and July, the men of the family spend most days in the fields. Even María occasionally helps out with agriculture. Although the family sells some surplus production, the agriculture is aimed primarily at home consumption. I once asked María and Román if farming was worth the effort, given the family's income from other sources. They emphatically responded yes, showing the extent to which the family values food security.

The Jiménezes sometimes have difficulty keeping up with orders. Many customers want large saints or angels, which can take two weeks to carve and another week to paint. The demand from dealers and collectors for such labor-intensive pieces ordinarily results in a six- to nine-month period between placing an order for a large carving and the time when it is ready to be picked up. Orders for medium-sized pieces such as owls and toucans are filled more quickly. The prices for saints and angels range between US$70 and $600, depending on their size and the complexity of the painting and carving. Owls and toucans sell for $20 to $50, while pigs cost $10 and smaller pieces even less.

Most of the family's wood carving earnings come from sales to wholesalers and store owners from the United States. They also sell some pieces to stores in Oaxaca. Casual visitors to San Martín rarely find their way to the Jiménez compound, which is away from the town center. Even tourists visiting nearby artisans such as Jesús Sosa and Inocencio Vásquez are likely to miss the Jiménez compound, which lacks a sign and is behind a closed gate. Tourists and collectors who manage to find the family's workshop discover at best a few small pieces for sale. Nonetheless, Spanish-speaking visitors enjoy seeing the workshop and talking to family members, who are courteous, friendly, and have a gentle sense of humor.

María refers to herself as the "designer" for the painting styles on the family carvings. When María first started painting in her current style in the

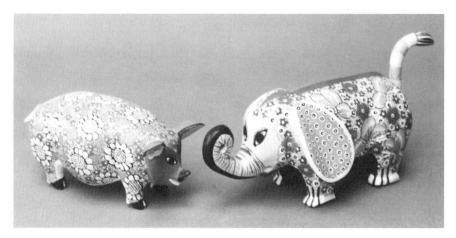

Pig and elephant painted by María Jiménez, carved by one of her brothers. Don Roberts, collection of Michael Chibnik.

late 1980s, she had only two or three designs. By the late 1990s she had about thirty. Although María gives some of these designs to other painters in the family, she reserves certain patterns for herself. María's designs are so detailed that they cannot be easily sketched on paper. Customers can see the designs in photographs; her siblings learn them from looking at completed pieces. While two pieces with the same design may be painted in different colors, María attempts to make their patterns as similar as possible.

When María was a girl, she worked with her mother on embroidered dresses. María's designs clearly have their origin in this earlier work in a different craft. The very concept of a limited number of fixed "designs" is much more common in embroidery than in the painting of wood carvings. Furthermore, some of María's designs—in particular the geometric patterns—resemble those on the dresses she once sewed. However, her "natural" motifs such as birds and flowers were never part of dress designs.

By winter 2000 María was having problems coordinating carving and painting. Cándido, Alberto, Miguel, and Aron were all married and made some pieces on their own or with their new wives. (As the brothers started families, they moved into their own places in the family compound.) Román had returned to southern California, and Miguel was often busy plowing other farmers' fields with his new tractor. Although María and Victoria painted most days, there was no one brother who consistently provided carvings for them.

The household composition of the Jiménez family was unusual for many years because of the many adult unmarried siblings living together with their parents. The large number of potential carvers in the compound over the years has allowed María to keep working despite the ever-changing eco-

nomic activities of her brothers. By the beginning of the twenty-first century, the family's long-standing system of work organization was clearly changing as the brothers married and started families. Cándido had signed pieces for years; now Alberto, Miguel, and Aron were also putting their signatures on carvings. It might appear that María will have difficulty finding family members to carve the pieces she so beautifully paints. In all likelihood, however, someone will continue to provide carvings for her. María is the source of the painting designs, the most skilled painter (although Cándido is also very talented), and the family member sought out by dealers. Aside from these economic considerations, the brothers and sisters have always had a strong commitment to help each other out.

María's success raises an obvious question. Why has she established a superstar reputation within the wood-carving trade, while other women have not? Certainly, the main reason is María's unique, acclaimed, hard-to-copy painting style that differentiates her work from that of other women. María's marital status and other family circumstances are also relevant. The great majority of women her age in the carving villages are married and raising children. While many of these married women paint pieces, they have less time to devote to craft production than María does. Moreover, they usually paint pieces carved by their husbands, who are likely to represent the family in its dealings with wholesalers, store owners, and journalists. In such circumstances the husband is likely to become better-known for their jointly produced pieces. María, in contrast, is the business representative, principal painter, and only constant in a family enterprise with many carvers. Dealers and journalists therefore regard her as the most important member of the family workshop.

GABINO REYES

Because their village is visited by few dealers and tourists, carvers in La Unión have difficulty finding outlets for their work. When I asked the better artisans there which dealers they sold to, the same names came up again and again. Dealers such as Carol Cross, Henry Wangeman, Marcia Lucas, and Cheryl Seim who travel to La Unión to purchase high-quality, expensive pieces are therefore very important to the carvers' economic well-being. Some artisans sell all the work to two or three dealers. If one of these dealers stops buying, these artisans have serious economic problems. In such circumstances, they may sell their pieces to store owners in the city of Oaxaca, who ordinarily pay less than the dealers. La Unión carvers also

Gabino Reyes.
Fidel Ugarte.

sell pieces to Oaxaca store owners when they need cash quickly and are not expecting a dealer to visit them soon.

Gabino Reyes, born in 1962, works with more dealers than any other carver in La Unión. Although carvers such as Maximino Santiago and Octaviano Santiago make more expensive multipiece sets, Gabino's individual carvings are the highest-priced in the community. In 1998 Gabino's medium-sized goats, crocodiles, deer, donkeys, zebras, mermaids, Virgins, angels, devils, tourists, and prostitutes cost 250 to 600 pesos. Smaller pieces started at 150 pesos. Gabino's most expensive carvings were large dragons, which sold for 900 pesos. Despite these relatively high prices, Gabino's income from carving during the 1990s did not approach that of the other artisans profiled in this chapter. Gabino makes no more than eighty pieces a year. Assuming an average price of US$35 a piece, Gabino's earnings from carving in 1998 might be estimated as $2,800. My guess is that he actually earned somewhat less and that my estimates of number of pieces produced and average price are both too high.

The Museo de Arte Popular in San Bartolo Coyotepec held an exhibition of wood carvings from La Unión in May, June, and July 1998. The poster describing the exhibit said that "the pieces mostly represent the daily lives of the people and their traditions" (my translation). This is an accurate depiction of the work of many of the better artisans in La Unión, whose

*"Woman of the streets" by
Gabino Reyes. Don Roberts,
collection of Michael Chibnik.*

*Crocodile by Gabino Reyes. Don
Roberts, collection of Michael
Chibnik.*

carvings at the exhibition included Nativity scenes, market women, court-
ing couples, bullfights, Virgins, mariachis, ox-carts, and churches. While
Gabino's pieces are certainly related to his experiences and observations,
some can hardly be said to represent daily life and traditions in La Unión.
His three pieces at the museum exhibition were a mermaid, an armadillo,
and a cow with a Virgin on its stomach. This last piece in particular illus-
trates the limited applicability to Gabino's work of the museum's charac-
terization of La Unión carvings. Certainly cows are part of daily life in La
Unión and certainly Virgins are part of local "tradition." The combination
of the two, however, is neither "traditional" nor part of daily life.

Gabino's technical skill is evident in a small carving of a "woman of the
streets" that I bought for 250 pesos in March 1998. His attention to detail
can be seen in the fingers, painted nails, tiny handbag, cigarette, and brace-
let. This piece, which resembles the clay figures made by the Aguilar sis-
ters of Ocotlán (Wasserspring 2000), took about twelve hours to complete.
Gabino was helped on the carving by his wife, Analí Vásquez, who sanded
and applied the first coat of paint.

In 1998 Gabino's household consisted of Analí (twenty-nine), his par-
ents, Juan (seventy-three) and Ricarda (seventy-six), and his sons Jobani
(eight) and Uriel (six). One of Gabino's sisters and her family lived in a
separate part of the family compound. Gabino and Analí both finished pri-
mary school; neither Juan nor Ricarda had any formal education. While
Gabino and Analí and their sons are monolingual in Spanish, Ricarda is
bilingual in Spanish and Zapotec, as are both of Analí's parents. Juan un-
derstands Zapotec but cannot speak the language well.

Although Gabino's family is one of the best-off in La Unión, their mate-
rial conditions would place them at best in the middle among San Martín
households and distinctly below the average in Arrazola. Their compound
includes a cement workshop, but the walls of the other buildings are adobe,
reed, and sheet metal. The family members get water from a well, eat a
largely vegetarian diet (not entirely by choice), and do not own a car. They
do own a television and a VCR, which a dealer gave them in exchange for
some wood carvings. Other family members have perhaps reasonably con-
cluded that only limited amounts of money can be made from wood carv-
ing in La Unión. Between 1994 and 1996 one of Gabino's brothers migrated
to the United States, as did four brothers and a sister of Analí. By 2000
Gabino was also considering temporary migration.

Almost every carver in La Unión is also a farmer. Gabino and his father

farm more land than most other artisans in the community. In 1997 they used six different parcels of land, totaling four hectares. Four parcels were planted with corn, beans, and alfalfa in two hectares of irrrigated land. The family raised corn, beans, and wheat on their other two hectares of unirrigated land. Although their agriculture was almost entirely for home consumption, Analí, like many other women in La Unión, sells tortillas (made from the family's corn) in the large Abastos market in the city of Oaxaca.

Gabino was a full-time farmer until he began carving in 1989. When he started out, he sold all of his pieces to a store owner in Oaxaca. After a few years of carving, Rocky Behr, an influential California dealer and tour leader, bought some pieces from Gabino and brought his work to the attention of other dealers. Wholesalers and dealers saw that Gabino had an original style and painted and carved in a more detailed, less rustic manner than the Santiago family. They appreciated the technical skill and sly wit of his pieces. Gabino then received some welcome publicity when his work was prominently featured in the Barbash book (1993). This led more collectors and dealers to make the trip to La Unión to order pieces from Gabino. Despite his relative success since the publication of Barbash's book, Gabino has never been able to support his family well by wood carving. Because the family's farming is of crucial importance, they suffer greatly in the many years when rains are insufficient. Gabino worries about future expenses of supporting his children's education and hosting the large fiestas associated with graduations and weddings.

Gabino's modest economic success demonstrates the importance of a carver's location. Many people involved in the wood-carving trade regard Gabino as one of the three or four most talented artisans. This well-deserved reputation, however, is not enough to entice most buyers to La Unión, where there are relatively few pieces of interest. Because Arrazola and San Martín have more visitors than La Unión, artisans such as José Hernández and Epifanio Fuentes are able to charge higher prices for their pieces than Gabino can. Although these artisans are no more talented than Gabino, the greater number of dealers visiting their communities means that there is more demand for their pieces. Gabino once asked me how much I had paid for a ram painted by Miguel Santiago and carved by his father, José. When I told him that I had paid 800 pesos for the piece, Gabino unhappily remarked (in my view, correctly) that he could never get that much money for pieces of his own that were at least as good.

The annual income earned by a Oaxacan wood-carver selling expensive pieces to dealers can be approximated by multiplying the number of pieces produced per year by the average price per piece. The cost of materials is minimal, given the prices of the pieces, and labor is ordinarily unpaid. What, then, determines the number of pieces produced and the prices charged by extraordinarily successful carvers?

The number of pieces produced per year is influenced by how carefully an artisan works. All the artisans profiled in this chapter work so meticulously that they produce relatively few pieces annually. This is partly because I selected artisans with reputations for producing especially original, technically remarkable work. Other respected artisans such as Margarito Melchor, Jesús Melchor, Antonio Mandarín, and Maximino Santiago make some expensive carvings slowly but work more quickly on a variety of cheaper, well-crafted, unremarkable pieces.

The labor force available to artisans also affects their production. Three of the artisans profiled here—Miguel Santiago, Isidoro Cruz, and Gabino Reyes—work either alone or with limited help other than their wives. María Jiménez, who works every bit as slowly as the three men, is able to make more pieces because she is part of a family enterprise in which there are several carvers and painters. Miguel, Isidoro, and Gabino are unusual in the extent to which they work alone. Most other acclaimed carvers (e.g., José Hernández, Jesús Sosa, Epifanio Fuentes) work closely with other family members. Such carvers can produce more pieces per year than the male artisans profiled in this chapter but have less control over their work. Miguel, Isidoro, and Gabino are such perfectionists that they are unwilling to sacrifice quality for quantity by working much with other artisans.

The demand for pieces is another obvious influence on the number of carvings an artisan sells. Miguel Santiago and María Jiménez have so many customers that their pieces are often delivered many months after they have been ordered. Isidoro Cruz and Gabino Reyes, in contrast, could make more pieces per year and sometimes bemoan their lack of clients. Most of the other very successful carvers fall somewhere between these extremes. These artisans are usually busy but occasionally have slack periods in which they wish for more orders.

The prices artisans receive for their pieces are partly a matter of supply and demand. One reason the artisans profiled in this chapter receive high prices for their carvings is that they make so few of them. However, the

rarity of their pieces alone obviously cannot explain why they are in high demand. Dealers are willing to pay high prices for pieces that are distinctive, hard-to-copy, and easy to sell; collectors value carvings that are unusual, clever, and technically remarkable. Reputation is also important, and pieces by well-known carvers such as Miguel Santiago and Manuel Jiménez sell for more than equally good carvings by other artisans.

Although dealers occasionally comment that they do not much like the work of a carver whose pieces sell well, for the most part the artisans whose carvings fetch the highest prices are also those most critically acclaimed. This is not a craft where there are unappreciated geniuses. Nevertheless, the artistic reputation of carvers is an imperfect predictor of the demand for their work. The reputations of Isidoro Cruz and Gabino Reyes are comparable to those of Miguel Santiago and María Jiménez. Yet there is less demand for their carvings. Isidoro pays little attention to market trends when making pieces; Gabino lives in a place that many potential clients are reluctant to visit.

Artisans' personalities also affect the prices they receive for their carvings. Miguel Santiago, Isidoro Cruz, and Manuel Jiménez take great pride in their work, cultivate the image of a talented artist, and believe that their pieces are worth the high prices they ask. These men are charming hosts and wonderful storytellers and know how to convince customers they are buying special, one-of-a-kind pieces. While María Jiménez and her family are equally proud of their work, they are less assertive and outgoing and may not always get as much for their pieces as they might. Gabino Reyes is low-key, confident in his ability, willing to talk with potential clients (or anyone else) forever, and sells his carvings for about as much as he might reasonably expect.

What Colloredo-Mansfeld calls "selection by merit" seems to me to be the most important reason why some Oaxacan wood-carvers have become exceptionally successful. Almost all artisans selling expensive pieces to dealers grew up in families of impoverished farmers and wage laborers. These artisans' ability to make original, technically remarkable pieces caught the eyes of wholesalers and store owners who found that they could sell these carvings for high prices. "Merit" does not consist entirely of artistic talent. The most successful artisans also understand market trends, maintain smooth relations with their clients, and ask appropriate prices for their pieces.

Until recently, most carvers whose success could be easily related to structural inequities were entrepreneurs hiring salaried laborers and piece workers to make inexpensive pieces. These workshop operators were able

to start their businesses because of family money acquired via migration to the United States, shop ownership, and agriculture. There are now, however, an increasing number of second- and third-generation artisans in prominent wood-carving families. Grandsons of Manuel Jiménez and sons of Epifanio Fuentes and Margarito Melchor, for example, are successful carvers. These talented artisans have benefited greatly from the tutelage and business contacts of their parents and grandparents.

Perhaps the most glaring structural inequity is simply geographical location. Artisans in Arrazola and San Martín have much greater opportunities to learn their trade and meet dealers than those living in La Unión, San Pedro Taviche, and elsewhere. There are only a few carvers living outside Arrazola and San Martín whose financial success approaches that of artisans such as Miguel Santiago, Isidoro Cruz, and María Jiménez. One is Luis Pablo, who lives near Arrazola and knows some of the carvers there. The rest are all members of the Blas family of San Pedro Cajonos.

The conditions that characterize winner-take-all economies are barely present in the wood-carving trade. Such economies develop when extensive publicity and ease of transportation make it easy for consumers to learn about and obtain the "best" products. The wood carvings receive little publicity in the industrial countries where most buyers live; obtaining good-quality pieces is not particularly easy. Furthermore, there are many niches within the wood-carving trade that enable artisans to obtain some success. These niches reduce competition among artisans and arguably render moot the concept of a "best" carver. In crafts with fewer niches, winner-take-all economies may be more likely to develop.

Colloredo-Mansfeld (2001, 2002) finds that exceptionally well-off artisans in some places maintain their relative position by amassing "social capital" that enables them to mobilize labor and attract customers. This may not be the case in the wood-carving trade. Social capital does not seem very relevant to the mobilization of labor. Although many successful artisans have been political leaders in their community and regularly host fiestas, these activities do not help carvers attract the attention of potential clients. Wholesalers, store owners, and collectors are pleased to buy pieces from community stalwarts such as Jesús Sosa, Gabino Reyes, and María Jiménez's family. But they are equally willing to buy from Manuel Jiménez, who rarely talks to most of his neighbors.

POPULAR JOURNALISM, ARTISTIC STYLES, AND ECONOMIC SUCCESS

In August 2000 I stopped by the gift shop at the Peabody Museum at Harvard University to look at crafts and books. Five Oaxacan wood carvings were for sale. The shop also had seven copies of *Oaxacan Wood Carving: The Magic in the Trees,* written by Shepard Barbash with photographs by Vicki Ragan. I was not surprised. In my previous searches for Oaxacan wood carvings in the United States and Mexico, I had often found pieces displayed alongside this book (Barbash 1993) or the couple's earlier *Smithsonian* article (Barbash 1991).

In recent years anthropologists interested in cultural politics, discourse, and representation have paid increasing attention to the ways in which "indigenous" crafts sold in the global marketplace are described in advertisements, museum exhibitions, and newspaper and magazine articles (García Canclini 1993; Hendrickson 1996; Price 1989; Wood 2000b). The description and displays of various crafts by journalists, museum personnel, and merchants clearly affect the market for ethnic and tourist art. Most purchasers of Guatemalan textiles

and Navajo rugs, for example, have previously read about these crafts in books, newspapers, magazines, and catalogs or seen them in shops and museums. What they have read about and seen shapes their perception of what is available, what is well-made, what is collectible, and what is valuable. Publications and exhibitions thus implicitly or explicitly promote certain craft styles and the work of particular artisans and communities.

Although there are anecdotes galore, surprisingly little has been published about the effects of the representations of crafts by intermediaries and cultural brokers on artisans' styles and consumer purchases. Most of what has been written focuses on the activities of merchants, museums, private foundations, and state organizations promoting tourism and the arts (e.g., Mullin 1995; Stocking 1985). Many potential buyers, however, learn about particular arts and crafts through newspapers, magazines, and books. They may become interested, for example, in pottery from a Mexican village by reading an article in *Natural History* magazine, a piece in the Sunday *New York Times* travel section, or a coffee-table book on folk art in Latin America. A prolific journalist with an interest in a particular craft could conceivably have a significant effect on the demand for certain styles and the work of publicized artisans.

This chapter examines the effects of the Barbash/Ragan publications on the wood-carving trade. The *Smithsonian* article brought the wood carvings to the attention of many potential purchasers. The book is prominently displayed in artisans' workshops and is advertised in mail-order catalogs distributed widely in the United States. Many artisans now specialize in pieces similar to those shown in the book, which at one time was a quasi-catalog for buyers. Although the article and book have clearly affected artistic styles, they seem to have had only a limited effect on the overall sales of wood carvings. Despite the visibility of the Barbash/Ragan publications, artisans and dealers tend to downplay their effects on business. They point out that the wood-carving boom started before Barbash began writing and that many other people and institutions have given publicity to Oaxacan crafts.

AN ETHNOGRAPHER LEARNS ABOUT BARBASH, RAGAN, AND "THE BOOK"

Before I began field research on the wood-carvers on a short trip in the summer of 1994, I had read the *Smithsonian* article and browsed through the popular art book. I was amazed, however, to discover the impact of these publications upon my own subsequent research. When I first approached artisans in their workshops, they quite naturally assumed that I

was there primarily to buy carvings. After chatting with the carvers and painters and buying a small piece or two, I would launch into what I expected to be a long-winded description of my project. Much to my surprise, I was almost inevitably interrupted by the quick, friendly response: "Oh—you're writing a book. Like Pastor [the Spanish word for shepherd]." Some artisans would then bring out a copy of *Oaxacan Wood Carving* and show me a Ragan photo of one of their pieces. Others complained that their work was not featured in the book and expressed the wish that I would take pictures of their work for my own publications. The result was that I was immediately identified as a writer working on a book that would give welcome publicity to some artisans' pieces.

I had a mixed reaction to being involuntarily given this role. Most artisans were willing to talk at length with a writer who might produce a book including descriptions of their work and photographs of their pieces. While I was pleased with the ease with which I could begin research, I worried about misleading the carvers about what I could do for them. I often pointed out that in comparison to *Oaxacan Wood Carving* "my book" would take much longer to complete, would contain more text and fewer photographs, and would not sell nearly as well. Few artisans seemed to pay much attention to my disclaimers.

Artisans talked at great length about "Pastor," whom I came to think of as a quasi-anthropologist preceding me in my field sites. Barbash, who was well liked, had spent plenty of time in Arrazola and even more in San Martín. He would arrive in the communities early in the morning and stay until late in the day. Barbash regularly went to ceremonies and fiestas and seemed, in general, to have done a lot of what we anthropologists call "participant observation." I was repeatedly told that he knew much more than was included in his publications. Although the artisans also liked Ragan, they knew her less well. She came to the communities less often and did not speak Spanish as well.

As my research progressed, I quickly became aware of the impact of the Barbash/Ragan publications on the artisans' work. On my second visit to San Martín in 1994, I met Margarito Melchor, whose sculpture of a cat is on the cover of *Oaxacan Wood Carving.* He and his family were busy working on an order for seven cats identical to the one on the cover. Several artisans had signs in English in front of their houses saying that their work is featured in the book. Artisan after artisan told me that tourists and dealers sought out pieces and carvers featured in the book and *Smithsonian* article. My research on the carvers obviously would have to include looking at what I came to think of as the "Barbash/Ragan effect."

Shep Barbash first saw Oaxacan wood carvings when he was working in Mexico City in the late 1980s as bureau chief for the *Houston Chronicle.* He moved to the city of Oaxaca with his photographer wife, Vicki Ragan, to work on a book about the carvings. They lived in Oaxaca for two years and came to know well many of the carvers in Arrazola and San Martín. In 1991 an article about the wood-carvers written by Barbash with photographs by Ragan was the cover story in *Smithsonian,* a magazine with a circulation of more than two million and a staple of waiting rooms for doctors and dentists. Two years later *Oaxacan Wood Carving* was put out by Chronicle Books, a highly regarded West Coast publisher. This nicely designed book includes photographs by Ragan on almost every one of its 107 pages.

Oaxacan Wood Carving has sold over 30,000 copies and can be found in bookstores and gift shops throughout the United States and Mexico. The book is also marketed along with wood carvings in the mail order catalogs of businesses such as the Nature Company and the Daily Planet. After the book was published, Barbash arranged exhibitions by several wood-carvers in museums, schools, and shops in eleven cities, including Atlanta, Philadelphia, Austin, and San Francisco. He gave talks at these exhibitions and helped publicize them in local newspapers. Barbash and Ragan later published a children's book about the artisans (1996) and a calendar featuring the carvings. Although the children's book is available in Spanish, few carvers have seen it. Their familiarity with the Barbash/Ragan publications is mostly with *Oaxacan Wood Carving* and to a lesser extent the *Smithsonian* article.

Because *Oaxacan Wood Carving* and the *Smithsonian* article were published in English, for a number of years most artisans had only a vague idea of what Barbash had written about them. In early 1997 a wholesaler of ethnic arts translated the text of *Oaxacan Wood Carving* into Spanish and gave copies to a few carvers. The translation was modified in a few places in an effort not to offend the artisans. For example, an artisan Barbash described (1993:40) as "a thoughtful, otherwise impractical sort" was characterized in the translation as "pensativo, introspectivo, y *distinto*" (my emphasis). "Distinto" here perhaps is best translated as "different." Most wood-carvers, in any case, have not seen this translation.

The text in the *Smithsonian* article and *Oaxacan Wood Carving* is that of an entertaining travel book—lively, readable, and realistic. Barbash devotes as much space to the artisans' lives and local economies and culture as he does to the carvings themselves. His approach and writing style are

exemplified by the beginning of the *Smithsonian* article. Barbash does not start off by saying what the wood carvings are like or how they might be related to other Mexican crafts. Instead, he sharply and amusingly tells the reader his perception of the founder of wood carving (Barbash 1991:119):

> Manuel Jiménez is every bit the difficult artist. He is by his own account one of the greatest geniuses the world has ever seen. A master woodcarver, he commands prices four times that of his most expensive competitors. A reformed alcoholic, he lives behind a wall topped with shards of glass that overwhelms the adobe huts and open dirt patios of his neighbors. He is a self-proclaimed faith healer and prophet, and is convinced the world will end with the end of the century.

Oaxacan Wood Carving contains many such colorful portraits of woodcarvers, stories about their experiences, and descriptions of what the carving communities are like. After an introduction, subsequent chapters are called "Fiestas," "Nature," "Death," and "Superstition," with text and photos related to their themes. The chapter title which most obviously shows that this is journalism rather than ethnography, of course, is "Superstition." This short chapter tells about "folk beliefs and remedies" (Barbash 1993:104) and includes photos of carvings of devils, Nahuals (people who are said to make themselves into animals at night), and alebrijes.

The Barbash/Ragan publications make it crystal clear that the author and photographer regard the wood carvings as a recent market-driven phenomenon that is not fine art. Their take on the trade is perhaps stated most explicitly near the beginning of *Oaxacan Woodcarving* (Barbash 1993:14):

> Most of the people now carving began after 1985. Lacking the constraints and wisdom of a long artistic tradition, they rummage freely through the region's immense creative heritage, its jumbled culture of Indian and Spanish, Catholic and commercial, tourist and local. Motifs change monthly, driven by competition, the market's emphasis on novelty, and the carvers' own restlessness. Quality varies wildly, both among artisans and in the day-to-day work of individuals, and the magic is often serendipitous. Artisans—they almost never refer to themselves as artists—are the first to admit that they don't always know what they're doing or why a piece is deemed good. If it sells, they say, it's good. If it's big and it sells, then it's very good. (Clients pay by the centimeter.)

Ragan's photographs are at least as important as Barbash's prose in attracting readers to their publications. Most of the photos of carvings in these publications are of pieces Barbash and Ragan own. Even someone who knows little about picture-taking can see that the photos have been carefully, imaginatively, and thoughtfully composed. Ragan took many pictures of carvers and carvings while she and Barbash were in Oaxaca. The couple wanted to include some of these ethnographically interesting pictures in their publications. Although the *Smithsonian* article has a number of such photos, the editors at Chronicle Books for the most part preferred the more artistic shots from the Barbash/Ragan collection.

LOCAL COMMENTARY ON THE PUBLICATIONS

Artisans' comments on the Barbash/Ragan publications usually focus on the photographs in *Oaxacan Wood Carving.* Many carving families have been given this book by dealers. Artisans readily told me whose pieces are featured in *Oaxacan Wood Carving* and the kinds of carvings in the book's photos. Those artisans with pieces in the book take pride in their inclusion and often say that this sort of recognition encourages them to continue their work. Carvers without pieces in the book envy their neighbors whose work is featured.

Although artisans usually know if there is something written about them in *Oaxacan Wood Carving,* they often have only a vague idea about what the text says. Occasionally they attempt to decipher the English themselves; more often their information about the text comes from English-speaking visitors who have seen the book. Even those artisans who know what the text says about them may have little idea of what Barbash has written about anything else. For this reason, most do not say much about his depiction of local culture. Those who are willing to comment usually feel that the book gives a favorable portrait of their communities.

A few of the more thoughtful artisans remark on the difficulties outsiders have in learning about another place. The comments of one successful carver could have been made by a contemporary anthropologist contemplating the difficulties of ethnography. Rafael (a pseudonym) said that Barbash's book was 80 percent "true" and 20 percent "interpretation." He told me this while showing a sketch of a potential carving of a human with several heads. This sketch—simply labeled "a human"—made the point that people present one face in some situations and another face in different situations. Furthermore, no person can know exactly what is going on

within another's head. Rafael said that Barbash might have interpreted certain things incorrectly because of these aspects of human communication.

Promoters of ethnic arts, craft sales, and tourism around Oaxaca often have stronger opinions about the Barbash/Ragan publications than the artisans. Many intermediaries in the folk art trade applaud the attention given to the carvers and appreciate the lively text and superb photographs. Some regret that more attention was not given to artisans living in places other than the three main carving communities. Barbash's depiction of local culture draws diverse reactions. A large-scale dealer characterized *Oaxacan Wood Carving* as a "home run" and commended the attention to life in rural communities. (He also remarked that only 5 to 10 percent of the buyers of the book would pay attention to anything but the photos.) A Mexican guide, in contrast, thought that Barbash overstated the prevalence of "superstitions" in the region and objected in any case to his characterizations of local beliefs. Some dealers with "traditionalist" views are ambivalent about the publicity given to the wood carvings in the Barbash/Ragan publications. The traditionalists do not much like the wood carvings because they are not part of a long-standing indigenous culture, although they recognize that the *Smithsonian* article and *Oaxacan Wood Carving* promote interest in and purchases of all kinds of local crafts.

EFFECTS ON SALES AND STYLES

When I began my research in the summer of 1994, I learned from carvers and dealers that business was rebounding after a slump of several years. I thought that the Barbash/Ragan publications might have significantly influenced the demand for carvings. The artisans and types of pieces featured in the publications seemed to be popular, and many buyers visiting Arrazola and San Martín took along the *Smithsonian* article and *Oaxacan Wood Carving* as quasi-catalogs. Most people I talked to disagreed with my hypothesis. Artisans and dealers alike pointed out that business had picked up not long after the *Smithsonian* article was published and well before the book came out. The article and book had certainly given extraordinary amounts of publicity to the wood carvings and helped the business of particular artisans, especially in La Unión. But the effects of these publications should not be overestimated; even those carvers most prominently featured told me that they were only one of many factors affecting carving sales. The dollar-peso exchange rate, for example, significantly affects carving sales. While much of Mexico suffered during the devaluation of the

peso in 1994, the carvers prospered when their pieces became cheaper for buyers from the United States.

As the years have passed, the direct effects of the Barbash/Ragan publications on sales have diminished. Very few visitors to Oaxaca nowadays know about the *Smithsonian* article. The book is less often carried by dealers and displayed by artisans.

The *Smithsonian* article and *Oaxacan Wood Carving* have had unmistakable effects on the types of pieces artisans have made in recent years. Dealers and tourists have come to Arrazola and San Martín Tilcajete seeking out specific pieces shown in the Barbash/Ragan publications. The *Smithsonian* cover had a photo of a piece by Alejo Morales described as "an acrobatic armadillo . . . from a fanciful menagerie by Oaxacan woodcarvers." (Alejo Morales lives in a village on the road to Monte Albán. Armadillos resembling the one on the cover have come to be most closely identified with the Coindo Melchor family of San Martín.) A few years later a dealer's brochure advertised armadillos by Magdalena Méndez which were said to be "à la Smithsonian." Another dealer approached the Coindo Melchor family and tried to place an order for miniature versions of every piece featured in *Oaxacan Woodcarving.* They had neither the time nor the desire to do this and turned the offer down.

Some artisans now specialize in carvings that happened to be photographed by Ragan and selected for display in the article or book. The consistent production and sales of Ventura Fabián's dancing chickens and Leoncio Martínez's gorillas, for example, must be partly attributed to the inclusion of carvings by these San Martín artisans in Barbash's book. Furthermore, some of the pieces in the book and article have come to be regarded as emblematic of Oaxacan wood carving. Margarito Melchor's cats appear on postcards and T-shirts. Animal musicians similar to those on the back cover of *Oaxacan Wood Carving* (by Martín Melchor and Melinda Ortega) are also ubiquitous.

Carving families vary in the extent to which they have continued to make the pieces chosen for inclusion in the article and book. A few artisans have become so identified with the figures shown in the book that they have been successful making only minor modifications in their carvings. Most carvers find, however, that the best economic strategy involves experimentation with novel pieces alongside the production of carvings that are becoming "traditional" as the result of their inclusion in the article and book. Although dealers are interested in pieces featured in the Barbash/Ragan publications, they are also looking for carvings that will

appeal to collectors and gift-givers who are seeking something different. Furthermore, many artisans say they would become bored if they kept making the same pieces. Some artisans even seem slightly vexed when customers ask for pieces featured in the book. Epifanio Fuentes, who is prominently featured in *Oaxacan Wood Carving,* says that he can now make pieces that are much better than those shown in the book. He will make carvings similar to those shown in the book if a customer requests him to but would prefer to make something new.

Most carvers regard the diffusion of successful styles as inevitable. The increased demand for certain types of carvings in the Ragan/Barbash publications has led to their production by many artisans. For example, armadillos similar to the Alejo Morales carving on the cover of *Smithsonian* are made by several other artisans. Many cases of copying cannot so easily be attributed directly to the Barbash/Ragan publications. Carvers obviously will imitate only those pieces they think will sell well. The inclusion of a piece in the *Smithsonian* article or *Oaxacan Wood Carving* may have little to do with its salability. Carvings by Epifanio Fuentes and Manuel Jiménez, for instance, were in high demand and worth copying long before Barbash and Ragan were writing about and photographing them. In any case, the distinction between "copying" and making a piece that has come to be thought of as "typical" is not always clear-cut. Is the carver making an armadillo "à la Smithsonian" copying or producing something that is now "traditional"? Furthermore, because carvers and painters have distinctive styles, many alleged "copies" are quite different from the "originals." Few artisans agree with Manuel Jiménez's assertion that every wood carving made by other people in Arrazola is a "copy" of his work.

DISCUSSION

Some carvers have prospered via sales of pieces featured in the Barbash/ Ragan publications. Nonetheless, the article and book appear to have had only a minor direct effect on the overall sales of Oaxacan wood carvings from Arrazola and San Martín, the communities where most pieces are made. (The publications do seem to have had a significant effect on sales in La Unión.) The carving boom started before the Barbash/Ragan publications were written and continued after their influence had waned. These publications were much less relevant to wood-carving sales than the activities of dealers and the fluctuations of the peso. Barbash's writings and Ragan's photos, however, may have had an important indirect effect on

long-term wood-carving sales. When the wood carvings were first sold, they were denigrated by many ethnic arts dealers because they were not part of a long-standing indigenous culture. Only the work of Manuel Jiménez was generally recognized as a contribution to local artisanry. The *Smithsonian* article and the popular art book brought the carvings to the attention of hundreds of thousands of potential buyers in the United States and furthered the recognition of the wood figures as creative "folk art." By helping make Oaxacan carvings emblematic of the region, Barbash and Ragan have contributed to the invention of a tradition.

The effects of the *Smithsonian* article and *Oaxacan Wood Carving* on artistic styles have been more straightforward. Some carvings featured in these publications have been copied and modified by other artisans and come to be regarded as "typical" of the area. These pieces have been sold in large numbers to dealers from the United States and offered for sale on the Internet. Nevertheless, innovations remain important in the wood-carving business; many new artisans and styles have appeared since the publication of *Oaxacan Wood Carving.*

Contemporary anthropologists are often concerned about the reactions to their publications by the people they write about. Many ethnographers fear that their representations of local culture in text and photographs may be regarded as inaccurate or misleading by insiders. The popular journalism of the *Smithsonian* article and *Oaxacan Wood Carving* is easier to understand and more widely distributed than most publications by professional anthropologists. Although some artisans think that some of what Barbash has to say about local culture is not quite right, only a few have strong feelings about this aspect of his publications.

In contrast, everyone is interested in whose carvings are included in photographs in the article and book. This is partly because the English-language texts are largely inaccessible to the Spanish-speaking artisans. Moreover, many carvers take great pride in being recognized by outsiders after their pieces have been selected for inclusion in a widely read publication. I think, however, that the artisans' focus on the photographs can most directly be explained by straightforward economics. Artisan families know that the appearance of one of their carvings in a publication is likely to bring dealers and tourists to their door. This is much more economically important to them than a journalistic or ethnographic text about their lives and culture. A picture is literally worth a thousand words.

SALES IN OAXACA

The central square of the city of Oaxaca is said by some to be the most attractive zócalo in Mexico. This pleasant, green area is dotted with benches where people sit and listen to band concerts and itinerant musicians and watch an ever-changing panorama of craft vendors, balloons, food stalls, newspaper stands, enamored couples, relaxed tourists, and political protestors. The zócalo is ringed with cafes in which Oaxaqueños and tourists from Mexico City, the United States, and Europe sip coffee, drink beer, and eat tacos and local foods such as *mole* and *tlayudas* (large, crisp corn tortillas). During major tourist seasons the zócalo is especially lively, as the state and city sponsor musical performances, dances, and crafts exhibitions in and around the square.

The blocks north of the zócalo have many good restaurants, interesting shops, and moderately priced hotels. This area also includes the enormous Santo Domingo Church, several excellent museums, and the Camino Real, the most luxurious hotel in the city. Some of the biggest tourist attractions of Oaxaca are along a

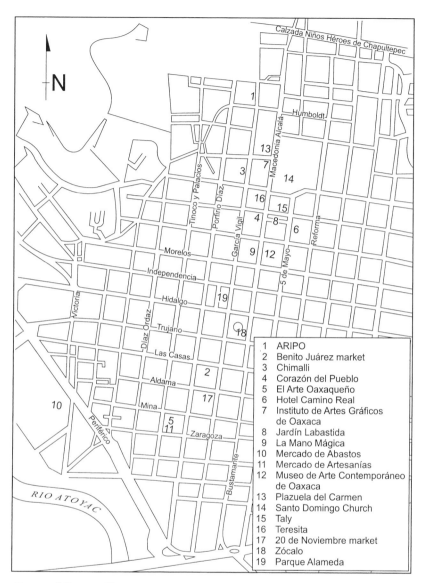

1 ARIPO
2 Benito Juárez market
3 Chimalli
4 Corazón del Pueblo
5 El Arte Oaxaqueño
6 Hotel Camino Real
7 Instituto de Artes Gráficos de Oaxaca
8 Jardín Labastida
9 La Mano Mágica
10 Mercado de Abastos
11 Mercado de Artesanías
12 Museo de Arte Contemporáneo de Oaxaca
13 Plazuela del Carmen
14 Santo Domingo Church
15 Taly
16 Teresita
17 20 de Noviembre market
18 Zócalo
19 Parque Alameda

Center of Oaxaca City.

street called Macedonia Alcalá (usually referred to in English as "the Alcalá") that runs north of the zócalo past the fine arts museum, the Santo Domingo Church, the historical and archaeological museum, and the graphic arts institute. Because cars are not permitted on most of the Alcalá, throngs of tourists stroll along the street between the zócalo and the Santo Domingo Church. It is hard to imagine a better place for a crafts shop.

Between 1989 and 1993 I went to Oaxaca most Christmases and joined the tourists walking up and down the Alcalá. On one of my later visits, I noticed a small shop called Teresita on the block south of the Santo Domingo Church. The shelves of Teresita were covered with excellent wood carvings of varied sizes, shapes, and prices. The owner, Víctor Vásquez, was an animated, friendly man in his early thirties who talked nonstop with the tourists and dealers who maneuvered around one another in the close confines of the store. By the time I began research in 1994, Teresita had the largest and most diverse selection of pieces in all of Oaxaca. The only other store in Oaxaca which specialized in wood carvings was Saúl Aragón's much smaller shop around the corner in Arte y Tradición. There were, however, many other stores north of the zócalo where tourists could find wood carvings. Just down the Alcalá from Teresita were two places with high-quality, expensive pieces. Corazón del Pueblo sold wood carvings along with books and a variety of other crafts. La Mano Mágica was principally a gallery selling paintings and fine rugs but also carried wood carvings by the best-known artisans in Arrazola and San Martín. Other stores in the area with fine collections of wood carvings included Mi México, Taly, Chimalli, and the state-run ARIPO (Artesanías y Industrias del Estado de Oaxaca).

Although tourists are most likely to buy wood carvings on the blocks north of the zócalo, there are many other places where pieces are sold. Stores selling carvings from Arrazola, San Martín, and elsewhere can be found south of the zócalo and in the middle-class Colonia Reforma section of the city. Vendors sell carvings on the zócalo, in parks around the city, and in several open-air markets. Many tourists, of course, purchase pieces during visits to Arrazola and San Martín.

SHOPS

Over the years different shops in the city of Oaxaca have been major purchasers of wood carvings. Stores that once bought many pieces have gone out of business (e.g., Salsa Picante, Casa Víctor) or decided to emphasize other crafts (e.g., Cocijo). Newer shops buying wood carvings have been established

(e.g., Corazón del Pueblo); older shops have changed their focus to wood carvings (e.g., Teresita). Only a few stores (e.g., El Arte Oaxaqueño, Chimalli) have sold large numbers of wood carvings for several decades. Yalálag, the store that is perhaps the most important in the history of the wood-carving trade, is a special case. Although the store went out of business under the name "Yalálag" in the mid-1990s, a successor now operates in a different location under the name "El Patrón." Wood carvings were only a minor part of the business of both Yalálag and El Patrón during the 1990s.

The owners of the various crafts stores differ in the ways in which they have been involved in the wood-carving trade. Some have restricted their activities to buying pieces from artisans and selling them to customers. Most have in addition acted as intermediaries for wholesalers, store owners, and collectors. They may take orders from customers, travel to wood-carving villages to buy pieces, and pack and send carvings to the United States and elsewhere.

Just as the wood-carvers establish market niches through their production strategies, the store owners establish niches within the retail and wholesale markets centered in the city of Oaxaca. The varied niches that crafts stores occupy in the wood-carving trade can best be understood by a brief examination of the economic activities of several shops. These stores differ in the extent to which they specialize in wood carvings, the scale of their operations, and the quality of their pieces. They also vary in the extent to which the owners act as intermediaries for wholesalers, store owners, and collectors.

TERESITA

When Víctor Vásquez took over a watch repair store on the Alcalá from his father in the late 1980s, he saw tourists stream by the shop every day. Víctor had considerable empty space in the store and decided to earn extra money by selling crafts to passers-by. He began in 1990 with clay figures but soon added wood carvings. After Víctor got his first pieces from Pepe Santiago's large workshop in Arrazola, he started to buy carvings from other places. Business improved greatly after one of the Blas brothers from San Pedro Cajonos dropped by the store to offer pieces for sale. The Blas pieces sold very well, and Víctor saw that high-quality wood carvings were a worthwhile investment. He stopped buying clay figures and focused exclusively on wood carvings. While Víctor continued to repair watches, this became a sideline done in his spare time.

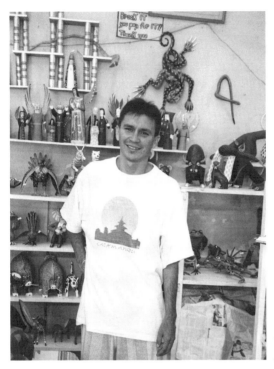

Víctor Vásquez in Teresita.
Michael Chibnik.

Teresita's superb location is obviously one reason why the shop has prospered. Because almost every tourist who comes to Oaxaca walks along the Alcalá, Víctor has no trouble attracting people to his shop. Nevertheless, Teresita's prosperity must be attributed primarily to Víctor's energy, imagination, artistic eye, charm, and good business sense. Because he learned to speak English fairly well during several years in the United States in the early 1980s, he can communicate with his many customers who speak little or no Spanish. Many wholesalers and store owners from the United States who do not speak Spanish well pay Víctor to be their intermediary. They send him orders for pieces, which he buys and ships to the United States. Even dealers who speak Spanish well often work with Víctor. Although dealers could buy pieces more cheaply from carvers, they save a lot of time by buying through Víctor. Furthermore, some dealers who regularly buy pieces directly from artisans in San Martín and Arrazola purchase carvings from San Pedro Cajonos and La Unión from Víctor.

When Víctor began dealing carvings, most of his sales were to tourists dropping into the shop. By 1995 he was earning approximately half of his income from tourists and the rest from dealers. By 1998 Víctor estimated

that three-quarters of his income came from dealers. Moving around his tiny shop had become even more difficult because there were inevitably one or two large baskets (*canastas*) packed with carvings ordered by dealers that Víctor would soon send to the United States.

The prices in Teresita are only modestly higher than those in the carving villages. Pieces that sell for 70 pesos in San Martín, for example, typically cost about 110 pesos in Víctor's shop. Furthermore, he often gives discounts of 10 to 20 percent to regular or even occasional customers. Because of this low markup, Víctor cannot offer as much for high-quality pieces as upscale dealers from the United States. Although Víctor carries some pieces by well-known artisans such as María Jiménez and Margarito Melchor, he could not until recently compete with high-end dealers for the work of the most noted carvers in Arrazola and San Martín. Nevertheless, Víctor has found over the years that he can make more money selling relatively expensive pieces than he can by selling cheap carvings. He therefore is constantly looking for high-quality pieces by artisans who are not yet famous (e.g., Eleazar Morales of Arrazola) or live in relatively inaccessible places that dealers may be reluctant to visit (e.g., the Blas brothers, Luis Pablo, Agustín Cruz).

As dealers became more willing to buy directly from artisans in Arrazola and San Martín, Víctor increasingly stocked his store with pieces from other places. He has many pieces from San Pedro Cajonos, La Unión, and the city of Oaxaca. Every time I go into Teresita, I see pieces from new places where a few people are experimenting with carving. Usually these experiments fail, but Víctor is always willing to see if something new will sell.

By summer 2001 Teresita had become significantly more upscale. Víctor was selling larger, more expensive pieces by artisans from Arrazola and San Martín whose work he was previously unable to afford. Most of these were bought by wholesalers from the United States and Mexico, who would stop by the store and place orders for large numbers of pieces. While most of these dealers continued to buy directly in Arrazola and San Martín, they appreciated Víctor's eye for interesting pieces and the time saved by making some purchases of wood carvings in the city of Oaxaca.

LA MANO MÁGICA

Mary Jane Gagnier Mendoza began buying carvings from Arrazola and San Martín during the 1985–1990 boom. She is a Canadian married to Arnulfo Mendoza, a noted rug weaver from one of the wealthiest families in Teotitlán

del Valle. Mary Jane and Arnulfo run La Mano Mágica, perhaps the most upscale gallery in the city of Oaxaca. La Mano Mágica is in an attractive stone building on the Alcalá near the Museum of Contemporary Art. Paintings from the best-known artisans of Oaxaca—often in a colorful, magical-realist style—hang on walls in two rooms alongside Arnulfo's prize-winning rugs. Another part of the gallery is dominated by a large loom, where Arnulfo weaves. The paintings and weavings are expensive, ranging from several hundred U.S. dollars to as much as five thousand dollars. La Mano Mágico is a social center for the elite artistic community of Oaxaca, both local and foreign, and often hosts openings, benefits, and auctions.

La Mano Mágica has been in business, although not always in its current location, since the late 1980s. One room in the gallery sells local folk art, postcards, and magazines. As might be expected, everything in the room is of excellent quality and quite expensive. There are more wood carvings than any other craft. Because La Mano Mágica attracts wealthy customers, Mary Jane can charge high prices for wood carvings. In June 2000 there were several pieces selling for more than 1,000 pesos (US$100) and a Nahual (a combined human/animal figure) by Moisés Jiménez (grandson of Manuel) was priced at 4,875 pesos. The most expensive carving in Teresita, in contrast, was a raccoon by Luis Pablo at 1,000 pesos. Furthermore, a carving that sells for 300 pesos at Teresita is likely to cost 500 pesos at La Mano Mágica. But such a comparison is artificial since few artisans sell to both Teresita and La Mano Mágica. Most artisans with pieces at La Mano Mágica rarely sell their carvings to other shops in the city of Oaxaca. Although these carvers (e.g., Moisés Jiménez, Narciso González, Jesús Sosa) ordinarily sell their work to dealers from the United States, La Mano Mágica pays well enough for them to be willing to display their pieces in this prestigious space.

CORAZÓN DEL PUEBLO

In the early 1990s a two-story crafts store opened on the Alcalá a few doors down from Teresita. Corazón del Pueblo carried high-quality ceramics and wood carvings as well as the best collection of English-language books in the city. The store was run by Henry Wangeman from the United States and his Mexican wife, Rosa Blum Pérez. Corazón del Pueblo occupied part of a large building that included a good restaurant and numerous other enterprises. Customers wandering in from the Alcalá were most likely to spend time in a large room on the ground floor, which was mostly devoted to crafts. The smaller room on the second floor, which had both books and

crafts, was harder to find and less crowded. In 1999 the owners decided to emphasize books more. The most visible sign facing the Alcalá was changed from "Corazón del Pueblo" to "Amate Books," and the first-floor room became a superb English-language bookstore with a few crafts for sale. The second-story room retained the name "Corazón del Pueblo" and carried a fine collection of wood carvings and ceramics.

Henry Wangeman sold what he calls "ethnographic art" in the United States during the 1980s and early 1990s. After starting out in Seattle, he moved to Berkeley, California, where the market for ethnic arts and crafts was better. His business in Berkeley, which was called Tzintzuntzan (after a town in the state of Michoacán in Mexico), prospered. Henry had seven employees and a large catalog business. He brought four artisans a year to the store to give exhibitions.

When Henry started his business, he saw himself as selling "ethnographic art" in general and in particular pieces that had a "traditional" role within a culture. Since the wood carvings were a new craft, he did not find them very interesting. Over time, however, Henry came to appreciate their humor and art. He also saw that they sold well. During the 1980s Henry worked especially closely with the carvers in La Unión, and his purchases had a considerable influence on the development of the craft there. He and Rosa continue to have close relations with some artisan families in La Unión and have employed members of carving families from that community at their store. In the early 1990s Henry and Rosa moved to Oaxaca and set up Corazón del Pueblo. Although Henry is no longer connected with Tzintzuntzan, he has continued to work as a wholesaler and has a large warehouse in the city of Oaxaca.

In 1997 Henry told me that wood carvings had the widest appeal of any craft sold at Corazón del Pueblo. They were liked by both people who were artistically conservative (I found this surprising) and those who appreciate unusual pieces. The many different types of wood carvings meant that there might be something in the shop that would appeal to any particular customer. Henry emphasized the fun and brightness of the carvings and said that some of them were almost "Hallmarky."

Although all the wood carvings in Corazón del Pueblo are high-quality, their prices vary greatly. Both casual tourists seeking inexpensive gifts and serious collectors can find carvings they like in the store. The hypothetical carving that cost 300 pesos at Teresita and 500 pesos at La Mano Mágica might sell for 400 pesos at Corazón del Pueblo. The average price of a carving at Corazón del Pueblo is somewhat higher than that at Teresita but

much less than the average price at La Mano Mágica. Corazón del Pueblo carries by far the best selection of carvings from La Unión. The shop is the only place in the city where one can find expensive, multipiece sets made by the Santiago family that depict weddings, rodeos, churches, kiosks, fruit sellers, musicians, and courting couples.

Corazón del Pueblo plays an important role in providing publicity for Oaxacan folk art. Henry and Rosa have arranged several exhibits of carvings and other local crafts at the museum of popular arts in San Bartolo Coyotepec. In 2000 Ramón Fosado was hired to manage Corazón del Pueblo. Ramón had previously owned Casa Víctor, one of the oldest ethnic arts stores in Oaxaca, and was knowledgeable about diverse local crafts. In summer 2001 Ramón and Henry were planning a permanent exhibit of pieces from La Unión for a new museum in Ocotlán. (This museum is associated with the late Rodolfo Morales, a famous and beloved artist from Ocotlán.)

TALY

Angela García Hernández has run Artesanías Taly since 1961. In 2000 Taly was the one of the two oldest craft shops in the city of Oaxaca. For some years this attractive, two-room store had been a block east and several blocks

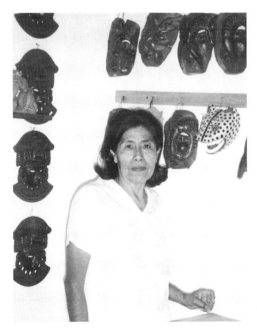

Angela García in Taly.
Michael Chibnik.

north of the Santo Domingo Church. Although this was not a bad location, Angela thought that she would get more drop-in business if the shop were nearer the principal tourist attractions. In early 2001 she moved to a better location on Cinco de Mayo near the Santo Domingo Church and a block away from the Camino Real hotel.

Before founding Taly, Angela worked in a government office and a jewelry store. She has always been interested in crafts, partly because her ethnic background exposed her to a variety of indigenous arts. Her father spoke three indigenous languages as well as Spanish, and her mother was Mixe. Angela liked to sew and embroider, and the work in the jewelry store made her interested in silverware and other ornamental metalwork. She is a lively, friendly woman with good business sense and an eye for extraordinary crafts.

When Angela founded Taly, she sold more textiles than anything else. Sales of clothing were particularly good between 1966 and 1980, when huipiles were very popular. In the 1980s Angela sold fewer textiles and was forced to seek out other crafts for the shop. While the market for textiles has recovered somewhat, Taly still sells fewer clothes and weavings than in earlier years. This is a disappointment to Angela, who greatly enjoys making and selling clothing.

Angela began buying wood carvings from San Martín during the 1970s. She was familiar with the community because of its embroidered blouses and dresses. At first Angela bought masks from carvers in San Martín, but she soon started buying other types of wood carvings. Over the years, wood carvings from varied places have become an important part of her business. She sells only high-quality carvings and has few cheap pieces. The average price of her pieces is probably higher than in any shop other than La Mano Mágica. The carvings at Taly are fairly priced, however, and Angela's markups seem no greater than those at Teresita.

The items that sell the best in crafts stores are not necessarily those that the owner is most interested in. The sign outside Taly in July 2000 said (in Spanish): "Typical Regional Products—curios, dresses, skirts, sandals, crockery, tablecloths, sarapes." Although this indicates how Angela thought about her store, she reported that Taly made the most money from tinware, followed by antique clothing and wood carvings. She had just bought some fine ceramics by members of the Aguilar family of Ocotlán and was hoping that they would sell well. Such direct sales are not the only way in which Angela makes money. She also packs and ships crafts from Taly and other stores.

When I have visited Taly over the years, there have usually been only twenty to thirty carvings for sale. Angela stocks somewhat fewer carvings

than La Mano Mágica and many fewer than Corazón del Pueblo and Teresita. Although the quality of carvings at Taly is unusually high, the number for sale is rather typical of crafts stores in Oaxaca. Wood carvings are only one of many crafts sold there. If the demand for wood carvings dropped precipitously, most craft shops in the city would continue to thrive.

EL ARTE OAXAQUEÑO

In 1961 Nicodemus Bastulo Vásquez left Yalálag and established El Arte Oaxaqueño. At the turn of the twenty-first century El Arte Oaxaqueño was the only craft store in the city of Oaxaca that had been around as long as Taly. The shop has always been located several blocks south of the zócalo on Mina, a heavily trafficked commercial street. While this location is not as good as those of stores along the Alcalá, many tourists nonetheless pass by El Arte Oaxaqueño every day. The store is next to the Artisans' Market and not far from several chocolate shops, the Benito Juárez market, and the 20 de Noviembre market. Tourists also walk by Nicodemus's shop on their way to the Abastos market (the biggest in the city) or the hotel where buses leave for Monte Albán.

Nicodemus is a soft-spoken man from Yalálag, a Zapotec-speaking mountain town. He has a great appreciation for the history and culture of the state of Oaxaca and likes crafts that can be linked to longtime customs. He is, however, not opposed to innovation and has often suggested new ways of making crafts to the artisans he buys from. Nicodemus has always preferred to work with artisans with whom he has exclusive contracts.

El Arte Oaxaqueño consists of five rooms crowded with a variety of crafts. Although the great majority of the pieces in the store are new, they often have the appearance of antiques. Most of what Nicodemus sells is inexpensive and—because of the exclusive contracts—cannot be found in other stores in Oaxaca. The crafts in El Arte Oaxaqueño look much more like "simple folk art" than those of the other stores profiled here. Some of the wood carvings in El Arte Oaxaqueño barely resemble the invented tradition that developed during the 1985–1990 boom. These masks, religious figures, and toys have been made by artisans in the city of Oaxaca for many decades. Such carvings, which are sometimes said to be the predecessors of the pieces now made in Arrazola and San Martín, resemble certain early work of Manuel Jiménez and Isidoro Cruz. They do not, however, look anything like the contemporary work of anyone in the wood-carving villages, including Manuel and Isidoro.

The rest of the wood carvings in El Arte Oaxaqueño are in the La Unión rustic style. These simply carved wooden animals are usually painted in one or two solid colors. Most carvings in the store are painted with aniline, which Nicodemus prefers to acrylic. Although Nicodemus sells some carvings from Arrazola and San Martín, he does not particularly like the complex carvings and elaborated painted decorations of most pieces from these villages. Even the simplest pieces from these villages are painted with acrylic and are not rustic enough for Nicodemus. He therefore buys many carvings from La Unión that resemble those that Martín Santiago began making in 1967. Nicodemus has also contracted with various carvers from Cuilapan (not far from Arrazola) who make pieces that are perhaps even more rustic than those from La Unión.

Nicodemus's purchases of wood carvings are clearly guided in part by his personal taste. Nonetheless, they are part of an overall economic strategy that has enabled El Arte Oaxaqueño to fill a distinctive niche among craft shops in the city. Nicodemus does not have the capital to compete for high-quality wood carvings with the owners of La Mano Mágica and Corazón del Pueblo. However, his exclusive contracts enable him to sell pieces that cannot be found at these and other stores. In summer 2000 wood carvings were second best-selling craft in El Arte Oaxaqueño (behind tinware).

THE MIXE WORKSHOP

Perhaps the most distinctive wood carvings in the state of Oaxaca are made by Mixe speakers, originally living near Ayutla. I first learned about Mixe carvings in June 1996, when I saw a few unusual carvings in Teresita. According to Víctor Vásquez, these graceful, fragile pieces were made by Mixe speakers who lived near Ayutla. The Mixe peacocks, giraffes, birds, dragons, and lizards did not resemble any other carvings I had seen. They had smooth curves that looked very difficult to make by hand and were made of cedar rather than copal. The Mixe pieces were not cheap, selling for the equivalent of US$10 to $50 in Teresita. When I asked about the possibilities of my going to see the makers, Víctor suggested that this would be difficult. The carvers lived in a remote area, he said, and were enmeshed in obscure political struggles. The makers had previously worked in some sort of factory making wood carvings that had closed down as a result of these problems. They might not be all that friendly to strangers.

When I returned to Oaxaca on a later fieldtrip in January 1998, one of the first things I did, as usual, was to walk over to Víctor's shop. His place

was filled with the Mixes' distinctive pieces. Víctor told me that a group of Mixes had set up a large workshop near the city of Oaxaca, where they made wood carvings using a variety of machines. The workshop was run by Noel Martínez, a Mixe entrepreneur who had been in charge of the Ayutla factory. Through my connections with Víctor, I was able to visit the Oaxaca workshop several times and learn about its history from Noel.

James Baker, a wholesaler from San Diego, California, who was living in Oaxaca, came to the Ayutla area around 1983 looking for crafts. He hired Noel as his driver for his trips to the scattered Mixe communities. Baker wanted to buy large quantities of pottery and often had a hard time finding enough pieces. Noel therefore set up a small enterprise in which he hired Mixes to make large pots (*ollas*) which were sold to Baker. When Baker left Oaxaca around 1985, Noel and his employees lost their only client. Noel's factory began making wood carvings. Around 1989 Noel reached the conclusion that the Mixes could compete better with artisans from Arrazola and San Martín by speeding up production by mechanizing some of their carving. The mechanization also enabled the Mixes to create curves in their pieces which could not be made by artisans carving only with hand tools. The mechanized Mixe pieces were thus quite distinctive and sold well. The number of Noel's employees, originally 15, reached 110 at one point. Tribus Mixes (the name Noel gave his enterprise) sold some pieces to a shop in Oaxaca (Chimalli) but conducted most of its business directly with dealers. The wholesalers and store owners rarely went to Ayutla, which is off the beaten track and a little difficult to get to. Instead, the dealers would send messages to Noel, who would meet them in Oaxaca.

Tribus Mixes ran into difficulties in Ayutla around 1994 (the "political struggles" Víctor had alluded to), and Noel moved to Mexico City for a while. In my conversations with him, Noel spoke little about what the problems had been, referring obliquely to local jealousy of his success and conflicts over loans. In any case, in 1996 Tribus Mixes resurfaced in the city of Oaxaca. About forty Mixes moved with their families to work in the new location. Although most of the employees in Oaxaca have been Mixes, Noel has begun to hire non-Mixes as well.

Noel runs two workshops, one in the center of Oaxaca and the other on the outskirts of the city in a place called Viguera. I visited Noel in Viguera, where he lives and has his office. About twenty painters, mostly women, work in Viguera; at the other workshop about twenty men carve using thirty or so different machines. When I talked to Noel in February 1998, he was considering buying bigger machines which would enable greater produc-

tion. At the time, the carvers were making 300 medium-sized pieces per day; the new machines would enable them to make 800 pieces a day. I commented that this would not make painting any faster, and Noel agreed that he would have to hire more painters if he decided to buy the new machines. According to Noel, the use of machines has not led to standardization of pieces. While many pieces are carved identically, each one is painted differently.

Most of Noel's sales are within Mexico. Tribus Mixes sells many pieces to state (ARIPO) and national (FONART) buying organizations and even more to Mexican wholesalers and store owners. They also have a number of customers in the United States. An increasing number of dealers and tourists who learn about the Mixe pieces through the large ARIPO store in Oaxaca now visit the shop in Viguera. Noel is very pleased about the move to Oaxaca because he can much more easily keep in contact with his current customers and attract new ones.

The Tribus Mixes carvings are aimed at the high end of the market. Prices at the Viguera workshop in 1998 mostly ranged between 300 and 800 pesos (US$35 to $90). The cheapest pieces in the shop were 70-peso orange mosquitos which Noel makes in coordination with artisans from San Pedro Cajonos. The mosquitos are carved by Tribus Mixes and painted by members of the Blas family. Aside from the Blas pieces, the least expensive carving in the shop was a 200-peso deer; the most expensive was an ornate 3,500-peso peacock that had been specially ordered. Since I have occasionally seen Mixe carvings selling for less than 200 pesos at Víctor's shop, Noel's workshops obviously make other relatively inexpensive pieces.

The Tribus Mixes have prepared a bilingual flier that is displayed at the workshop and the ARIPO store in Oaxaca. Despite the care with which Noel markets his pieces, the English version is an awkward translation from Spanish:

Within the hills of Oaxaca, the mixes tribes have managed the way to survive along with other cultures, preserving their spirit and most profound traditions. With their hands, mixe people carve and decorate magically the cedar and crooked wood artifacts. The constant living through centuries, with the jungle forests, where the different colors of nature mix, has given the inspiration and encouraged imagination to become beautiful representations of the mixe world and legend. This is the way the mixes tribes from Oaxaca bring together their historical responsibility and the need of surviving, along with the com-

promise of maintaining the ecological balance, developing a positive enterprise that solves production obstacles with creativity. One of the most antique mesoamerican cultures shares with the world its high plastic expression, gained through the experience of living with nature and wisely solving their way of living.

I have reproduced this blurb verbatim because it shows well what Noel thinks will attract buyers for his carvings. The emphasis is on the indigenous origin of the artisans, their connections with nature, and their imaginative, magical ways of representing legends. Nothing is said about how the carvings are made by machine in a factory in a city.

SALES ON THE STREET AND IN SQUARES AND MARKETS

Many visitors to the city of Oaxaca first see wood carvings in the zócalo. Vendors of various crafts sit on the ground with their wares, hoping to attract the attention of tourists. The vendors are more than willing to bargain while quietly hawking their mostly inexpensive, low-quality pieces. The number of vendors of wood carvings and other crafts in the zócalo increases greatly during the major holiday seasons. Wood carvings are also sold in other public spaces in the city where tourists are likely to go. There are wood-carving stalls at the Artisans' Market, the Benito Juárez market, and two small squares north of the zócalo. The two weekly markets that tourists are most likely to visit outside of the city—Ocotlán on Fridays and Tlacalula on Sundays—have stands selling wood carvings. Vendors occasionally sell wood carvings along the streets north of the zócalo. Such selling is technically illegal but is only sometimes prohibited. Two families from a sierra (highland) village two hours north of Oaxaca come weekly to sell their dinosaurs, monkeys, and other animals made from the wood and cones of pine trees. Another artisan, Francisco Tenorio Reyes, regularly makes a ten-hour trip from a Mixtec village near the Pacific Coast (Santiago Coyocan de Flores) to sell tiny guitars and exquisitely carved unpainted animals on the street and to shops.

Few wood carvings are sold in the gigantic Abastos market. Every guidebook to the city of Oaxaca urges tourists to visit the teeming, colorful Abastos market on Saturdays. Despite the guidebooks' recommendations, the market is not particularly tourist-friendly, consisting of a maze of stalls and crowded passageways. The Abastos can be very hot and has disagreeable odors in places. Even though tourists often visit the market, they rarely

stay there long unless they get lost in the labyrinth of stalls. Because the Abastos market is not oriented toward tourists, there is only a relatively small section selling crafts. The few wood carvings that can be found at the Abastos market are of low quality.

Sales in the streets, squares, and markets of Oaxaca are only a small part of the wood-carving trade. Most of the pieces sold in the square are made by artisans living in places other than the principal carving villages. Most of the vendors are merchants from the city of Oaxaca who make few or none of the pieces they sell. They nonetheless often tell tourists that they are from Arrazola or San Martín and claim to have made the pieces being displayed. There are, however, certain vendors from San Martín who regularly sell in the squares and markets, especially during holiday seasons. The two brief profiles that follow of vendors in the city indicate a few of the complications of selling in streets, squares, and markets. My presentation barely touches on the morass of regulations, political maneuvers, and long-standing customs affecting sales in markets and other public spaces in Oaxaca (Todd 1998).

MIGUEL DÍAZ AND MANUEL DUARTE

When I first began studying the wood-carving trade, I noticed that the same vendors would turn up at different places. A man I saw selling wood carvings in the Abastos market one day would be staffing a stand another day in the Jardín Labastida (across from the local state university a few blocks north of the zócalo) and be in the Tlacalula market on a subsequent Sunday. After a while I figured out that there were at least two families that I would regularly see selling carvings in different places. I eventually learned that the people I recognized were the families of Manuel Duarte and Miguel Díaz. Although I have had only brief conversations with Manuel, I have talked at some length with Miguel.

Manuel Duarte and Miguel Díaz are compadres who live in San Pedro Ixtlahuaca, a community that adjoins Arrazola and is not far from Monte Albán. Most San Pedro families support themselves through a combination of farming and wage labor. Several decades ago Manuel Duarte decided to supplement his income by making wood carvings, which he sold in the markets in Oaxaca. In 1989 Miguel Díaz, who had previously worked as a helper for a mason, learned how to carve from Manuel and began selling in Oaxaca. Miguel and Manuel also purchased pieces from various artisans, which they later resold in the city.

When I met Miguel in 1995, he appeared to be in his mid-fifties. He and his oldest son carved figures; his wife, Fidela, daughter, and younger son painted pieces. Miguel continued to raise two hectares of corn during the rainy season. There were about six families carving in San Pedro Ixtlahuaca at this time. They sold pieces in the Abastos market, the Jardín Labastida, the Plazuela de Carmen (north of the Santo Domingo Church), and the Sunday market in Tlacalula. The San Pedro Ixtlahuaca pieces were of middling quality and ranged in price from 10–20 pesos to 800 pesos (about US$125). Most carvings sold for 20–40 pesos. Although the great majority of sales were to tourists, Miguel, Manuel, and the other families from San Pedro Ixtlahuaca occasionally sold to wholesalers and store owners. In 1997 Manuel Duarte abandoned his stall in the Abastos market and worked mostly at home. His family sold his pieces at the various markets and squares. Miguel Díaz and his family continued to sell wood carvings at the usual places during most of the year throughout the 1990s. During Christmas, Guelaguetza, and Semana Santa they moved down to the Alameda, the square adjoining the zócalo.

Artisans who wish to sell their products in a market, square, or other public space must be union members. Unions are subdivided into groups, which have leaders who negotiate for space from the city and allocate spots to members. The whole process is intensely political, and it is not easy for artisans to gain access to good spaces. Although I was unable to find out how Miguel and Manuel gained access to their spots, I do know that Miguel was paying the union about 20 pesos a day in 1996 for his regular space at the Plazuela del Carmen.

RICARDO LÓPEZ

In late July 1997 I walked over to the zócalo to look at the sales of carvings there during the Guelaguetza. I was accompanied by Amy Todd, a graduate student in anthropology at Brandeis University carrying out doctoral research on the politics and economics of markets in the city of Oaxaca. One stall with an exceptionally large number of wood carvings was staffed by four men from San Martín. We talked briefly with one of these men, Ricardo López (a pseudonym), about market organization during the Guelaguetza.

The Guelaguetza is a two-week celebration of the art, music, and dance of the state of Oaxaca. This government-organized festival is organized around two dance performances that take place on successive Mondays (lunes de cerro) at the end of July in a large, open-air auditorium on a hill

that looks over the city. Because many of the tickets to the performances are expensive (as much as US$25–$40), the audience consists mostly of tourists. While people come from all over the world to Oaxaca for the Guelaguetza, it is primarily a national celebration, and most of the visitors to the city during this time are from Mexico City. On the two lunes de cerro, the area around the auditorium is crowded with vendors selling food, drink, and crafts. During the week between the dance performances on the lunes de cerro, there are many other cultural events that take place in the city. Amy knew that there were about a thousand vendors near the auditorium on the lunes de cerro and asked Ricardo why he had not tried to sell carvings there. He said that the leader of his group had not been able to get permission to sell near the auditorium. Instead, the leader had gained access to good space on the zócalo.

Because Ricardo was busy selling at the square, Amy and I were not able to talk to him at length during the Guelaguetza. However, I was later able to interview Ricardo in more comfortable circumstances in San Martín. He is a short, muscular man who began carving at the age of twenty-seven in 1994. Ricardo said that the great majority of pieces that he sold at the zócalo were made by himself and his wife, Elena (another pseudonym). Ricardo, who does not farm, splits his work time between wage labor in construction and carving. He is a skilled mason who in early 1998 was able to earn 60 to 80 pesos per day (US$6.50–$9). He estimates that his income from masonry is approximately equal to what he makes from wood carving.

Ricardo sells the great majority of his family's pieces during Christmas, Semana Santa, and Guelaguetza. He belongs to one of the groups from San Martín whose directors obtain vending space from the government. Ricardo's group had twelve members. In 1997–1998 each member paid the director 10 pesos per day for space on the zócalo.

In Christmas 1997 Ricardo and Elena earned about 5,500 pesos in fifteen days from selling wood carvings in the zócalo. Assuming an average price of 60 to 70 pesos per piece, this suggests that they sold five to seven pieces per day. Ricardo and Elena obviously spent a lot of time sitting around the zócalo without much business. They sold from nine in the morning to nine at night, commuting from San Martín each day. On a typical day, they average a sale every two hours.

The figures from Christmas allow an estimate of the income of Ricardo and Elena's family from wood-carving sales. They sell in the zócalo about twenty-eight days during the year. If their average daily sales at other holiday seasons are the same as during Christmas (about 350 pesos per day),

this suggests a yearly gross income from wood carving of about 9,800 pesos (about US$1,200). I do not know how many of the carvings that the family sold were made by other artisans. Ricardo, like most other wood-carvers in San Martín, does not like to talk about the reselling of pieces.

SALES TO TOURISTS IN CARVING VILLAGES

Casual visitors to Arrazola or San Martín often understandably think that sales to tourists are essential to the prosperity of these villages. Many houses have colorful signs in English indicating that wood carvings are for sale. As visitors walk down the streets, men, women, and children ask if they want to buy pieces. When tourists show any interest at all, they are invited inside houses where pieces are neatly displayed on shelves. The wood-carvers cheerfully pose for pictures and show photos given to them by previous tourists. They are usually willing to talk at length to Spanish-speaking visitors about how they make pieces, about life in the villages, and about friends and relatives in the United States.

Thoughtful visitors to Arrazola and San Martín might make observations suggesting that sales to tourists are of limited importance. Even in Arrazola, the most tourist-friendly of the carving villages, artisans frequently tell visitors that particular pieces on display are unavailable because they are part of an order for a dealer. Tourists in Arrazola, moreover, are concentrated on a few streets near the center of the village. Visitors walking even a few blocks from the plaza see few signs and fewer tourists. Although some tourists visit San Martín almost every day, they are much less common than in Arrazola. A visitor to that community can walk around for several hours at the middle of the day without seeing another tourist.

When questioned, most artisans in Arrazola, San Martín, and even La Unión say that they sell some pieces to tourists. It took me a while to learn, however, that wood-carving families often do not distinguish between tourists and store owners. They ordinarily classify buyers as either dealers (*mayoristas*) or tourists. Store owners who buy several pieces are usually regarded as tourists unless they come back several times. Repeat visitors who buy small numbers of pieces are usually classified as either collectors (a different category from "tourists") or store owners. (A few artisans from whom I have bought pieces over the years are convinced, despite my explanations, that I have a small business selling carvings.)

While sales to tourists may not be as important as many casual visitors to carving villages assume, they nonetheless are important sources of in-

come to a number of families in Arrazola and San Martín. Some tourists arrive in organized tours in buses or vans; others drive their own or rented cars to the villages or take taxis from the city of Oaxaca. Only a few take public transportation. Some tourists have the names of artisans they want to see; most, however, know very little about the craft, the carvers, and the communities.

Many visitors to Arrazola are on an inexpensive organized bus tour that leaves the city of Oaxaca every Thursday. This five-hour tour also includes the Zaachila market and an old monastery in Cuilapan. The members of the tour are a mix of nationalities, including many Mexicans. Organized tours to San Martín, in contrast, are usually parts of packages that include air transport, lodging, and visits to archaeological sites and craft villages. The cheapest of these tours typically involve a bus that stops in front of a large operation near the school in the center of San Martín. Passengers have about fifteen minutes to explore this shop, which consists of several rooms of pieces, and any other places they can get to in their brief stay. Since these workshops mostly sell inexpensive carvings made in San Pedro Taviche and painted in San Martín, these tourists rarely see high-quality pieces or noted artisans.

In the late 1990s some roads were improved in San Martín, making it easier for buses to get to a part of town where a number of the better-known wood-carvers live. Some buses began to stop in front of Epifanio Fuentes's house. Passengers would reboard the bus several blocks away nearer the center of town at an intersection not far from the houses of Inocente Melchor, Roberto Matías, Jesús Sosa, Jacobo Angeles, Leoncio Martínez, Isidoro Cruz, and other talented artisans. Tourists taking these buses had the opportunity to see some of the best carvings in San Martín. However, their limited time in the community usually meant that they only had time to look carefully at pieces at Epifanio Fuentes's workshop and perhaps one or two other places.

A few of the best-known wood-carvers in San Martín arrange demonstrations and exhibitions in their workshops for tour groups especially interested in crafts. These tours are often associated with art museums in the United States. Carvers such as Epifanio Fuentes, Isidoro Cruz, Jesús Sosa, and Margarito Melchor have developed connections over the years with both the leaders of the tours and the owners of the hotels (e.g., Casa Colonial, Posada de Chencho, Hotel Victoria, Hotel Misión del los Angeles) where the groups stay. The carver hosting an exhibition often invites other artisans to show their pieces. Such invitations are coveted since participants

in these tours appreciate crafts and often spend a lot of money at the shows. Although such expositions usually result in good sales, only a small minority of artisans have the opportunity to participate in them.

An exposition at the house of Isidoro Cruz in March 1998 illustrates well what these shows are like. Isidoro has worked since the 1970s with his compadre Raoul de la Sota, a Los Angeles–based tour operator. Raoul sent Isidoro a letter saying that he was arriving with a group sponsored by the Southwest Museum of Los Angeles. Isidoro then arranged an exposition to which he invited numerous other artisans and some craft dealers from the United States. The wood-carvers invited to the exposition were mostly artisans who had been making pieces since the 1970s. They included Justo Xuana, Epifanio Fuentes, Xenén Fuentes (Epifanio's father), Coindo Melchor, and Inocencio Vásquez. Besides the carvers, Isidoro invited some female weavers from the nearby community of Jalieza. Although the wives of the male wood-carvers were at the exposition, they did not play much of a role in the display. Most artisans exhibited their pieces on individual tables in a spacious patio. Isidoro's carvings were displayed in an interior workshop.

The tour group arrived around 10:30 in the morning in a large bus from the Hotel Misión de los Angeles. Isidoro greeted them wearing one of his masks and embraced his compadre. Raoul de la Sota was an excellent guide—bilingual, amiable, relaxed, and informative. The tour group consisted mostly of pleasant, intellectually curious older people. Raoul told them that Isidoro was trying to preserve traditions of painting and carving. The group then proceeded to shop for a couple of hours. Each artisan was in dress-up peasant clothes. The older wood-carvers all wore straw hats; the weavers wore huipiles. The pieces were almost all high-quality and expensive. The artisans talked at length about their pieces (with Raoul translating) and gave demonstrations of how carvings and weavings were made.

Although wood-carvers in Arrazola and San Martín are especially interested in attracting large tour groups, at least as many visitors to these communities arrive in taxis. Since few tourists know much about the wood-carvers and their pieces, passengers often ask taxi drivers to take them to the workshops of good artisans. The drivers are pleased to do this because they often receive commissions from carvers for this service. However, artisans vary greatly in their willingness to give these commissions. Workshop operators such as Pepe Santiago and Olga Santiago in Arrazola depend on taxis for a large part of their business and are more than willing to pay drivers. Tourism is sufficiently important in Arrazola that most carv-

ing families also accept the taxi commissions as part of doing business. Many well-known carvers in San Martín, however, bitterly resent the amount of money (usually 10 percent of sales) requested by taxi drivers, saying that this really cuts into their profits. These carvers do most of their business with dealers and are not accustomed to losing money via commissions. I have listened to lengthy harangues on this topic by otherwise amiable longtime artisans. (The only topic that established artisans in San Martín complain about more is local competition from painters of pieces carved in San Pedro Taviche.)

Tourists who arrive on their own in Arrazola and San Martín often greatly enjoy seeing village life and meeting the artisans. Despite all the signs and the information in guidebooks, their buying is usually haphazard. Most tourists from the United States and Europe wander into a few houses and attempt to talk to the artisans, who for the most part good-naturedly cope with the tourists' faltering Spanish and sometimes insensitive photograph-taking. An increasing number of Mexican tourists visit the villages, especially during Guelaguetza and Christmas. Mexican tourists obviously do not have language problems but otherwise can be as bewildered as their counterparts from the United States and Europe. Few tourists of whatever nationality know where the better artisans live or where particular types of pieces can be found. Because of the location of many workshops in the backs of houses, visitors are sometimes reluctant to enter places where carvings are sold. The contrast in tourist-friendliness with the weaving town of Teotitlán del Valle—with its showrooms facing the street and many English speakers—is striking.

The economic importance of tourism in the wood-carving trade is not restricted to direct sales. When tourists from the United States return home, they show what they have bought to friends, neighbors, and relatives. Returning tourists also give Oaxacan wood carvings to friends and relatives. By increasing the visibility of Mexican crafts in the United States, tourists play an important role in developing a market for wood carvings among customers who have never been to Oaxaca.

SALES IN THE UNITED STATES

Oaxacan Carvings—Mexico. Oaxaca, pronounced (Wa-Hah-Ka), is one of Mexico's largest and poorest states, yet its folk art and traditions are among the richest. Unsurpassed for their originality, colors, and wizardry, Oaxacan wood carvings have become a prized folk art. The majority of . . . carvings are called Alebrijes. Alebrijes are wood carvings made by the Zapotec Indians . . . The wood-carving techniques and artistic capacity of the Zapotec people are legendary, honed over hundreds of generations. Each of the wood sculptures are [sic] hand-carved from the wood of the Copal (or copillo) tree. Each piece is hand-sanded and painted in bright and exciting motifs. Oaxacan wood carvings were featured on the cover of the Smithsonian magazine (May, 1991). There are two hundred or so families of wood-carvers in the Oaxaca valley. Most are poor farmers who carve when nothing pressing is to be done in the fields. They still believe in many of the old Zapotec rituals and gods. As with

many other Indian groups in Mexico, the Oaxacans are trying to keep their culture alive.

(ADVERTISEMENT FOR WOOD CARVINGS ON THE WORLDWIDE WEB,
EL COQUI GIFTS, EVANSTON, ILLINOIS, DOWNLOADED JUNE 4, 2000,
http://elcoquigifts.com/woodplantcarvings.htm)

When I first learned that most Oaxacan wood carvings were sold to wholesalers and store owners from the United States, I wondered how the dealers marketed their pieces. In my subsequent travels around the United States, I therefore sought out ethnic arts stores in which carvings might be found. Despite my best efforts, I rarely saw more than a few carvings in any one store and often found none at all. Even in New York City, there seemed to be only one store (the now-closed Bazaar Sábado in Soho) with a large collection of high-quality pieces.

There is a simple—if incomplete—explanation for why Oaxacan wood carvings are not omnipresent in the United States. The approximately 300 wood-carving workshops make a limited number of pieces, and the United States is a large country with many stores. Nonetheless, my marginally successful search for wood carvings had been specifically directed at the kinds of places where I thought carvings were likely to be sold. I had explored university towns, gentrifying, politically progressive urban neighborhoods in midwestern and eastern cities, and picturesque New England towns near the summer homes of well-off, highly educated professionals from New York and Boston. I eventually concluded that the only way that I would see large numbers of carvings for sale was to visit the U.S. Southwest, where many dealers lived. My May 1998 trip to Arizona and New Mexico was successful; in many shops in these two states I was able to see displays of 50 to 100 wood carvings.

Oaxacan carvings in U.S. stores are ordinarily displayed alongside crafts from all over the world. In the Southwest, Oaxacan wood carvings are most commonly found among textiles and pottery from other parts of Mexico, Guatemala, and the Andean countries and near Navajo, Hopi, and Zuni fetishes, jewelry, dolls, and drums. In the Midwest and East, the wood carvings are usually thrown into more wide-ranging displays of crafts and "ethnic" art that might also include pieces from Africa, South Asia, the Philippines, and Indonesia. Stores with sizable collections of carvings often included brief descriptions of the history of the craft. The blurb at the museum shop of the Arizona Historical Society in May 1998 is typical in its sketchiness:

In the mountains of Oaxaca (pronounced Wa-Hah-Ka) lives one of the largest and poorest populations of Mexico. [I am not sure what "largest" refers to here, but my guess is that this is an allusion to the number of speakers of indigenous languages.] For hundreds of years, the Oaxacan people have been carving toys for children and masks for religious fiestas. The style that dominates today can be traced to one artist. Seventy three year old Manuel Jimenez. These colorful figures are hand carved from the wood of the copalillo tree and then hand painted. Thus creating a colorful and unique piece of Mexican folk art.

The quality and prices of carvings in the shops I looked at in the Southwest varied greatly (from $14 to $755) and unpredictably. Although I could sometimes guess the kinds of pieces in a store from its exterior and location, my suppositions were often wrong. I saw expensive, high-quality pieces in an unpretentious curio shop in Nogales (on the Mexican side of the Sonora-Arizona border) and cheap, poorly made carvings in an upscale store in Tucson. Furthermore, there was surprisingly little consistency in prices from store to store. This could be seen most clearly in Tubac, Arizona, a community along a major highway between Tucson and the Mexican border that includes numerous art galleries, restaurants, and bookstores. The first place I entered was a chic shop with crafts from all over Latin America. There were a few good pieces made by noted artisans such as Margarito Melchor and Jacinto Mandarín. Most of the approximately seventy-five wood carvings, however, were unremarkable pieces made either in the factory workshops of Arrazola or by artisans who were justifiably unknown. Prices ranged from $22 to $175; the average was about $50. A nearby, equally chic, shop had what I thought were much better pieces at considerably lower prices. The average price of a carving was about $30 and fine pieces by artisans such as Juan Melchor and Martín Melchor cost about $50.

Inconsistencies in wood-carving prices are perhaps not all that surprising. Many sellers have little experience with the pieces and can only guess what customers will be willing to pay. The relatively small number of buyers and sellers and the uniqueness of some carvings may lead the forces of supply and demand to interact in ways somewhat different from those described in introductory economics textbooks. There are certainly similar price inconsistencies in the trade of antiques, paintings, and rare books in the United States. One reason why auctions of such unstandardized items are so often intriguing is that the limited numbers of buyers and sellers result in an unclear market value.

There are several different marketing channels for wood carvings sold in the United States. At gift shows, wholesalers sell pieces they have bought in Mexico. Ethnic arts stores and museum shops sell carvings that retailers have bought either on site in Mexico or from wholesalers. Customers bypassing shops purchase carvings from catalogs or over the Internet. Although some dealers of wood carvings use only one of these marketing methods, others sell pieces in several different ways. For example, a dealer might sell at gift shows, have a retail outlet, and advertise over the Internet.

WHOLESALERS

Barbash (1993:109) has aptly described intermediaries in the wood-carving trade as "an independent-minded, colorful group who lead hectic, bilateral lives." The U.S.-based wholesalers I have met are motivated only partly by the need to make a living. There are many easier ways to make money than by importing folk art into the United States. Most wholesalers love to travel and appreciate the intercultural exchanges their work requires. Although their knowledge of Spanish varies, all know enough to conduct their business transactions. Many have long-term friendships with wood-carving families; some have brought artisans to the United States for exhibitions.

The wholesalers differ considerably in the methods they use to buy and sell pieces. A few sell only wood carvings; most also buy Mexican textiles and pottery. Many deal in diverse "ethnic" crafts from around the world. There are several large-scale dealers who have warehouses filled with wood carvings and spend thousands of dollars hawking their pieces in enormous gift shows in major cities. The large, regular purchases of two such dealers—Jerre Boyd and Clive Kincaid—are so important to the livelihood of many wood-carving families in Arrazola and San Martín that there are serious repercussions in these communities when they cut down on orders. While other folk art dealers buying Oaxacan crafts have bigger businesses, none buy as many wood carvings as Clive and Jerre. Most folk art dealers visiting Oaxaca operate on a much smaller scale. They may make one or two trips to Mexico a year in which they buy carvings and other crafts. These smaller-scale dealers usually sell crafts directly to shop owners. Their profits sometimes barely cover the costs of their trips.

The following descriptions of four wholesalers and their businesses illustrate some of the varied niches for intermediaries in the wood-carving trade. Clive Kincaid runs a successful large wholesale operation specializing in inexpensive wood carvings. Carol Cross and Steven Custer sell high-

quality pieces during the summer and fall that are purchased during winters and springs in Mexico. Fran Betteridge is a retired lawyer whose small-scale dealing in wood carvings pays for her travels in Mexico. Rick (a pseudonym) is a dealer with very little working capital who ekes out a living buying and selling wood carvings from Arrazola.

A LARGE-SCALE OPERATION

I had wanted to talk with Clive Kincaid long before I first spoke to him. He seemed to be the second most important buyer of wood carvings (behind Jerre Boyd from California) and employed Antonio and Saúl Aragón as his representatives in Oaxaca. Clive was known in Mexico as "Andrés," a Hispanicization of Andrew, his middle name. Although Clive and I were occasionally in Oaxaca at the same time, he was too busy working with Antonio, Saúl, and the carvers to meet with me. I eventually interviewed Clive in May 1998 in his warehouse in Wickenburg, Arizona.

Clive, who was about forty-five at the time, had dealt in folk art for more than a decade. After graduating from the University of California at Los Angeles in the 1970s with an anthropology major, Clive received a master's degree in wilderness management and founded an environmental organization in the mountain states, where his wife, Chris, was employed as an archaeologist for the National Park Service. Clive's work was busy and tense, involving testimony before Congress and conflicts with logging and ranching interests. In 1989 he became exhausted, quit his job, and had what he describes as a "life crisis." After sitting around his house for several months, Clive drove a van into Mexico, where he traveled for three months. On this trip he first met the Aragón family in Arrazola, where he had gone to look at wood carvings. Chris joined Clive for his last two weeks in Mexico.

During the 1989 trip, Clive bought a variety of crafts, which he and Chris packed into eight large canastas. After some confusion concerning customs forms at Douglas, Arizona, the couple crossed the border and took their purchases to a department store in Los Angeles. When the store was willing to pay $9,000 for the crafts, Clive decided to go into the import-export business. He bought Designer Imports, a company that mostly sold rugs from Teotitlán. Between 1990 and 1993 Clive specialized in rugs, working with an intermediary from Teotitlán. He also sold carvings, pottery, and other Mexican crafts and continued to visit the Aragón family. In 1994 Clive decided to try to sell more carvings and hired Antonio Aragón to be

his representative. Clive wired money and orders for wood carvings to Antonio, who then bought the pieces and sent them via airfreight to Clive's warehouse in Page, Arizona. Antonio received 10 percent of what the carvers were paid for the orders.

The wood-carving business started out small-scale, but by 1995 Clive was spending $60,000 to $70,000 a year on wood carvings. The couple's son was born about then. Chris left the Park Service and began working full-time for Designer Imports. Clive later moved Designer Imports to Wickenburg, a small town about 50 miles northwest of Phoenix. Clive nowadays makes only one or two trips to Oaxaca annually. These visits last just a few days. Saúl's competence in managing the wood-carving business for Designer Imports allows Clive to concentrate more on obtaining other crafts.

In 1998 wood carvings comprised about 60 percent of the business of Designer Imports, which also sold Mexican pottery and Panamanian baskets. Clive employed about eight people at the Wickenburg warehouse. Two employees in Wickenburg spent most of their time painting and gluing pieces that had been broken. Clive estimates that about 3 percent of pieces that arrive by airfreight need repairs. Although Designer Imports sends pieces to customers in ziplock bags, some additional breakage also occurs at this stage of the commodity chain. When this happens, Designer Imports will repair pieces without charge. Most of the relatively few returns to Designer Imports are of irrevocably damaged pieces. While shops that buy from Clive sometimes have the option of returning unsold pieces, this rarely happens.

In 1998 Clive had 500–600 clients for wood carvings and said that the market seemed to be holding firm. Although he sold mostly to gift shops, his clients included about 100 museum stores. Most of his sales take place during seven gift shows that Clive attends each year, paying thousands of dollars for exhibition space. Some of these shows (e.g., Los Angeles, San Francisco, Phoenix) are at the same time and place each year; others (e.g., museum shows held in conjunction with a meeting) move around from year to year. Clive's exhibitions at the shows include examples of artisans' work, a catalog, and a price list. Clive had customers in about thirty states in 1998 and thought that the regional concentration of his clients in California and Arizona had more to do with his location than with any particularly southwestern appeal of the carvings. The features that make wood carvings attractive to buyers from the United States create certain problems for Clive. Many people from industrial countries are drawn to Oaxacan wood carvings because they are handmade and no two pieces look exactly alike. However, this means that buyers cannot be guaranteed

that they will receive pieces exactly like those exhibited by Clive or shown in Designer Imports catalogs.

Clive's airfreight bill for a typical shipment of wood carvings is about $2,000. Even though most handicrafts are duty-free (the major exception is textiles), Clive has significant expenses associated with import regulations. In 1998 anyone who imported more than $1,200 in wood carvings (or other handicrafts) needed to employ a customs broker. Clive ordinarily spends about $300 on a customs broker and other minor government-imposed fees when importing carvings by airfreight. The size of his shipment is largely irrelevant to this cost.

Clive buys a carving only if he thinks that a retailer will be able to sell the piece for five times the cost in Arrazola or San Martín. He estimates that if he pays $10 for a piece in a village, there are another $5 of expenses (airfreight charges, customs fees, Saúl's commissions) associated with getting the carving to Arizona. In the United States, Clive has overhead costs such as employees' salaries, gift show costs, and rent ($1,000 monthly for the Wickenburg warehouse). Clive's wholesale price for a carving is typically three times what Saúl pays in Oaxaca. This markup enables him to make a net profit of 15–18 percent of the wholesale price. According to Clive, retailers sell the pieces for 1.7 to 4 times the wholesale price, with 2.2 times being the average.

I was able to obtain records of all of Clive's wood-carving purchases in 1995, 1996, 1997, and 1998. During this time the average price he paid for a piece in Oaxaca was about $5. Clive's estimates of costs and profits along the commodity chain can perhaps be most easily understood by examining the economics of the sales associated with a $5 carving. Designer Imports might sell this carving for $15 at a gift show. The retailer buying the piece would sell it in a shop to a customer for perhaps $35. While I cannot estimate the retailer's net profit on the carving, I know enough about the overhead costs of other people involved in the commodity chain to estimate what they clear. The carvers would earn about $4.50, Saul $0.50, and Clive $1.60.

Although Clive's intermediaries are from Arrazola, two-thirds of the money he spent on wood carvings between 1995 and 1998 went to artisans in San Martín. About one-quarter of Designer Imports wood-carving expenditures were for pieces made by Arrazola artisans; the remainder was spent on carvings made by the Blas family in San Pedro Cajonos. The greater number of carvers in San Martín is not the only reason why Clive buys most of his pieces in that community. While Designer Imports buys some expensive pieces, the company specializes in the medium to low end of the

TABLE 12.1 Purchases in Different Communities by Designer Imports, 1995–1998

	ARRAZOLA		SAN MARTÍN		SAN PEDRO CAJONOS	
	Pesos	Dollars[a]	Pesos	Dollars	Pesos	Dollars
1995						
Total Purchases	129,872	20,229	275,084	42,848	63,330	9,864
Average Price/Carving[b]	31.76	4.95	22.90	3.57	63.65	9.91
1996						
Total Purchases	104,492	13,749	374,502	49,277	42,585	5,603
Average Price/Carving	40.64	5.35	33.43	4.40	63.37	8.34
1997						
Total Purchases	95,100	12,008	327,647	41,370	31,490	3,976
Average Price/Carving	37.28	4.71	36.29	4.58	94.00	11.87
1998						
Total Purchases	96,415	10,549	277,495	30,360	49,071	5,369
Average Price/Carving	41.19	4.51	33.01	3.61	76.08	8.32

[a] Pesos were converted to dollars using the exchange rates in Table 1.1.

[b] The "average price" is the mean price Designer Imports paid per piece.

market. The proportion of artisans willing to make large numbers of cheap pieces is greater in San Martín than in Arrazola. Table 12.1 shows that even those artisans in Arrazola selling to Designer Imports receive on the average more per piece than their counterparts in San Martín. The most expensive pieces Clive buys, however, are from San Pedro Cajonos. But the differences between communities are not large. The average price per piece was about $4 in San Martín, $5 in Arrazola, and $10 in San Pedro Cajonos.

Between 1995 and 1998 Clive bought pieces from thirty-six carving families in Arrazola, sixty-nine in San Martín, and thirteen in San Pedro Cajonos. Designer Imports also indirectly supports artisans in San Pedro Taviche since many of the pieces Clive buys in San Martín are carved in that community. The company, however, has not helped carvers in La Unión. Clive said in 1998 that he had never found it worthwhile to make buying trips to La Unión because there were not enough artisans there making pieces. This seems surprising, since there are more wood-carvers in La Unión than in San Pedro Cajonos. Probably what Clive meant is that there were not enough

artisans in La Unión making pieces in quantities that he can use. There were only two carvers in La Unión (Jaime Santiago and Angel Cruz) who worked quickly enough to be potential suppliers for Clive. There were, in contrast, six or seven branches of the Blas family in San Pedro Cajonos who made carvings rapidly enough to fill large orders from Designer Imports.

Clive's purchases provide some hard-to-get quantitative evidence about what kinds of Oaxacan carvings are being sold in the United States. Obviously, his purchases are to a certain extent unrepresentative since Clive specializes for the most part in medium-priced and inexpensive pieces, buys from selected carvers and villages, and has his own particular preferences. Nonetheless, he buys from a wide variety of carvers and sells to stores and museum shops all over the United States. His purchases therefore reflect consumer demand in the United States fairly well.

My data on Designer Import purchases come from notebooks in which Saúl recorded purchases that he or Antonio made at Clive's request. Saúl listed 170 different types of carvings bought between 1995 and 1998. The diversity of niches in the wood-carving trade is shown by the lack of dominance of any particular carving type (see Table 12.2). Designer Imports spent the most money on cats, which comprised 7.2 percent of total expenditures. The company spent only 38.5 percent of its total expenditures on the most popular ten items combined and 58.0 percent on the top twenty carving types.

The fifteen carving types that Designer Imports spent the most money on were (in descending order) cats, armadillos, frogs, dogs, alebrijes (in the limited sense of Linares-like fantastic figures), iguanas, lizards (recorded by Saúl as *lagartos*), dragons, porcupines, gazelles, donkeys, cactuses, giraffes, crabs, and coyotes. The relative ranking of these items for the most part did not vary dramatically from year to year. (Porcupines, which Clive started buying in quantity in 1996, are an exception to this generalization.) There are diverse reasons for the popularity of these particular items, which include animals found in Oaxaca, nonindigenous animals, fantastic creatures, and a plant. Cats and dogs are beloved pets of many potential customers. Armadillos, coyotes, and cactuses are semi-iconic in parts of the U.S. Southwest; burros and lizards are emblematic of Oaxaca. The shapes of iguanas, dragons, gazelles, and porcupines enable artisans to demonstrate their carving skills; alebrijes and dragons are fantastic creatures that may have an appeal similar to that of characters in Disney cartoons. Frogs, first popularized by Manuel Jiménez, are perhaps the most "traditional" Oaxacan animal wood carving. The reason for the popularity of the remaining item, the crab, is not obvious to me.

Clive's purchases reflect the dominance of animals in the wood-carving

The Fifteen Carving Types Most Often Bought by Designer Imports,
995–1998

	1995–1998		1995		1996		1997		1998	
	Sales %[a]	Rank	Sales %	Rank	Sales %	Rank	Sales %	Rank	Sales %	Rank
at	7.2	1	6.7	2	6.0	1	8.9	1	7.3	1
rmadillo	5.4	2	7.4	1	4.9	3	4.6	3	4.8	2
og	5.1	3	2.6	9	4.9	2	8.1	2	4.6	4
og	4.1	4	5.7	3	3.0	8	3.4	7	4.3	5
lebrije[b]	3.8	5	5.3	4	3.5	4	3.2	8	3.1	9
guana	3.0	6	3.2	7	2.9	10	4.3	4	1.7	20
zard	2.7	7	2.1	12	1.9	21	2.2	10	4.7	3
ragon	2.5	8	3.5	5	3.4	5	1.7	19	1.1	32
orcupine	2.4	9	0.03	107	3.4	6	3.8	5	2.2	12
azelle	2.3	10	1.6	20	2.3	13	3.5	6	2.0	13
onkey	2.2	11	1.7	17	2.1	15	1.9	16	3.4	8
actus	2.2	12	1.7	16	2.0	16	1.8	18	3.5	6
iraffe	2.2	13	2.1	11	1.0	33	2.4	9	3.4	7
rab	2.2	14	0.8	37	3.3	7	2.0	15	2.3	11
oyote	2.1	15	3.0	8	1.6	23	2.1	12	1.8	19

Percentage of all money spent by Designer Imports on Oaxacan wood carvings.

"Space-age" figures modeled after Linares papier-mâché sculptures, also called *marcianos* (Martians).

trade. I divided the carving types recorded by Saúl into six categories—animals, folkloric and religious beings (e.g., saints, angels, devils, alebrijes, unicorns), humans, plants, inanimate objects (e.g., frames, jewelry boxes), and others (including hard-to-classify items). Designer Imports spent 72 percent of its wood-carving expenditures between 1995 and 1998 on animals, 13 percent on folkloric and religious beings, 7 percent on inanimate objects, and 8 percent on other kinds of items (including human beings and plants). These proportions were about the same in Arrazola, San Martín, and San Pedro Cajonos and did not vary much from year to year.

In 2000 Clive's sales at gift shows began to drop, and he was forced to reduce his orders of Oaxacan wood carvings. By summer 2001 Clive was buying perhaps half the number of pieces that he had ordered in previous years. Designer Imports was increasingly relying on sales of Mexican pottery (from Mata Ortiz, Chihuahua) and Panamanian baskets.

Carol Cross and Steven Custer have sold high-quality Mexican crafts to collectors and store owners since the late 1980s. Although most of their business takes place in seven summer and fall art fairs and gift shows in different parts of the United States, they also sell directly to clients they have known for many years. Wood carvings are only part of the couple's business (Fish Out of Water), which they run out of their home in Chicago and a rented apartment in Oaxaca. Carol is much more active than Steven in buying and selling wood carvings because she likes them more. Steven is more interested in antiques. However, Carol speaks only rudimentary Spanish and relies heavily on Steven's knowledge of the language when communicating with the artisans.

Carol and Steven were in late middle age when I met them in March 1998. Their personalities contrast notably. Carol, who once worked as a news editor at a Chicago television station, is enthusiastic, chatty, and opinionated. Steven, who studied many years ago in Mexico and knows a lot about local culture, is low-key and quiet. Fish Out of Water supports their travels and provides some useful income but obviously is not nearly as profitable (or time-consuming) as Designer Imports.

The couple drives a van from Chicago to their apartment in Oaxaca every winter. Their buying takes place at a leisurely pace during their annual stay in Mexico from early January to late April. Carol and Steven buy pieces from all the high-end carvers (e.g., Miguel Santiago, Manuel Jiménez, Isidoro Cruz, Francisco Morales, Luis Pablo) and are willing to pay several hundred dollars for something they like. Most of the pieces they buy, however, cost between $25 and $75.

Carol and Steven have become close friends with several artisan families. They have especially strong ties with some artisans from La Unión who earn a considerable percentage of their annual income from sales to Fish Out of Water. Carol and Steven regularly bring used clothes to Mexico, which they give mostly to families from La Unión. Of all the dealers I have met, they are perhaps the most involved in the personal lives of the wood-carvers.

Fish Out of Water typically sells pieces for two or three times their price in Oaxaca. Carol and Steve can afford to do this because their overhead is less than that of a store owner or even a large-scale wholesaler such as Clive Kincaid. They have no employees and avoid airfreight fees and breakage by transporting crafts by van across the border. The low markup on their pieces may also be related to their relatively high prices. Retailers do not seem to have problems selling pieces that cost $8 in Oaxaca for $40 in

the United States. It may not be so easy to sell a piece that costs $60 in Oaxaca for $300 in the United States.

Frances Betteridge is a retired lawyer from Tucson, Arizona, who likes to travel. She pays for some of her trips to Mexico by buying wood carvings, which she sells to shops in Arizona. Small-scale dealers such as Fran earn insignificant incomes by U.S. standards. While there are artisans whose livelihoods depend on sales to Designer Imports and Fish Out of Water, no wood-carving family would suffer if Fran stopped buying. Nonetheless, purchases by small-scale dealers are an important part of the wood-carving trade. Fran buys much more than even the most enthusiastic collectors and tourists.

After Fran graduated from college (Mount Holyoke), she married, raised four children, divorced, and received a law degree. Fran worked as a lawyer for the city of Greenwich, Connecticut, for a number of years but eventually decided to move to Tucson, where her anthropologist daughter lives. Anne Betteridge, who has a University of Chicago Ph.D. and works with a Middle East association at the University of Arizona, is married to an Iranian architect. Fran worked primarily as an immigration lawyer in Tucson. Her clients were mostly Iranians and other people from the Middle East she met through her daughter and son-in-law.

In the mid-1980s Fran went to a Thanksgiving dinner in Tucson at which Jane and Thornton Robison (the current owners of the Casa Colonial) were present. Fran decided to go on a tour to Oaxaca that Jane was about to lead. The group stayed at the Casa Colonial, which at that time was owned by a cousin of Jane's. Fran liked Oaxaca and bought some carvings. She was planning to leave her law practice when she reached seventy in 1992 and was looking for something to do during her retirement. Fran is a lively and energetic woman who likes to keep busy.

When I met her, Fran was coming to Oaxaca four times a year. On two trips she co-runs elderhostels (educational/travel programs aimed at older people) based at one of the better hotels in Oaxaca. Fran buys carvings either before or after the elderhostel trips. The other two trips to Oaxaca, which can last as long as a month each, are devoted to wood-carving purchases. Since Fran ordinarily stays at the Casa Colonial, which cost US$45 a day (including some meals) in the late 1990s, wood-carving sales may not entirely cover her expenses on these trips.

Fran sells carvings out of her house in Tucson. She has found customers in several ways. Fran volunteers as a docent at the Tucson Museum of Art, where she meets people and tells them about the carvings. She has a home page on America Online with information about the carvings and also sells some pieces in Oaxaca to elderhostel participants and guests at the Casa Colonial. Many of Fran's sales in Tucson are to the organizers of gift shows run by nonprofit organizations such as national parks and museums.

Getting Fran's purchases from Oaxaca to Arizona is somewhat complicated. She typically flies home with four canastas filled with carvings. The airlines sometimes, but not always, charge her excess luggage fees. Fran, who lists her reasons for travel as both "business" and "tourism" on her tourist card, tries to keep the official value of her merchandise below $1,200 in order to avoid paying for a customs broker. With the help of a friend in Oaxaca, she fills out a form called a pro forma invoice that describes her merchandise and lists costs. In theory, this has to be done for every carving purchased, but in practice customs officials have no objections when similar pieces are lumped together. Fran worries that if she comes through the same airport too many times a year she will be required to use a customs broker even if the value of pieces on any one trip is less than $1,200. Although this has not happened so far, the customs officials in Phoenix now know Fran well.

Fran sells her pieces on average at about twice what she pays for them. Her relatively few big, expensive carvings sell for less than double the buying price; small, cheap pieces often sell for more than twice what Fran paid. Fran sells mostly to the medium end of the market, with typical pieces costing her $10 to $30 in Oaxaca. Because of her dislike of most cheap carvings, she prefers not to sell them. Fran's shipping methods prevent her from taking back many big, expensive pieces; in any case, she cannot afford to deal in high-end carvings. Her reluctance to buy pricey carvings is exacerbated by the wood-carving market around Tucson. According to Fran, there are few customers for expensive pieces there. She contrasts Tucson with Phoenix, where she thinks there are more wealthy aficionados of folk art.

When Fran is in Oaxaca, she makes buying trips to Arrazola and San Martín. Because Fran speaks only basic Spanish, she usually goes on these trips with her friend Toni Sobel, a New Yorker married to a Oaxacan doctor. Fran especially likes to buy pieces made by female carvers and has written a short, unpublished paper about these women. She buys about half the pieces she sells on trips to carving villages. She buys the rest of her carvings from Víctor Vásquez.

One day in March 1998 I went to the Abastos market in Oaxaca to catch a collective taxi to Arrazola. (This trip costs about five pesos and is the ordinary mode of transport between Arrazola and the city of Oaxaca.) One of the other passengers was a fellow in his mid-thirties with long blond hair who was carrying a Guatemalan bag. In another generation, Rick would have been a stereotypical hippie. In the late 1990s he was a minor entrepreneur attempting to support himself and a Mexican wife by importing crafts to the United States.

Although Rick was originally from Minnesota, he had been living for a number of years in Missoula, Montana. He had worked for an architectural firm and also supported himself as a carpenter and flute maker. Rick had recently married a rural Oaxacan women who ran a vegetable stand near the hotel where he had been staying. Conversations between Rick and his bride must have been limited in scope since his Spanish was not good and she spoke no English. Rick complained about having had to buy four sheep for the wedding and was having trouble obtaining papers for his wife that would enable her to enter the United States. He was not in a particularly good mood the day I talked with him.

Rick buys wood carvings and Teotitlán rugs, which he sells to stores in the mountain states and in an outdoor market in Missoula. He pays only $30 a summer for renting a stand in the Missoula market. Rick sells pieces for double or triple what he pays for them. The wood carvings that he sells are an eclectic mix varying considerably in price. Rick takes them across the border as a tourist, paying custom fees if he declares that he is bringing in more than $400 of crafts. (Presumably, he never brings in more than $1,200 since he said nothing about using a customs broker.)

All the pieces that Rick buys are from Arrazola. He obviously had not been dealing wood carvings very long since he knew almost nothing about the artisans and the places where pieces are made. He was unsure of Manuel Jiménez's name, for example, and had never heard of either San Martín Tilcajete or La Unión Tejalapan. Rick's ignorance may have hurt his business, given his obviously limited funds. He could have found cheaper pieces in other carving villages.

I thought that the most interesting aspect of Rick's forays into the crafts trade was his attempt to barter for wood carvings. He had brought with him two wooden flutes modeled on North American Indian instruments. Using machines, Rick had taken five hours apiece to make the flutes. On

our visits to carving families, he played haunting Native American melodies that are popular in western parts of the United States. The wood-carvers were intrigued by both the music and the artisanship of the flutes and seemed tempted by Rick's offer of an exchange for wood carvings. Rick told me that he had already traded one flute for wood carvings worth 300 pesos (about US$40 at the time). Since he said that he had sold similar flutes in Montana for the equivalent of 1,200 pesos, this struck me as a reasonable exchange. If wood carvings in the United States sell for three to five times their price in Mexico, a fair price for a flute in Mexico might well be one-quarter its price in the United States. Although I was surprised by Rick's attempt to barter flutes for wood carvings, what he suggested was really not all that unusual. Dealers from the United States sometimes exchange televisions and other electronic items for wood carvings.

Rick had brought little money with him the day I accompanied him in Arrazola. He ended up buying a number of small, inexpensive pieces. I knew, however, that he was occasionally willing to buy more expensive carvings. Rick's favorite artisan, Damián Morales (who specializes in deer and moose), makes pieces that cost US$25 to $50. Furthermore, the Teotitlán rugs that Rick buys often cost $50 to $100. Nonetheless, he obviously had much less capital than any of the other wholesalers I have profiled here. Given Rick's ignorance of the wood-carving trade and his peripatetic job history, I had my doubts that he would be dealing in crafts for long.

SHOPS

Retail sales of wood carvings in the United States ordinarily take place in stores selling crafts from around the world. Some such stores are entirely devoted to "ethnic" arts and crafts; others (e.g., Pier One) have sections devoted to such items. Although many store owners acquire wood carvings on buying trips in Mexico, pieces in retail shops are more commonly obtained from wholesalers. A typical commodity chain for a wood carving might involve an piece made in Inocente Melchor's workshop in San Martín ordered by Clive Kincaid for US$8, picked up by Saúl Aragón, and airfreighted from Oaxaca to Phoenix. After Clive picks up the carving in Phoenix, he takes it to his warehouse in Wickenburg. A store owner from San Diego later visits Clive's exhibition in a gift show in Los Angeles and places an order for Inocente's piece for $20. Designer Imports mails the piece to the store in San Diego, where the carving is placed among other Latin American crafts. Eventually, someone looking for a gift buys Inocente's carving for $45.

The distinction between store owners selling retail and wholesalers is not always straightforward. Wood-carvers told me that they sold large numbers of pieces to owners of stores such as Milagros in New Hope, Pennsylvania, and Folk Art International in San Francisco. The number of pieces sold to some such stores seemed greater than could possibly be displayed in retail outlets, even if a store had several branches. I later found out that some store owners also dealt pieces in other ways. Some pieces were sold through catalogs or the Internet; others were sold wholesale to owners of smaller shops.

Stores selling Oaxacan wood carvings obviously tend to be located in areas where there are likely to be customers interested in folk art. Such shops are perhaps most often found in major tourist destinations (e.g., New Orleans, Santa Fe, San Francisco) in sections of cities where highly educated, sophisticated (but not necessarily well-off) visitors like to go. Craft stores are often found near bookstores and ethnic restaurants in neighborhoods undergoing urban gentrification. These stores are also often found in university towns and upscale resort areas. Museum shops are another important outlet for Oaxacan wood carvings.

Despite certain similarities in the ambience of many crafts stores (world music in the background, posters advocating liberal causes on the wall, information about neighborhood associations), they vary considerably in size and quality. Some stores display numerous, high-quality, expensive carvings in a gallery-like atmosphere. Others just have a few cheap pieces mixed in haphazardly with other crafts. Many carry both expensive and cheap carvings. The following brief descriptions of three crafts stores illustrate some of this variability.

EYES GALLERY — PHILADELPHIA, PENNSYLVANIA

While I was conducting my fieldwork in Oaxaca, the names of certain stores in the United States popped up again and again in my conversations with wood-carvers. One such place was the Eyes Gallery in Philadelphia. The owner, Julia Zagar, regularly came to Oaxaca to buy crafts with two friends who owned stores in Boston (Nomad) and New York City (Bazaar Sábado). Wood-carvers such as Jesús Sosa and Inocente and Jesús Melchor had given exhibitions at Eyes. A wood carving by Miguel Santiago of Julia's husband, Isaac, an artist, appears in the Barbash book (1993:26). I later learned that Isaac had given Miguel sketches for this and other carvings. Isaac thinks that this is the origin of Miguel's current practice of providing clients with drawings of potential carvings.

I learned more about Eyes and the Zagars through conversations with Enrique Mayer, a prominent anthropologist now at Yale University. Enrique's parents had fled Germany in the 1930s and settled in the city of Huancayo in highland Peru, where they were later joined by his aunt Francisca, who had studied crafts in Sweden. Francisca Mayer adapted Peruvian crafts for market production. Julia and Isaac Zagar worked closely with Francisca on developing a market for crafts when they were in the Peace Corps in Peru in the 1960s and became good friends with the Mayer family. Enrique told me that the Zagars had been very involved in community affairs in the revitalized South Street section of Philadelphia after returning from the Peace Corps. Julia ran the Eyes Gallery, which was more than twenty years old; Isaac's murals could be seen on many buildings that he had renovated. The Zagars had received numerous grants from arts organizations and seemed to know everyone in the neighborhood.

I visited the Eyes Gallery for the first time with Enrique in April 1998 and have returned there several times. The store is an attractive two-story building amidst the shops, restaurants, and clubs of South Street. Although Eyes carries folk art from all over the world, the focus is on Latin American crafts. Prices vary, but there are numerous items that cost between $40 and $100.

The second story of Eyes includes a large number of high-quality wood carvings from Arrazola and San Martín. Julia told me in 1998 that she used to display even more Oaxacan wood carvings, which were selling more slowly than formerly. Julia was not particularly optimistic about the prospects of the wood-carving trade, since the popularity of many crafts ebbs and fades. Furthermore, southwestern design—which the wood carvings fit into well—had become less fashionable. Julia was surprised when I told her that sales of wood carvings from Oaxaca overall seemed as good as ever.

JACKALOPE — SANTA FE, NEW MEXICO

Jackalope, which occupies several acres on a major road, is something of an institution in Santa Fe, New Mexico. Founded in the 1970s by Darby McQuade, a former stockbroker from New York, Jackalope describes itself as selling "folk art by the truckload." McQuade began by importing Mexican pottery but soon added rugs, tinware, furniture, and clothing. The store's emphasis is on affordable items and is more noteworthy for quantity than quality. Jackalope regularly brings Oaxacan weavers, potters, and wood-carvers to the store, where they give demonstrations. In recent years new

Jackalopes have opened outside of Albuquerque and Denver, and in 1998 the company established a web site (www.jackalope.com).

I visited the two New Mexico Jackalopes in May 1998. The store in Bernalillo (near Albuquerque) had about three shelves of carvings in a remote part of the complex. The pieces were cheap, with most carvings costing between $20 and $35. The carvings were all animals, and only one was signed. Wood carvings were more prominent in the Santa Fe store. There were over 100 carvings displayed in a large area near the entrance. Although there was a varied selection of pieces, the quality and prices were similar to those in the Bernalillo store. A number of pieces were signed, but the signatures were often covered with price tags.

Alejandrino Fuentes of San Martín (a brother of Epifanio) makes several trips each year to Jackalope. He takes carvings from San Martín to Santa Fe and gives demonstrations in the store. The wood-carving section of the complex in 1998 included an old photograph of Alejandrino painting a piece and a map of Mexico showing the location of Oaxaca. The photo, map, and wood carvings were accompanied by a 1990 description of the craft, which is worth quoting in part:

> Woodcarver Alejandrino Fuentes Vasquez comes from San Martin Tilcajete, located in the Ocotlan de Morelos valley of Oaxaca, Mexico. The tradition of woodcarving in Alejandrino's family began with his great-grandfather who carved for the joy of it, making toys for his children. [This seems to be an attempt to convey the "authenticity" of wood carving as a folk art.] The art was passed down the line and Alejandrino's father became the first carver to commercialize woodcarving by selling his work outside the village. [This conveniently omits Isidoro Cruz, who is married to Epifanio Fuentes's sister.] Alejandrino and his four brothers and sisters, all wood carvers, learned their art from their father . . . Alejandrino loves what he does, and feels that his carving is art because he does it out of a deep desire to do so, not for commercial purposes. [This obviously is intended to appeal to prospective buyers. While Alejandrino is a fine artisan, he is known in San Martín primarily as an entrepreneur and intermediary in the wood-carving trade.] Before he begins to carve a piece of wood, he examines it very carefully and sees the possibility of what it can become before he picks up his knife. He feels he is freeing its spirit as he carves. [The appeal of such indigenous spirituality to certain potential buyers—especially in Santa Fe—is clear.]

I visited Minneapolis–St. Paul in May 1998 to give a lecture in a class my friend Jim Weil was teaching at the University of Minnesota. Jim is an anthropologist who works in Latin America and, like me, has developed an interest in crafts (Weil 1997), after concentrating for many years on agriculture. Jim knows about ethnic arts shops in the Twin Cities and told me that I was most likely to find Oaxacan wood carvings along Grand Avenue in St. Paul.

Grand Avenue is a long street filled with shops and restaurants in a neighborhood that has revived in recent years. Although Grand Avenue in St. Paul and South Street in Philadelphia (the location of Eyes Gallery) have both undergone considerable renewal, the two neighborhoods are quite different. South Street is hip, funky, and noisy; Grand Avenue is respectable, moderately upscale, and sedate.

Biloine (Billy) Young was an active participant in the renewal of the Grand Street neighborhood. She is an energetic woman in her seventies who ran a crafts shop in St. Paul for many years that sold Mexican crafts. Billy's readable, amusing book about her experiences in the business (Young 1996) is one of the few first-person accounts of a dealer in Latin American crafts. Billy closed her shop a few years ago, but her example and book inspired people such as Tanya Moden, the owner of Mexico on Grand, to set up businesses in the area.

Mexico on Grand was a small, one-room family operation. When I stopped by in May 1998, Tanya was on a buying trip in Guadalajara and the shop was being tended by her son, an undergraduate at the University of Minnesota. This shop had the only sizable collection of Oaxacan wood carvings I found in my explorations with Jim in Minneapolis–St.Paul. There were about twenty pieces, priced between $20 and $120. The carvings, mostly from San Martín, were rather ordinary. This suggests that high-quality Oaxacan wood carvings, while easily found in Texas, California, and the Southwest, are not yet available in Minnesota.

The following blurb accompanied the wood carvings:

Manuel Jiménez of Arrazola is the Granddaddy of all carvers. In 1957 he was discovered by an American living in Oaxaca (in southeast Mexico) who launched his career. [Presumably, this refers to Arthur Train, but it overlooks Jiménez's entrepreneurial ability and the activities of Enrique de la Lanza and others.] Around 1985 the people of three villages outside Oaxaca began carving on their own. [This is

about the time when the carving boom began, but the expression "carving on their own" is cryptic and misleading.] No one is idle in a successful carving family. Fathers and sons carve, mothers and daughters paint, and small children and elders sand. [This is an understandable oversimplification of the division of labor.] Zapotec Martians: legend has it the Zapotec Indians of the region lived in peace with visitors from outer space. This antenna-covered monster (time traveler) brings luck to your home.

This blurb is typical of the semiaccurate material that often accompanies displays of wood carvings in shops. As in this case, the blurbs often seem to have taken their information from *Oaxacan Wood Carving* (Barbash 1993) but make minor (and sometimes not-so-minor) mistakes in attempting to summarize the author's (accurate) comments. The part of the blurb by Mexico on Grand about Martians is amusing. Barbash's book (1993:26) quotes an advertisement from a catalog called *Objects by Design* as an "imaginative bit of sales humbuggery purporting to explain an antenna-covered monster." The advertisement describes the monster (a "Zapotec Martian," which must be an alebrije) in almost exactly the same words as the blurb in Mexico on Grand. Tanya obviously copied this advertisement from *Oaxacan Wood Carving* and presented it without irony.

Mexico on Grand had closed by spring 2000. Tanya had opened a new shop selling Mexican crafts at the Mall of America in Bloomington, Minnesota.

CATALOGS AND THE INTERNET

The wood-carving trade in Oaxaca depends largely on decisions to buy pieces made by thousands of people in the United States. A complete analysis of the wood-carving commodity chain therefore should include a systematic examination of the motivations of people buying pieces in stores or via catalogs and the Internet. I would have liked to have made such an investigation, which would have involved the methods of market research. Although I informally talked with many people about why they liked or disliked Oaxacan wood carvings, I eventually concluded that I had neither the time nor the resources to conduct a systematic survey of buyers. Moreover, I found that few people were able to give carefully articulated ideas about their aesthetic view of the carvings. Those liking the carvings casually stressed their color, whimsicality, and imagination; those disliking the carvings seemed to regard them as frivolous, too bright, and "kitsch." Thus,

the same traits that attracted some people to the carvings turned off other potential customers.

In recent years, economic anthropologists (e.g., Howes 1996; Miller 1998; Rutz and Orlove 1989; Wilk 1999) have increasingly emphasized consumption. A focus on consumption bridges the material concerns of economists and ecologists and the symbolic and political interests of culturally oriented anthropologists. Anthropological analyses of consumption invariably invoke deeper motivations for purchases than those I was able to elicit in my casual conversations with potential buyers of wood carvings. Inspired by Carol Hendrickson's astute analysis (1996) of how Guatemalan Mayan crafts are represented in mail-order catalogs, I decided to take a close look at the text and pictures accompanying advertisements for Oaxacan wood carvings in catalogs and on the Internet.

An examination of advertisements in catalogs and on the Internet obviously does not provide direct information about what motivates buyers of wood carvings. Instead, these advertisements indicate what dealers in wood carvings think will attract potential buyers. The dealers' ideas are certainly based on their conversations with customers and previous attempts to market wood carvings and other folk art. Material that recurs in many advertisements therefore provides some clues about what attracts potential buyers to Oaxacan wood-carvers. This is so even though much of the prose in advertisements is clearly either copied directly or adapted from Barbash's publications and other websites and catalogs. Presumably, such prose is replicated because it is thought to be effective.

Advertisements in catalogs and on the Internet are especially interesting because dealers cannot rely on the ambience that encourages sales in workshops in Oaxaca and stores in Mexico and the United States. Potential customers in workshops are likely to want souvenirs of their visits to remind them of the sights, sounds, and smells of their trip. In both workshops and stores, buyers can pick up pieces. Catalogs and websites, in contrast, must entice potential customers with two-dimensional photographs and text.

In what follows, I look separately at advertisements for wood carvings in catalogs and on the Internet. This separation is somewhat artificial. Many places that sell pieces by catalog also have a website. In other cases, websites serve much the same function as the catalogs they have replaced. Nonetheless, there are two important differences between catalogs and cyberspace that have implications for advertisements. The cost of producing and mailing a catalog is much higher than that of maintaining a website. Very small businesses selling wood carvings therefore are able to have websites; cata-

logs, in contrast, are mostly put out by large companies that can afford the time and cost of production and mailing. Nowadays the number of websites selling wood carvings and other folk art is much greater than the number of catalogs. Furthermore, every additional line of text or photograph in a catalog costs money in postage and materials; expanding a website involves only the cost of labor. This is why advertisements for wood carvings in websites tend to be much more detailed than those in catalogs.

Oaxacan wood carvings most often show up in catalogs advertising gifts from around the world. They also can sometimes be found in more general gift catalogs featuring offbeat items. Catalogs occasionally prominently feature Oaxacan wood carvings. They appeared, for example, on the cover of at least four *Daily Planet* catalogs in the mid-1990s. However, carvings are more commonly just one of hundreds of advertised items occupying a small space in the middle of the catalog. Advertisements for carvings are almost always accompanied by a photograph or drawing and a few lines of prose.

Perhaps because of space limitations, the advertisements I have seen in catalogs tend to focus on the artistic merits of the wood carvings and engage in relatively little fanciful exaggeration about the makers of the pieces. The following advertisements are typical:

Oaxacan Wood Carving The fine craftsmanship of this special table with chairs drew us in. Rarely has folk art charmed, amused, and delighted us as much as with this terrific set. Handmade, not in mass quantities, and painted individually so that no two sets are ever alike, you'll find these pieces will be treasured collectables and add spice to your decor. (five-piece set of four small chairs and a table priced at $48 from winter 1997 *Flax Art & Design* catalog, p. 31)

ART & SOUL, Oaxacan Animals In the hands of Oaxaca's incomparable craftsmen, the physical world and the realms of the spirit merge in each extraordinary wood carving. These fascinating and humorous figures add color to any environment. (*Daily Planet* catalog, late fall 1995, pp. 16–17, four pieces—snake $32, armadillo $58, porcupine $48, and spirit [alebrije] $49)

Oaxacan Wood Carving Book Complement our exclusive wood

carvings . . . with the spectacular gallery of photos in this exceptional book. This full-color volume illuminates the mesmerizing folk art and tells the remarkable tale of the carvers' rise from subsistence farmers to celebrated craftsmen. (advertisement for the Barbash book in late fall 1995 in the *Daily Planet* catalog, p. 17)

The Nature Company is probably the largest mail-order catalog that has sold Oaxacan wood carvings. Although its advertisements in the late 1990s said nothing directly about the ethnicity of the carvers and the history of their craft, the catalog attempted to situate the carvers within a long-standing indigenous tradition:

Long before Europeans arrived in the Western hemisphere, Oaxaca, Mexico was the site of an indigenous civilization whose remains reveal exceptional artistic achievement. Today, Oaxaca is one of Mexico's largest and poorest states, yet its folk art tradition is among the richest. Oaxaca is also a land rich with superstition. [A surprising lapse in an otherwise unobjectionable advertisement.] Unsurpassed for originality and wizardry, Oaxacan carvings have become a prized folk art. (*Nature Company* catalog, spring 1997, p. 29, three pieces—a fish, a frog, and a cat at $18 apiece)

The same catalog advertised the Barbash book using language similar to the *Daily Planet* blurb cited earlier (including the identical phrase "rise from subsistence farmers to celebrated craftsmen"). The catalog also advertised (for $18) a "Oaxaca Folk Art T-Shirt" decorated with a cat obviously inspired by the wood-carvers.

I did find one catalog which outdid even the most outlandish websites in its depiction of the artisans and their carvings. This undated catalog was shown to me in 1996 by William Warner Wood, an anthropologist who works with Teotitlán weavers and has written at length about representations of Oaxacan crafts (Wood 1997: 45–130, 2000a, 2000b). Bill has a good eye for extraordinary prose in advertisements, and I was not disappointed by *Rosie Coyote's Catalog of High Sensory Impact Regional Gourmet Foods & Folk Art Which Touches the Heart.* This catalog includes eight pages of wood carvings priced between $29 and $88. The introduction (p. 12) manages in two sentences to include almost every cliché associated with descriptions of wood carvings as well as misrepresenting the ethnicity of the carvers and the antiquity of their craft:

In the shadow of the pyramids of Southern Mexico, the Zapotec Indian artisans make irrepressible "Oaxacan Toys." Here is a five hundred year old tradition nurtured by mask-making, sculpture-making & toy making for fiestas . . . [ellipsis in original] these are personal statements, magically inspired by the wood-carvers for their children's children.

Although I will not quote at length from this remarkable catalog, I cannot resist the temptation to include the following advertisement (with my bracketed comments) for an $84 alebrije (p. 12):

Village Protectors. Friendly, Kachina-like fire breathing totems [an attempt to connect the carvings to an indigenous tradition more familiar to many potential buyers], each . . . hand-carved and hand-painted by the Ortega Mendez family in the Oaxacan Valley. Home to sixteen Indian tribes [implying that the carvers are exotic "Indians" belonging to "tribes"], the Valley has been inhabited for thousands of years [implying that the carvers are bearers of an ancient culture]. The ancient beliefs surrounding gods of Harvest and gods of Thunder have inspired the creation of Village Protectors [utter hokum about alebrijes inspired by the papier-mâché creations of the Linares family of Mexico City]. In the courtyard of the Ortega Mendez hacienda [a glorification of an ordinary house] which dates back to the sixteenth century [again associating the craft with a long tradition], graze huge oxen [probably smaller than most cattle in the United States] used in the planting of corn and bean fields. Other wildlife, including backyard pigs, goats, chickens, & burros [an unusual notion of "wildlife"] inspire magic wooden sculptures. The Village Protectors are especially enjoyed by Americans [not to be confused with Mexican residents of North America] & placed on top of computers or on top of microwave ovens, to protect home offices and kitchens!

WEBSITES

I first became aware of wood-carving sales on the web in February 1996 through a dealer named Kyle Widener who was then living in Waterloo, Iowa. Kyle had seen the card of Holly Carver from the University of Iowa Press in an artisan's workshop in San Martín. Surprised that someone from Iowa was interested in wood carvings, Kyle sent an e-mail to Holly. After

Holly told me about the message, I called up Kyle and later talked with him in a coffeehouse in Iowa City. I was already thinking about the transnational, postmodern context of this bit of fieldwork when Kyle began telling me about how he was selling carvings.

Kyle, who was in his late twenties, had studied international business after leaving the air force. Although Kyle liked the carvings, he said that he was not "arty" and regarded his work as purely a business enterprise. He was in Iowa for a year because of his wife's job. Kyle sold inexpensive carvings at gift shows around the country, focusing on the Midwest. But what he was really enthusiastic about was selling pieces on the Internet. Kyle provided carvings on consignment to a business called Folk Art Exchange, which advertised them on its website along with many other crafts. Kyle gave Folk Art Exchange photographs and text for the advertisements. He was at the time setting up his own website (http://jkworthy.com) to sell carvings. (This website still existed in summer 2000 but was no longer selling wood carvings.)

Although the web was much in the news in early 1996, the thought had not occurred to me prior to talking with Kyle that this was a possible marketing channel for Oaxacan wood carvings. I went online and discovered that there were four or five companies selling pieces on the Internet. Since 1996 millions of people have gained access to the web, and shopping by Internet is now routine. Using a good search engine (Google) in June 2000, I quickly found two dozen sites where carvings were advertised as well as records of pieces for sale on eBay, an online auction.

About half the websites selling wood carvings in June 2000 were associated with retail stores (mostly in the southwestern and West Coast states); the rest existed only in cyberspace and warehouses. Prices of pieces were at least five times their cost in Mexico and averaged about $60. Some sites specialized in high-quality carvings; the most expensive piece I saw advertised was a crab priced at $1,900 by Milagros (downloaded June 9, 1999, http://www.milagrosseattle.com/Oaxacan%20Art.htm), a Seattle store that buys from many talented artisans.

The recurrence of certain themes in web advertisements suggests a consensus among dealers about what might attract customers to the carvings. The artisans and their pieces are said to be part of a long-standing Zapotec crafts tradition in Oaxaca. The carvings are advertised as handmade, "authentic," and collectible. The carvers are often depicted as simple farmers at home with nature. The most common adjectives used to describe the

carvings are "whimsical" and "magical." Advertisements occasionally include alleged folklore about how the carvings are used in daily life.

The following website advertisement is typical:

> The valley of Oaxaca . . . , located in southern Mexico, is home for the Zapotec Indians. Over 2,600 years ago their ancestors began building the city of Monte Alban. Recently Zapotec woodcarvers living near Oaxaca city have developed the tradition of carving masks and wooden toys into an internationally appreciated art form. From the small pueblos of Arrazola and San Martin Tilcajete, the carvers journey to the mountains to gather the copal wood that is used in the carvings. This copal tree has the rich tradition of being the incense tree for the Aztecs and Zapotecs. The carving is done at home with simple hand tools. The whole family pitches in to paint figures using safe, colorfast acrylic paints. Because of the complexity of the carving and the highly detailed painting, the figures often take many weeks to complete. The wooden figures created by these modern-day Zapotec Indians have gained an international reputation for quality . . . Each piece is signed by the artist (website for Folk Art & Lore, downloaded June 25, 1999, http://folkartlore.viamall.com/folkartlore/oaxwoodcar.html)

The common identification of the wood-carvers as "Zapotec" found in this and many other advertisements is not totally inaccurate. As noted earlier, some carvers (e.g., in San Pedro Cajonos) speak Zapotec or another indigenous language; others who are monolingual Spanish speakers in San Martín, Arrazola, and La Unión had grandparents who spoke Zapotec. However, the great majority of the carvers speak only Spanish and do not think of themselves as Indian. Even those who speak an indigenous language identify themselves primarily as residents of a particular community rather than as Zapotecs or Mixes or Mixtecs. Many dealers are unaware of the complexity of ethnic identity in Oaxaca and simply assume that the carvers are "Zapotecs." Others may be more sophisticated but nonetheless know that their customers like to think that the pieces they buy are made by "Indians."

The other ways in which the advertisement from Folk Art & Lore is misleading are also worthy of note. The dealers know that customers want to think that the carvings are the result of painstaking work done entirely by families using only a few tools. The advertisement therefore says that carvers from Arrazola and San Martín make "journeys" to gather copal when actually almost everyone buys wood from entrepreneurs with trucks or

mules. While a few expensive pieces take several weeks to complete, many of the cheaper carvings sold over the web are made quickly. But a customer might be reluctant to buy a piece honestly advertised as "carved in three hours and painted in an additional two hours as part of an order for 25 frogs at 15 pesos apiece."

Many websites make imaginative (often totally fictional) attempts to link the carvings with past and present traditions and folklore:

> Animal wood carving is a curious and new craft, although its origins reach deep into the native past. The Zapotec Indians of the Oaxaca Valley have always celebrated their festivals with ritual dance masks and each village had a resident maskmaker. In recent years enterprising local craftsmen started carving masks directly for the occasional visitor. Eventually a few carvers whittled a child's toy animal . . . [ellipsis in original] And from this inauspicious beginning blossomed the extraordinary art form we witness here. (The Ram's Head Gift Shop, Borrego Springs, California, downloaded June 4, 2000, http://www.ramsheadgifts.com/gallery.html)

> In Mexico, the figures are placed in children's room to scare away witches and other evil spirits. (Gwen's Discount Jewelry and Gift Shop, La Crescent, Minnesota, downloaded June 17, 1999, http://www.gwensjewelry.com/oxy/oaxacan.html)

> In Mexico, the figures are believed to bring good luck, and for this reason are placed throughout the home. (La Fuente, Colorado Springs, Colorado, downloaded June 6, 1999, http://lafuente.com/oaxacan.html)

> Alebrije means dream or nightmare figure. (The Turquoise Door, Austin, Texas, downloaded June 11, 1999, http://www.unmall.com/aus/turq)

> Full of movement and humor, the figures spring from the imaginations and superstitions of the carvers, for whom myth and magic are as much a part of daily life as conventional religion. (Casa Mexicana, Dallas, Texas, downloaded June 3, 1999, http://www.dallas.net~casa mex2/p000548.html)

Anthropologists such as myself are likely to focus on the invented tradi-

tions and the ways in which the lives of the artisans are depicted in the advertisements. However, the websites devote at least as much space to the aesthetic merits and individuality of the carvings:

> The valley of Oaxaca . . . in Southern Mexico is the home of many folk artists who create fantastic wood sculptures. Each is hand-carved from the native copal wood and hand-painted. Colors and designs vary so that no two are exactly alike. The unique qualities of the carvings have made them very popular in recent years with art collectors and those who want to add some whimsy to their lives. (Crizmac Gift Catalog, Tucson, Arizona, downloaded June 9, 1999, http://www.crizmac.com/oaxacancarvings.html)

> After being intricately carved, each piece is hand-sanded and painted in bright and exciting motifs. Whether purchased for a personal collection or as a gift, these wonderful pieces of art are amazing in their quality, design, and impression. (Kingdom Come Enterprises, Gilbert, Arizona, downloaded June 11, 1999, http://home.att.nt/~brocklee/oaxacan.html)

> The outstanding characteristic of this work, produced by the family of Pedro Ramirez of Arrasola, Oaxaca, is the artists' pointillist brush technique. Thousands and thousands of tiny dots merge into intricate and colorful patterns. (The Folk Tree, Pasadena, California, downloaded June 18, 1999, http://www.folktree.com/Shopping/wood.htm)

While the texts in the wood-carving advertisements on the Internet provide ample opportunities for deconstruction (see Brulotte 1999 for a more detailed examination along these lines), dealers and website designers know that browsers are likely to pay at least as much attention to photographs and other graphics. Furthermore, the web, unlike catalogs, allows potential customers to enlarge photographs on the screen and print them. Despite the sometimes lengthy text, every wood-carving site I have looked at is dominated by photographs of pieces.

Perhaps the ultimate insertion of the wood carvings into the commerce of cyberspace takes place at online auctions on eBay. In 1999–2000 my spot checks revealed an average of about fifty carvings a day being auctioned. These carvings, sold by about five different companies, comprised about half of the items from Oaxaca being auctioned on eBay. The suggested open-

ing bid prices were modest (usually $10–$20) and trade seemed slow, with many items not having been bid on. The sites were attractive and, as a group, more accurate than most on the web, including one seller ("Wirebird") who knew enough to describe the carvers as "descendants of Zapotec Indians." Another seller was auctioning the only pieces I have seen on the web from San Pedro Taviche.

The trade in carvings on the Internet epitomizes a transnational, globalized commodity chain in which the market for pieces made in a rural Mexican community is determined by the whims of consumers in the industrialized world. Advertisements on the web provide the greatest amount of readily available text indicating what dealers think will attract customers to wood carvings. Nonetheless, the great majority of buyers of wood carvings in the United States continue to find them in retail brick and mortar stores. As late as summer 2000 the two largest dealers of Oaxacan wood carvings (Jerre Boyd and Clive Kincaid) did not have websites.

CONCLUSION

The trade in Oaxacan wood carvings is an almost paradigmatic example of globalization. The wood-carving boom would not have been possible without large-scale tourism, air transport, a weakened peso, and multinational tariff agreements. Carvers travel to the United States to exhibit their craft in schools, museums, and shopping centers. Their pieces are advertised in websites and auctioned on eBay. Artisans and local intermediaries use cellular phones to take orders from U.S. wholesalers.

The effects of globalization in impoverished areas of Africa, Asia, and Latin America have been debated endlessly. Some writers (e.g., Friedman 1999) note that the rural and urban poor have often improved their standard of living in recent years by taking advantage of an expanding world marketplace. Others (e.g., Barry 1995; Ross 1998) point out that globalization typically leads to increased socioeconomic stratification, erosion of local self-sufficiency, and the exploitation of peripheral regions by multinational enterprises. These interminable arguments echo earlier disagreements between proponents of mod-

ernization and dependency theorists. Yet there are important differences between the globalization of the past several decades and earlier immersions of local cultures into world systems.

"Globalization" has become a buzzword that refers to diverse interrelated phenomena. The term is perhaps most often used as a shorthand description of the increasing integration of particular regions into the world economy. A recent edited volume entitled *Commodities and Globalization* (Haugerud et al. 2000), for example, includes articles about the local socioeconomic effects of the export of Sardinian cheese (Vargas-Cetina 2000), Congolese popular dance music (White 2000), and Brazilian grapes (Collins 2000). Global economic integration, of course, is not new. Although the editors of *Commodities and Globalization* call the period from the 1870s to 1914 the "first age of globalization" (Stone et al. 2000:2), worldwide commodity chains for products such as sugar, cotton, and tea were established hundreds of years earlier. The reason why globalization is so much in the news nowadays is that rapid improvements in transport and communications have tightened and multiplied economic connections among various parts of the world. The increased local integration into world markets has resulted in new types of multinational economic agreements and a remarkable diversity of products available for consumers.

The wood-carving trade depends on methods of transportation and communications that did not come to Oaxaca until the middle and later parts of the twentieth century. The commercialization of Oaxacan crafts became important only after the Pan-American Highway reached the Central Valleys in the mid-1940s. The building of the highway led to an increase in the number of tourists interested in buying local crafts. The state therefore provided incentives for craft production; private entrepreneurs opened ethnic arts stores. When air transport to Oaxaca became more frequent in the 1970s and 1980s, the state improved the zócalo and expanded its tourist agencies. New hotels and restaurants opened every month.

Technological developments such as jets, faxes, and cellular phones have made it much easier for entrepreneurs from the United States and Europe to create businesses importing Oaxacan crafts. These improvements in communications and transportation allow dealers to place orders from outside the country and to transport textiles and carvings quickly to the United States, Canada, and Europe. By the end of the twentieth century, the Internet had made it possible for Oaxacan crafts to be bought by anyone with a credit card and access to a computer connected to the worldwide web.

The ever-faster means of transport and communications have influenced

recent changes in the world economic system. Since the 1970s multinational agreements have removed many barriers to the movement of capital and goods and led to increasing instability of currency values and commodity prices (Stone et al. 2000:2). Many indebted nations in Africa, Asia, and Latin America have been compelled by global financial institutions such as the International Monetary Fund to adopt neoliberal "free-market" policies. Other countries have adopted such policies more or less voluntarily. One result has been an explosion in the number of vertically integrated commodity chains run by transnational firms. These chains rely greatly on flexible accumulation systems involving subcontracting and dispersed sites of production and processing.

Shepard Barbash (1993:20) astutely places the Oaxacan wood-carving boom in the context of Mexican state policy with respect to the global economy:

> Although few of them realize it, the wood-carvers are doing exactly what the Mexican government has been urging the country's business elite to do for nearly a decade, which is to hitch their wagons to the world economy. Instead of working for other Mexicans at depressed peso wages, or not working at all, the carvers are in effect working on favorable terms for Americans, generating wealth through exports, working efficiently and competitively, doing the patriotic thing by bringing much-needed dollars into the country and social peace to the countryside.

The wood-carvers' economic strategies, as Barbash points out, are not consciously driven by their awareness of global economic transformations. Nonetheless, two policies of the Mexican government that were reactions to the new world economic system played a key role in the wood-carving boom. The government's devaluation of the peso in the mid-1980s enabled U.S.-based wholesalers to make significant amounts of money by importing wood carvings. Furthermore, binational agreements that existed decades before the North American Free Trade Agreement (NAFTA) allowed Mexican wood carvings (and many other crafts) to be imported duty-free into the United States.

Although the wood-carving trade is relatively small, and many wholesalers and store owners run their businesses somewhat informally, the structure of the trade resembles many other global commodity chains that have been established in recent years. U.S. based wholesalers—sometimes via

local intermediaries—place orders for carvings with Oaxaca workshops. Most of these workshops are family-based operations in Arrazola and San Martín that hire laborers when needed. Some workshops buy unpainted pieces from artisans in their own and neighboring communities, which are then painted and sold to tourists and intermediaries. The subcontracting and piece-work labor arrangements associated with links in the wood-carving commodity chain can be regarded as examples of the flexible accumulation systems associated with globalization. The returns to labor for hired workers and makers of unpainted pieces are not much higher than the local minimum wage. Wood-carving families are often dependent on orders from one or two U.S.-based dealers who may abandon them in the future as they "flexibly" seek other economic opportunities.

The flow of images, commodities, and people across national borders has greatly affected consumption patterns as potential buyers learn more about and have easier access to products from distant places. Consumers buy products from other countries for diverse reasons. Some foreign goods are not available locally; others are cheaper or of better quality than similar items made closer to home. In many cases the very foreignness of a particular product is alluring because it allows consumers to demonstrate their sophisticated, cosmopolitan tastes and appreciation of other cultures.

The export of Oaxacan wood carvings therefore takes place in a globalized era when consumers are increasingly willing and able to buy products from other countries. Although Oaxacan carvings bear certain resemblances to wood sculptures from other parts of the world (particularly Bali), they are unlike anything made in industrialized countries. Marketers of Oaxacan carvings assume that potential buyers are consciously or unconsciously looking for exotic crafts whose origins are as different as possible from the machine-made products that dominate the industrial world. This is why advertisements for the carvings in catalogs and websites emphasize (more-or-less accurately) the simple toolkits and (more-or-less inaccurately) the "Indian" ethnicity of the makers.

The trade in Oaxacan wood carvings cannot be understood solely as an instance of globalization leading to craft commercialization. While the carvings are a new craft without long-standing cultural importance, they were invented in a region where indigenous communities have specialized for hundreds of years in making different crafts. Postrevolutionary Mexican governments have consistently promoted craft production in Oaxaca and elsewhere for both ideological and economic reasons. The whimsical, colorful carvings fit in well with the magical realism of much Latin American

art and literature. Globalization helps explain why the wood-carving boom could occur in Oaxaca but does not explain why it happened there rather than in some other part of the world.

ARE THE WOOD-CARVERS AN EXAMPLE OF SUCCESSFUL DEVELOPMENT?

The wood-carving trade is in some respects an unusual case of successful rural development. Many families have improved their standard of living considerably by selling pieces to tourists, store owners, and wholesalers. Although carving sales have clearly increased differences between the rich and poor in some places, even the worst-off artisans are better off than they were before the boom. Few carvers think that they are exploited by wholesalers and store owners; instead, most express great appreciation for the dealers' patronage.

In many parts of the world the commercialization of crafts has led to class divisions between a few well-off merchants and artisans and a larger group of poorly paid hired laborers and piece workers. While such class divisions have arisen in the wood-carving trade, they seem less striking than in most other cases of craft commercialization. Young men and women from Arrazola and San Martín who learn the craft as piece workers or salaried laborers do not face financial obstacles when they later wish to work on their own. Artisans living in places where dealers visit less often, however, have more trouble establishing independent workshops. Although family workshops operate successfully in La Unión and San Pedro Cajonos, carvers and painters in San Pedro Taviche and other communities remain dependent on sales to intermediaries in Arrazola and San Martín.

When I began my research, I thought that the wood-carvers might provide a model for small-scale development via craft commercialization. After observing the trade over the past several years, I am much less sure about what generalizations can be drawn from this case. The key factors in the relatively equitable economic development in Arrazola and San Martín seem to be the low cost of materials, a demand for high-end pieces, and a marketplace that encourages experimentation and specialization. While these conditions doubtless exist for other crafts, they may not be all that common. More importantly, I am now less convinced that the wood-carvers are an unambiguous example of successful development. The money the carvers have earned has enabled them to live more comfortably over the past decade. But this money for the most part has not been invested in ways that will enable families to continue to prosper if the market for carvings collapses. Some families have

been able to provide more education for their children because of carving income. Many young men and women, however, have preferred the short-term profits from carving to the uncertain, potential long-term gains from education. Furthermore, the amount of money that can be earned from carving is ordinarily less than can be made through immigration to the United States. Even in the most prosperous carving villages, the best way for most young people to get ahead is to leave.

FUTURE PROSPECTS

Only eight years after the wood-carving boom began, Barbash (1993:40–42) was already concerned about the future prospects of the craft:

> How long will it last, this serendipitous interplay of market forces and creative spirit? Sales peaked in the late 1980s and have been hurt since by a sick U.S. economy [and] a gradual reevaluation of the peso . . . Many dealers have stopped buying entirely and are looking to the Pacific and the more impoverished Latin nations for bargains. Who knows? Perhaps ten years from now someone will write a book about the great carving boom in Bali, where people are also talented and prices are low.

Barbash's worries were unfounded in the short term, as carving sales rebounded and remained good throughout the 1990s. The major devaluation of the peso in late 1994 made wood carvings much cheaper for dealers; the U.S. economy became extraordinarily strong in the latter half of the decade. These economic factors alone, however, cannot account for the carvings' continuing popularity in the 1990s. Even (or perhaps especially) in prosperous times, consumers' preferences can change rapidly.

The carvers' success at the end of the twentieth century did not guarantee that sales would remain good in future years. Guatemalan textiles, for example, sold well between 1970 and 1990 with only a brief downturn during the height of a horrendous civil war in the early 1980s. But in the 1990s tastes in the United States changed, and the market for embroidered blouses, belts, and handbags weakened. One of the reasons for the wood-carvers' success was that their pieces fit in with a southwestern style of home design that was fashionable in the United States in the late 1980s and early 1990s. Some dealers speculated that the decreased popularity of this design style would weaken the demand for carvings. Yet Teotitlán rugs, which fit

in even better with this style than the carvings, sold reasonably well after the peak of the popularity of southwestern design.

By the end of the 1990s the carvings were featured prominently in guidebooks, videos, state tourist pamphlets, and websites about Oaxaca. Carvings were sold in government stores, displayed in museums, and advertised in catalogs and over the Internet. The wood carvings had become a "typical" Oaxacan craft along with textiles, pottery, and tinware. Although this invention of a craft tradition might help the sale of carvings, there was really no way to predict the future of the wood-carving trade. If the demand for inexpensive carvings had remained strong, the number of local intermediaries might have increased. Merchants from Teotitlán and Mitla specializing in textiles had already begun to buy wood carvings in Arrazola and San Martín. These pieces were taken to cities along the U.S. border and Mexican resorts such as Cancún. Furthermore, several wholesalers had Oaxacan representatives who were paid commissions to buy carvings and send them to the United States. Although Antonio Aragón and Saúl Aragón were until recently the only representatives from a wood-carving community, other entrepreneurial individuals from Arrazola and San Martín took up such work as dealers tired of trips to Oaxaca.

The likeliest consequence of a growing market in cheap pieces would have been the spread of wood carving to other communities. So far the only places where carvers have established significant ties with dealers are Arrazola, San Martín Tilcajete, La Unión Tejalapan, and San Pedro Cajonos. This situation might have changed as wholesalers sought out new artisans. I think it is more likely, however, that families in new carving communities would have been piece workers for merchants in Arrazola and San Martín. San Pedro Taviche would no longer have been the only satellite wood-carving village.

The future effects of the wood-carving trade on Oaxacan communities depended on more than whether sales continued to be good. The relative demand for expensive and cheap carvings would influence forms of work organization. A greater demand for high-end pieces would be likely to result in more carving specialties as families create new styles in efforts to attract wholesalers and collectors. An expanded market for low-end carvings would have quite different effects. Piece work would be more common in Arrazola and San Martín, and local merchants would become more important. More large workshops would be established.

Such speculation is now largely beside the point. At the beginning of the twenty-first century the demand for high-end carvings remained strong,

but the market for inexpensive pieces had collapsed. The results so far have not been surprising. The large factory-like workshops have either shut down or greatly reduced their scale of operations. Wood-carvers in satellite villages have suffered. The wood-carving trade is more than ever dominated by families making high-end, specialized pieces.

Critics of globalization could justifiably point to the uncertain future of the wood-carving trade as yet another example of the perils of local economies depending on unpredictable world market forces. Rural Oaxacan households, who know well the dangers of relying on only one source of income, have long pursued flexible economic strategies involving a mix of agriculture, crafts, wage work, and emigration. If the market for expensive carvings also collapses, there is no question that many families would suffer in the short run. The residents of Arrazola, San Martín, and La Unión, however, are ingenious and resilient. Their first reaction would undoubtedly be to rely more on subsistence farming, seek additional sources of wage work, and migrate more often and for longer periods. But they would probably not give up craft production. Someone, I suspect, would think of a new art form that tourists might like.

THE ROMANTICIZATION OF INDIGENOUS CRAFTS

Most Oaxacan wood-carvers are straightforward and matter-of-fact when asked about their craft and ethnicity. They readily say that wood carving is a new art form, that their primary motivation for making pieces is monetary, and that they would abandon the craft with little regret if the market collapsed. Many like making pieces and appreciate the artistic talent of their neighbors. But they know what it is like to be poor and cannot afford to be sentimental about their work. Although artisans in Arrazola, San Martín, and La Unión acknowledge indigenous ancestry, they talk about themselves as residents of a particular community, the state of Oaxaca, and the country of Mexico. I have never heard artisans in these villages identify themselves as "Indians" or "Zapotecs." Very few speak an indigenous language.

The portraits of the wood-carvers and their craft in many advertisements and tourist brochures differ greatly from what the artisans tell anyone willing to listen. The artisans are depicted as Zapotec Indians working in a craft tradition hundreds of years old. Men and women (never children) work together when they can spare time from farming. The inspiration for their pieces comes in dreams and often has a spiritual component. The discourse

of the marketers of wood carvings says nothing about the makers' color televisions, Michael Jordan T-shirts, and relatives in California.

Why is it necessary to portray the wood-carvers as noble Indians practicing an ancient craft? Is not a realistic story of ingenious men and women inventing an imaginative, appealing art form more interesting? The answers are obvious. The sellers know that crafts sell well when they fit into a romantic narrative that places the maximum cultural distance between artisans and customers. Many marketers of folk art are not being consciously untruthful, since they honestly believe that the carvers are Zapotec Indians who have been making pieces for many years. More knowledgeable dealers may be willing to mislead their customers by simply noting that the Indians of Oaxaca have been making crafts for a long time. Customers are allowed to infer that the carvings are part of this indigenous tradition.

Oaxacan wood carvings can aptly be described as an invented tradition. The artisans are not the primary creators of this particular tradition and are often surprised to learn how their craft has been depicted. The invented tradition results from cultural assumptions romanticizing indigenous crafts that are shared by the marketers and buyers of folk art. The artisans' lack of control over how they are represented is a consequence of their peripheral position in a global commodity chain. But would the carvers change the advertisements if they could? The romantic misrepresentations, after all, help the artisans sell their pieces. The wood-carving trade depends in part on intercultural miscommunication.

EPILOGUE

In May 2002 I had an unsettling telephone conversation with Clive Kincaid, the large-scale Arizona dealer of wood carvings who employed Saúl Aragón as his intermediary in Oaxaca. Although I knew that Clive's company, Designer Imports, was having some problems, I was surprised when he told me about a dramatic business decision that he had recently made. Designer Imports would no longer sell Oaxacan wood carvings.

Throughout the 1990s potential customers had crowded around Designer Imports' displays at gift shows. But at the beginning of the new millennium store owners and museum representatives were walking right past Clive's booth. Oaxacan wood carvings had become old news; the retailers of folk art, as always, were searching for something different. Clive's response was to reduce Designer Imports' purchases of wood carvings and to rely more on sales of baskets from Panama and pottery from the Mexican state of Chihuahua. Despite this new business strategy, Clive lost thousands of dollars during fall

2001. He was forced to give up his warehouse in Arizona and to lay off his eight employees. In spring 2002 Clive and his wife, Chris, were running the business from their home and exploring alternative employment possibilities.

When I talked to Clive, he and Chris had just turned down job offers from the U.S. Park Service and were attempting to keep Designer Imports operating a while longer. They had reached the conclusion that dealing in wood carvings was a dead end. For the next year the business would focus exclusively on Panamanian baskets and Chihuahuan pots. The decision to stop buying wood carvings was only partly related to dropping sales. The transaction cost for selling a wood carving was much greater than that for baskets and pots. Designer Imports received on average $9.50 for a wood carving; sales of baskets and pots averaged $40 to $50 apiece. Moreover, wood carvings usually consisted of multiple parts, which were sometimes lost or broken in transit from Mexico to Arizona.

Clive dreaded the phone call that he was going to make later in the day. The time had come to tell Saúl that there would be no further wood-carving orders. Because Saúl is educated, resourceful, and capable, I thought that he would eventually find another good job. I was more worried about the many wood-carving families who relied on Designer Imports as their most important customer.

Although Clive's decision reflects a weakening of the market for inexpensive Oaxacan wood carvings, there is no reason to assume that the trade will disappear. At the beginning of the twenty-first century there was still considerable demand for high-end wood carvings. Furthermore, one cannot make inferences about the fate of a craft from the actions of one company. Designer Imports, for example, had stopped buying weavings from Teotitlán after rug sales dipped in the early 1990s. Nonetheless, Teotitlán rugs were selling well in 2002, if perhaps not at the level of previous years.

Despite a genuine desire to help the wood-carvers of Oaxaca, Clive Kincaid ultimately reached the bottom-line conclusion that Designer Imports would do better by selling products made elsewhere. This decision will affect the livelihoods of hundreds of people in Oaxaca, Chihuahua, and Panama. Critics of globalization might suggest that Clive's actions illustrate how rural Third World artisans have lost autonomy as they have become more immersed in the world economy. Proponents of globalization might point out that the purchases of Designer Imports enabled many rural Oaxacan families to improve their standard of living over the past two de-

cades. Both the critics and the proponents would be right. I cannot think of a better example of the double-edged impact of globalization.

When I told this story to my friends, many asked if they could do something to help the wood-carvers. In the long run individual actions can have only limited effects on the inexorable changes in demand for particular types of folk art. But there is a small way in which everyone can help right now: just buy a Oaxacan wood carving.

REFERENCES CITED

Annis, Sheldon
1987 God and Production in a Guatemalan Town. Austin: University of Texas Press.
Annis, Sheldon, and Peter Hakim, eds.
1988 Direct to the Poor: Grassroots Development in Latin America. Boulder, Colo.: Lynne Rienner.
Appadurai, Arjun
1986a Introduction: Commodities and the Politics of Value. *In* The Social Life of Things: Commodities in Cultural Perspective, Arjun Appadurai, ed., pp. 3–63. Cambridge: Cambridge University Press.
1996 Modernity at Large: Cultural Dimensions of Globalization. Minneapolis: University of Minneapolis Press.
Appadurai, Arjun, ed.
1986b The Social Life of Things: Commodities in Cultural Perspective. Cambridge: Cambridge University Press.
Atl, Dr. [Gerardo Murillo]
1922 Las artes populares en México. Mexico City: Secretaría de Industria y Comercio.
Baird, David, Lynne Bairstow, and Lynne Pérez
1999 Frommer's Mexico 1999. New York: Macmillan.
Barbash, Shepard
1991 These Magicians Carve Dreams with Their Own Machetes. Smithsonian (May):119–129.
1993 Oaxacan Wood Carving: The Magic in the Trees. With photographs by Vicki Ragan. San Francisco: Chronicle Books.

1996 Margarito's Carvings. With photographs by Vicki Ragan. Glenview, Ill.: Celebration Press.

Barlett, Peggy
1982 Agricultural Choice and Change: Decision Making in a Costa Rican Community. New Brunswick, N.J.: Rutgers University Press.

Barnard, Nicholas
1991 Living with Folk Art: Ethnic Styles from around the World. Boston: Little, Brown.

Barry, Tom
1995 Zapata's Revenge: Free Trade and the Farm Crisis in Mexico. Boston: South End Press.

Baskes, Jeremy
2000 Indians, Merchants, and Markets: A Reinterpretation of the *Repartimiento* and Spanish-Indian Relations in Colonial Oaxaca, 1750–1821. Stanford: Stanford University Press.

Berrigan, John, and Carl Finkbeiner
1992 Segmentation Marketing. New York: Harper Collins.

Blanton, Richard, Gary Feinman, Stephen Kowaleski, and Linda Nicholas
1999 Ancient Oaxaca. Cambridge: Cambridge University Press.

Blim, Michael, and Frances Rothstein, eds.
1992 Anthropology and the Global Factory: Studies of the New Industrialization in the Late Twentieth Century. New York: Bergin and Garvey.

Brulotte, Ronda
1999 www.alebrijes.com: The Commodification of Oaxacan Woodcarving in Cyberspace. M.A. thesis, Department of Anthropology, University of Texas.

Burrows, Colin
1990 Processes of Vegetation Change. London: Unwin Hyman.

Cabrera Santos, Rene
1998 Diagnóstico de salud de la unidad de San Martín Tilcajete 1997. Report for the Secretaría de Salud en el Estado de Oaxaca, Jurisdicción Sanitaria No. 1.

Cancian, Frank
1989 Economic Behavior in Peasant Communities. *In* Economic Anthropology, Stuart Plattner, ed., pp. 127–170. Stanford: Stanford University Press.

Capron, Noel
1978 Product Life Cycle. Boston: HBS Case Services, Harvard Business School.

Chayanov, A. V.
1966 [1920s] The Theory of Peasant Economy. Translated from the Russian and German editions. Homewood, Ill.: R. Irwin.

Chibnik, Michael
1981 The Evolution of Cultural Rules. Journal of Anthropological Research 37: 256–268.

1994 Risky Rivers: The Economics and Politics of Floodplain Farming in Amazonia. Tucson: University of Arizona Press.

1997 Las figuras de madera de Oaxaca. Huaxyácac 4(12):4–6.

Cohen, Jeffrey
1998 Craft Production and the Challenge of the Global Market: An Artisans' Cooperative in Oaxaca, Mexico. Human Organization 57:74–82.

1999 Cooperation and Community: Economy and Society in Oaxaca. Austin: University of Texas Press.

2001 Transnational Migration in Rural Oaxaca, Mexico: Dependency, Development, and the Household. American Anthropologist 103(4):954–967.

Colinvaux, Paul
1973 Introduction to Ecology. New York: Wiley.
Collins, Jane
2000 Tracing Social Relations in Commodity Chains: The Case of Grapes in Brazil. *In* Commodities and Globalization: Anthropological Perspectives, Angelique Haugerud, M. Priscilla Stone, and Peter Little, eds., pp. 97–109. Monographs in Economic Anthropology No. 16, Society for Economic Anthropology. Lanham, Md.: Rowman and Littlefield.
Colloredo-Mansfeld, Rudi
1999 The Native Leisure Class: Consumption and Cultural Creativity in the Andes. Chicago: University of Chicago Press.
2001 Artesanía, competencia, y la concentración de la expresión cultural en las comunidades andinas. Ecuador Debate 52:135–150.
2002 An Ethnography of Neoliberalism: Understanding Competition in Artisan Economies. Current Anthropology 43(1):113–137.
Consejo Estatal de Población
1994 Población indígena de Oaxaca, 1895–1900. Oaxaca: Consejo Estatal de Población.
Cook, Scott
1993 Craft Commodity Production, Market Diversity, and Differential Rewards in Mexican Capitalism Today. *In* Crafts in the World Market: The Impact of Global Exchange on Middle American Artisans, June Nash, ed., pp. 59–83. Albany: State University of New York Press.
Cook, Scott, and Leigh Binford
1990 Obliging Need: Rural Petty Industry in Mexican Capitalism. Austin: University of Texas Press.
Cook, Scott, and Martin Diskin, eds.
1976 Markets in Oaxaca. Austin: University of Texas Press.
Cook, Scott, and Jong-Taick Joo
1995 Ethnicity and Economy in Rural Mexico: A Critique of the Indigenista Approach. Latin American Research Review 30(2):33–59.
Cummings, Joe, and Chicki Mallan
1999 Moon Handbooks: Mexico. Emeryville, Calif.: Avalon Travel Publishing.
Durham, William
1990 Advances in Evolutionary Culture Theory. Annual Review of Anthropology 19:187–210.
Fisher, John
1998 Mexico. London: Rough Guides.
Foster, George
1962 Traditional Cultures. New York: Harper and Row.
Frank, Robert, and Philip Cook
1995 The Winner-Take-All Society: Why the Few at the Top Get So Much More Than the Rest of Us. New York: Free Press.
Friedman, Thomas
1999 The Lexus and the Olive Tree. New York: Farrar, Straus and Giroux.
García Canclini, Néstor
1993 Transforming Modernity: Popular Culture in Mexico. Translated from Spanish by Lidia Lozano. Austin: University of Texas Press.
González Esperón, Luz María
1997 Crónicas diversas de artesanos oaxaqueños: Tradiciones, memorias, y relatos. Oaxaca: Instituto Oaxaqueño de las Culturas.

Goody, Esther

1982 From Craft to Industry. Cambridge: Cambridge University Press.

Graburn, Nelson

1993 Ethnic Arts of the Fourth World: The View from Canada. *In* Imagery and Creativity: Ethnoaesthetics and Art Worlds in the Americas, Dorothea Whitten and Norman Whitten, eds., pp. 171–294. Tucson: University of Arizona Press.

1999 Epilogue: Ethnic and Tourist Arts Revisited. *In* Unpacking Culture: Art and Commodity in Colonial and Postcolonial Worlds, Ruth Phillips and Christopher Steiner, eds., pp. 335–353. Berkeley: University of California Press.

Graburn, Nelson, ed.

1976 Ethnic and Tourist Arts: Cultural Expressions from the Fourth World. Berkeley: University of California Press.

Gunder Frank, Andre

1969 Latin America: Underdevelopment or Revolution. New York: Monthly Review Press.

Gupta, Akhil

1998 Postcolonial Developments: Agriculture in the Making of Modern India. Durham, N.C.: Duke University Press.

Hall, Dinah

1992 Ethnic Interiors: Decorating with Natural Materials. Photographs by James Merrell. New York: Rizzoli.

Hancock Sandoval, Judith

1998 Shopping in Oaxaca. Oaxaca: Gobierno del Estado de Oaxaca.

Harvey, David

1989 The Condition of Postmodernity. Oxford: Basil Blackwell.

Haugerud, Angelique, M. Priscilla Stone, and Peter Little, eds.

2000 Commodities and Globalization: Anthropological Perspectives. Monographs in Economic Anthropology No. 16, Society for Economic Anthropology. Lanham, Md.: Rowman and Littlefield.

Hendrickson, Carol

1996 Selling Guatemala: Maya Export Products in U.S. Mail-Order Catalogues. *In* Cross-Cultural Consumption: Global Markets, Local Realities, David Howes, ed., pp. 106–121. London: Routledge.

Hernández-Díaz, Jorge, Gloria Zafra, Thelma Ortiz Blas, and Alfonso Hernández Gómez

2001 Artesanías y artesanos en Oaxaca: Innovaciones de la tradición. Oaxaca: Instituto Estatal de Educación Pública de Oaxaca.

Hirschman, Albert

1984 Getting Ahead Collectively: Grassroots Experiences in Latin America. New York: Pergamon.

Hobsbawm, Eric

1983 Introduction: Inventing Traditions. *In* The Invention of Tradition, Eric Hobsbawm, and Terence Ranger, eds., pp. 1–14. Cambridge: Cambridge University Press.

Howes, David, ed.

1996 Cross-Cultural Consumption: Global Markets, Local Realities. London: Routledge.

INEGI (Instituto Nacional de Estadística, Geografía e Información)

1995 Conteo de población, 1995. Oaxaca: Instituto Nacional de Estadística, Geografía e Información (INEGI).

Innes, Miranda
1994 Ethnic Style, from Mexico to the Mediterranean. New York: Cross River Press.

International Financial Statistics Yearbook
1999 International Financial Statistics Yearbook. Washington, D.C.: International Monetary Fund.

Kaplan, Flora
1993 Mexican Museums in the Creation of a National Image in World Tourism. *In* Crafts in the World Market: The Impact of Global Exchange on Middle American Artisans, June Nash, ed., pp. 103–125. Albany: State University of New York Press.

Kearney, Michael
1995 The Effects of Transnational Culture, Economy, and Migration on Mixtec Identity in Oaxacalifornia. *In* The Bubbling Cauldron: Race, Ethnicity, and the Urban Crisis, Michael Smith and Joe Feagin, eds., pp. 226–243. Minneapolis: University of Minnesota Press.
1996 Reconceptualizing the Peasantry: Anthropology in Global Perspective. Boulder, Colo.: Westview Press.

Kleymeyer, Charles, ed.
1994 Cultural Expression and Grassroots Development: Cases from Latin America and the Caribbean. Boulder, Colo.: Lynne Rienner.

Knight, Alan
1990 Racism, Revolution, and Indigenismo: Mexico, 1910–1940. *In* The Idea of Race in Latin America, Richard Graham, ed., pp. 71–107. Austin: University of Texas Press.

Lee, Molly
1999 Tourism and Taste Cultures: Collecting Native Art in Alaska at the Turn of the Twentieth Century. *In* Unpacking Culture: Art and Commodity in Colonial and Postcolonial Worlds, Ruth Phillips and Christopher Steiner, eds., pp. 267–281. Berkeley: University of California Press.

Lenin, V. I.
1964 [1899] The Development of Capitalism in Russia. Moscow: Progress Publishers.

Little, Kenneth
1991 On Safari: The Visual Politics of a Tourist Representation. *In* The Varieties of Sensory Experience, David Howes, ed., pp. 148–163. Toronto: University of Toronto Press.

Little, Walter
2000 Home as a Place of Exhibition and Performance: Mayan Household Transformations in Guatemala. Ethnology 29(2):163–181.

Littlefield, Alice
1979 The Expansion of Capitalist Relations of Production in Mexican Crafts. Journal of Peasant Studies 6(4):471–488.

López Gómez, Ana María
2001 Evaluación de la demanda y extracción de madera de copal (*Bursera* spp.) para artesanía en comunidades de los valles centrales de Oaxaca. Tesis de Licenciatura, Universidad Nacional Autónoma de México (UNAM), Facultad de Ciencias.

Luna, Luis Eduardo, and Pablo Amaringo
1991 Ayahuasca Visions: The Religious Iconography of a Peruvian Shaman. Berkeley: North Atlantic Books.

Marcus, George
1995 Ethnography in/of the World System: The Emergence of Multi-Sited Ethnography. Annual Review of Anthropology 24:95–117.
Marcus, George, and Fred Myers, eds.
1995 The Traffic in Culture: Refiguring Art and Anthropology. Berkeley: University of California Press.
Masuoka, Susan
1994 En Calavera: The Papier-Mâché Art of the Linares Family. Los Angeles: UCLA Fowler Museum of Cultural History.
Meisch, Lynn
1998 The Reconquest of Otavalo, Ecuador: Indigenous Economic Gains and New Power Relations. *In* Research in Economic Anthropology, vol. 19, Barry Isaac, ed., pp. 11–30. Stamford, Conn.: JAI Press.
Miller, Daniel
1998 A Theory of Shopping. Ithaca, N.Y.: Cornell University Press.
Mintz, Sidney
1985 Sweetness and Power: The Place of Sugar in Modern History. New York: Viking.
Mullin, Molly
1995 The Patronage of Difference: Making Indian Art "Art, Not Ethnology." *In* The Traffic of Culture: Refiguring Art and Anthropology, George Marcus and Fred Myers, eds., pp. 166–198. Berkeley: University of California Press.
Murphy, Arthur, and Alex Stepick
1991 Social Inequality in Oaxaca. Philadelphia: Temple University Press.
Myers, Fred
1991 Representing Culture: The Production of Discourse(s) for Aboriginal Acrylic Paintings. Cultural Anthropology 6:26–63.
Nash, June
1993a Introduction: Traditional Arts and Changing Markets in Middle America. *In* Crafts in the World Market: The Impact of Global Exchange on Middle American Artisans, June Nash, ed., pp. 1–22. Albany: State University of New York Press.
1994 Global Integration and Subsistence Security. American Anthropologist 96(1):7–30.
Nash, June, ed.
1993b Crafts in the World Market: The Impact of Global Exchange on Middle American Artisans. Albany: State University of New York Press.
Noble, John, Michelle Matter, Nancy Kelly, Daniel Schechter, James Lyon, and Scott Doggett
1999 Lonely Planet Mexico. Oakland: Lonely Planet Publications.
Novelo, Victoria
1976 Artesanías y capitalismo en México. Mexico City: SEP-INAH.
Oettinger, Marion
1990 Folk Treasures of Mexico: The Nelson A. Rockefeller Collection in the San Antonio Museum of Art and the Mexican Museum, San Francisco. New York: Abrams.
Onkvisit, Sak, and John Shaw
1989 Product Life Cycles and Product Management. New York: Quorum Books.
Ortiz, Sutti
1979 The Effect of Risk Aversion Strategies on Subsistence and Cash Crop Decisions. *In* Risk, Uncertainty, and Agricultural Development, James

Roumasset, Jean-Marc Boussard, and Inderjit Singh, eds., pp. 231–246. New York: Agricultural Development Council.

Peden, Margaret Sayers
1991 Out of the Volcano: Portraits of Contemporary Mexican Artists. Washington, D.C.: Smithsonian Institution Press.

Phillips, Ruth, and Christopher Steiner
1999a Art, Authenticity, and the Baggage of Cultural Encounter. *In* Unpacking Culture: Art and Commodity in Colonial and Postcolonial Worlds, Ruth Phillips and Christopher Steiner, eds., pp. 3–19. Berkeley: University of California Press.

Phillips, Ruth, and Christopher Steiner, eds.
1999b Unpacking Culture: Art and Commodity in Colonial and Postcolonial Worlds. Berkeley: University of California Press.

Price, Sally
1989 Primitive Art in Civilized Places. Chicago: University of Chicago Press.

Rogers, Everett
1969 Modernization among Peasants: The Impact of Communication. New York: Holt, Rinehart, and Winston.

Roseberry, William
1989 Anthropologies and Histories: Essays in Culture, History, and Political Economy. New Brunswick, N.J.: Rutgers University Press.

Ross, John
1998 The Annexation of Mexico: From the Aztecs to the I.M.F. Monroe, Maine: Common Courage Press.

Rouse, Roger
1988 Mexican Migration to the United States: Family Relations in the Development of a Transnational Migrant Circuit. Ph.D. diss., Department of Anthropology, Stanford University.

Rutz, Henry, and Benjamin Orlove, eds.
1989 The Social Economy of Consumption. Monographs in Economic Anthropology No. 6, Society for Economic Anthropology. Lanham, Md.: University Press of America.

Schmitz, Hubert
1982 Manufacturing in the Backyard: Case Studies on Accumulation and Employment in Small-Scale Brazilian Industry. London: F. Pinter.

Scott, James
1976 The Moral Economy of the Peasant: Subsistence and Rebellion in Southeast Asia. New Haven: Yale University Press.
1985 Weapons of the Weak: Everyday Forms of Peasant Resistance. New Haven: Yale University Press.

Serrie, Hendrick
1964 The Emerging Artist in a Society of Craftsmen: Three Case Studies. M.A. thesis, Department of Anthropology, Cornell University.

Silverman, Eric
1999 Tourist Art as the Crafting of Identity in the Sepik River (Papua New Guinea). *In* Unpacking Culture: Art and Commodity in Colonial and Postcolonial Worlds, Ruth Phillips and Christopher Steiner, eds., pp. 51–66. Berkeley: University of California Press.

Spencer, Charles
1999 Palatial Digs. Natural History 108(2):94–95.

Spencer, Charles, and Elise Redmond
2001 Multilevel Selection and Political Evolution in the Valley of Oaxaca 500–
 100 B.C. Journal of Anthropological Archaeology 20:195–229.
Steiner, Christopher
1994 African Art in Transit. Cambridge: Cambridge University Press.
Stephen, Lynn
1991 Zapotec Women. Austin: University of Texas Press.
1993 Weaving in the Fast Lane: Class, Ethnicity, and Gender in Zapotec Craft
 Commercialization. In Crafts in the World Market: The Impact of Global
 Exchange on Middle American Artisans, June Nash, ed., pp. 25–57. Albany:
 State University of New York Press.
Stocking, George, ed.
1985 Objects and Others: Essays on Museums and Material Culture. Madison:
 University of Wisconsin Press.
Stone, M. Priscilla, Angelique Haugerud, and Peter Little
2000 Commodities and Globalization: Anthropological Perspectives. In Com-
 modities and Globalization: Anthropological Perspectives, Angelique
 Haugerud, M. Priscilla Stone, and Peter Little, eds., pp. 1–29. Monographs
 in Economic Anthropology No. 16, Society for Economic Anthropology.
 Lanham, Md.: Rowman and Littlefield.
Stromberg, Gobi
n.d. El juego de coyote: Platería y arte en Taxco. Unpublished manuscript.
Stromberg-Pellizzi, Gobi
1993 Coyotes and Culture Brokers: The Production and Marketing of Taxco
 Silverwork. In Crafts in the World Market: The Impact of Global Exchange
 on Middle American Artisans, June Nash, ed., pp. 85–100. Albany: State
 University of New York Press.
Taylor, William
1976 Town and Country in the Valley of Oaxaca, 1750–1812. In Provinces of
 Early Mexico: Variants of Spanish American Regional Evolution, Ida
 Altman and James Lockhart, eds., pp. 63–95. Los Angeles: UCLA Latin
 American Center Publications.
Thompson, Richard
1974 The Winds of Tomorrow: Social Change in a Maya Town. Chicago: Univer-
 sity of Chicago Press.
Tice, Karin
1995 Kuna Crafts, Gender, and the Global Economy. Austin: University of Texas
 Press.
Todd, Amy
1998 The Structure and Function of Vendors' Associations in the City of Oaxaca,
 Mexico. Paper presented at the Third Biennial Conference of Oaxacan Stud-
 ies, Oaxaca, Mexico.
Turok, María
1988 Cómo acercarse a la artesanía. Mexico City: Plaza y Valdés.
Vargas-Cetina, Gabriela
2000 From Handicraft to Monocrop: The Production of Pecorino Cheese in High-
 land Sardinia. In Commodities and Globalization: Anthropological Perspec-
 tives, Angelique Haugerud, M. Priscilla Stone, and Peter Little, eds., pp.
 219–238. Monographs in Economic Anthropology No. 16, Society for Eco-
 nomic Anthropology. Lanham, Md.: Rowman and Littlefield.
Wallerstein, Immanuel

1974 The Modern World System: Capitalist Agriculture and the Origins of the European World-Economy in the Sixteenth Century. New York: Academic Press.

Wasserspring, Lois

2000 Oaxacan Ceramics: Traditional Folk Art by Oaxacan Women. San Francisco: Chronicle Books.

Waterbury, Ronald

1989 Embroidery for Tourists: A Contemporary Putting-Out System in Oaxaca, Mexico. *In* Cloth and Human Experience, Annette Weiner and Jane Schneider, eds., pp. 243–271. Washington, D.C.: Smithsonian Institution Press.

Weil, Jim

1997 An *Ecomuseo* for San Vincente: Ceramic Artisans and Cultural Tourism in Costa Rica. Museum Anthropology 21(2):23–38.

Weil, Jim, ed.

1995 "Multiple Livelihoods" in Contemporary Societies: Ethnographic Sketches of Individuals, Households and Community. Anthropology of Work Review 16 (1–2):1–46.

Weinstein, Art

1987 Market Segmentation. Chicago: Probus.

White, Bob

2000 *Soukous* or Sell-Out?: Congolese Popular Dance Music as Cultural Commodity. *In* Commodities and Globalization: Anthropological Perspectives, Angelique Haugerud, M. Priscilla Stone, and Peter Little, eds., pp. 33–57. Monographs in Economic Anthropology No. 16, Society for Economic Anthropology. Lanham, Md.: Rowman and Littlefield.

Wilk, Richard

1999 "Real Belizean Food": Building Local Identity in the Transnational Caribbean. American Anthropologist 101(2):244–255.

Wolf, Eric

1982 Europe and the People without History. Berkeley: University of California Press.

Wood, William Warner

1997 To Learn Weaving below the Rock: Making Zapotec Textiles and Artisans in Teotitlán del Valle, Mexico. Ph.D. diss., Department of Anthropology, University of Illinois.

2000a Flexible Production, Households, and Fieldwork: Multisited Zapotec Weavers in the Era of Late Capitalism. Ethnology 39(2):133–148.

2000b Stories from the Field: Handicraft Production and Mexican National Patrimony: A Lesson in Translocality from B. Traven. Ethnology 39(3):183–203.

Young, Biloine

1996 Mexican Odyssey: Our Search for the People's Art. St. Paul, Minn.: Pogo Press.

INDEX

Arreola, Alma, 36, 37
Arte y Tradición, 36–37, 186
Artisan families: in Arrazola, 45, 46, 86,
119; and Barbash/Ragan publications,
179, 181–182, 183; and capitalism, 118,
123; changes in lives of, xiv; and deal-
ers, 41–44, 238; and hiring of piece
workers, 110; household economic
strategies of, 82–92; in La Unión
Tejalapan, 47, 86, 239; and organization
of labor, 113, 114, 117, 118, 119, 123;
organizations of, 51–53, 156, 201; and
prices, 138; and rural communities, 5–
6, 118; in San Martín Tilcajete, 46, 50,
86, 119; and signatures, 58; signs and
business cards of, 46, 58–59; and suc-
cess, 148; and wood-carving boom, xv,
37–40

Barbash, Shepard: and carving tools, 103;
effect of publications on wood-carving
trade, xiv, 51, 91, 139, 174, 175–183; on
future prospects of wood-carving trade,
240; on global economy, 237; and mar-
keting of Oaxacan wood carvings, 56,
174, 175, 178, 226; on migration, 101;
and Reyes, 170; and sales, 49; on
Miguel and José Santiago, 155;
Smithsonian article, xiii, 177–183, 206;
on wholesalers, 209; and wood-carving
boom, 39
Bastulo, Nicodemus, 34–35, 50, 194–195
Betteridge, Fran, 210, 217–218
Blas family, 50, 173, 187, 189, 197, 212,
214
Boyd, Jerre, 87, 209, 210, 234

Cabrera Santos, Rene, 73, 74
Calvo, Francisca, 100
Calvo, Juana, 89, 90
Capitalism: and agriculture, 85; and Cen-
tral Valleys of Oaxaca, 61; and factory-
like workshops, 113, 117, 118, 119,
122, 123; household economic
strategies, 61–62, 93; and input/output
calculations, 110–111; and interna-
tional capital, 3–4; and marketing, 125;
and post-Fordist systems, 6; and rural
communities, 5
Cárdenas, Lázaro, 64, 67
Carrillo, Catarino, 38, 104, 108
Carter, Jimmy, 1, 53
Carver, Holly, 229–230
Casa Víctor, 143, 186, 192
Catalogs, 2, 42, 225–229, 238

Cedar, 95, 159, 162, 195
Central Valleys of Oaxaca: and agricul-
ture, 60–61, 63, 83; cultural traditions
of, 60–61; and ethnic and tourist arts,
15; and ethnicity, 65–66; general de-
scription of, 60, 63–79; and land tenure,
64; map of, 61; and sociopolitical rela-
tions, 63–65; and tourism, 14
Chayanov, A. V., 5, 110–111, 123
Chimalli, 186, 187, 196
Cohen, Jeffrey, 74, 86
Colloredo-Mansfeld, Rudi, 147–148, 150,
172, 173
Commodity chains: and catalogs and
Internet sales, 225, 234; and ethnic and
tourist arts, 2, 3–5; and globalization,
236, 237–238; and international capi-
tal, 3–4; and organization of labor, 4,
119; and social life of commodities, 16;
and wholesalers, 211, 212, 220; and
wood-carving production, 109
Cook, Scott, 61, 66, 119–120
Copal, 25, 29, 50, 52, 94–98, 96–97, 135,
162, 231–232
Corazón del Pueblo, 186, 187, 190–192,
194, 195
Cortez, Edilberto, 133
Craft commercialization: and artisan sig-
natures, 57–58; and ethnic and tourist
arts, 2, 4, 6–7; and globalization, 2, 236,
238; and Manuel Jiménez, 23–26; and
Oaxacan wood carvings, 6–7, 23–30;
and organization of labor, 113; and so-
cial stratification, 9, 239; and special-
ization, 146
Cross, Carol, 166, 209–210, 216–217
Cruz, Augustín, 132, 189
Cruz, Isidoro: and commercialization of
wood carving, 27–28, 30, 33; display
room of, 161; economic strategies of,
149; and exhibitions, 55; and location of
wood-carvers, 50; and Coindo Melchor,
29, 41, 42; and painting, 104; photo-
graph of, 159; and position at FONART,
29, 32, 42, 160; and prices, 137; and San
Martín Tilcajete, 45; and sharing of
knowledge, 31; style of, 128, 194; and
success, 151, 153, 159–162, 172, 173;
and tourism, 159, 160, 161, 203, 204;
and wholesalers, 216; work style of,
171; and zompantle, 95, 159, 162
Cruz, Mercedes, 115–116, 117, 122, 143
Cultural representations: and Barbash/
Ragan publications, 177, 179–180, 183;
and ethnic and tourist arts, 3, 4–5, 9;

Hancock Sandoval, Judith, 14–15
Hendrickson, Carol, 11, 226
Hernández, José, 29, 31, 32, 45, 136, 151, 170, 171
Household economic strategies: and capitalism, 61–62, 93; changes in, xiv, 80; examples of, 86–92; and globalization, 242; and multiple economic goals, 82–86; and risk aversion, 81–82; and specialization, 130; and wood-carving boom, 37; and wood-carving trade changes, xv
Hybrid art forms, 2, 3, 10

Internet: and globalization, 234, 236; sales from, 2, 225–227, 229–234, 238; and U.S. shop owners, 221, 223; and wholesalers, 218
Invented tradition, 2, 232–233, 238, 241, 242–243

Jiménez, Agapito, 43, 163
Jiménez, Alberto, 163, 164, 165, 166
Jiménez, Angélico, 21, 23, 31, 32
Jiménez, Aron, 43–44, 163, 164, 165, 166
Jiménez, Cándido, 163, 164, 165, 166
Jiménez, Galinda, 163, 164
Jiménez, Isaías, 21, 23, 31, 32
Jiménez, Manuel: and artisan organizations, 52; Barbash on, 178; and cedar, 95; and commercialization of wood carving, 23–26, 30; and dealers, 45; and exhibitions, 28, 55; as founder of Oaxacan wood carving, 18, 19–20, 23, 158, 208, 224; paint used by, 32; photographs of, 20; and prices, 137, 138, 153, 172; Miguel Santiago related to, 154; style of, 45, 128, 182, 183, 194, 214; and success, 151, 152, 173; and tourism, 22, 23, 30, 54, 156; and Train and de la Lanza, 24–26; and wholesalers, 216; and wood-carving contests, 29; and wood-carving trade, 20–23; work of, 21, 22
Jiménez, María: economic strategies of, 149, 162, 165–166; and exhibitions, 55; and Kincaid, 43–44; and Oaxaca (city) shops, 189; and organization of labor, 122; photograph of, 163; and San Martín Tilcajete wood carving, 45; style of, 43, 129, 135, 136; and success, 153, 162–166, 172, 173; and tourism, 164; work of, 165; work output of, 109–110, 171
Jiménez, Miguel, 163, 164, 165, 166

Jiménez, Román, 163, 164, 165
Jiménez, Victoria, 163, 164, 165
Journalism: and cultural representation, 174–175, 183; effect on wood-carving trade, 175–183; and gender relations, 162; and success, 150

Kearney, Michael, 61, 62
Kincaid, Chris, 210, 211, 246
Kincaid, Clive, 37, 43–44, 49, 111, 209, 210–215, 216, 220, 234, 245–246

La Mano Mágica, 186, 189–190, 191, 192, 193, 194, 195
La Unión Tejalapan: and Barbash/Ragan publications, 180, 182; and copal, 95; and dealers, 46–47, 51, 166, 170, 188, 241; and differences among carving communities, 44–47; ethnicity of, 78; and exhibitions, 55; general description of, 62, 77–79; and household economic strategies, 82, 84, 86, 90–91, 242; and influence of wider world, 60; and Oaxaca (city) shops, 188, 189, 191, 192; and signs and business cards, 46, 59; and success, 150, 151, 166, 173; and tourism, 77, 202; and wholesalers, 213–214, 216; and wood-carving boom, 44, 47, 69; as wood-carving community, xiii–xiv, 2, 18, 26, 30, 34–35, 51, 79; and wood-carving production, 84, 104; and wood-carving styles, 46, 47, 127–128, 129, 131, 136, 140–143, 144, 153, 167, 169, 195
Lenin, V. I., 5, 6, 123
Linares family, 10, 131, 229
López, Reina, 102, 103, 107, 107, 134
López, Yolanda, 48
Lucas, Marcia, 166

Mandarín, Antonio, 96–97, 114–115, 151, 171
Marketing: and artisan signatures, 58; and artisans' markets, 52; and Barbash, 56, 174, 175, 178, 226; and Bastulo, 34; and catalogs and Internet sales, 226–227; and comparisons with other Oaxacan crafts, 120–121; and craft production, 63; and ethnic and tourist arts, 4; and invented tradition, 243; and journalism, 174, 175; and market development, 125–127; and Mixe workshop, 197–198; of Oaxacan wood carvings, 2; and organization of labor, 123; and post-Fordist systems, 6; and prices, xv,

49, 137; and product life cycles, 125–126; and San Martín Tilcajete, 31, 32–33; and specialization, 123, 124, 127, 144–145, 146; state support of, 29–30; and success, 151, 152, 153, 159, 172; and tourism, 205; U.S. marketing channels, 209–234; and wood-carving boom, 39

Martínez, Leoncio, 181, 203

Martínez, Noel, 196–198

Matías, Alba, 143–144

Matías, Roberto, *135*, 203

Mayer, Enrique, 222

Mayer, Francisca, 222

Mayordomo system, 63, 64, 66, 70, 71, 76, 79

Melchor, Coindo: carving tools of, 103; and Isidoro Cruz, 29, 41, 42; and Juventino Melchor, 88; and Rockefeller, 32; and San Martín Tilcajete, 45; and specialization, 130; style of, 41–42, 181; and tourism, 204; and wholesalers, 34; work of, *33, 42*

Melchor, Inocente, 42–43, 101, *102*, 103, 105, 107, *134*, 203, 220

Melchor, Jesús, 42–43, 95, 103, 171, 221

Melchor, Martín, 103–104, 107, 138–140, *139, 140, 141*, 151, 181, 208

Melchor Fuentes, Margarito: and Barbash, 129, 176, 181; and Isidoro Cruz, 29; and exhibitions, 56–57; and Oaxaca (city) shops, 189; and success, 171, 173; and tourism, 203; and U.S. shops, 208; and wholesalers, 34; and wife's painting style, 162

Melchor Santiago, Margarito, 56–57, *132, 133*

Méndez, Isidoro, 90, 92

Méndez, Jaime, 90, 91–92

Mendoza, Arnulfo, 189–190

Mendoza, Rafael, *134*

Mexican government: and craft promotion, 26, 29, 61; ideological and economic goals of, 7–10, 24, 237, 238; and state-sponsored exhibitions, 53, 150; and wood-carving trade in San Martín Telcajete, 27–30

Mexican Revolution, 7–8, 64, 73

Migration: and bracero program, 26, 67, 160; and Isidoro Cruz, 160; effects of, 63, 65; and household economic strategies, 33, 80, 81, 82, 84, 85, 86, 91, 92, 173; and María Jiménez' family, 163, 164, 165; and material well-being, 149; and Inocente Melchor, 101, 103; moti-

vations for, 40, 65, 73, 74–76, 78, 79; polybian migrants, 62; and Reyes' family, 169; and specialization, 145; woodcarving production compared to, 240

Mitla, 63, 161, 241

Mixe workshop, 195–198

Mixtecs, 63, 66, 78

Modernization theory, 5, 6, 235–236

Monte Albán, 24, 25, 31, 38, 63, 66, 67, 68–69

Morales, Alejo, 181, 182

Morales, Eleazar, *133*, 189

Morales, Francisco, 136–137, 151, 216

Morales, Maximiliano, 138

Morales Martínez, Damián, 87, 220

NAFTA (North American Free Trade Agreement), 237

National identity, 7, 9

Oaxaca (city): and ethnic and tourist arts, 14, 15; and La Unión Tejalapan, 35; map of, *185*; and migration, 67–68, 73, 78; shops of, 34, 35, 38, 41, 53, 144, 186–198; and street sales, 198–202; tourism in, 14, *14*, 184, 186, 188, 194, 198–199, 200; and wood-carving styles, 128; zócalo of, 11, 184, 198, 201

Oaxaca (state): and artisan organizations, 52–53; economics of, 64; map of, *13*; and state-sponsored wood-carving contests, 128; and tourism, 12, 14, 54. *See also* Central Valleys of Oaxaca

Oaxacan wood carvings: advertisements for, 206–207, 226–234, 238, 241, 242; and craft commercialization, 6–7, 23–30; cultural representations of, 2, 16; early examples of, *xii*; exhibitions of, 55–57; history of, 2, 19–35; institutionalization of, 53–55; new sources of, 49–51; popularity of, 1–2, 15; social life of, 15–18; state's ambivalent attitude towards, 10. *See also* Wood-carving production; Wood-carving styles; Woodcarving trade

Ojeda, Dionicia (Celia), 43, 163

Organization of labor: and Arrazola, 45, 113, 115–117, 118; and artisan families, 113, 114, 117, 118, 119, 123; and commodity chains, 4, 119; and comparisons with other Oaxacan crafts, 119–122; and craft commercialization, 113; and demand for different styles, 241; differences among wood-carving communities, 30; and economic structures,

U.S. marketing channels, 209–234;
wholesalers from, 18, 40, 209–220
Usos y costumbres system, 65, 66, 70, 71,
76–77

Vásquez, Analí, 169, 170
Vásquez, Inocencio, 34, 45, 99, 137, 151,
164, 204
Vásquez, Víctor, xiii, 50, 186, 187, *188*,
195–196, 218
Velásquez, Gabriela, 117–118

Wage labor: and agriculture, 73; archaeo-
logical labor, 92; and household eco-
nomic strategies, 33, 77, 78, 81–86, 88–
93; wood carving as alternative to, 45
Wangeman, Henry, 141, 143, 166, 190–
191
Wasserspring, Lois, 121–122
Weil, Jim, 224
Wholesalers: and appeal of wood carving,
15; and globalization, 237–238; and
household economic strategies, 81;
large-scale operations, 210–215; novice
wholesalers, 219–220; and San Martín
Tilcajete, 34, 46, 209, 212–213, 215,
218, 238; small-scale wholesalers, 217–
218; from United States, 18, 40, 209–
220; and U.S. ethnic arts shops, 220;
upscale wholesalers, 216–217; and
wood-carving communities, 38–39, 40,
41; and wood-carving styles, 129, 241.
See also Dealers
Widener, Kyle, 229–230
Women: comparative earnings of, 121–
122; and embroidered dresses, 74; and
factory-like workshops, 115; and may-
ordomo and usos y costumbres sys-
tems, 70; and migration to U.S., 65;
and organization of labor, 40–41, 50,
87, 88, 107–108, 121, 136, 162; and tor-
tilla sales, 77, 78, 170; and transporta-
tion, 67; and wood-carving production,
85. *See also* Gender relations
Wood-carving production: and agricul-
ture, 81, 82, 83–84, 86; and artisan sig-
natures, 57–58, 108, 155; carving, sand-
ing, and soaking, 95, 98–101; carving
toolkits, 101, 103–104; and carving
types, 214–215; and copal types, 94–95;
economic value of carving and paint-
ing, 108–109; examination of, 2; exclu-
sive focus on, 86, 87; and household
economic strategies, 80–81; and migra-
tion to United States, 80, 81, 82, 84, 85,

86; and multiple economic goals, 82–
86; obtaining wood, 95–98, 231–232;
painting, 40–41, 95, 104–108, 121, 135,
136, 162, 166; strategies of, 18; time al-
located for, 95, 109–111
Wood-carving styles: and Arrazola, 46,
129, 136, 144; and Barbash/Ragan pub-
lications, 175, 181–182, 183; changes
in, xiv; and differences among wood-
carving communities, 46; and La
Unión Tejalapan, 46, 47, 127–128, 129,
131, 136, 140–143, 144, 153, 167, 169,
195; rustic style, 105, 127–128, *128*,
136, 140–143, 195; and specialization,
127–128, 130, 136; and tourism, 128–
129, 135, 144; and transnational iden-
tity, 62
Wood-carving trade: and artisan signa-
tures, 58; Barbash/Ragan publications'
effect on, xiv, 51, 91, 139, 174, 175–
183; boom in, xiii, 35, 37–41, 44, 45,
46, 47, 69, 95, 114, 175, 180, 182, 239;
changes in, xv; comparison with other
Oaxacan crafts, 119–122; and craft
commercialization, 6–7; and exhibi-
tions, 55–57; fieldwork on, xiii, xiv,
16–18, 36–37; future prospects for, 240–
242, 246; and globalization, 235–236,
238–239, 242; and ideology, 10; institu-
tionalization of, 53–55; and Manuel
Jiménez, 20–23; and Oaxaca (city)
shops, 186–198; and product life cycles,
125–126; and romanticization of indig-
enous crafts, 242–243; and sales, 49;
and wood-carving communities, 30–35,
202–205. *See also* Marketing; Special-
ization; Success
Wood, William Warner, 228
Work organization. *See* Organization of
labor
World systems theory, 3, 4

Xuana, Antonio, 45, *134*
Xuana, Justo, 29, *100*, 204

Yalálag (store), 25, 26, 28, 35, 187, 194
Yalálag (town), 34, 194

Zagar, Isaac, 221–222
Zagar, Julia, 221–222
Zapotec Indian identity, 2, 66, 231, 232,
234, 242–243
Zapotecs, 63, 65–66, 71–72, 78, 206, 230–
231
Zompantle, 27, 29, 95, 159, 162